**Hogarth** Mark Hallett

ART&IDEAS

Φ

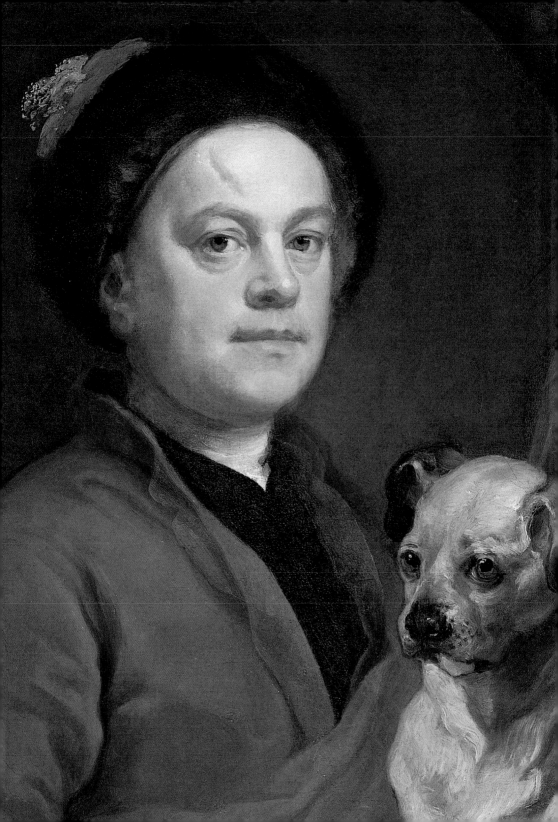

Hogarth

**Opposite**
*The Painter
and his Pug*
(detail of 100),
1745.
Oil on canvas;
90×69cm,
35 $\frac{1}{2}$×27$\frac{1}{8}$in.
Tate Gallery,
London

The hero of *The Distrest Poet* (1) sits in the forlorn light of a garret window, his quill hovering over the unfinished 'Riches: a poem'. Scratching his head and staring blankly into space, he vainly searches for inspiration. Even as he is exposed as a literary failure – his manuscript will no doubt join its crumpled predecessors under the table – this man still seems to wallow in a misguided sense of his own elevated status, and to dream of the wealth his poetry might bring him: he has purchased the sword and wig proper to the gentleman-poet, and pinned a map of the 'Gold Mines of Peru' to the wall. Meanwhile, he is utterly oblivious to the squalid realities of poverty, debt and discomfort faced by the rest of his family. His baby bawls from the gloomy corner of a room dominated by cracked and peeling walls, a feeble fire, an empty cupboard and bare floorboards. His wife, sitting repairing the poet's one remaining pair of trousers, is interrupted by the entrance of an angry milkmaid, who has burst through the doorway demanding the payment of long-due debts. Behind the intruder, and completing this satirical depiction of self-delusion and misery, a dog creeps in and pilfers the family's last piece of food.

In another picture (2), this time a painting rather than an engraving, we find a very different family, shown gathering together in a room graced with expensively panelled walls, fine furniture and elaborately framed works of art. A well-dressed gentleman, still wearing the hat that suggests he has just come in from outside and proudly carrying a newly killed trophy of the hunt, stands next to an ornate silvered tea-table with his decorously posed female companion. Nearby, a pink-cheeked clergyman sits giving orders to a servant. Even as he does so, his gown is playfully tugged by the woman in the centre, who appears to be inviting everyone to abandon their other pursuits and gather together to enjoy the

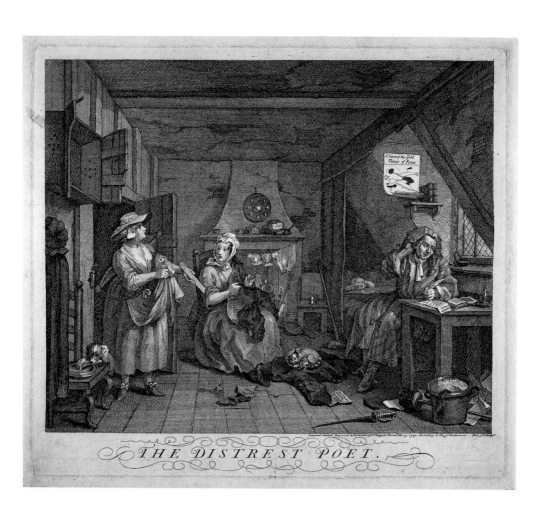

I
*The Distrest
Poet,*
1740.
Engraving;
31·8 × 39·1 cm,
12$\frac{1}{2}$ × 15$\frac{3}{8}$ in

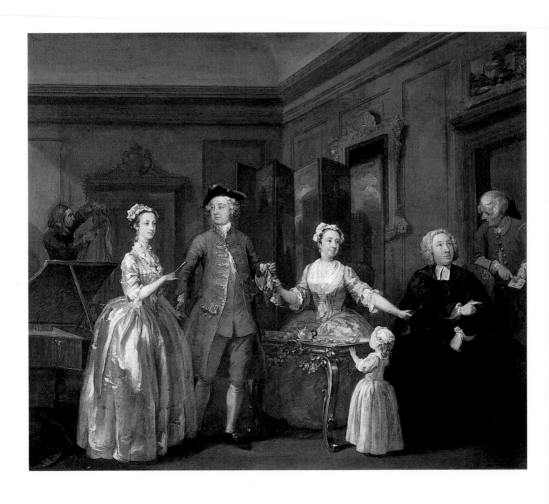

2
*The Western
Family*,
1738.
Oil on canvas;
71·8×83·8 cm,
28¼×33 in.
National
Gallery of
Ireland, Dublin

civilized pleasures of conversation and tea. Here, in utter contrast to the scene in the distressed poet's garret, everything is calm, comfortable and genteel. The very air these people breathe seems pervaded with wealth and politeness.

Both pictures, of course, are by the same eighteenth-century artist, William Hogarth (1697–1764), who was the most celebrated English painter and engraver of his day. These contrasting images demonstrate how Hogarth excelled in both graphic and painted art, adapting established pictorial genres such as satire and portraiture, and infusing them with his own brand of invention and wit. These scenes, concentrating as they do on what Hogarth called 'the highest and lowest life' of the nation, also confirm the intimate relationship of his art to the shifting social and ideological structures of early Georgian England. Hogarth's works – whether focusing on the squalor of a garret, and on figures like the milkmaid and the hack-poet, or celebrating the exquisitely choreographed body language and conversational etiquette of upper-class politeness – were the products of a society in rapid transition, and of a nation that was becoming increasingly commercialized, urbanized and politicized. Pictures such as *The Distrest Poet* and *The Western Family* are both commentaries upon, and testaments to, these broader social, cultural and political developments. Finally, these two images encourage further investigation of Hogarth as a fascinating individual in his own right, a man who experienced both the rigours of economic hardship and the comforts of refined society. He was someone who, in his life as well as his art, moved between those very different communities embodied by the protagonists of *The Distrest Poet* and *The Western Family*, and whose brilliance in depicting the rituals of high and low culture was sharpened by his personal experience of both.

This book, while exploring the interconnections between Hogarth's life, work and the English society in which he lived, will also argue that his art and career can only be properly understood if they are related to the particular environment

of eighteenth-century London, and to the crowded and competitive art world that developed in England's capital over the first fifty years of the century. During Hogarth's lifetime, London grew from a city of about 575,000 inhabitants to one of 700,000, and became established as the undoubted cultural and political centre of the nation. This expanding and dynamic city provides the immediate context for all of Hogarth's work, and his engravings and paintings continually responded to developments and controversies within contemporary metropolitan society. At the same time, it is important to realize that Hogarth was part of an increasingly vibrant artistic culture in the capital. He lived alongside a host of other painters, engravers, art dealers and print publishers, who generated a range of goods and services, both traditional and innovative, for an ever-expanding art-buying public. I shall suggest that Hogarth's career and work were crucially shaped by what he encountered in this rapidly expanding artistic milieu.

In writing this book, I have necessarily relied on the vast scholarship that has accumulated around Hogarth's name, and in particular on the ground-breaking studies of Professor Ronald Paulson, who over recent decades has excavated enormous amounts of material relating to the artist, and offered many provocative interpretations of his output. At the same time, however, I have consistently tried to look at Hogarth's paintings and engravings anew, and to bring to bear my own extended research on the visual arts of the period. In doing so, I have found that Hogarth's work, even after many years of study, continues to repay sustained analysis and investigation, continues to provide a powerful form of aesthetic pleasure and interest, and continues to intrigue and surprise in equal measure. I hope that readers will share at least some of this sense of discovery and excitement.

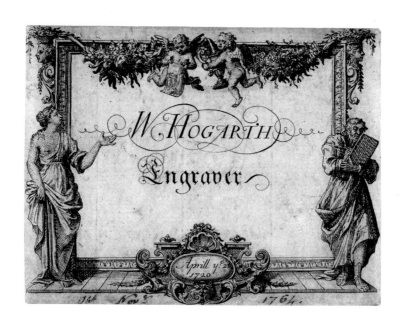

W. Hogarth
Engraver

Aprill yᵉ 23
1720

In the spring of 1720, at the age of twenty-two, William Hogarth
made a subdued but eloquent entry into the world of printmaking.
Sometime in April of that year he issued a small trade card (3),
which formally signalled his decision to set up shop as a profes-
sional copperplate engraver. Despite its modest dimensions and
restricted content, this piece of commercial paraphernalia provides
a powerful indication of Hogarth's skills and aspirations right at
the beginning of his career. On the card, Hogarth's name and
profession are inscribed with a calligraphic flourish that flaunts
his ability as a 'penman' – an accomplished engraver of elegant
lettering. Meanwhile, the figures symbolizing Art and History

on either side, and the floating putti above – one of whom carries a
drawing signifying artistic invention – demonstrate his proficiency
in depicting the human figure, his knowledge of the pictorial
language of allegory and his willingness to engage with the most
elevated subjects and themes. Finally, it is worth noting the elabo-
rately gilded frame, the heavy swags, the sculptural portrait busts
and the swirling, extravagant cartouche that lies at the base of the
image, all of which confirm Hogarth's ability to assemble and
manoeuvre a range of decorative forms drawn from classical
and Continental precedents. It is clear, therefore, that even the
card's tiniest details were designed to show off the young artist's
versatility and sophistication, and to announce a new and ambitious
presence in the field of English engraving.

Hogarth was setting up business in a city crowded with graphic art.
In the first half of the eighteenth century engravings, etchings and
woodcuts covered the walls of London houses, shops and taverns.
They illustrated books, pamphlets and ballads, and brightened
up the promotional material of shopkeepers and merchants.
They were found on the shelves and counters of bookshops and

stationers, and in the catalogues and showrooms of London auction houses. Cheap prints were carried around the city by hawkers, and sold on the streets. More substantial items could even be perused while having a quiet drink: the London coffee-shops held frequent print sales in this period, and hundreds, sometimes thousands, of engravings and etchings would be put on display for days beforehand. Most commonly of all, prints of all kinds filled the windows and interiors of the numerous specialist print shops that clustered around the centre of the city. Walking into these establishments, contemporaries would typically find scores of exquisitely worked engravings, old and new, that translated the most famous masterpieces of Western art, and a host of other painted images, into printed form. At the same time, they could peruse independently designed and engraved prints that ranged across a mass of subjects and styles, and which varied enormously in price. In such places expensive historical engravings, shilling portraits, sixpenny satires and penny woodcuts mingled with landscape etchings, maps, scientific diagrams, religious images, pornography and playing cards, all jostling with each other for the viewer's attention.

Significantly, many of the goods sold in the London print shops, coffee houses, bookshops and auction houses were foreign in origin. Continental engravings and etchings had long been considered superior to English prints in terms of their technique and their links to the more established national schools of European art, whether French, Italian or Dutch. They were imported in their thousands throughout the period, and print-sellers and auctioneers would frequently announce the arrival of a new batch in the daily newspapers. However, locally produced prints were also becoming an increasingly common, reputable and varied component of London's graphic culture over the first half of the century. A community of native and immigrant engravers – of whom Hogarth was soon to become the most famous – began to establish themselves in the city, and to produce works which competed in their sophistication and range with those imported from abroad. As well as supplying local print-sellers, these

engravers also tended to set up shops of their own, normally in a room that fronted their workshops, in order to display their own goods alongside other kinds of graphic art.

London engravers, however, faced more problems than the continuing prejudice against locally produced work. They often found it difficult making their way in a trade that was dominated by a small group of major print publishers who commonly relegated the graphic artist to the role of a jobbing hack. Even as local engravers sought to combat this situation by opening up shops of their own and by becoming increasingly active in devising and promoting their own graphic projects, they still normally relied for their economic survival on being given commissions by the leading print publishers and on being asked by the booksellers and businessmen of the city to provide small-scale illustrations and decorations for their goods. In this guise, unsurprisingly, they tended to be treated as skilled but subordinate craftsmen who would agree to carry out most kinds of graphic task, however petty or badly remunerated. For such men, particularly those with real talent and ambition, the London print trade must frequently have seemed an inhospitable and unpromising place to make a career.

This, then, was the world that Hogarth entered when he set up shop in the spring of 1720. The seeming confidence of his first trade card not only belies the difficulties he was about to face as a novice engraver, but also the complications that had marked his personal and working life up to this point. Hogarth was born on 10 November 1697 in a small house in the City of London near the sprawling medieval hospital of St Bartholomew's, the thriving meat market of Smithfield and the melancholy edifices of Newgate and Fleet prisons. His father, Richard, who had moved to the city from the north of England in the late 1680s and married Hogarth's London-born mother, Anne, in 1690, was the kind of petty entre-preneur found increasingly often in the city, who sold not so much a range of commodities as a range of learning. Self-taught and with no private income, inheritance or connections to speak of, he struggled as a schoolmaster, a linguist, an author and even as

the owner of a Smithfield coffee house where guests were encouraged to speak Latin, before being arrested for debt sometime during the winter of 1707/8. He and his family, which included his daughters Anne and Mary as well as William, were suddenly forced to live in debtors' lodgings near the Fleet prison, where they eked out an existence for four years. They finally escaped this life in 1712, thanks to a parliamentary Insolvent Debtors Bill that offered relief to such families. Six years later, however, in the midst of developing yet another grand but ill-fated scheme – this time the publication of a huge Latin dictionary – Richard Hogarth died, aged fifty-five.

For William Hogarth the pathetic example of his father's life, work and premature death was an extraordinarily powerful one. Still embittered, he was to write towards the end of his own life about how Richard had been let down both by 'great men' – the nobility who promised to support his projects – and by deceitful tradesmen who stole or abused his ideas, and how this in turn had alerted him, the young son, to the vicissitudes of the cultural market-place and the ruthlessness of its leaders: 'I had before my Eyes the precarious State of authors and men of learning. I saw … the difficulties my father went through whos[e] dependence was cheifly on his Pen, [and] the cruel treatment he met with from Bookseller[s] and Printers.' The artist would always define his own career, and the problems he encountered with patrons and print publishers, in relation to Richard's harrowing example. Even during his greatest success, it is clear that he still partly saw himself as sharing his father's status as a social and cultural outsider, permanently in conflict with the dominant interests within his profession. Unsurprisingly, perhaps, given the failure of so many of Richard Hogarth's plans to provide his family with a living, William himself, at the age of sixteen, took a far more conventional and stable route to a career. Having already demonstrated a precocious aptitude for art – 'when at school my exercises were more remarkable for the ornaments which adorn'd them than for the Exercise itself' – in January 1714 he was apprenticed to the silver-plate engraver Ellis Gamble, whose house and workshop lay near Leicester Fields (today's Leicester Square) in the West End of London.

Over the next few years, during which he both lived and worked with Gamble, Hogarth learnt and continually practised the basic graphic skill that underpinned his subsequent career as a print-maker: the art of using a burin – a hand-held instrument that, when pushed firmly and steadily, will cut a clean V-shaped path through silver or copper – to carve out a succession of tightly controlled lines across the hard, resistant surfaces of a metal plate. At Gamble's, Hogarth was put to work carving heraldic and decorative patterns on an endless succession of silver plates, forks, knives, spoons, bowls and tureens, while occasionally being asked to engrave watch-cases and bookplates. Having perfected this painstaking mode of engraving, Hogarth became restless. This was partly an issue of temperament and talent. Hogarth was an impatient, easily bored individual, and he soon came to feel that the work he was being asked to do was stultifying and restrictive: in his own words, 'too limited in every respect'. But it was also an issue of status. Even more acutely than copperplate engravers, silver-plate engravers like Gamble were generally seen as highly skilled craftsmen, rather than men with any pretensions to being artists. Hogarth, having passed the halfway point of his appren-ticeship, clearly felt ready to make a transition not only from apprentice to master, but also from the practices and status assumed by the silver-plate engraver to what he clearly saw as the wider and more prestigious range of graphic possibilities and artistic identities offered by copperplate engraving. Rather unusually and riskily, Hogarth decided to break his apprenticeship with Gamble two years before it was officially due to end, and to strike out on his own as a copperplate engraver.

In this role, Hogarth was soon busy with commissions for book illustrations. These illustrations, as well as being interesting in themselves, usefully reveal how the early eighteenth-century English engraver was expected to rely upon, and respond to, ready-made images. In this period, the publishers and consumers of graphic art more often appreciated the engraving or etching as a pictorial relay, something that successfully passed on an extant image, than as a self-sufficient work of art. Consequently, many

engravers made their careers through producing graphic translations of celebrated or popular paintings, whether for the major print-sellers or for themselves. Even when engravers turned to tasks that might, to modern eyes, seem less dependent on established pictorial models – such as producing book illustrations – they commonly felt little need to design anew, but would often closely follow the most appropriate pictorial precedents. Hogarth, in his early career as a copperplate engraver, is unusual because, while he maintains this practice, he at the same time defines himself in rather different terms, by introducing into his work the unmistakable signs of artistic invention. In doing so, he was beginning, even at this preliminary stage, to align himself with an emergent and more recognizably modern identity for the graphic artist, in which the engraver is lauded more for the force of his imagination and creativity than for his skill in duplicating already existing images.

This is nicely demonstrated by an extensive set of book illustrations which Hogarth produced sometime around 1721. It consisted of seventeen small engravings that were designed to accompany a new edition of Samuel Butler's famous poem *Hudibras*, which had first been published in the 1660s. Butler's work, which was itself loosely based on the narrative of Don Quixote, offered a satiric account of the cataclysmic Civil Wars that had raged in England during the seventeenth century, and focused on the ridiculous figure of Hudibras, a Presbyterian pedant and zealot who, with his similarly deluded companion, Ralpho, wanders through the war-torn English countryside on his horse and gets caught up in a series of farcical encounters with mobs, magicians, lawyers and violent females. By the eighteenth century Butler's poem, at turns mock-heroic, mock-romantic and grossly satirical, had come to stand as the great comic and poetic counterpart to more established and decorous historical accounts of the Civil Wars, and was frequently reissued by the London booksellers. Thus, in 1710, John Baker published an edition that was copiously illustrated by an anonymous engraver, who began with an image of Hudibras and Ralpho setting out on their journey (4) and who then went on to depict some of the most comic and colourful episodes from

Butler's narrative, including the incident when Trulla, a 'bold *Virago*, stout and tall', who has just attacked and vanquished the prostrate Hudibras, defends him from further ignominy at the hands of a stave-wielding mob (5).

Significantly, when Hogarth came to engrave sixteen illustrations for yet another edition of *Hudibras* a decade or so later, he closely followed the scenes depicted in the 1710 publication, and repeatedly duplicated their contents. Thus, his first image (6) clearly uses the earlier engraving as a blueprint: look, for instance, at the way in which Hogarth's image reproduces the silhouette of the squat, misshapen Hudibras found in the 1710 illustration, together with that of his scrawny horse. Similarly, Hogarth's fifth illustration (7) again depends on his predecessor's plate in its depiction of Trulla defending Hudibras against the mob, down to the details of the dropped hat and pistol. This kind of repetition, it is worth stressing, is not so much the consequence of any laziness or fraudulence on Hogarth's part, but rather the product of a culture in which graphic images frequently functioned as repositories of previously established pictorial forms. At the same time, however, when comparing Hogarth's images with those produced earlier in the century, it is also clear that he reworked his sources quite extensively. Even in his first image, where the correspondence is so strong, he not only depicts Hudibras with a far looser and more lively line, but also twists Ralpho's body around and introduces the swirl of trees in the background. In the second example, his manipulation of his model is even more dramatic. The mob have spilt into the image, the horse has retreated to the background and, most noticeably of all, the houses that so discreetly mark the horizon in the former etching are pulled into prominence, and tower over the participants. In all of these ways, Hogarth deviates from his role as copyist, reassembles his given pictorial materials and translates them into something quite fresh.

Soon after completing these illustrations, and alongside the variety of graphic works he continued to produce throughout the 1720s – which included other book illustrations, trade cards, theatre

4
**Anonymous**,
*Hudibras
Sallying Forth*,
1710.
Engraving

5
**Anonymous**,
*Hudibras
Vanquished
by Trulla*,
1710.
Engraving

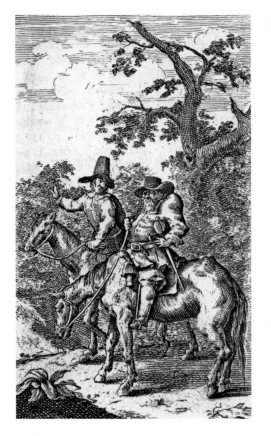

6
*Hudibras
Sallying Forth,*
*c.*1721/6.
Engraving;
12·1×7·2cm,
4¾×2⅞in

7
*Hudibras
Vanquished
by Trulla,*
*c.*1721/6.
Engraving;
12·1×7·3cm,
4¾×2⅞in

tickets and funeral tokens – Hogarth began to experiment with
a pictorial genre which allowed him to pursue and develop the
creative play with different kinds of imagery found in the *Hudibras*
engravings. This was graphic satire. Satirical engravings and
etchings combined witty, vitriolic or propagandistic commentary
on contemporary social and political life with a highly eclectic
formal character as assemblages of very different kinds of pictorial
and literary materials. They provided an ironic, topical and
experimental alternative to other kinds of print. They were often
densely allusive and technically sophisticated, and appeared with
particular frequency at times of crisis. Significantly, just as
Hogarth was turning to this graphic genre, a new mode of satire
was being introduced into the print shops of the city.

In 1721, the print-seller Thomas Bowles organized the reproduction
and translation of a number of Dutch satires that commentated on
the episode known in history as the South Sea Bubble. This is the
name given to a Europe-wide frenzy of share-dealing in the South
Sea Company over the summer of 1720, in which huge amounts of
money were invested in a bewildering array of improbable trading
ventures. Over the following autumn and winter, the over-inflated
financial markets collapsed, and there was widespread bankruptcy
among small and large investors. London – and the financial
district around the street known as Exchange Alley in particular –
suffered badly, and commentators feverishly described the Bubble's
catastrophic aftermath in the city: the *London Journal*, for instance,
wrote of how 'the cries of widows, orphans and distressed families,
fill our streets … Exchange Alley is the mere representation of
Hell, and nothing appears but Rage, Distraction, and Despair
… the Affair plunges every day deeper into ruin and destruction.'
The prints that Bowles adapted for the English market offered
a similarly apocalyptic imagery of urban delusion, breakdown
and madness. Most dramatic of all was *A Monument Dedicated
to Posterity* (8) by Bernard Picart (1673–1733) and Bernard Baron
(1696–1762) which depicts a chaotic cavalcade of investors following
the allegorical figures of Fortune and Folly, and the emblematic
representatives of the different trading companies, as they proceed

8
Bernard Baron
after Bernard
Picart,
*A Monument
Dedicated to
Posterity*,
1721.
Engraving;
21×34.3 cm,
8¼×13½ in

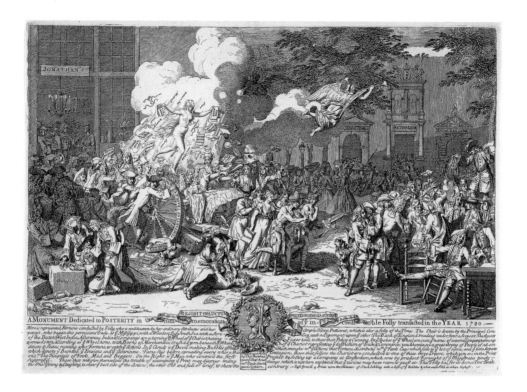

through Exchange Alley, where men gamble their money away, fight to the death and mill around a share dealer. *A Monument Dedicated to Posterity* and its companions made a dramatic impact on the London print market, combining as they did caustic social criticism of urban gullibility and greed with the most adventurous kind of pictorial eclecticism, in which angels and devils, outlandish figures of allegory, displaced fragments of architecture and a whole gamut of written quotations and inscriptions are intermixed with the carefully observed figures of contemporary men and women crowding the streets of the modern city.

Hogarth's first attempt at producing an independent satiric image was highly responsive to the Dutch engravings imported by Bowles, and maintained satire's traditional combination of acidic critique and pictorial heterogeneity. *The South Sea Scheme* (9) depicts a similarly frenetic urban scene to that pictured by Picart and Baron, dominated by the same Bubble-induced narratives of greed, speculation and violence. Here, everyone is caught up in a

**9**
*The South
Sea Scheme,*
*c.*1721.
Engraving;
22·2 × 31·8 cm,
8¾ × 12½ in

W. Hogarth Invent. et Sculp.

See here ȳ Causes why in London,
So many Men are made, & undone,
That Arts & honest Trading drop
To Swarm about ȳ Devils Shop,(A)
Who Cuts out (B) Fortunes Golden Haunches

Trapping their Souls with Lotts & Cha
Shareing ȇ from Blue Garters down
To all Blue Aprons in the Town.
Here all Religions flock together
Like Tame & Wild Fowl of a Feath

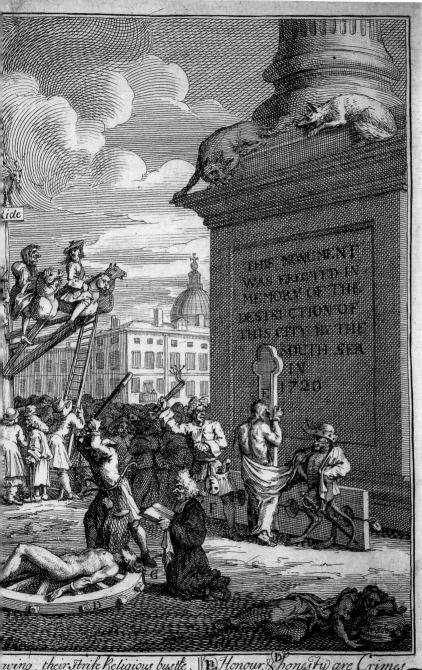

ide

THE MONUMENT
WAS ERECTED IN
MEMORY OF THE
DESTRUCTION OF
THIS CITY BY THE
SOUTH SEA
IN
1720

wing their Strife Religious bustle,
l donn to play a pitch & Hussle, (C)
s when the Sheepherds are at play
ir flocks must surely go Astray,
woeful Cause y in these Times.

(D) Honour, & honesty, are Crimes,
That publickly are punish'd by
(G) Self Interest, and (F) Vilany;
So much for Mony's magick power
Guess at the Rest you find out more
price 1 Shilling

form of collective fantasy, which Hogarth partly conveys through the monstrous, hallucinatory combination of the grotesque and the everyday. Two emblematic figures of Honesty and Honour, their flesh exposed and their bodies bound, are flayed and battered by the thug-like personifications of Self-interest and Villainy. An ape symbolizing vain emulation stands on the right, while a kneeling clergyman reads the last rites in the foreground. A wheel of fortune surmounted by a goat spins dizzily around, whirling a prostitute, a clergyman, a shoeblack, a hag and a Scotsman to their ruinous fates. Nearby, expectant spinsters gather on a balcony, hoping to win a husband in a lottery. On the far left, the Devil appears next to the hacked, hanging figure of Fortune, offering one of her severed hands to the milling crowd of speculators standing below (in a bizarre echo of the scene on the right-hand side of Picart and Baron's print). As in *A Monument Dedicated to Posterity*, a pickpocket is at work on the fringes of this crowd, yet another symbol of the ways in which ordinary Londoners, temporarily bereft of all sense of reason and caution, were being robbed of their fortunes.

10
Anonymous,
*Monument
to the Fire
of London*,
c.1680.
Engraving

Hogarth reinforces his print's pervasive sense of disorientation and fantasy by transforming London into a conglomeration of displaced public buildings, pulled from their rightful positions into a new and chaotic proximity – the Guildhall on the left, St Paul's in the distance and the Monument to the Fire of London on the right, which is newly decorated with sly, prowling foxes, and pictorially transformed into a Monument to the Bubble itself. These structures, rather than being shown in isolated and ordered grandeur, as was the case in other engravings from the period (10), are depicted with a haphazard, careering perspective that is clearly meant to suggest the erratic, deluded perspectives of the South Sea phenomenon itself.

In 1724, having seen that graphic satire was a viable commodity on the print market and recognizing its potential as a vehicle of artistic invention and freedom, Hogarth for the first time decided to design, engrave and – most importantly – publish a satiric print.

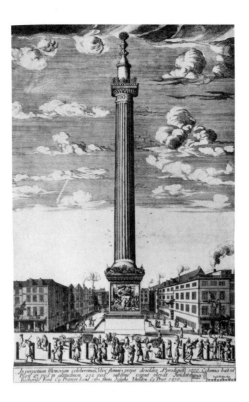

In perpetuam Memoriam celeberrimae, felicisq flammis prope deuolutae A prodigiose 1666. Columna haec ex
Pixel 27. ped in altitudinem, 202. ped sublime caput elevat Fundatione
Richardi Ford Eq Pretore Lond 1671 finita Iosepho Sheldon Eq Pret 1676.

*The Bad Taste of the Town* (11), issued in February that year, marks
Hogarth's first real attempt to operate outside the commercial
hierarchy of the graphic arts in London and finance his own
artistic ventures. Other leading engravers in this period were
making similar declarations of independence, but what is striking
about Hogarth was his turn to satire as a means of carving out a
distinct identity for himself in the marketplace for graphic art.
*The Bad Taste of the Town*, although small in scale and sketchy in
execution, was a provocative and sophisticated image with which
to begin this process.

Hogarth's print suggests that high culture has become little more
than a prostituted form of spectacle in the modern city, dominated
by foreign entertainments, manipulated by mercenary entrepreneurs
and patronized by an urban élite who have become as enthralled by
this culture's superficial allure as they were by the vapid promises of
the Bubble. As in *The South Sea Scheme*, the scene Hogarth depicts
is made up of a fantastic, tripartite constellation of different

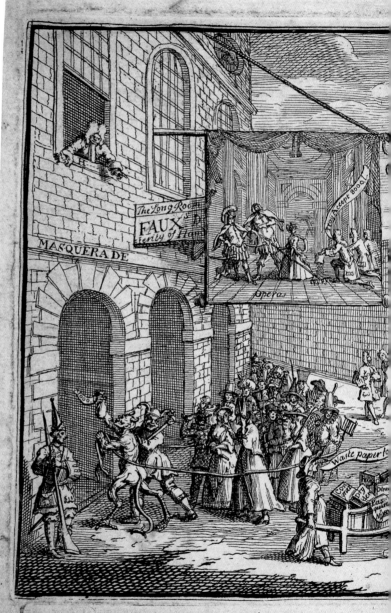

Could new dumb Faustus, to reform the Age,
Conjure up Shakespear's or Ben Johnson's Ghost,
They'd blush for shame, to see the English Stage
Debauch'd by fool'ries, at so great a cost.

Price 1

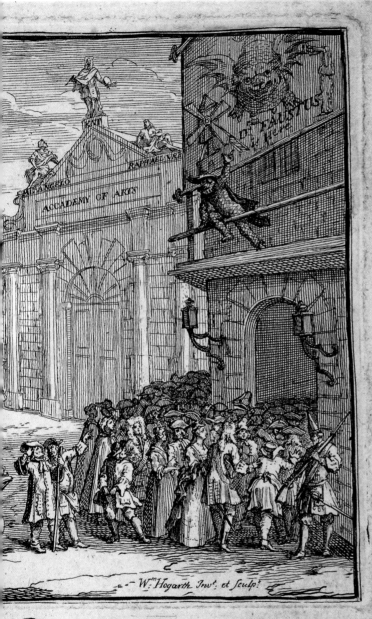

11
*The Bad Taste
of the Town*,
1724.
Engraving;
12.7 × 14.3 cm,
5 × 6⅝ in

*hat would their Manes say? should they behold*

*Monsters and Masquerades, where usefull Plays*

*dorn'd the fruitfull Theatre of old,*

*nd Rival Wits contended for the Bays.*

*9.1724*

London buildings: the Opera House on the left, the gateway of Burlington House in the centre and Lincoln's Inn Fields Theatre on the right. Hogarth ridicules each in turn. In front of the opera house a huge, hanging sign depicts three of its foreign singing stars, Senesino, Berenstadt and Cuzzoni, receiving bags of money from a group of prostrate noblemen. The same building is also exposed as a venue for the newly fashionable entertainment of the masquerade, to which a gullible group of masked and costumed Londoners are herded by a fool and a devil; above them, the man perceived as chiefly responsible for promoting this craze in the city, the Swiss impresario Heidegger, looks gleefully down from an upper window. Meanwhile, another sign announces that the conjuror Fawkes – his name inscribed as 'Faux' – is performing a show in the adjacent Long Room. In the background, Hogarth satirizes another site of high culture, the house of Lord Burlington and his protégé, the painter, designer and decorator William Kent (1685–1748), who were famous at the time for their dissemination of a 'foreign', Palladian taste in architecture and their patronage of an Italianate mode of art. Inverting all natural hierarchies, Kent is shown at the head of the gateway, towering over the recumbent figures of Michelangelo and Raphael, and being admiringly discussed by three deluded connoisseurs in the roadway.

Meanwhile, on the right, Hogarth attacks another imported urban fashion, that for the *commedia dell'arte* pantomime. In the early 1720s, pantomime – which was also closely associated with the traditions of 'low' fairground entertainment – had become the most popular form of playhouse performance in the city, and was particularly linked to John Rich's reign as actor-manager at Lincoln's Inn Fields Theatre. Rich's *Harlequin Doctor Faustus*, the pantomime advertised in *The Bad Taste of the Town*, was particularly successful, combining extravagant special effects with acrobatic forms of physical display. In Hogarth's print, the harlequin who leans over the balcony, urging the crowds into the theatre and standing in an equivalent position to those occupied by Heidegger and Kent elsewhere in the print, surely symbolizes Rich himself. Finally, in the centre of the satire, we

see a wheelbarrow piled high with abandoned books and journals, destined to be turned into 'waste paper for shops': significantly, these include the dramatic works of William Congreve, John Dryden, Thomas Otway, William Shakespeare, Joseph Addison and Ben Jonson. The inference is clear: the great tradition of English literature and drama was being laid to waste by the alien and irrational forms that had newly colonized the English stage, and that threatened to overwhelm every kind of cultural tradition and practice native to the nation, including those of art and architecture.

Hogarth was not alone in mounting this kind of attack. Beyond the field of graphic satire, numerous commentators wrote of a revolution taking place on stage, in which the activities of authors and actors had been superseded by the visceral thrills of sensation and the irrational attractions of spectacle. As early as 1720, an issue of *The Theatre* had bemoaned this transition: 'I forsee the theatre is to be utterly destroy'd, and sensation is to banish reflection, as sound is to beat down sense … the head and heart are to be mov'd no more, but the basest parts of the body to be hereafter the sole instrument of humane delight.' Others maintained this melancholy sense of a whole cultural tradition being lost. In this context, it is particularly suggestive to hunt up the clue Hogarth leaves by placing a copy of the journal *Pasquin* in the wheelbarrow full of books. In the months previous to the publication of *The Bad Taste of the Town*, this journal had pointedly remarked on the 'fall'n condition of dramatic poetry, between the fashionable gout for Opera's on the one hand, and the more unaccountable curiosity for I know not what on the other. All taste and relish for the manly and sublime pleasures of the stage are as absolutely lost and forgotten, as though such things had never been.' Finally, the satirical poem *The Dancing Devils: or the Roaring Dragon*, published in 1724, comments that Rich's pantomime offered a grotesque, mechanical and spectacular successor to the rational traditions of the English playhouse: 'now, the Stage revolts from these / Dramatick rules that us'd to please, / And does, in scorn of wit, impose / Upon the Town, Dumb Raree Shows, / Compos'd of Vizards and Grimaces, / Fine Scenes, Machines and Antick Dresses.'

*The Bad Taste of the Town* dramatizes a similarly melancholy transition from a culture of intellectual engagement and rational pleasure to one which revolves around spectacle and sensation. Hogarth's print places intriguing emphasis on how a modern culture of spectacle operates through powerful forms of visual advertisement. It is filled with signs and placards glamorizing the entertainments that lie in wait for modern consumers, including the huge signboard that hangs outside the Opera House and the enormous painted screen covering the façade of Lincoln's Inn Fields Theatre. Similarly, the mock-heroic statues on the distant gateway dramatize the space behind the wall as a refined 'Accademy of Arts' populated by a new breed of cultural sophisticate. Hogarth, through placing such an emphasis on this kind of promotional imagery, can be understood as already gesturing to the alluring but deceptive power of artistic representation in guiding consumer desire. More broadly, however, *The Bad Taste of the Town*, by pulling together three seemingly different buildings and institutions – and linking them to each other through such pictorial devices as the repeated use of archways across the engraving – suggests how all sectors of modern cultural activity have become subsumed within a vulgarized whole, within which the fairground huckstering of the harlequin, the decorative follies of the aristocrat and the exaggerated posturing of the opera singer are merely interchangeable, overlapping elements.

In making this critique, Hogarth again exploited graphic satire's characteristic strategy of appropriating established pictorial forms and materials. Thus, to give just one example, the opera house sign is blatantly adapted from a recent, anonymously produced graphic satire ridiculing the foreign stars of the Opera House (12). This alerts us to the fact that *The Bad Taste of the Town*, like the other graphic satires of the period, needs to be understood not only as witty commentary on a contemporary urban phenomenon but also as a self-consciously composite image that playfully meshes together a mass of pictorial materials in order to suggest the parlous state of contemporary theatre, music and art. Looking at the print in this way also suggests, paradoxically, quite how

**12**
**Anonymous,**
*Berenstadt,*
*Cuzzoni and*
*Senesino,*
1723.
Engraving;
18.7 × 26 cm,
7³⁄₈ × 10¹⁄₄ in

closely its fractured, discordant and indecorous mode of pictorial organization parallels the confusion, grotesquery and eclecticism of the modern urban entertainment that it was attacking. In this respect, Hogarth's satire is ultimately exposed as itself a product of the culture that it criticized, and as something that inevitably mimicked that culture's values and practices even as it sought to undermine them.

While *The Bad Taste of the Town* proved that Hogarth was becoming increasingly confident in the hybrid genre of satire, its publication also demonstrated the power of the print trade to confound the individual engraver's attempts at commercial independence. Very quickly, cheap copies of Hogarth's print began to be sold in the print shops of the city, and the artist was forced into the position of repeatedly using the London newspapers to declare that authentic versions were only to be found in his premises in Little Newport Street, and at a clutch of selected print shops nearby. Given these problems, which ultimately forced the disillusioned Hogarth into selling his copperplate to a rival print-seller, it is no surprise to find that he returned to a more conventional commercial arrangement for his next major project, in which he produced a new set of *Hudibras* engravings, issued in February 1726, for the print publishers Philip Overton and John Cooper. The twelve large prints were designed to stand alone as independent works of graphic art – accompanied by captioned extracts from Butler's poem – rather than be understood as mere illustrations.

In his new series, Hogarth selected certain scenes from his previous set of *Hudibras* illustrations – themselves adaptations of an earlier, anonymous group of pictures – and transformed them into images fitting for such a grand graphic project. Comparing the engravings which correspond to those illustrations discussed earlier in this chapter, *Hudibras Sallying Forth* (13) and *Hudibras Vanquished by Trulla* (14), demonstrates that while Hogarth maintained the basic features of his earlier pictures, he also made many changes. The new engravings are horizontal rather than vertical in format, and are engraved with far greater detail and sophistication. The

environments they depict are subtly different: enclosed pockets
of the English countryside are suddenly turned into grand vistas,
complete with distant fields and bridges. New participants are
added, and existing figures are arranged more decorously. Thus,
two peasants are introduced into *Hudibras Sallying Forth*, while in
*Hudibras Vanquished by Trulla* we encounter a relatively ordered
frieze of individuals rather than the riotous crush of bodies
found in the smaller illustration. In both of the larger engravings,
moreover, there is a far stronger sense of pictorial hierarchy than in
the illustrations, whereby the main protagonists of each scene are
not only uniformly centralized, but also defined in more obvious
relation to responsive groups of subordinate figures – the yokels in
the first instance, the mob in the second. This gives characters like
Hudibras, in the first plate, and Trulla, in the second, a new status
as figures occupying the pictorially dominant positions expected of
heroes, even as they are satirically exposed as being wholly unfit to
carry out these roles. In all of these ways, Hogarth elevated the
aesthetic status of his prints, something that he reinforced by
engraving an elaborate frontispiece (15), complete with a decorous
portrait of Butler himself, an elegant figure of Britannia and the
classical details of the satyr, the putti and the stone relief.

Making these changes not only announced the artistic ambition
and refinement of the new *Hudibras* series, but also confirmed its
status as a mock-heroic counterpart to more obviously idealized
images of the Civil Wars. Here it is worth remembering that
Butler's text had come to function in the eighteenth century as
a burlesque but learned alternative to the grand histories of the
wars, exemplified most famously by Clarendon's *History of the
Rebellion*. Hogarth's new prints enjoyed a similar kind of status
in relation to a burgeoning genre of modern art which pictured the
wars in terms of virile heroes, dramatic battles and enlightened
ideals. Most intriguingly, the new *Hudibras* set was ordered and
produced at a time when a group of other major print-sellers
in the city – led by John Bowles – was commissioning paintings
and engravings of *The Reign of Charles the First*, finally issued
as a set of prints in 1728 but begun in the early 1720s. Comparing

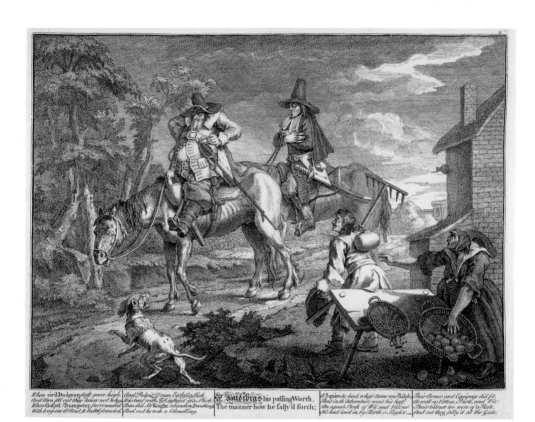

When civil Dudgeon first grew high,
And Men fell out they knew not why,
When Gospel-Trumpeter, surrounded
With long-ear'd Rout, to Battel sounded,

And Pulpit, Drum Ecclesiastick,
Was beat with Fist, instead of a Stick;
Then did Sr Knight abandon Dwelling,
And out he rode a Colonelling.

Hudibras his passing Worth,
The manner how he sally'd forth;

A Squire he had, whose name was Ralph,
That in th' Adventure went his half.
An equall Stock of Wit and Valour
He had laid in, by Birth & Taylor.

Their Armes and Equipage did fit;
As well as Vertue, Parts, and Wit:
Their Tallons too were of y Rate,
And out they sally'd at the Gate;

13
*Hudibras*
*Sallying Forth,*
1726.
Engraving;
24.5 × 33.7 cm,
9⅝ × 13¼ in

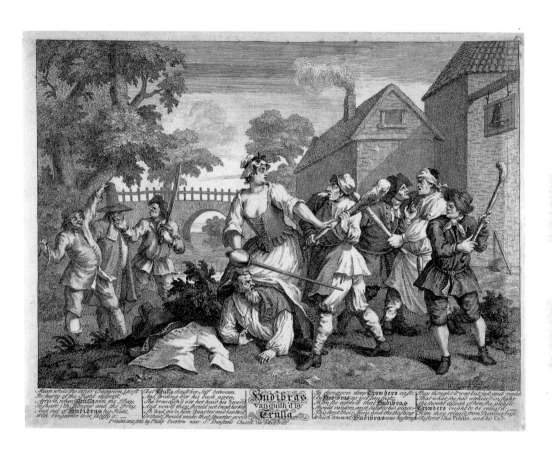

**14**
*Hudibras*
*Vanquished*
*by Trulla*,
1726.
Engraving;
23.5×33.3cm,
9¼×13⅛in

Hogarth's images, which included such engravings as *Hudibras's First Adventure* (16) with those sponsored by Bowles, of which *The King's Declaration* by Peter Tillemans (1684–1734; 17) is exemplary, suggests how the Hudibras prints, in their pictorial form and composition as much as in their narratives, offered mock-heroic versions of the most serious kinds of modern history painting and engraving. The comparison with *The King's Declaration* not only defines the figures found in plates like *Hudibras's First Adventure* as grotesque, comic, plebeian and Puritanical antitypes to the refined, tragic, aristocratic and Anglican heroes of the Civil Wars, but also situates Overton, Cooper and Hogarth's project as an

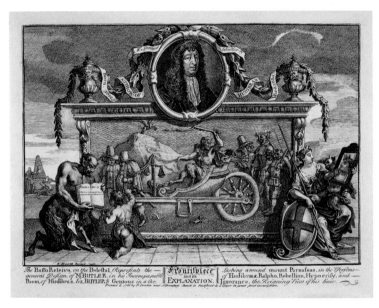

15
*Hudibras,*
frontispiece,
1726.
Engraving;
23.8 × 34.3 cm,
9⅜ × 13½ in

16
*Hudibras's First
Adventure,*
1726.
Engraving;
24.1 × 33 cm,
9½ × 13 in

17
Gerard
Vandergucht
after Peter
Tillemans,
*The King's
Declaration,*
c.1720–8.
Engraving;
36 × 44.8 cm,
14½ × 17⅝ in

ambitious satiric alternative to the kinds of pictorial histories of the seventeenth century represented by *The Reign of Charles the First*.

The twelve engravings of *Hudibras*, while confirming the artistic promise Hogarth had demonstrated throughout the 1720s, also contributed to his growing sense of disillusion with the workings of the print trade. While he was given increasing recognition in the advertisements for the series, his name and his earnings remained under the control of Overton and Cooper. In the years immediately after his involvement in this series, Hogarth

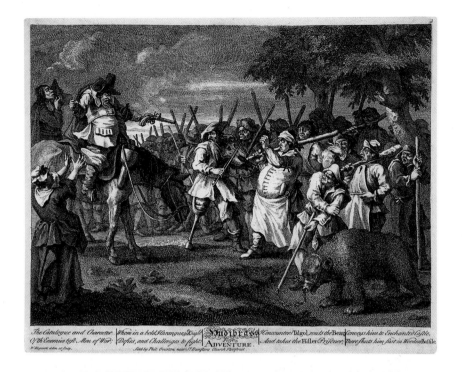

The Catalogue and Character : Whom in a bold Harangue Knight **Hudibras** He encounters Talgol, routs the Bear, convoys him to Enchanted Castle.
Of th' Enemies best Men of War : Defies, and Challenges to fight. **first ADVENTURE**. And takes the Fidler Prisoner : There shuts him fast in Wooden Bastile.

W.m Hogarth delin: et Sculp.                    Sold by Phil: Overton, near S.t Dunstans Church Fleetstreet.

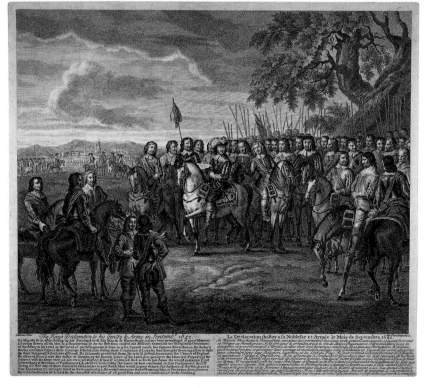

The Kings Declaration to his Gentry & Arms in Septemb.r 1642.          La Déclaration du Roy a sa Noblesse et Armée le Mois de Septembre 1642.

increasingly sought to extricate himself from such arrangements, and to think of new ways to improve his reputation and his fortune. For now, publishing independent satires remained too difficult and unpromising an option; in his own words, financing *The Bad Taste of the Town* had only served to confirm the power of 'a monopoly of printsellers' who were 'destructive to the Ingenious', by which, of course, he meant men like himself. Instead, he temporarily turned his attentions away from the world of ink, and of graphic art, and began a parallel career in the world of paint.

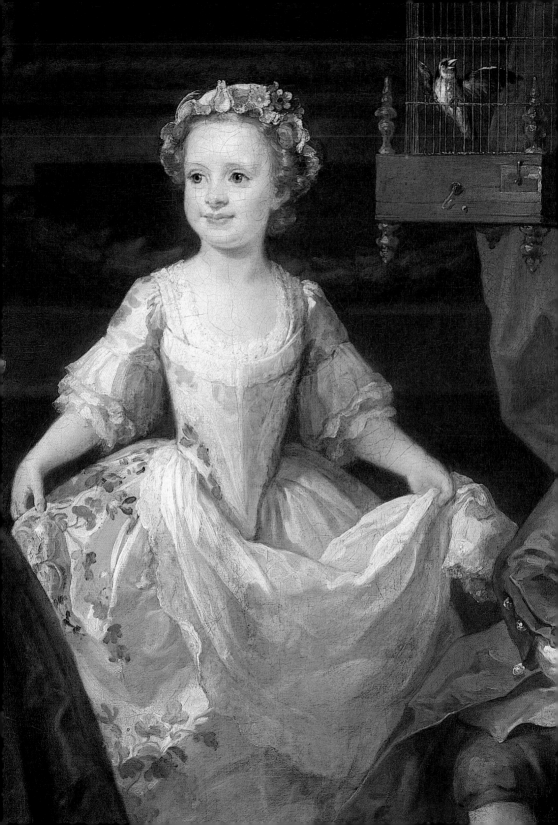

In October 1720, some six months after he issued his first trade card, Hogarth enrolled in a newly founded 'Academy of Painting' housed in a large, hired room in St Martin's Lane, and open five evenings a week over its annual winter season. Set up by the engraver Louis Chéron (1660–1725) and the painter John Vanderbank (1694–1739), and comprising some thirty-five members, who each paid a two-guinea subscription, this informally run body advertised itself as 'The Academy for the Improvement of Painters and Sculptors by drawing from the Naked'. While the practical study on offer was indeed limited to drawing from the unclothed male and female model, the 'Improvement' which such an institution promised to a young artist like Hogarth amounted to far more than this. For, at the St Martin's Lane Academy, Hogarth entered a space that was strikingly cosmopolitan and socially elevated in comparison with his print shop and workroom. For the first time, he rubbed shoulders with established painters, engravers and sculptors on a day-to-day basis, in an environment that must have resembled a gentleman's club as much as a place of artistic practice. More occasionally, he came into contact with interested connoisseurs and socialites, including his future patron Sir Andrew Fountaine, who visited the academy with the Prince of Wales in 1722. In this process, Hogarth underwent an alternative, unofficial and far more wide-ranging apprenticeship compared to that he had undergone with Ellis Gamble. It was one which gave him the technical and social skills necessary to move into a new artistic milieu, one that was defined by the medium of paint.

18
*The Graham Children*
(detail of 33)

However much the vocabulary, membership and guest list of the St Martin's Lane Academy might suggest otherwise, the practice of painting in early eighteenth-century London – like that of

engraving – was in many ways a constricted and unpromising one for locally born artists. In this period, public patrons of art such as the Church and the Crown had neither the finances nor the authority to sponsor ambitious works of contemporary painting, while the traditional sources of private patronage – the landed aristocracy and gentry – favoured paintings produced abroad to furnish their houses and foreign-born painters to paint views of their estates. The demand for contemporary British painting was further dampened by the fact that London coffee-houses, taverns and auction houses held numerous sales of imported canvases, both old and new. Even the practice of portraiture, which remained the pictorial genre most open to local painters, was dominated by a clutch of foreign artists who had settled in London at the turn of the century. Contemporary English patrons, searching for someone to paint their likeness, remained suspicious of hiring artists who, unlike their Continental counterparts, could claim neither links to established national schools of painting nor a training in one of the famous European academies of art. Lacking this kind of pedigree and unable to prove themselves in the most challenging categories of painting, local painters struggled to shake off the prejudice that they were engaged in a 'mechanick' and not a 'liberal' form of pictorial practice. They were often perceived as artisans whose work centred on their dexterity of hand and steadiness of eye, rather than as artists whose output was the fruit of intellect and imagination.

The loosely organized academies of painting which developed in London over the first decades of the eighteenth century offered a dual response to this situation. On the one hand, they consolidated the position of immigrant painters in the capital, and offered a potent symbol of the refined practices they had brought with them to the local market. The first of these academies, which opened in 1711, was run on continental lines by the German-born portraitist Sir Godfrey Kneller (c.1646–1723), and the English names on its membership list, just as in the case of the St Martin's Lane Academy a few years later, are regularly interspersed with those of Italian, French, Dutch and German painters who had

travelled to London to further their careers. Therefore, it is clear that these academies partially functioned to promote the fact that skills and painters normally found abroad were now available in London itself. On the other hand, these same academies offered aspiring English painters a training in hitherto undeveloped techniques and, even more crucially, an arena in which they could publicly compete with their fellow academicians from abroad. Furthermore, through linking pictorial practice to the intellectual and pedagogic associations of an academy, and to the etiquette and values of a gentleman's club, such places encouraged English painters to define themselves as men of learning and gentility, fit to cater to the demands of the most stringently refined patrons. No wonder, then, that Hogarth was so attracted to the idea of entering the academy at St Martin's Lane, and that he continued to maintain his links with this body – and others like it, such as the drawing academy run by Sir James Thornhill (c.1675–1734) in Covent Garden from the mid-1720s onwards – in the years after he first joined.

Nevertheless, artistic credibility and commercial success were not guaranteed by membership of the academy alone, nor even by the demonstration of great promise within its walls. To make his breakthrough as an English painter, Hogarth also depended on shifts in the nature of demand. More specifically, he benefited from the emergence of a new generation of patrons, whose wealth was as frequently derived from commerce as from land, and who defined themselves in relation to the values of the city as much as to the mores of the countryside. These were people cultivating and participating in what they themselves understood as a modern culture of 'politeness', which was partially based on the virtues of a decorous sociability, but which also expressed itself in distinctly modern forms of aesthetic discrimination and artistic patronage. In this respect, it is significant that the 1720s and 1730s saw a series of innovative and highly novel forms of painting being produced for such patrons by younger London artists. Ranging from canvases celebrating the fashionable forms of urban theatre to those picturing the subtle calibrations of genteel conversation, these paintings are linked together by their explicit engagement,

however idealized or satirical, with the contemporary entertainments and rituals of polite society. As such, they provided their buyers with a sophisticated pictorial commentary, both laudatory and witty, on their own newly fabricated culture.

Hogarth first became the beneficiary of such developments at the end of the 1720s, when he produced a series of paintings depicting a scene from John Gay's *The Beggar's Opera*, which had become the most celebrated and commercially successful theatrical production of the period. First performed in John Rich's Lincoln's Inn Fields Theatre in January 1728, Gay's play had a cast of low-life characters taken from the modern city and included numerous ballad

19
*Scene in the Beggar's Opera,*
c.1728.
Black chalk;
37.2 × 49.2 cm,
14⁵⁄₈ × 19³⁄₈ in.
Royal
Collection

interludes. The production systematically parodied the extravagant music, mythological protagonists and historical settings of contemporary opera. At the same time, it wittily aligned its world of beggars, highwaymen, thieves, informers, jailers and prostitutes with the manners and morals of high society. The play's fictional author, the beggar himself, declares that 'through the whole piece you may observe such a similitude of manners in high and low life, that it is difficult to determine whether (in the fashionable vices) the fine gentlemen imitate the gentlemen of the road, or the gentlemen of the road the fine gentlemen.' Intriguingly, this satiric comparison between the vulgar and the refined was made all the

more vivid by the fact that, at Lincoln's Inn Fields Theatre, the actors playing criminals and prostitutes were bodily juxtaposed with numerous wealthy men and women who had paid extra money to sit on and around the edges of the stage. Finally, *The Beggar's Opera* was also distinguished by a complicated plot of romance and intrigue, in which its glamorous anti-hero, the highwayman Macheath, ends up married to both Polly Peachum, the innocent but gullible daughter of a rakish crook who turns fellow-criminals over to the authorities, and Lucy Lockit, the similarly naive daughter of a corrupt Newgate jailer.

This tangled triangular relationship became the central subject of Hogarth's numerous paintings of *The Beggar's Opera* produced between 1728 and 1731, the starting-point of which was a drawing in black chalk (19) that the artist made of a late scene in the play, in which Macheath, clamped in leg-irons, stands between Lucy and Polly, who implore their fathers – Lockit on the left, Peachum on the right – to set the highwayman free. Across the background, we see the lightly sketched outlines of that part of the audience that spilt on to the stage, as well as a detail from the set showing an opened prison door. In depicting *The Beggar's Opera* in this way and turning it into the basis for a sustained artistic project, Hogarth was participating in a broader form of cultural commentary and commercialization. The success of Gay's play generated numerous textual and visual spin-offs, including John Faber's (1660–1721) mezzotint prints of the actors who played the roles of Macheath and Polly Peachum (20, 21), taken from designs by John Ellys (1701–57), another member of the St Martin's Lane Academy. At the same time, graphic satirists attacked *The Beggar's Opera* for its immoral protagonists, low-life language and debased subject matter. *The Stage Medley* (22) satirically adapted Faber's images and incorporated them into a wide-ranging attack on the contemporary craze for *The Beggar's Opera* in genteel society. Reproducing the eclectic pictorial organization and many of the sentiments of Hogarth's own *Bad Taste of the Town* (see 11) of four years earlier, this satirical medley focuses in particular on the contemporary glamorization of Polly Peachum, played by the

20 Overleaf
John Faber
after John
Ellys,
*Mr Walker in
the Character
of Captain
Macheath*,
1728.
Mezzotint;
34.9×25.1cm,
13³⁄₄×9⁷⁄₈in
21
John Faber
after John
Ellys,
*Miss Fenton*,
1728.
Mezzotint;
34.9×25.1cm,
13³⁄₄×9⁷⁄₈in
22
Anonymous,
*The Stage
Medley*,
1728.
Engraving;
36.5×26cm,
14³⁄₈×10¹⁄₄in

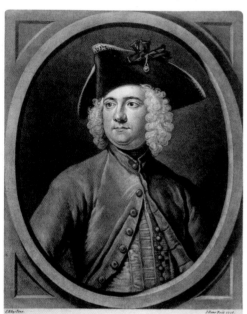

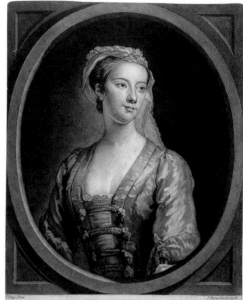

J. Ellys Pinx.                                    J. Faber Fecit 1728.

If Wit can please, or Gallantry engage,
Macheath may boast he justly charms ye Age,
A second Dorimant; like him in Fame,
The Fops Example, & the Ladies Flame.

**Mr. Walker**
in the Character of
Capt. Macheath

The Fair in Troops attend, his sprightly Call,
Nor longer doat upon an Eunuch's Squall,
Well pleas'd they blush, & own behind ye Fan,
His Voice, his Looks, his Actions speak a Man.

J. Ellys Pinx.                                    J. Faber Fecit 1728.

While Crowds attentive sit to Polly's Voice,
And in their native Harmony rejoyce;
Th' admiring Throng no vain Idea strain'd,
Nor Affectation prompts a false Applause:

**Mifs Fenton.**

Nature untaught, each Pleasing Strain supplys,
Artless as her unbidden Blushes rise,
And Charming as the Mischief in her Eyes.

The original Polly, Macheath in the Beggar's Opera; afterwards married to Charles Paulet Duke of Bolton.

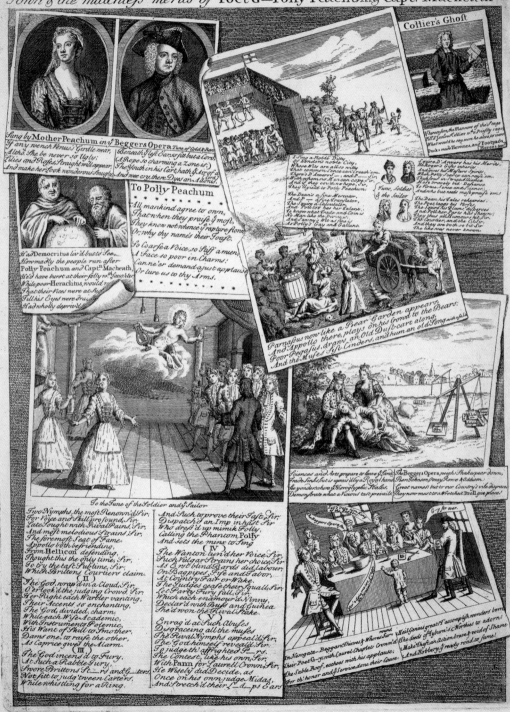

actress Lavinia Fenton, and on what this revealed about
the degraded state of contemporary culture. Meanwhile,
an anonymous print entitled *The Beggar's Opera Burlesqued* (23)
depicts the same scene from the play as Hogarth did himself,
which is transformed into the bestial centre of a motley range of
entertainments and activities. Exploiting a common criticism that
Gay's play served only to replace the high-pitched warble of opera
with the screech of badly sung ballads, the satire turns the actors
at Lincoln's Inn Fields into braying donkeys, howling cats and
bellowing cattle.

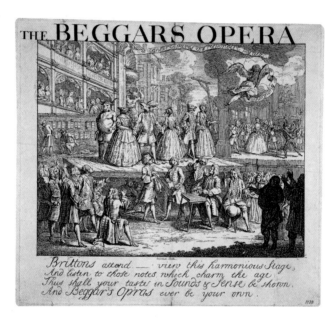

23
Anonymous,
*The Beggar's
Opera
Burlesqued*,
1728.
Engraving;
25×26cm,
9⁷⁄₈×10¹⁄₄in

24
*The Beggar's
Opera*,
1728.
Oil on canvas;
48.2×55.5cm,
19×21⁷⁄₈in.
Birmingham
Museum and
Art Gallery

Hogarth's chalk drawing, and his earliest paintings of *The Beggar's
Opera* (24), can therefore be related to two artistic contexts that
were clearly crucial to him at this moment in time: the academies
of painting that he had attended in the years before 1728, and that
satiric practice with which he had become increasingly associated
over exactly the same period. Intriguingly, Hogarth fuses the
media – drawing and painting – particularly associated with
places such as the St Martin's Lane Academy with a subject matter
– a scene from Gay's *Beggar's Opera* – that was being repeatedly
depicted in engraved satire. His sketch, even as it suggests an

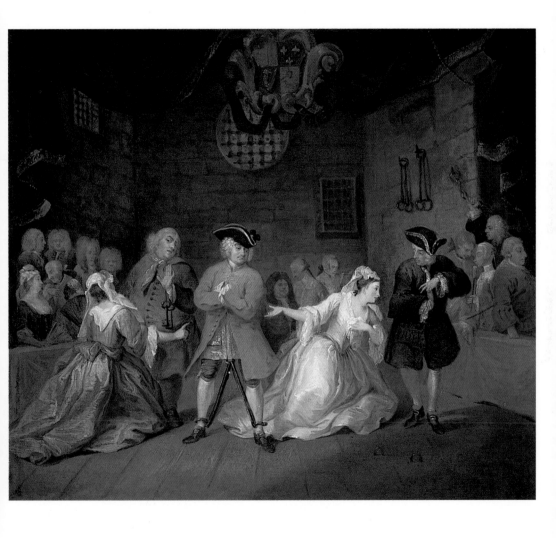

eyewitness transcription of an actual performance of the play, testifies to his growing skill in accurately and rapidly delineating posed masculine and female figures, which is something he would have done repeatedly in his evenings at St Martin's Lane. Indeed, the way in which the actors are placed on view at the centre of a semicircle of spectators offers a close parallel to the spatial, bodily and observational arrangements at the academy, where groups of students would have been similarly gathered to inspect the gesturing model. At the same time, Hogarth's canvas confirms his continuing interest in, and deployment of, the practices of pictorial satire. This is particularly evident in the way in which he transforms the depicted audience into a series of caricatures, many of which are actually witty portraits of aristocrats who had attended early performances of the play. In Hogarth's painting, a cluster of plebeian protagonists are surrounded by a comic crew of misshapen, foppish and flirtatious men from high society. In this respect, the picture clearly mimics the satiric comparison of high and low that was found in the play, and that was visible on a nightly basis at the theatre itself. But it also suggests Hogarth's continuing adherence to a satiric convention of juxtaposing different pictorial vocabularies for comic and aesthetic effect. Here, he generates a playful discrepancy between the relatively respectable portrayal of subcultural figures like Macheath – whose demeanour and pose can indeed be seen to offer a playful echo of those found among the traditional heroes of history painting – and the grotesque language of caricature he uses to depict the supposedly refined audience.

Significantly, a painted replica of this canvas was bought by the play's producer, John Rich, who then went on to order another larger version of the same scene from Hogarth in 1729 (25). There is an irony here, given that Rich had been one of the main targets of Hogarth's *Bad Taste of the Town*. But this development also usefully suggests how artists like Hogarth were attracting new kinds of patron, in this case a theatrical entrepreneur whose fortune was made by the staggering success of Gay's play at his London theatre. What is also interesting about the second, grander painting Rich commissioned is that it suggests both his

and Hogarth's increasing desire to define themselves not only in relation to the attractions of satire, but also to that polite culture discussed earlier in this chapter. For if Hogarth's first canvas carries the satirical and disruptive edge that was one of the primary attractions of the play when it first appeared, his later work presents a new decorum and sophistication in its treatment of subject and its handling of paint. This is partially conveyed by the enlarged scale of the image, and by numerous subtle changes within it. Look, for instance, at some of the shifts in detail that have taken place in the central band of figures. Polly and her father are turned into more delicate and elegant individuals than before, and are placed on a richly decorated carpet, which covers the bare floor of the stage. This kind of pictorial smartening-up extends outwards and encompasses the newly incorporated satyrs, who refer to a pair of actual statues within the theatre itself but also help aesthetically to elevate the image, thanks to their classical and mythological allusions. Most striking of all, however, is the extent to which Hogarth transforms his depiction of *The Beggar's Opera*'s spectators. In the background, the trio of aristocrats found in the first image is replaced by a group of stage extras. Even more importantly, the audience as a whole is no longer pictured with the language of caricature, but in a style that bears a new resemblance, on a miniaturized scale, to the vocabulary of society portraiture.

The effect of these changes is a very different pictorial relationship between actors and audience, and foreground and background, to that found in the earlier canvas. Hogarth's second painting integrates the newly refined figures of the actors and the newly respectable figures of the audience into a remarkably seamless strip of elegant individuals that stretches from the anonymous female on the far left, shown conversing with Lady Jane Cook, across to the seated figure of the Duke of Bolton on the far right, celebrated for falling in love with Lavinia Fenton, the actress playing Polly. In this process, both the performance taking place in the theatre, and the figures occupying the margins of the stage (who include Rich and Gay) are redefined in resolutely decorous terms and thoroughly reconciled with each other – indeed, they could almost

**25**
*The Beggar's
Opera*,
1729.
Oil on canvas;
60.3×73.3cm,
23¾×28⅞in.
Yale Center
for British Art,
Paul Mellon
Collection,
New Haven,
Connecticut

be interchangeable. Finally, as if to confirm the more dignified tone of this painting, Hogarth pictorially stitches two Latin quotations into the exceptionally lavish theatrical curtains overhead, one reading 'utile dulci' ('usefulness with pleasure'), taken from Horace's *Ars Poetica*, and the other 'veluti in speculum' ('as in a mirror').

The shift that takes place between these two versions of *The Beggar's Opera* suggests how quickly Gay's play, however scandalous, was becoming canonized in polite culture as an ultimately refined and unthreatening form of dramatic performance. This change also demonstrates how carefully Hogarth himself was crafting a polite pictorial style and appeal. It is not only, as many scholars have suggested, that the later *Beggar's Opera* painting indicates his growing confidence and versatility with the paintbrush. It is also that in this picture he has begun producing an imagery which celebrates the theatrical interactions and social interconnections between cultivated modern individuals, and which encouraged the painting's viewers to see these exchanges as reflective – 'as in a mirror' – of their own social experience. In doing so, moreover, Hogarth was beginning to develop his own variant on a rather specific and rather novel pictorial format. This was the conversation piece, which was to play a crucial role in his early career as a painter.

In *An Essay on Conversation* Hogarth's friend, the author and dramatist Henry Fielding, declared that conversation was the 'grand business of our lives, the foundation of everything, either useful or pleasant'. Fielding's was not an isolated point of view. For many of the artist's and the writer's contemporaries in the wealthier realms of metropolitan and provincial culture, conversation was privileged as the primary means through which polite social and cultural status was displayed, and as something that bound together and refined the socially disparate, economically competitive and often newly monied elements of an increasingly commercialized and urbanized society. Through genteel conversation, suggested numerous commentators and diarists,

affluent individuals – whether aristocrat or commoner, male or female – were given the chance to prove their learning, wit and broadness of outlook, and to demonstrate the virtues of sympathy and fellow-feeling as they listened and responded to their interlocutors. Given these conditions, proficiency in the kinds of verbal and bodily performance required to converse successfully with other cultivated men and women was an unusually prized skill in this period. It is no surprise, perhaps, that London publishers rushed to issue tracts and self-help guides dealing with what was often described as the 'art' of conversation. The year 1731 saw the publication, for instance, of John Taperell's *New Miscellany*, which contained a long essay on 'The Art of Conversation', while in 1736 Henry Ozel's *The Art of Pleasing in Conversation*, published in French and English, extended to two lengthy volumes.

Publications like these, to which we can add *The Conversation of Gentlemen Considered*, published in 1738, offered their readers extraordinarily detailed advice on conversation, ranging from the kind of subjects that could be legitimately raised, and the tone of voice in which they could be discussed, to the proper ways in which to position the body and hold one's facial expression while talking and listening to others. Reading these books, it is clear that the kind of conversation they describe was a highly developed form of private theatre, normally taking place among one's family, friends and social peers in the spaces of the home, club or assembly, and thus uninfected by the raucous representatives and signs of popular culture. It was a theatre, of course, in which participants moved continually between the roles of actor and audience, and in which they needed to tread a fine line between excessive informality and an over-assiduous adherence to convention. Wit, for instance, was not to descend to vulgar ribaldry nor flirtation to unrestrained lasciviousness. At the same time, as the author of *The Conversation of Gentlemen Considered* explains using two suggestive similes, the etiquette and mechanics of good conversation should not be made too obvious: 'It is in the Agreeableness of men, as in that of Painting. In both there may be an excess of care'; moreover,

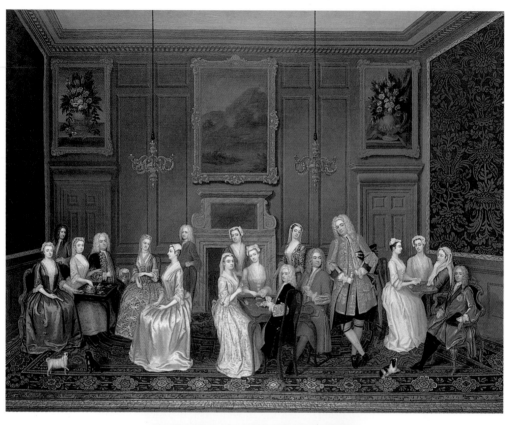

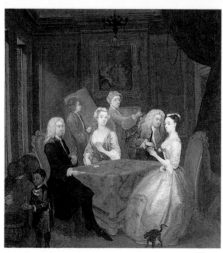

'artificial links and twists of Discourse, are like the Ropes and Wires, without which we know that machines in a theatre cannot move; yet if they appear, the Pleasure of the Spectacle is lost, or even becomes Ridiculous.'

The private theatre of polite conversation came with its own sets, props and rituals. It was expected to take place, whether within or without the household, in rooms explicitly designed for social intercourse, thoughtfully laid out with elegant chairs and tables arranged so as to promote group interaction. These rooms were to be lined with pieces of furniture and works of art that were reputable without being too distracting, so that they collectively formed a restrained decorative backdrop to the figures and activities occupying the room's centre. Meanwhile, diversions such as tea-drinking and playing cards were understood to both complement and promote discussion. The tea party was a fashionable fixture of daily life within élite society in this period, and tea – which remained at this point far too expensive to be consumed by any other than affluent families – was continually praised as an invigorating stimulant to conversation. Having initially been associated with women, it was becoming increasingly acceptable as something for men to drink in company, and as such could be understood as fostering a companionate relationship between the sexes. Similarly, card games such as whist, which involved working closely with a partner and being highly responsive to the smallest actions and expressions of others, were widely accepted as entertaining and even educative accompaniments to conversation for men and women, provided gambling for money was not involved. In the words of Ozel's *The Art of Pleasing in Conversation*, 'there are games both genteel and allowable, which are not inconsistent with probity, especially, when one plays rather for amusement than gain'.

While texts such as Ozel's were aimed at those who remained anxious about the rules of polite verbal and social exchange, paintings known as conversation pieces, which customarily showed groups of figures (often families) engaged in conversation

26
Charles
Philips,
*Tea Party
at Lord
Harrington's
House*,
1730.
Oil on canvas;
102×126.5cm,
40⅛×49¾in.
Yale Center
for British Art,
Paul Mellon
Collection,
New Haven,
Connecticut

27
Gawen
Hamilton,
*An Elegant
Company
Playing Cards*,
c.1730.
Oil on canvas;
59.1×53.3cm,
23¼×21in.
Private
collection

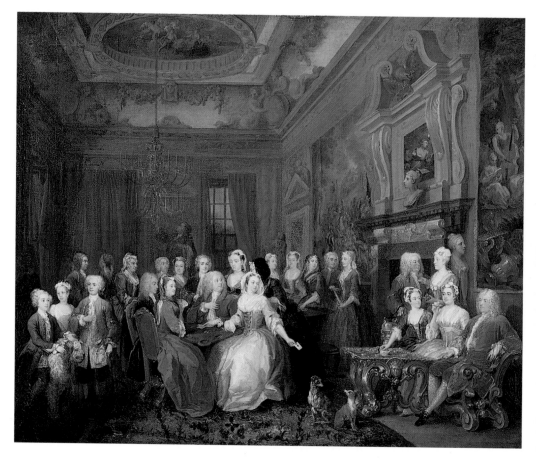

**28**
*An Assembly
at Wanstead
House,*
1728–31.
Oil on canvas;
63.5×74.3 cm,
25×29¼ in.
Philadelphia
Museum of Art

within elegant interiors, offered their purchasers an eloquent confirmation of their mastery of these rules. Hogarth, having already moved towards this inherently theatrical mode of painting in his *Beggar's Opera* canvases, was quick to recognize the commercial attractiveness of a genre that allowed the patron to define himself, his family and his friends in terms of a newly fashionable social ideal. Again, he was not working alone – other painters such as Joseph van Aken (*c.*1699–1749), Gawen Hamilton (*c.*1697–1737) and Charles Philips (1708–48) produced fascinating and complex paintings of a similar kind at this time, including Philips's *Tea Party at Lord Harrington's House* of 1730 (26)

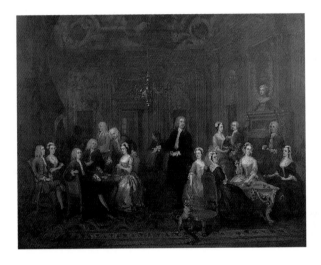

29
*The Wollaston Family*, 1730.
Oil on canvas; 99·1×124·5cm, 39×49in.
Private collection on loan to Leicestershire Museums and Art Galleries

and Hamilton's *An Elegant Company Playing Cards* of around 1730 (27). Hogarth, in paintings such as *An Assembly at Wanstead House* of 1728–31 (28) and *The Wollaston Family* of 1730 (29), combined the rituals of tea-drinking and card-playing, and placed them at the centre of even more elaborate compositions, in which a throng of genteel men and women are depicted talking and listening to one another in particularly lavish and spacious environments. The first is the recently built home of the hugely wealthy banker's son Richard Child, Viscount Castlemaine, shown sitting on the far right of Hogarth's painting, while the second is the town house of another financier, William Wollaston, seen standing, one arm outstretched, at the centre of the canvas.

Both men – just like the rest of the figures in the two paintings – are linked through their gestures, expressions and looks to other individuals within the group. Thus, Castlemaine looks across at his wife sitting in the centre of the scene, who turns affectionately towards him holding a winning card, her gaze a domesticated version of the look Lavinia Fenton casts at the Duke of Bolton in Hogarth's later *Beggar's Opera* painting. At the same time, one of Castlemaine's daughters, her eyes following her mother's, turns to offer him tea. Meanwhile, Wollaston looks fondly towards his wife sitting on the far right, and appears to be asking her to join the group of card players on the left. A male member of this group – seemingly without a playing partner – turns away from the card table towards her, as if encouraging Mrs Wollaston to come over and join him. These kinds of pictorial connections, which are reproduced throughout both canvases, define such people not only as self-sufficient individuals, but also as men and women supremely adept at acting and conversing companionably within small groups of like-minded equals. At the same time, of course, these smaller groupings are themselves pictorially fused together into a unified whole, through Hogarth's compositional strategy of placing them within the larger strip of figures that gently winds through the image, and that ends on both edges of the canvas with men and women who turn inside towards the rest of the group. Bound together by a subtle choreography of swivelled heads, pointing fans, gesturing hands and inquisitive eyes, Hogarth's numerous subjects are dramatized as a genteel conversational collective, and their activities made into a microcosm of those defining a wider culture of politeness. And even if it is impossible to know exactly what they are all saying to each other, the spaces between them can easily be imagined as full of the sounds of their carefully modulated voices. Hogarth, it is clear, knew how to provide good pictorial acoustics.

While *An Assembly at Wanstead House* and *The Wollaston Family* offer particularly intricate and crowded versions of the conversation piece, paintings such as *The Strode Family* of *c.*1738 (30) were more restrained and modest in scale. In this work, another figure whose

30
*The Strode Family*,
*c.*1738.
Oil on canvas;
87·6 × 91·4 cm,
34$\frac{1}{2}$ × 36 in.
Tate Gallery,
London

wealth had its origins in the City, William Strode, is shown poised
between his old friend and tutor, the clergyman Dr Arthur Smyth,
sitting to his right, and the figures of his aristocratic new wife, the
former Lady Anne Cecil, and his brother, Colonel Samuel Strode.
The family butler, Jonathan Powell, pours tea. As well as commemo-
rating Strode's recent marriage, the picture celebrates his mastery
of the codes of polite learning, sociability and conversation. In
Hogarth's picture, Strode is linked to the world of education and
culture, not only by the book-lined cabinets in the background

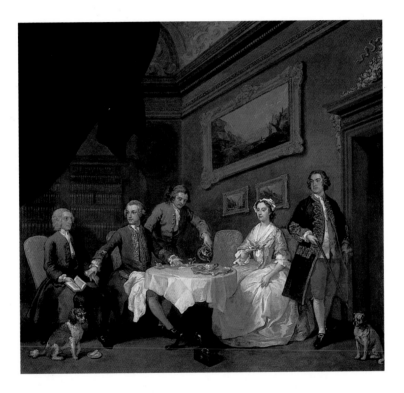

and by the painted trophies of his Grand Tour of Europe hanging
nearby, but also by being so closely juxtaposed with the figure of
the learned clergyman. But it is also clear that Strode is shown
gently urging Smyth to momentarily abandon his somewhat
pedantic and antisocial concentration on the open book on his lap
and turn to the lighter, more convivial pleasures of tea, embodied
most obviously by the dreamily self-satisfied figure of Lady Anne.
In this process Strode is depicted as someone who not only moves

comfortably between the worlds of academic learning and domestic ritual, but who also recognizes the importance of conversation in bringing people with different backgrounds and characters together. The socializing power of conversation lies at the heart of this picture: the conversation of Strode as he amiably entreats his rather hesitant, non-aristocratic friend to join his noble wife sitting at the table, and the conversation that is expected to begin when he does so. Meanwhile, it seems as if the rather intimidating figure of Colonel Strode is waiting stiffly to be invited by his brother to sit in the empty chair next to Lady Anne. Once he is there, it is implied, he will be able to abandon the rigid and public guise of the army officer he currently adopts, and adapt himself to the more informal and responsive dynamics of conversation. Wittily extending this deceptively relaxed depiction of polite interaction between different personal and social types, Hogarth introduces those dogs that we find in the Wanstead and Wollaston paintings, which in this case also seem to be waiting rather hesitantly to be introduced to each other, before proceeding with their own brand of canine conversation.

Works like these, as well as picturing the private theatre of polite conversation, need also to be understood as objects that accompanied this theatre as it was acted out in the homes of Hogarth's patrons. The conversation piece, when put on display in the houses of families such as the Strodes, would have corresponded in an unusually explicit way with its environment, providing an idealized pictorial version of the activities and conversations – the tea parties and the card games, the repartee and the gossip – that took place around the painted image on an everyday basis. Moreover, it was a kind of painting that must itself have acted as a catalyst for conversation among its owners and viewers. This is nicely suggested by another of Hogarth's works in the genre (31), painted for Sir Andrew Fountaine and set this time in the environs of an aristocratic garden. The artist shows Fountaine, his hand tucked into his jacket, among a select group of men and women conversing with each other about the work of art that stands in front of them. As such, they would clearly have functioned in an intimately

31
*Conversation Piece with Sir Andrew Fountaine*, c.1730–5. Oil on canvas; 47×59·7cm, 18½×23½in. Philadelphia Museum of Art

analogous relation to the real-life spectators – the members of Fountaine's immediate family, and his visitors – who would have looked at, and talked about, this conversation piece of Hogarth's in the environment of Fountaine's house. They would frequently have been doing this, of course, in the company of a relatively small number of friends or relatives. Realizing this, it becomes clearer how works such as the Fountaine painting could function not just as celebratory depictions of genteel discussion, but also

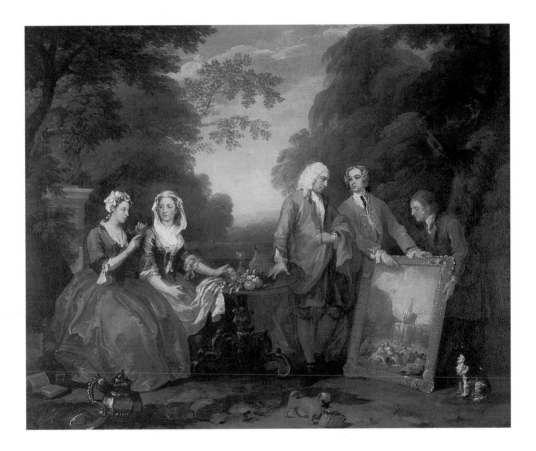

as active agents of conversation and sociability in their own right. When looked at by a group, they turned the space in which they were exhibited into the setting for what might be called living conversation pieces, in which various men and women, analysing the painting on display in front of them, found themselves acting out and enjoying those conversational rituals so idealized within the canvases themselves.

Having looked at a number of Hogarth's pictures in this genre, to which we can add the sparkling examples of paintings such as *The Cholmondeley Family* of 1732 (32), which contrasts the mischievous play of the two young sons with the decorous poses of their family, and the later picture of *The Graham Children* (33), it becomes easier to appreciate why the engraver and cultural commentator George Vertue (1684–1756), even as early as 1730, could declare that 'The daily success of Mr Hogarth in painting small family pieces & Conversations with so much Air and agreeableness Causes him to be much followd, and esteemed.' Yet, even as his reputation as a painter of refined conversation pieces grew apace, it is typical of Hogarth that he also produced paintings that wittily parodied the conventions of the genre. *A Midnight Modern Conversation* (34), executed sometime in the early 1730s, depicts a scene in which the conversation of a group of London lawyers, merchants, clergyman and physicians – stimulated by alcohol and tobacco, rather than by tea and cards – has run riot, and descended into violence, drunkenness, madness and unconsciousness.

If, on one reading, this painting can be seen to have satirically punctured the pretensions of contemporary works that showed gentlemen decorously gathered around the wine bottle (35), it also demands to be understood as a kind of pictorial anti-conversation which ultimately reinforced the conversation piece's values by emphasizing the vicious and ridiculous results of deviating from the rules of politeness. Here, rather than talking to each other in dulcet tones, Hogarth's protagonists variously vomit, screech, whisper, shout, puff and snore. As such, they are the comic, negative counterparts to the uniformly equable men and women found in the Wanstead, Wollaston, Strode and Fountaine canvases, and their ragged and chaotic distribution across the picture space must have served only to heighten the sense of pictorial and social harmony in the other, more respectable conversation pieces that the artist was producing in his studio. These differences would have been finally confirmed by the fact that, very differently to the responses generated by the polite

32
*The Cholmondeley Family*, 1732. Oil on canvas; 71·1×90·8cm, 28×35¼in. Private collection

33
*The Graham Children*, 1742. Oil on canvas; 160·7×155·6cm, 63¼×61¼in. National Gallery, London

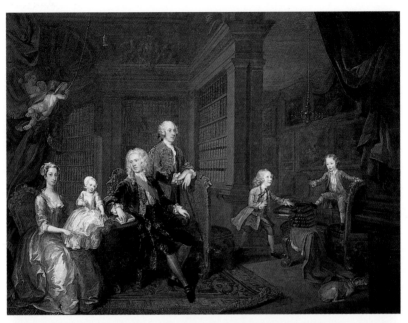

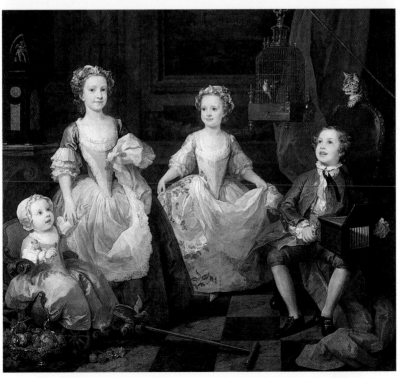

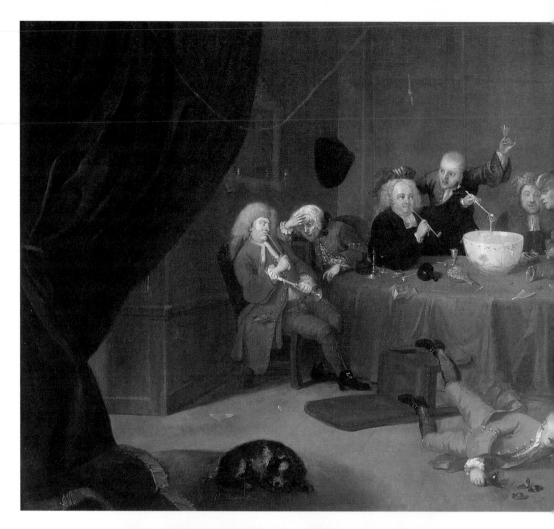

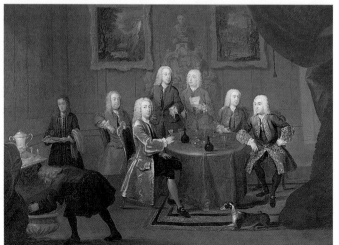

**35**
**Gawen Hamilton**,
*The Brothers Clarke and other Gentlemen Taking Wine*, c.1730.
Oil on canvas;
82.5×115.5cm,
32½×45½in.
Yale Center for British Art, Paul Mellon Collection, New Haven, Connecticut

conversations he painted, the viewer was expected to smile or laugh in front of an image like this, and not merely talk about it. Hogarth, in *A Midnight Modern Conversation*, was clearly beginning to recognize the power of humour as a means of making satire palatable, and of puncturing any anxieties that might have arisen on the viewer's part about contemplating such a decadent subject matter. It is also easy to imagine that, in painting such pictures, Hogarth himself must have had a smile on his face.

Hogarth's own entrance into the polite society he now found himself recording, and into that world of paint which idealized the rituals of this society, was further facilitated in 1729 when, after a dramatic elopement and marriage, he became the son-in-law of the highly respected artist Sir James Thornhill. Thornhill was celebrated for his grandiloquent decorative wall-paintings in places such as St Paul's Cathedral and the Royal Naval College at Greenwich, and lived in some splendour in the west corner of the Great Piazza in Covent Garden. He also, from the mid-1720s onwards, ran a drawing and painting academy of his own, which Hogarth in all probability joined after the gradual dissolution of the St Martin's Lane Academy in the same years. The young artist, falling in love with Thornhill's daughter Jane (36), and recklessly rushing away to Paddington to marry her, seems initially to have found himself at odds with his wife's family. Soon, however, no doubt bolstered by Hogarth's increasingly attractive prospects as a painter, the Thornhills became reconciled to their new son-in-law. This is most eloquently suggested by a sketched conversation piece executed by Thornhill around 1730, in which he depicted his own extended family (37). Here, for the first time, Hogarth is himself pictured within a group of sophisticated men and women bound by the bonds of family, connoisseurship and conversation. There he is, standing on the far left edge, and however insignificant he might seem at first sight – little more than a formulaic cluster of lines drawn across the paper – Hogarth's appearance in this drawing is a powerful testament to his emerging social and artistic respectability, and to his arrival in a new, more rarefied, cultural realm.

36
*Jane Hogarth*, c.1738.
Oil on canvas; 90.2×69.9cm, 35$\frac{1}{2}$×27$\frac{1}{2}$in.
Dalmeny House, Edinburgh

37
**Sir James Thornhill**, *Conversation Piece of his Family*, c.1730.
Ink and wash on paper; 22×50cm, 8$\frac{5}{8}$×19$\frac{3}{4}$in.
Private collection

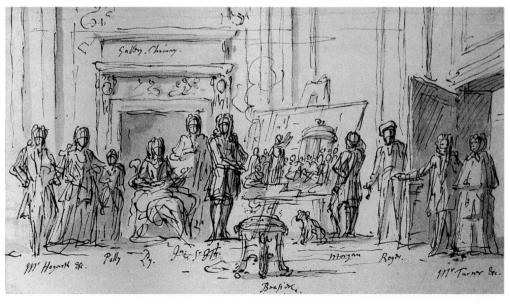

Only a decade beforehand, it is worth remembering, Hogarth had been nothing more than an aspirant engraver with a small workroom and shop, struggling to make a name as an artist. To have so quickly become someone who could pose in an ennobled painter's drawing room was quite an achievement, and suggests Hogarth's exceptional drive as well as his remarkable artistic talents. This personal ambition was something noted by his contemporaries and early biographers, who provide us with a compelling picture of Hogarth as a man who combined a gregarious, humorous and generous nature with a ferocious determination to succeed, an enormous capacity for work and an unrelenting belief in his own ability. This last trait was easily construed as boastfulness, and Hogarth's willingness to promote his own works and career at the expense of other artists, both past and present, was to continually irritate and outrage contemporaries like Vertue, who at one point described Hogarth as 'a man whose high conceit of himself & all his operations, puts all the painters at defiance'. They quickly, and rightly, perceived the anxiety-ridden, bumptious pride of the stereotypical self-made man. Nevertheless, there is no doubt that Hogarth – even as early as 1730 – had already established himself as a figure of outstanding character and ability, and would have been seen as someone who quite deserved his place on the fringes of Sir James Thornhill's sketched conversation piece. To move into the centre of things, however, was another matter, and to make this transition Hogarth launched himself into a novel and ambitious project, one that ultimately provided him with a new level of artistic fame and success. This was a work of art called *A Harlot's Progress*.

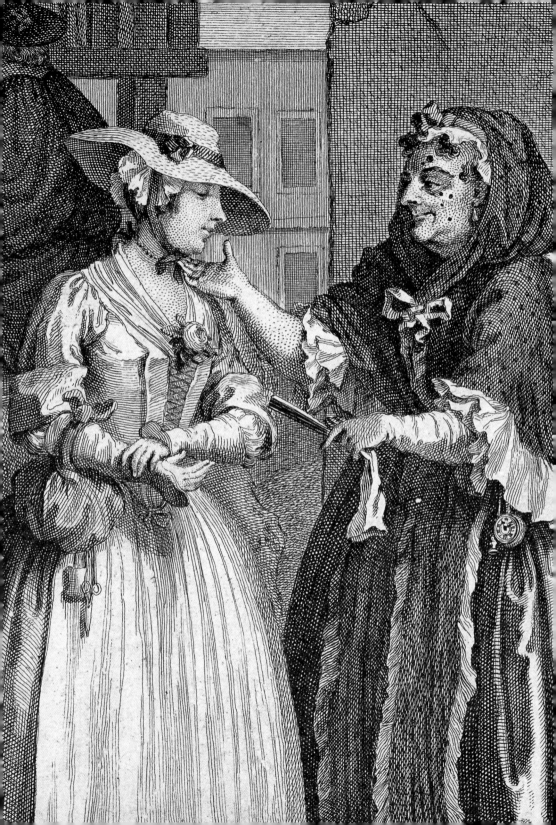

On Saturday 29 January 1732, *Read's Weekly Journal* printed a poem
that conveys a remarkable sense of what it must have been like to
wander through central London in the early eighteenth century,
and to pause and admire the engravings on view in the numerous
print-shop windows. Significantly, the poem's narrator, having
detailed the pleasures traditionally on offer during such a ramble,
ends up by criticizing the widespread display of a new, indecent
kind of print in the streets of the city:

Walking along the town I've oft stood still,
To see the engravers curious art and skill,
From Kneller's hand, or some fam'd penman's quill.

A curious Head, or else some new design,
To please the town, and make their parlours shine,
With Marlborough's Battles, or the Muses Nine.

New Days, new curious pieces did produce,
Some for their Beauty, others for their use,
But mostly modest, not obscene, or loose.

But now the scene is alter'd and presents
Unto your view only immodest prints,
Such as youth never saw, to give 'em hints.

Now scarcely in a print shop you shall see,
But what is scandalous to the last degree,
With obscene pieces of impiety.

In particular, the poet had in mind a spate of satirical prints, book
illustrations and frontispieces concentrating on an infamous case
of clerical lust and hypocrisy on the Continent, in which a French
Jesuit monk, Father Jean-Baptiste Girade, had subjected a young
devotee, Mary-Katherine Cadiere, to rape and systematic sexual

abuse. A typical example of this imagery (39), which in this case accompanied a sixpenny poem called *Spiritual Fornication*, combines anti-Catholic critique with a pornographic focus on the details of seduction and on the undressed female body. When looked at alongside the fulminations of the poem, such an image suggests the presence in early-1730s London of a new, controversial kind of engraving, which unashamedly fused satire and sex, and which, in this case at least, exploited the narratives of masculine lasciviousness and feminine vulnerability to artistic and erotic effect.

It was at this moment, and in this environment, that Hogarth published his famous series of six engravings entitled *A Harlot's Progress*, which brought him a new kind of artistic celebrity and commercial success, and which offered a comparably scandalous and sexually loaded subject matter to the print buyers of the city, focusing as it did on the life and career of a fictional London prostitute, Moll Hackabout. The series, which Hogarth engraved from his own paintings (unfortunately destroyed by fire later in the eighteenth century), was issued in April 1732, and begins with Moll's arrival in London (38 and 40). Having just alighted from the York wagon, she is immediately approached and propositioned by a woman whom contemporaries quickly recognized as a portrait of the brothel-keeper Mother Needham. Meanwhile, in the background, another notorious real-life figure from the period, the aristocratic rake Lord Charteris, stumbles out from an alehouse and leers at the virginal newcomer to the city. The implication is clear: Moll is about to be wheedled into the world of prostitution, and her first client will be Charteris himself, whose right hand, we might notice, already slides in anticipation towards his groin.

In Hogarth's next plate (41), which takes us forward some months in time, Moll has acquired the status of a mistress, kept by the bewigged Jewish merchant who occupies the engraving's centre. It seems that he has just disturbed her having sex with her own lover, and she hurriedly distracts his attention by kicking over the tea table and snapping her fingers, which facilitates the escape of

39
Anonymous,
Frontispiece
to *Spiritual
Fornication*,
1732.
Engraving

her youthful paramour, who tiptoes out of the door making a
contemptuous gesture about the size of the merchant's penis. By
the third engraving (42), however, it is clear that Moll has been
found out and ejected from her comfortable apartment. She now
pursues her business from a Drury Lane garret, and is pictured on
the point of getting out of bed late one morning. She smiles out at
the viewer while her cheerful but dishevelled maid pours tea. Far
more ominously, an arresting officer – a portrait of the examining
magistrate Sir John Gonson – enters unheard through the door and
is shown pausing and admiring Moll's beauty before proceeding
with his men to take her into custody.

In the fourth picture of Hogarth's set (43), Moll is depicted
undergoing her punishment, beating hemp in Bridewell Prison.
Strikingly, she continues to wear the finery associated with her
profession, even as she is bullied by a stick-wielding jailer, and
surrounded by a clutch of other prostitutes and unfortunates,
including her pock-marked maid. In Hogarth's fifth engraving

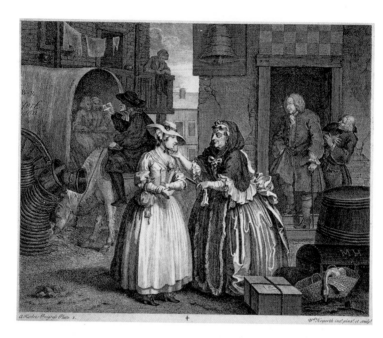

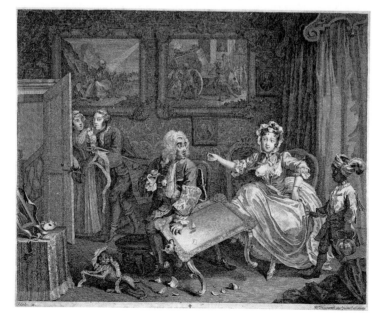

**40–41**
*A Harlot's
Progress,*
1732.
Engraving
**Above**
Plate 1,
29·8×37·5 cm,
11¾×14¾ in
**Below**
Plate 2,
30·2×37·2 cm,
11⅞×14⅝ in

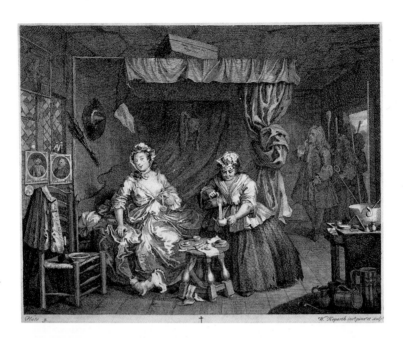

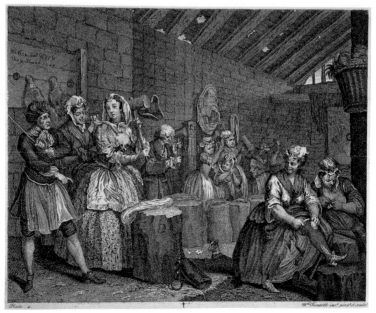

**42‑43**
*A Harlot's Progress*,
1732.
Engraving
**Above**
Plate 3,
29.8 × 45.4 cm,
11¾ × 17⅞ in
**Below**
Plate 4,
30.2 × 37.8 cm,
11⅞ × 14⅞ in

(44), Moll has left the brutal environs of Bridewell, but succumbed to the venereal disease that was so commonly associated with prostitution. She is depicted near death, swathed in a blanket, and utterly oblivious to the events that go on around her. While Moll's bastard child plays with fire, and a woman rifles through her portmanteau for burial clothes, two doctors – again recognizable portraits of the contemporary quacks Richard Rock and Jean Misaubin – argue over the efficacy of their respective anti-venereal pills, and ignore all pleas for help. In the final image of the series (45), Moll herself is no longer to be seen. Rather she has to be imagined lying in the opened coffin, which stands in a room crowded with prostitutes, a seated and sexually aroused cleric, a flirtatious, importunate undertaker and a bawd who cries crocodile tears into the handkerchief clasped in her heavy-knuckled hands.

Hogarth's series, in concentrating so assiduously on the prostitute and on her eventual descent into squalor, infection and death, was symptomatic of a far wider preoccupation with the figure of the prostitute in eighteenth-century polite culture. Throughout the century, the prostitute was reviled as the unacceptable face of both commerce and femininity. She was someone whose physical enslavement to capital transgressed all 'natural' distinctions between the living individual and the inert commodity – in fact, turned the one into the other – while at the same time invoking the logical, terrifying endpoint of human commerce, in which even the most traditionally intimate relations – with a lover, and with one's own body – had become invaded by economics. She was also someone whose supposed promiscuity, artificiality and independence threatened all the conventional tenets of virtuous femininity, while simultaneously symbolizing a femininity taken to terrible excess, in which chauvinist prejudices concerning women's proclivity to desire, their obsession with appearance and their tendency towards rebelliousness were shockingly confirmed and exaggerated. Thanks to these factors, the prostitute became dramatized in Georgian literature and art as a figure whose presence in the city threatened the normal values of economic and social life, and offered a nightmarish encapsulation of a world in which commerce

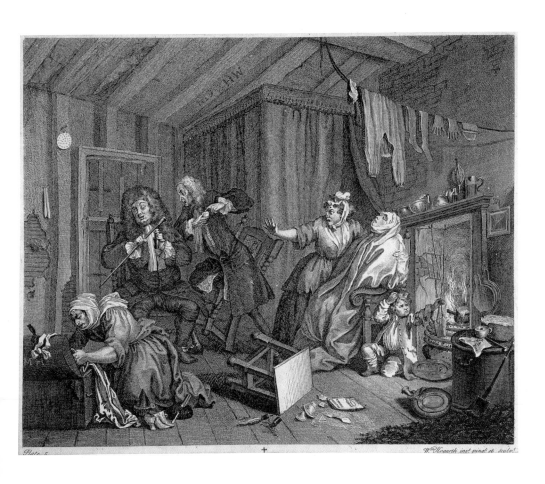

**44**
*A Harlot's Progress,*
plate 5,
1732.
Engraving;
30.5×37.5cm,
12×14¾in

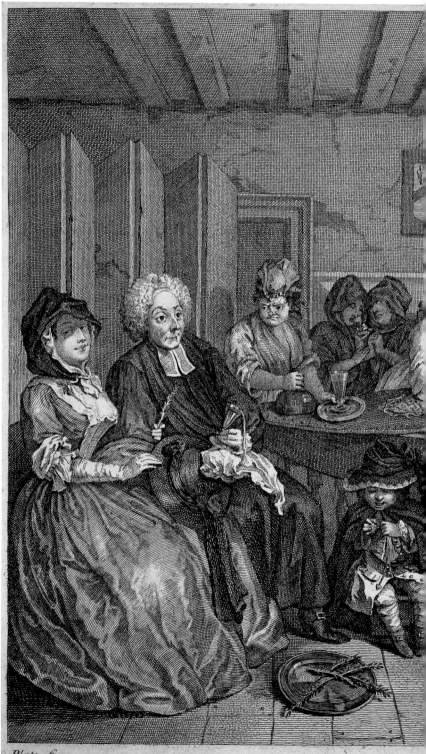

Plate 6.

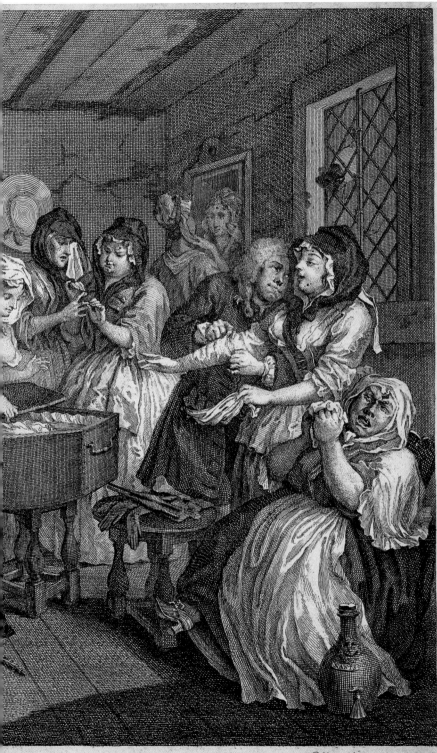

45
*A Harlot's Progress*,
plate 6,
1732.
Engraving;
29.8 × 37.8 cm,
11 3/4 × 14 7/8 in

W<sup>m</sup> Hogarth inv<sup>t</sup> Pinx<sup>t</sup> et Sculp<sup>t</sup>

and femininity had run riot. At the same time, her definition in these terms ultimately served the purpose of confirming polite society's own health to itself: the figure of the prostitute functioned as a necessary antitype against which more virtuous models of commercial exchange and feminine identity could be activated and established.

While *A Harlot's Progress* needs to be understood in terms of this longer pattern of anxiety and reassurance, it more specifically drew upon a host of assumptions and narratives about prostitution that had developed over the first three decades of the century. In the journalistic and literary writings of this period, for instance, the prostitute was conventionally given the identity of a young, naive countrywoman whose career begins the moment she sets foot in the metropolis, when she is tricked into the trade by the blandishments of a vicious bawd. Thus, Richard Steele, writing in a 1712 edition of the *Spectator*, describes waiting at an 'Inn in the City' for some luggage to be delivered from the country, and seeing 'the most artful Procuress in the Town, examining a most beautiful Country-Girl, who had come up in the same Waggon with my things'.

Other writings suggested that the customary sequel to such encounters was the installation of the recently arrived young woman as the mistress of an aristocrat or merchant. *The Kept Miss*, a story published in 1723, described a merchant who 'resolv'd to find out some agreeable girl, whom he might keep to himself, and spend his looser hours with in Enjoyment that a deprav'd appetite could not give him with his wife, tho' every way more accomplish'd than the lady of pleasure he chose'. Having found such a woman, provided her with 'very fine lodgings', and given her a present of a hundred guineas, he ultimately discovers that her real interests lie elsewhere. She begins frequenting the haunts of fashionable society – 'the park and the play, the Opera and all the resorts of the young and the Fair' – and embarks upon a string of secret affairs. Eventually the gullible merchant, having stumbled across her infidelity, throws her out, and she begins a life as a common prostitute, working the streets "til her face was so common that

none of the grand gusto would have anything to do with her; then she fell to filthy mechanicks, who had been so much her adversion; from thence to Porters and Footmen.' Finally, she is sent to Bridewell Prison, catches venereal disease and dies ignominiously at the gallows.

As this account suggests, the prostitute was frequently associated with disease. On the one hand, the prostitute herself was frequently seen as someone whose alluring appearance masked a corrupted, putrefying body, inexorably slipping towards an early death. On the other, she was often perceived to be spreading disease throughout society, not only infecting clients but, through them, their families. And while the men who exposed themselves to such dangers were criticized by a number of commentators, the prostitute herself was more normally targeted as the primary source of physical and moral contagion. A writer to the *Universal Spectator* in December 1729, for example, described how he had caught venereal disease from a prostitute, and transmitted it to his wife, and hypocritically condemns 'our streetwalkers' as 'a sort of creature, whose wickedness and wretchedness can hardly be parallel'd or described. It is sometimes horrid to walk along the streets at night, where multitudes of these prostitutes, like evil spirits, are tempting all they meet.' He goes on to declare that 'were proper officers appointed every night to clear the streets of these lewd women, and were they constantly committed to hard labour, as the law directs, I make no doubt but in a little while the PUBLIC would find the good of it.' Significantly, over the next few years, the London authorities did indeed make a concerted effort to combat this perceived threat. As the newspapers of the early 1730s report on a regular basis, the magistrate Sir John Gonson – who we will remember entering Moll's garret in plate 3 of *A Harlot's Progress* – led a campaign to rid the West End of its brothels and streetwalkers, and thus ensure that the spaces of the polite public sphere were cleansed of their supposedly infectious presence.

*A Harlot's Progress*, therefore, pictorially reiterates a stereotypical, and highly chauvinist, set of cultural prejudices and perceptions.

We begin, in the first image (see 40), by being assigned the same perspective as that adopted by Richard Steele in the *Spectator*: our viewpoint is precisely that of someone standing outside an inn, and we watch a similar encounter unfold before our eyes. In the second plate (see 41), just as in *The Kept Miss*, Moll has been installed as a mistress, and is acting out a similarly adulterated facsimile of high life. She is surrounded by the accessories and emblems of fashionable culture: a maid and an exotically dressed black servant, an elaborately decorated tea table, a curtained bed and the paintings and portraits that hang on the wall. On the left, the mirror signals the prostitute's vanity, and the mask that lies nearby suggests both her customary manipulation of appearance and her participation in one of the most controversial urban entertainments of the period, the masquerade, which was regularly criticized for its blurring of class distinctions and its incitement to promiscuity. The third engraving of the series (see 42), while dramatizing a conventional narrative of criminality and decline – Moll sits in a Drury Lane garret characterized by dilapidation and squalor – also works in obvious dialogue with those newspaper reports that allowed readers, on a day-to-day basis, to track Gonson's passage across the brothels of the West End.

Meanwhile, the final three engravings of *A Harlot's Progress* (see 43–45) offer detailed graphic translations of those narratives of punishment and disease that characterized many early-eighteenth-century formulations of the prostitute's life, career and death. Interestingly, Hogarth, in increasingly screening Moll's body from view over these three pictures – so that by the final plate it is no longer possible to see her – forces the spectator to actively imagine that body and its rapid decay. Contemporary commentators on Hogarth's series exploited this progressive withdrawal of Moll's physical presence to conjure up an imagery of rotting, infected flesh that is even more horrific because it is hidden from view. *Mr Gay's Harlot's Progress*, for instance, which was published in 1733, offered a melancholy poetic meditation upon Moll's gradual transformation from an alluring figure of fantasy into an abject, disease-ridden invalid:

Her charms decay, the boasted Roses fade
On her pale cheek, and now a lingering fire,
Not such as use'd to warm her loose desire,
Mars her fair form, and taints her beauteous skin
With many an ulcer foul: sharp pains within
Rick every joynt, and torture ev'ry Bone …
Lost are the charms that rais'd the world to lust.
What art thou all, vile putrefying Dust,
Shocking to sight! Such ghastly scenes attend
On vicious ways – such is their wretched end.

If *A Harlot's Progress* can now be seen as having chimed in with, and conformed to, a stereotypical model of the prostitute's character and profession, it is important to spend a little more time exploring the particular reasons why, given its degraded and problematic subject matter, the series made such a powerful impression. George Vertue jotted in his notebook soon after its publication that the *Progress* was 'The most remarkable Subject of painting that captivated the Minds of most People' – indeed, 'persons of all ranks & conditions from the greatest Quality to the meanest'. Vertue's next few lines provided a hastily written but suggestive account of some of the reasons why the series was such a success:

he [Hogarth] began a small picture of a common harlot, supposd to dwell in drewry lane. just riseing about noon out of bed. and at breakfast. a bunter waiting on her – this whore's desabille careless and a pretty Countenance & air – this thought pleasd many. some advisd him to make another. to it as a pair. which he did. then other thoughts encreas'd, & multiplyd his fruitfull invention. till he made six. different subjects which he painted so naturally. the thoughts, & striking the expressions that it drew every body to see them.

What these notes make clear is that the origins of Hogarth's series was in fact an image – 'the small picture of a common harlot' that eventually became plate 3 – which made an unapologetically erotic appeal to the viewer. As Vertue astutely recognizes, this depiction of a half-undressed young prostitute, who is given a 'pretty countenance

& air', offered a fantasy of sexual invitation and availability that was clearly aimed at the male visitors to Hogarth's studio.

By depicting Moll in this way, Hogarth was exploiting the concurrent contemporary identity of the prostitute and courtesan as a site of sexual fantasy within polite, patriarchal culture, desirable not only because of her professional manipulation of sexual attraction and exchange, and the simple fact of her sexual availability to those with enough money to pay for her services, but also because she was perceived to occupy a position on the vulgar, dangerous and thereby fascinating margins of respectable womanhood and society. In turning these aspects of the prostitute's contemporary reputation to artistic advantage, Hogarth was again participating in a wider form of cultural practice, in which the prostitute was consistently assigned an erotic as well as an abject identity. Thus, texts like *The Kept Miss* combined their strictures against the prostitute with a shameless form of literary titillation that constantly invoked the image of the semi-naked heroine and lasciviously detailed her sexual activity. Furthermore, the illustrations to these writings frequently emphasized the prostitute's attractiveness and her flirtatious engagement with the viewer. The frontispiece (46) to one such publication, which detailed the life of a famous contemporary prostitute, Sally Salisbury, shows her in a way which clearly evokes the glamorous seventeenth-century portraits of royal mistresses by painters like Sir Peter Lely (1618–80; 47), and which offers a suggestive precedent for the depiction of Moll in the originating image of the *Progress*.

Other categories of art also explored and exploited the erotic identity of the prostitute in this period. The print shops of the city, for instance, were still displaying and selling the seventeenth-century *The Cries of London* by Marcellus Laroon (1679–1772), which includes an engraving of 'The London Curtezan' (48) that catalogues and celebrates her artful manipulation of the sartorial, gestural, cosmetic and expressive languages of sexual attraction. Just like Moll in the second plate of Hogarth's series, she is identified by the elegance of her possessions, and by the white mask that here,

46
**Anonymous,**
Frontispiece to
*The Authentic
Memoirs of
Sally Salisbury*,
1723.
Engraving;
9.5×7cm,
3³⁄₄×2³⁄₄in

47
**Studio of Sir
Peter Lely,**
*Portrait of
Nell Gwyn*,
1670s.
Oil on canvas;
125.4×100.3cm,
49¹⁄₄×39¹⁄₂in.
Private
collection

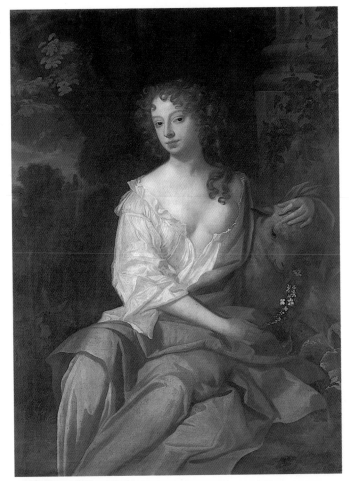

too, suggests the dubious but alluring deceptions of the masquerade. Another print after Laroon, a turn-of-the-century mezzotint entitled *The Cully Flaug'd* (49) combines satire and sexuality in its technically refined depiction of a young prostitute, armed with the same kind of birch rod that hangs next to Moll in her garret, spanking a masochistic, elderly 'Cully' who stares with unabashed lust at the exposed lower body of his tormentor. Significantly, even as the prostitute is embedded in a narrative of perversion and

London Curtezan
La Putain de Londres
Cortegiana di Londra

M. Lauron delin.                                            I. Tempest excud:
Cum Privilegio

48
Pierce Tempest after Marcellus Laroon, 'The London Curtezan', from *The Cries of London*, sixth edition, 1711. Engraving

49
After Marcellus Laroon, *The Cully Flaug'd*, *c.*1700. Mezzotint

ridicule, she is pictorially idealized and eroticized, stripped of her clothes not only for the delectation of her leering old client, but also for the visual pleasure of the (male) viewer of the print itself.

This range of images powerfully suggests that Hogarth, in *A Harlot's Progress*, was adapting an available iconography of prostitution circulating across different pictorial genres and media, which frequently exploited the prostitute's sexual appeal for aesthetic effect. Recognizing this, his series can now be

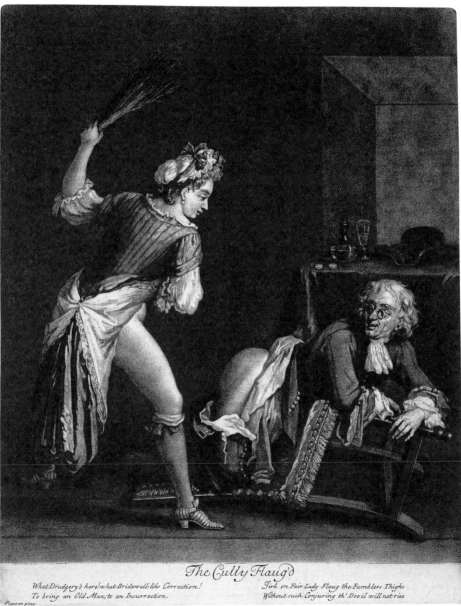

The Cully Flaug'd

What Drudgery's here! what Bridewell-like Correction!    Jirk on Fair Lady Flaug the Fumblers Thighs
To bring an Old Man, to an Insurrection.    Without such Conjuring th' Devil will not rise

Mauron pinx.

placed alongside the 'scandalous' and 'obscene' prints that were decried by the author of the poem quoted at the beginning of this chapter, who goes on to suggest that 'so great a scandal ought to be suppressed, / Modesty now-a-days is grown a jest, / And by the wiser few alone, confest.' From the point of view of print-sellers, engravers and booksellers, however, graphic art that fused satirical critique and sexual titillation clearly offered a lucrative way of attracting interest and buyers in a crowded and competitive market. It is now apparent that Hogarth – at least over part of his series – was engaged in a comparable kind of enterprise.

This is something that becomes even clearer when looking at the first three engravings in succession, when we watch Moll being pictorially stripped before our eyes. Thus, we move from seeing Moll tied up and enclosed in her clothing, and guarding her body with her arms, to seeing her caught in a state of dishevelment in which her stays are unlaced, her petticoat is revealed and her posture is opened out, to seeing her clothed only in a loose-fitting nightdress and making a direct physical appeal to the spectator: indeed, placing that spectator in the imagined position of a client standing in her place of business. Furthermore, each of these three prints includes a kind of surrogate viewer standing at a doorway, someone who looks at her as we do from a certain, controlled distance, and whose gaze is an explicitly eroticized one – whether perverse, as in the case of Charteris, confident, as in the case of Moll's young lover, or fused with the powers of judicial surveillance, as in the case of Gonson. These surrogate spectators collectively reinforce Moll's status as a sexually objectified figure, and encourage viewers of the prints to see her in similar terms. Finally, the voyeuristic and erotically exploitative power of these images, particularly the second and third, is grounded in a broader sexual symbolism, in which the space Moll occupies becomes a metaphor for her body, while the open doorways, and the men who pass through them, become a metaphor for the repeated physical penetration and withdrawal that the prostitute underwent each day of her working life.

If these features of Hogarth's series help suggest one reason why the *Progress* was found so fascinating, it is also clear that the artist carefully balanced the erotic associations of his imagery with an alternative aesthetic, one which ultimately rescued his work from the kind of condemnation voiced by the poetic correspondent to *Read's Weekly Journal*. This can be called the aesthetics of pity, in which the prostitute is reinterpreted as a victim of social circumstance and bestial appetite, and turned into a sympathetic figure whose fate provokes the most sensitive and benevolent feelings of the polite, more fortunate observer. This perception of prostitution, and the individual prostitute, grew in strength throughout the eighteenth century, and needs to be understood in terms of the increasingly central role that the expression of sympathy and benevolence came to play in defining the virtues of a polite, commercial society. An early and particularly telling example of such attitudes is found in that same issue of the *Spectator* looked at earlier in this chapter, in which a vicious old bawd hoodwinked a naive young country girl into her employ. A few paragraphs beforehand, Richard Steele's narrator describes another encounter with a young prostitute in Covent Garden:

we stood under one of the Arches by Twilight; and there I could observe as exact Features as I had ever seen, the most agreeable Shape, the finest Neck and Bosom, in a Word, the whole Person of a Woman exquisitely beautiful. She affected to allure me with a forced Wantonness in her Look and Air; but I saw it checked with Hunger and Cold: Her Eyes were wan and eager, her Dress thin and tawdry, her Mein genteel and childish. This strange Figure gave me much Anguish of Heart, and to avoid being seen with her I went away, but could not forbear giving her a Crown. The poor thing sighed, curtsied, and with a Blessing, expressed with the utmost Vehemence, turned from me. This creature is what they call newly come upon the Town, but who, I suppose, falling into cruel Hands, was left in the first Month from her Dishonour, and exposed to pass through the Hands and Discipline of one of those Hags of Hell whom we call Bawds.

These sentences, in which the male observer first interprets the prostitute as a powerfully 'agreeable' figure, and then moves on to perceive her in terms of sympathy and charity, can be seen not only as a testament to the experience and effects of benevolence, but also as yet another sign of the ways in which the polite culture to which Steele belonged both dramatized the attractions of the prostitute and anxiously sought to control and transmute her identity. Here the prostitute is initially made into an icon of desirability, quite literally framed by an archway of the piazza, before being systematically redrawn as a poverty-stricken victim. In both guises, it is worth noting, she remains economically and socially subservient to the affluent, educated male, whose relationship with the prostitute, even as he turns from a prospective client into a Good Samaritan, continues to be that of a provider of money to a social and sexual inferior. Nevertheless, it is clear that Steele's text ultimately promotes the prostitute as an object of pity, the victim not only of naivety and need, but also of the 'cruel Hands' of exploitative men and vicious brothel-keepers.

Returning to *A Harlot's Progress*, it is now clear that Hogarth effects a comparable transition: the eroticized first half of the series is succeeded by a depiction of Moll Hackabout's decline which is designed to generate precisely that sympathy rehearsed by Steele's text, and which is rendered particularly acute because of the haunting image of Moll's lost beauty. Poetic commentators on Hogarth's series dramatized this exquisite sense of pathos through the language of tears. Here, it is worth quoting extracts from a number of poems dealing with the *Progress*: 'How lovely Beauty in distress appears / This very criminal extracts our tears'; 'what heart untouch'd, could hear her piteous Moan, / Sure, strictest Virtue might let fall a Tear, / And wish the Pangs of folly less severe'; 'Alas! she dy'd; – weep – Sisters, weep; / To see the corpse would melt a stone'. And looking at the final two engravings of the series in particular, we can see that Hogarth further dramatizes this sense of loss not only through his progressive withdrawal of Moll's body from the picture space, but also through his reworking of the dynamics of spectatorship and gender. In these images, for the first

time, Moll is no longer subjected to the leers and approaches of men, but comes instead under the domesticated protection and supervision of women. In the penultimate plate, she is ignored by the squabbling doctors and clasped like a child to the breast of her loyal maid; in the final engraving, she is looked over by a woman who stands as a very different kind of surrogate viewer to those we encountered earlier, one whose gaze downwards into the coffin offers a feminine, charitable and sympathetic form of looking, rather than one built upon the narratives of sensuality or brutality.

Ultimately, however, what is striking about *A Harlot's Progress* is the way it brings together a whole range of representations and narratives relating to prostitution, and – as in so much of Hogarth's work – encourages the spectator to appreciate and pursue the overlaps and juxtapositions that emerge from a sustained process of assemblage. This not only generates the multifaceted depiction of Moll herself, but also extends outwards to encompass the depiction of the men who succeed each other across Hogarth's six plates, and her relationship to them. In *A Harlot's Progress* Moll's shifting identity as an emblem of corruption, desire and pity is pictorially played off against a similarly shifting cast of male aristocrats, merchants, magistrates, jailers, quacks, clergymen and undertakers. Hogarth's series encourages the viewer to compare each man to the other, and to satirically appreciate the continuities and correspondences between these seemingly diverse individuals, and the themes of corruption and self-interest that bind them together. For, from the myopic prelate in the first plate, who sits on his horse and ignores what goes on behind his back, to the lascivious cleric of the final engraving who, under the protection of his hat, slides his hand beneath a prostitute's skirt, Hogarth's series highlights the hypocrisy, selfishness and brutality of men in positions of authority and influence, whose collective depiction turns into a narrative of deluded and deviant masculinity that runs parallel to that of Moll herself. Even Gonson comes across as a rather ridiculous individual, whose assiduity in hunting down prostitutes in their dens might well, as numerous contemporaries suggested,

be driven by prurience rather than by civic virtue. While the *Progress*, in this light, can be understood as suggesting an extended satire not only against prostitution, but against a corrupted, masculine network of power and influence in the city, it also seems clear that this satire was not designed to offend or antagonize the polite and fashionable visitors to Hogarth's studio: rather, such visitors could define themselves, and their own sense of civic identity, against the activities, appetites and personalities of the multitude of men whom Hogarth showed so consistently deviating from respectable, urbane behaviour.

The artistic and commercial success of Hogarth's project was ensured by the fact that for the first time in his career he had brought his twin identities as a graphic satirist and a painter of conversation pieces fully together. On the one hand, *A Harlot's Progress* maintained and extended his activities as a satiric engraver. The series was explicitly designed to be reproduced, and represented a particularly ambitious kind of graphic project, in which the conventions and preoccupations of satire were fused with the format and demands of an engraved series, one that no longer illustrated a familiar text, as in the case of *Hudibras*, but that stood as a self-sufficient pictorial narrative. For the collectors and supporters of contemporary graphic satire Hogarth's must have seemed a bold and utterly modern initiative, indeed one which rewrote the rules of the genre altogether.

On the other hand, this series, which Hogarth promoted through the exhibition of his six modestly sized canvases, exploited his success and fashionability as a modern painter, and represented a new kind of conversation piece on his part, in which the relatively small-scale depiction of intimate exchanges between groups of modern individuals was redirected away from the world of high culture to that of the low. Again, the values that both kinds of painting promoted were ultimately thoroughly compatible: the 'low' conversation piece, loaded with satire and irony, offered a grotesque, distorted mirror image of the 'high' which only served to amplify the decorum and status of the latter. Furthermore, for the

genteel patrons who appreciated Hogarth as a portraitist in oil, the status of *A Harlot's Progress* as a legitimate and attractive form of contemporary painting could only have been confirmed by the fact that the series, although begun in Hogarth's bachelor premises on the east side of the Covent Garden Piazza, was finally exhibited in a new studio he had taken on the other side of the square, in the house of his father-in-law, Sir James Thornhill, the distinguished history painter. Viewing the painted and printed versions of *A Harlot's Progress* thus afforded an opportunity not only to appreciate a novel conjunction of the languages of ink and paint, and of the conventions of satire and conversation, but also to enjoy the thrill of a thoroughly modern, scandalous and heart-rending kind of art being displayed in a house associated more than any other with the most traditional, sober and dignified form of artistic practice.

No wonder, then, that *A Harlot's Progress* made such an impact in the contemporary art world, and – as George Vertue's jotted notes confirm – made its creator so much money. The engravings were sold by subscription, at a guinea a set, which prospective purchasers (having looked at the paintings) paid half in advance and half on receiving the six prints. Vertue writes that Hogarth 'had daily Subscriptions', which amounted to 'fifty or a hundred pounds in a week – there being no day but persons of fashion and Artists came to see these pictures'. Even dramatists and fan-makers got in on the act. John Nichols, Hogarth's eighteenth-century biographer, noted that the *Progress* 'was made into a pantomime by Theophilius Cibber; and again represented on the stage, under the title of *The Jew Decoyed*, or a *Harlot's Progress*, in a Ballad Opera. Fan-mounts were likewise engraved, containing miniature representations of all the six plates. These were usually printed off with red ink, three compartments on one side, and three on the other.' Hogarth, it is clear, had a hit on his hands, and it was quickly making him a small fortune.

Even so, he still had plenty to be dissatisfied about. For over the same period a number of print publishers in the city had rushed to issue plagiarized copies of the series, which they sold at cut-rate

prices in the print shops of the city. Hogarth, enraged by what he saw as yet another attempt to undermine his artistic status and rob him of his rightful earnings, immediately began to mobilize support among his fellow engravers to defend themselves against such practices. The success of this campaign is a testament to the increasing regard in which Hogarth was now being held by his artistic peers, to the energy with which he promoted the cause of the engravers and to his growing interest in working with other artists, and not only on his own. After a sustained campaign of lobbying and petitioning at Parliament, an act protecting the copyright of engravers was finally passed into law in the summer of 1735. This act, although it resulted from a collective sense of grievance among London engravers, has understandably come to be known as 'Hogarth's Act', and it was to have a powerful and lasting effect on the artist's own career and fortune. From now on, he could hope to design and issue his own engravings without expecting to find adulterated versions of the same images staring back at him from the print-shop windows, and – to his eyes, at least – picking money from his pocket.

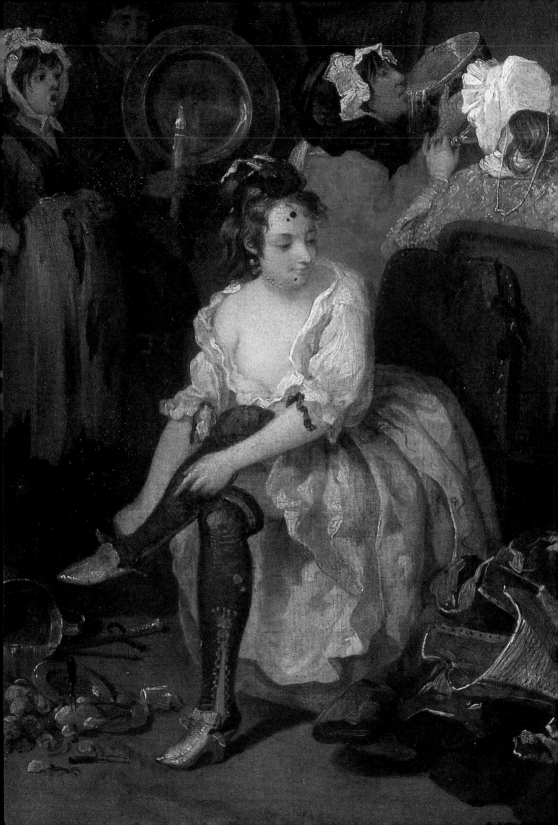

Jonathan Swift, in a poem of 1736 detailing a riotous episode in the life of the notorious Irish Legion Club, declared that he would love to have Hogarth alongside him, picturing the same scene, providing comic inspiration and offering entertaining companionship: 'How I want thee, Humorous Hogarth! / Thou, I hear, a pleasant rogue art.' Swift's words not only confirm Hogarth's growing celebrity in the years immediately following the publication of *A Harlot's Progress*, but also testify to one aspect of the artist's reputation in this period: that of the cheerful, worldly, even slightly rakish man-about-town. Hogarth's identity as a 'pleasant rogue', one that he was never entirely to abandon, was honed within a small community of jobbing artists, actors, lawyers, musicians, doctors and journalists that grew up around Covent Garden and Soho in the early decades of the eighteenth century. Numerous clubs and societies had developed in this area, fostering a variety of collective activities, ranging from boisterous evenings of feasting to animated exchanges about art and politics. The most eloquent indication of Hogarth's involvement in this convivial, masculine and frequently irreverent community is a five-day trip he undertook with four male companions at the end of May 1732, which began after a night's drinking at the Bedford Arms Tavern, just around the corner from his father-in-law's house. On this uproarious journey, Hogarth was accompanied by the painters Samuel Scott (*c*.1702–72) and John Thornhill (son of Sir James, d.1757), the businessman William Tothall and the lawyer and writer Ebenezer Forrest, who chronicled their journey in a notebook now stored at the British Library.

Starting off at midnight, the group strolled to Billingsgate, drank some more beer, and caught a boat down the Thames to Gravesend, where they embarked upon a comic, picaresque

journey around the villages and towns of north Kent, before returning to their London homes. As well as visiting churches, inspecting monuments and admiring the battleships berthed at places like Chatham, the men indulged in mammoth bouts of eating and drinking, endless practical jokes and a series of play-fights in which they threw pebbles and sticks at each other, were spattered by clumps of dung and soaked by the water of a village well. In all these activities Hogarth was at the fore, and in a

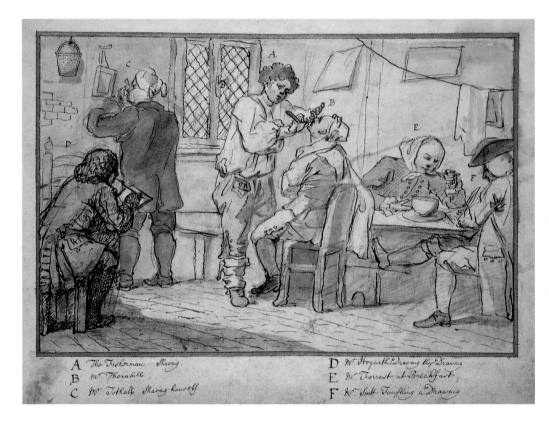

A The Fisherman Shaving.
B Mr Thornhill
C Mr Tothall Shaving himself
D Mr Hogarth Drawing this Drawing
E Mr Forrest at Breakfast
F Mr Scott Finifhing a Drawing

particularly scatological exchange described by Forrest, he found himself getting his bottom stung by one of his companions as he shat on a grave: 'Hogarth having a Motion; untruss'd upon a Grave rail in an Unseemly Manner which Tothall Perceiving administered pennance to ye part offending with a bunch of Netles, this occa-sion'd an Engagement which ended happily without Bloodshed and Hogarth Finish'd his Business against the Church Door.' Even if the artist was only intent on relieving his bowels, it seems entirely

characteristic – remembering his satirical jibes at hypocritical Christians in *A Harlot's Progress* – that he should do so in the hallowed space of a churchyard.

Forrest's written account of the trip and Hogarth's wonderfully fresh sketches of the expedition's more tranquil moments (51) were read out and displayed in the Bedford Arms after the men's return. For Hogarth at least, Forrest's text and his own illustrations must have functioned as an informal means of publicity, keeping his name at the centre of discussion among his immediate peers, and helping to fuel a burgeoning myth of the artist as a raucous, exuberant and playful observer of modern London and its environs. In allowing himself to be seen in this way, Hogarth was conforming to a long-standing model of satiric identity which had been revitalized by turn-of-the-century writers like Tom Brown and Ned Ward – that of the intelligent but resolutely unpretentious male urbanite who not only embarked upon tours of the countryside around London, but who cruised through the city itself, travelling by foot from one end of the metropolis to the other, scouring its streets, alleyways and interiors for scandalous, grotesque and comical subject matter, and laughing and pouring scorn as he goes. In this kind of satire, made famous by Brown's *Amusements, Serious and Comical* of 1700 and Ward's *London Spy* of 1710, the satirist emerges as a man who revels in the low cultures of the modern city even as he castigates its failings and hypocrisies, who mixes the foul-mouthed, crude and indecent language of the street with the vocabulary of learning and refinement, and who, even as he exposes the seedy and corrupted underside of urban culture, exploits its titillating and voyeuristic potential for all its worth. Hogarth, therefore, was clearly adapting and maintaining something of this persona in this period, both as the creator of *A Harlot's Progress*, with its comparable concentration on an abject but alluring aspect of urban society, and as the joshing, earthy and good-natured Londoner who could quickly move, on a brief jaunt into Kent with his metropolitan friends, from inspecting a battleship and exploring a graveyard to defecating at a church door and slinging dung at his fellow travellers.

51
*Breakfast*,
1732.
Pen with
brown ink
and grey wash
over pencil;
20·5×32cm,
8⅛×12⅝in.
British
Museum,
London

In other ways, however, Hogarth was cultivating a more respectable personal and professional identity at this time. This was signalled most obviously by his and Jane's decision to move to a new house and studio in Leicester Square, just to the west of Covent Garden (52). The square, which had been developed as an aristocratic residential area in the seventeenth century, was dominated by the presence on its north side of Leicester House, which accommodated a succession of English princes and European ambassadors during Hogarth's lifetime. Elegant three- and four-storey terraced houses made up the rest of the square, and it was into one of these – right in the southeast corner – that the artist and his wife, aided by the profits from *A Harlot's Progress*, moved in the autumn of 1732.

52
John Maurer,
*Leicester Square*,
1750.
Engraving

From the door and windows of his new house Hogarth looked out on to an uncluttered world of gentility, dramatized by the stately rhythms of the terrace facades opposite, by the manicured spaces of the communally owned garden – railed off against vulgar trespassers – and by the venerable presence of Leicester House itself, which remained an eloquent emblem of royal power and Continental sophistication. Here Hogarth's own sense of his new-found status would have been confirmed by the everyday sounds which drifted into his house, so different to those that pummelled the walls of his older residences in Covent Garden, which had overlooked the Garden's famous vegetable market. The intermittent trundle of coach wheels replaced the clatter of goods

being unloaded for the market, while the murmur of aristocratic conversation must have made the cries of hawkers and stallholders seem a mere memory.

This sense of refinement was also communicated by Hogarth's decision to signpost his new business premises by placing a gold-painted bust of the famous seventeenth-century artist Anthony van Dyck (1599–1641) over his doorway. Through this gesture, Hogarth was clearly seeking to symbolically insert himself into an artistic lineage that included not only his famous father-in-law,

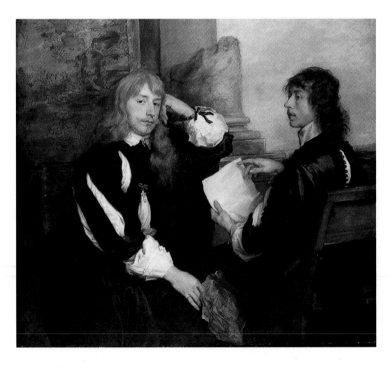

**53**
**Anthony**
**van Dyck,**
*Thomas*
*Killigrew and*
*Lord Crofts,*
1638.
Oil on canvas;
132·7×143·5cm,
52¹⁴×56¹⁄₂in.
Royal
Collection

but also the most celebrated painter working in England during the previous century. For the visitors to Hogarth's studio and showroom, particularly those who came to sit for a portrait, the bust must have worked as a visual prompt that conjured up a mental image of exquisitely crafted portraits and resolutely aristocratic subjects (53), in relation to both of which Hogarth's own work, and his sitters, could be flatteringly compared. While the 'Golden Head' helped secure Hogarth's credentials as a fine artist, it is worth suggesting that, even here, the artist may have

been playing a kind of joke, wittily exploiting Van Dyck's courtly art and persona in order to highlight just how different and novel his own artistic practice and identity were. The imaginative comparison between the attenuated and refined figures of Van Dyck's portraits and the grotesque, vulgar protagonists of a series like *A Harlot's Progress*, for instance, must surely have served to accentuate the modernity and heterogeneity of Hogarth's satiric work, while the sight of the bluff, squat artist – only some five feet tall – standing at his door underneath the iconic bust of his gentlemanly predecessor offered the visitor an opportunity not only to align the two men, but also to appreciate the comic incongruity between them.

However playful Hogarth remained, the new setting in which he lived and worked clearly encouraged the development of a rather different satiric persona to that which he had cultivated in the coffee-houses, taverns, studios and steak-houses of Covent Garden. More specifically, Hogarth was given the chance to adopt a more polished kind of identity, in which he reformulated himself as the ironic, refined observer of high society rather than the rakish man about town. And if Tom Brown and Ned Ward had helped define the latter role for the satirist in the early years of the century, the former was most closely associated with the writings and persona of Molière, the seventeenth-century French dramatist whose plays were constantly being translated, adapted and

performed on the London stage in the early 1730s, and which were published as a collection in an English edition in 1732. His works were lauded as satirical dissections of bourgeois and aristocratic life that, in the words of a contemporary advertisement, were 'chaste and moral, as well as … most diverting'. Significantly, Hogarth himself designed two frontispieces for the 1732 edition of Molière's works, respectively illustrating *The Miser* and *The Cuckold in Conceit* (54, 55). These engravings, however slight in themselves, suggest how closely Hogarth was engaging with an alternative kind of satiric template to that provided by writers like Brown and Ward, one which offered him the chance to subtly redefine his artistic personality and output in relation to the more dignified culture he had entered by moving to Leicester Square.

*A Rake's Progress*, the next great satiric series produced by Hogarth, which he painted, engraved, displayed and sold in his new house between 1733 and 1735, focuses on a similarly disreputable and intriguing central figure to that of the *Harlot's Progress*, and strikingly combines the garrulous, ironic perspectives and low-life subject matter of the roving, roguish satirist with that witty focus on the hypocrisies of wealth and social status so typical of the polite satire associated with Molière. Hogarth's eight pictures tell the story of a young man called Tom Rakewell, and begin by showing him being measured for a suit soon after inheriting his miserly father's fortune. Even as he is fitted for a new life in the metropolis, we see him trying to buy off a pregnant young woman, Sarah Young, seduced with promises of marriage while Tom had been a student at Oxford (56). The second canvas depicts Tom standing at the centre of a retinue of servants, lackeys and hangers-on in his newly acquired London town house (57), while the third shows him sprawling with prostitutes at the Rose Tavern in Drury Lane (58). The fourth scene shows Tom about to be arrested for debt on his way to St James's Palace, but being temporarily rescued by the loyal Sarah Young, who offers a bag of money to the bailiff pulling at the rake's jacket (59). We move on to find Tom temporarily financing new extravagances by marrying a wealthy old woman at St Marylebone Parish Church (60). In the

54
Frontispiece to Molière's *The Miser*, 1732. Engraving; 12·7×7·9 cm, 5×3⅛ in

55
Frontispiece to Molière's *The Cuckold in Conceit*, 1732. Engraving; 13×7·9 cm, 5⅛×3⅛ in

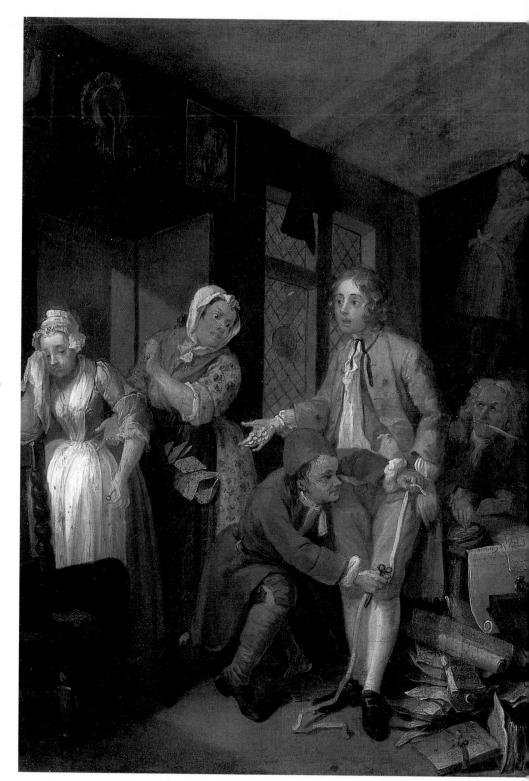

**56**
*The Rake's Progress* (1),
1733–5.
Oil on canvas;
62.2×74.9cm,
24½×29½in.
Sir John
Soane's
Museum,
London

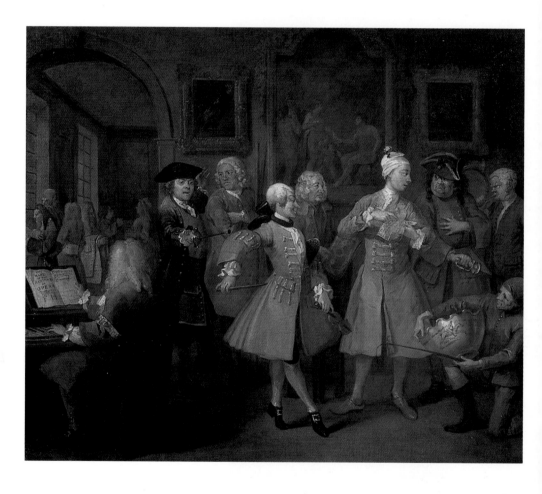

**57**
*The Rake's
Progress* (2),
1733–5.
Oil on canvas;
62.2×74.9 cm,
24$^1$2×29$^1$2 in.
Sir John
Soane's
Museum,
London

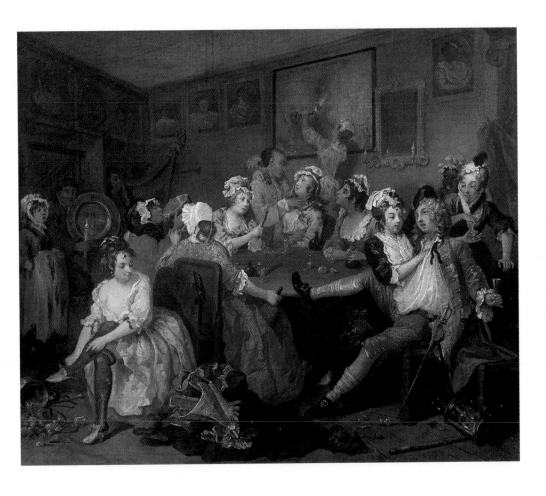

58
*The Rake's
Progress* (3),
1733–5.
Oil on canvas;
62.2×74.9 cm,
24¹₂×29¹₂ in.
Sir John
Soane's
Museum,
London

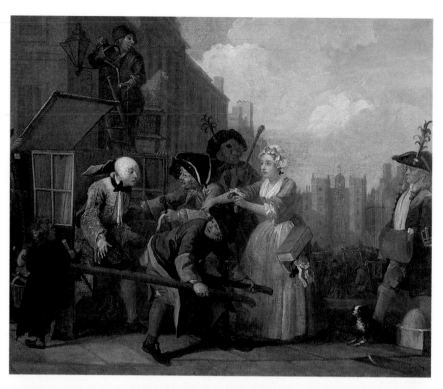

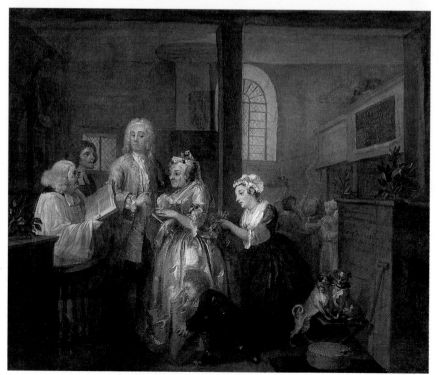

59–60
*The Rake's Progress* (4–5), 1733–5.
Oil on canvas; 62.2×74.9 cm, 24½×29½ in.
Sir John Soane's Museum, London

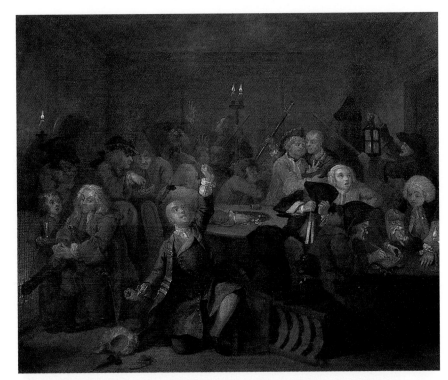

**61–62**
*The Rake's Progress* (6–7), 1733–5.
Oil on canvas; 62·2×74·9cm, 24½×29½in.
Sir John Soane's Museum, London

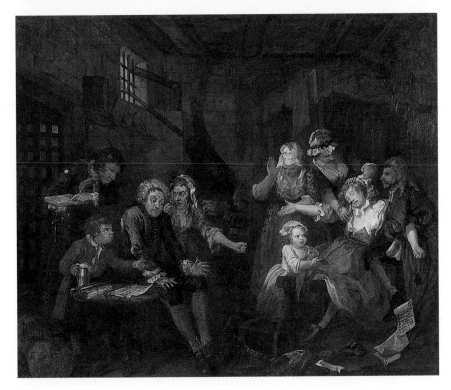

**63**
*The Rake's
Progress* (8),
1733–5.
Oil on canvas;
62.2 × 74.9 cm,
24½ × 29½ in.
Sir John
Soane's
Museum,
London

sixth image of the series, Hogarth focuses on a London gambling den – probably in Covent Garden – and depicts his protagonist exclaiming with grief after losing his remaining fortune (61). The last two canvases confirm the rake's doomed fate: in Hogarth's penultimate image, Tom sits in melancholy paralysis in Fleet Prison, having been jailed for debt (62), and in the final picture, we are taken inside Bedlam madhouse, where a near-naked Tom writhes across the stone floor, clamped in chains and nursed by the long-suffering Sarah (63).

In his new *Progress*, Hogarth was engaging with a powerful contemporary stereotype of errant masculinity. The rake regularly populated satirical and didactic writings during this period, in which his life acquired a formulaic pattern of rise and fall, and – just as in the case of Hogarth's series – served to reinforce a more respectable kind of manhood through the negative example it provided. Over and over again he is introduced as a non-metropolitan figure – normally a young aristocrat living in the country or studying at one of the old universities – who, upon receiving news of his father's death, travels to London and begins spending his inheritance with extravagant haste. Once settled in the city, the aspirant rake circulated around a well-established circuit of masculine sociability and pleasure, and repeated the same activities night after night.

These are well summarized in *The Rake Reform'd* of 1717, which describes the hung-over narrator getting up at midday and stumbling outdoors for a drink. At five he walks to a gaming house, then later to the playhouse, and later still to the Rose Tavern in Drury Lane, where, just like Tom Rakewell in Hogarth's series, he seduces a 'jilt', drinks more wine and blearily notices that 'glasses diffuse'd in broken fragments lay, / And cloathes distain'd with Wine did my Excess betray.' Next day, of course, he begins his routine all over again: 'Thus I a round of fancy'd Bliss pursu'd, / And each succeeding Morn my course renew'd.' In texts like these, rakes tended to be invoked as the butts of moral and satiric criticism, and are often made to look back on their careers with

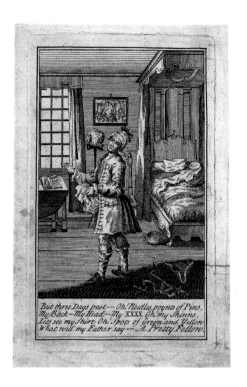

But three Days past — Oh! Needles poynts of Pins,
My Back — My Head — My XXXX Oh! my Shinns,
lets see my Shirt Oh! Spots of Green and Yellow,
What will my Father say — A Pretty Fellow.

regret and remorse, and given a last chance to mend their ways.
Thus, the narrator of *The Rake Reform'd*, in shock at seeing a fellow
libertine die, undergoes a sudden conversion to the values of rural
retreat towards the end of the poem, and moves to the country.
Meanwhile, in *The Rake's Progress, or Templar's Exit*, an illustrated
poem of 1732, the eponymous protagonist – bankrupt, disease-
ridden and friendless (64) – breaks down in his garret, bemoaning
his fate: 'Ah! Woeful, miserable me, / That can't one grain of
comfort see! / Where now are all my whores, false friends, / Now
they have secured the Devil's Ends.' He goes on to commit suicide,
hanging himself – in an eerie and intriguing detail – from a nail that
pins the third print from Hogarth's *A Harlot's Progress* to the wall.

Sifting through such publications suggests the ways in which
Hogarth's own pictorial series echoed the diverse concerns and
subject matter of contemporary writings dealing with the rake.
Here, to give one more example of this satirical overlap, it is help-
ful to turn to Tom Brown's works, and note a passage in which he
describes stumbling across a gaming house where 'rakes of various

humours and conditions met together … one that had played away
even his shirt and cravat, and all his clothes but his breeches, stood
shivering in a corner of the room, and another … fell a-ranting, as
if hell had broke loose that very moment.' Hogarth's sixth image
(see 61) suggests how thoroughly the artist has duplicated, and
expanded upon, this kind of satiric focus. This parallel also
confirms the close alignment of Hogarth's perspective in *A Rake's
Progress* and similar works with the viewpoint of writers such as
Brown and Ward. Like them, Hogarth frequently gives the
impression of having himself entered and minutely observed a
dissolute, marginal space of the city, crowded with the criminal,
the addicted and the insane, before emerging to depict what he has
seen in satirical terms.

65
John
Vandergucht
after
Bartholomew
Dandridge,
Frontispiece
to Molière's
*The Cit turn'd
Gentleman*,
1732.
Engraving

As well as adapting the stereotypes of rakery, Hogarth's depiction
of Tom also invokes other masculine antitypes, including the cit
(short for 'citizen'). The cit, the aspirant bourgeois who sought to
purchase genteel status rather than, like the rake, exhaust it, was
also a recurrent target of satiric humour in this period. Significantly,
Molière's newly translated *Le Bourgeois Gentilhomme* (*The Cit turn'd
Gentleman*) offered a powerful comic parable of the middle-class
tradesman attempting to turn himself into an aristocrat through,
among other things, the help of a dancing master, a fencing master,
a master tailor, a music teacher and a philosophy master. The
frontispiece that accompanies the 1732 translation of the play (65),
designed by Bartholomew Dandridge (1691–*c*.1754), shows the
extravagently dressed cit, Mr Jordan, blundering through a fencing
lesson, watched by the amused figures of his teachers.

The works of Molière and Dandridge make us realize that the
figure of the rake was only one element in an overlapping series of
stereotypes defining deviant forms of masculinity in early Georgian
England. Returning to Hogarth's set of pictures, we quickly find that
*A Rake's Progress* itself offers a similar form of overlap, in which Tom
himself is described not only in terms of rakery but also in ways which
suggest other satiric stereotypes, including the cit. In this context, it
is particularly suggestive to look at the second picture of the series

(see 57) in which Tom seeks to purchase and manufacture an aristocratic identity in the city, having inherited a fortune from his bourgeois father. Here, Tom is surrounded by exactly the same kind of retinue that Molière had introduced into *The Cit turn'd Gentleman*, and that Dandridge had summarized in his frontispiece – Tom's French dancing master tiptoes up to him holding a miniature violin, his fencing master thrusts his épée towards the viewer, his tailor stands in the background with a new coat draped over his arm, a paid musician plays on a harpsichord and his resident literary intellectual – an old poet – waits by the window holding an *Epistle to Rake*. While the depiction of the levee can now be seen as extending Hogarth's acidic critique to encompass the perceived failings of the emulatory bourgeois, such images simultaneously functioned to extend his satire to precisely those areas of genteel urban culture that had traditionally been the province of polite satirists like Molière. In this process, the narratives and spaces of high life – whether those of the levee or of the streets around St James's – are integrated into *A Rake's Progress* alongside the low-life scenes of gambling dens and tavern brothels.

If Hogarth's series can now be suggestively linked to contemporary writing, illustration and performance, the primary status of *A Rake's Progress* as a set of images demands a closer look at the ways

in which it responded to, and reworked, the materials of the visual arts. Here, for economy, I shall concentrate on the third picture of the series (see 58), and use it to suggest how Hogarth was again self-consciously defining his work in ironic relation to other kinds of art. In this respect, his image of the Drury Lane orgy – and his narrative more generally – can be seen to adapt a Christian iconography of the Prodigal Son. The biblical story of a young man who squanders his inheritance on 'riotous living' and 'harlots' had long been represented as a series of images in painted and graphic art. John Sturt (1658–1730), for instance, produced a series of elaborate illustrations of the prodigal's story for John Goodman's

The Penitent Pardoned, published in 1678, which included a detailed engraving of his dissolute behaviour in a brothel (66). The correspondences between this engraving and the depiction of Tom in the Rose Tavern – there is even a similar harpist playing in the background – suggest the extent to which the later artist was modernizing an established pictorial narrative of masculine irresponsibility and excess, something that he clearly expected his viewers to recognize and appreciate.

At the same time, the scene at the Rose Tavern provided a satiric version of more recent works like the Conversation Piece by Peter Angellis (67), which showed rakish gentlemen in a rather more

positive light. Here, there seems to be no implied criticism of the activities shown in the painting, where the men appear to be fashionable libertines and the women courtesans, already pairing off into couples. In this fantasy of sexual collusion, an actively predatory, libidinous and rakish masculinity is both celebrated and dressed up in sophisticated pictorial clothing. Hogarth's image offered an intimate dialogue with such works, uncovering and complicating the debauched way of life that lies beneath their luxuriously painted surfaces, and transforming the rake himself – shown stupefied, sexually exhausted and in the process of being robbed – into a comically emasculated counterpart to the men who

66
**John Sturt,**
Illustration
to John
Goodman's
*The Penitent
Pardoned,*
1678.
Engraving

67
**Peter Angellis,**
*Conversation
Piece,*
*c.*1715–20.
Oil on canvas;
93·7×79·7cm,
36⁷⁄₈×31¹⁄₂in.
Tate Gallery,
London

dominated their narratives. At the same time, of course – and this is reminiscent of Hogarth's practice in *A Harlot's Progress* – the closeness of his scene to more obviously celebratory depictions of hedonistic masculinity alerts us to the fact that, in depictions like that of the Rose Tavern, Hogarth was clearly exploiting the voyeuristic and erotic possibilities of his subject matter. Even as Hogarth depicts Tom as ridiculous and impotent, he invites the viewer – or, more particularly, the male viewer – to cast his eyes over the undressing figure of the beautiful prostitute in the foreground, and to imagine her activities in the immediate aftermath of this depicted moment, when it is suggested she will swivel nakedly on

the silver platter being carried through the door, and display her sex in a variety of different positions for the males sitting around the table.

The other images of *A Rake's Progress* similarly drew upon, and responded to, a variety of pictorial materials. Hogarth's depiction of Tom in the last image of the series, for example, deliberately echoed the statues of Melancholy and Raving Madness that stood over the doorway of Bethlehem Royal Hospital, or Bedlam, in this period (68). And part of the reason for Rakewell's compelling status as a pictorial anti-hero was the diversity of his representation, which helped to give him an exceptionally fluid and unstable pictorial identity in the series – he is variously depicted as immature, effeminate, aspirant, lecherous, conniving, addictive, melancholic and, by the final plate, insane. Yet despite the range and eclecticism of Hogarth's pictorial references, which offered an ambitious reassertion of traditional satiric practice, what must also have struck contemporaries was the extent to which *A Rake's Progress*, just like its predecessor, amounted to far more than the sum of its different parts, and succeeded in binding together a mass of representations into a single pictorial entity.

**68**
**Caius Gabriel Cibber**, Statues of *Melancholy* and *Raving Madness* from the portal of Bethlehem Royal Hospital, engraved by William Sharp, 1783

This was done partly by exploiting the emotive, imaginative and narrative potential of the pictorial series as a means by which an audience could become powerfully bound up in an individual protagonist's history. In this case the viewer not only responds to the varying depictions of Rakewell, but also fills in the gaps between the images to construct an imaginary existence for Tom that momentarily transcends or represses his actual status as a hybrid, artificial pictorial representation distributed across eight pieces of canvas or paper. While Hogarth's choice of format in *A Rake's Progress* facilitated the development of this 'reality effect', his particularly brilliant and complex manipulation of the series structure also ensured that his viewers were given a succession of narrative routes across the eight images. To understand these different visual pathways better, it is worth imagining the prints hanging on a wall, the first four images placed in line and hanging directly above the four others (69). This would have been a typical way of displaying the *Progress* in the period, and it was one which enabled the viewer, first of all, to interpret the eight prints as a single narrative in which one scene, packed with an ever-present hero and a wide cast of recurring characters, smoothly follows another. This kind of graphic continuum was encouraged by the broad compositional, figural and spatial correspondence between all eight images: from the first print to the last, we are presented with a repetitive succession of rectangular, box-like pictorial spaces in which Tom is constantly inserted into a strip of figures distributed across the width of the picture plane. Cumulatively, this arrangement gives the images a powerful linear momentum, in which each pictorial space, and each strip of figures, runs seamlessly into another.

This momentum is reinforced by the frequent use of doorways, archways and other openings at the sides of the engravings. These function as points of entry and exit that not only facilitate the movement of the story from one episode to the next, but also our own optical passage through the series. For we are invited, visually and imaginatively, to wander through these doorways, arches and apertures, and in doing so to move outward and 'into' the following scene: for example, through the doorway on the

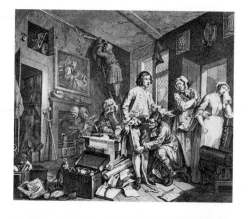

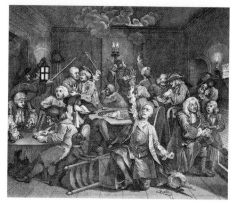

69
Composite
image of
Hogarth's
*Rake's Progress*,
1733–5.
Engravings

right-hand side of the first image into the archway on the left-hand
side of the second, or through the doorway on the right-hand side
of the orgy scene into the open street on the left of the fourth
engraving. Conversely, once we have reached the end of the series,
these openings also encourage us to track backwards visually
across the different engravings: for example, through the doorway
in the final image of the Progress into the doorway that dominates
the right-hand side of the penultimate plate. Through such subtle
methods, Hogarth adds to what can be called the *Progress*'s
horizontal visual drive.

But it is also striking how Hogarth encourages other kinds
of narrative and visual passage. Remembering our imagined
arrangement of the eight images on the wall, in which the first
print hangs directly above the fifth, and so on, we can now explore
the ways in which his set of prints also invites a vertical axis of

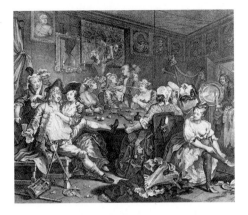

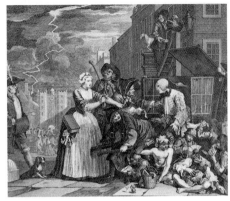

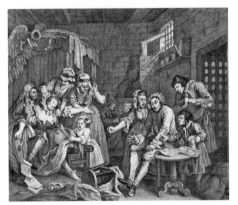

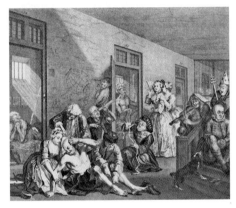

`interpretation and viewing. If we allow our eyes to move from
each engraving in the upper level of images to that immediately
below it, we quickly become aware of an alternative narrative logic,
whereby different images are linked together in new and powerful
ways, and the fall of our gaze from one print to the other becomes
a metaphor for the social, moral and personal decline of Tom
himself. We begin by moving from an image of Tom breaking his
promise of marriage to Sarah, and being berated by her mother for
doing so, to one that depicts his actual, later marriage to a wealthy
crone, complete with the depiction of Sarah and her mother
storming into the church to protest. Then we move from a picture
of Tom with one set of male companions, enjoying a deluded sense
of prosperity and sophistication, to one which depicts him with
another group of men, having lost not only his fortune and all
semblance of decorum, but his sanity. Then from one that

pictorially balances the carousing, extravagant rake with the figure of an undressing prostitute to one that similarly juxtaposes the debt-ridden Tom on one side of the print with the sprawling, pathetic figure of Sarah on the other. And then, finally, from an engraving that shows Tom standing above a cluster of semi-naked and anarchic adolescents to one that shows him having descended to their level, both literally and figuratively, and having become part of a similarly abject sprawl of bodies. Interestingly, Hogarth added the clutch of beggars and gamblers to the fourth plate soon after his initial publication of the *Progress* – it is as if he knew something was missing, something that helped complete a certain way of looking.

Tracing these different visual and interpretative pathways confirms not only Hogarth's growing confidence with the possibilities of the series format, but also the active and mobile kinds of spectatorship that *A Rake's Progress* demanded. Indeed, the artist also seems to be inviting viewers of the series to participate in a vicarious and thrilling pictorial tour of the modern metropolis as they move in front of his eight canvases and engravings, one which in this case encompassed St James's and Drury Lane, Marylebone and the Fleet, a Covent Garden gambling club and Bedlam hospital. Hogarth, in his next great series of satiric prints from the 1730s entitled *The Four Times of Day*, was to develop this idea of the satiric tour of the English capital even further.

This set of four paintings and engravings was published in March 1738, and focused on a succession of urban and suburban environments, depicted during different periods of day and night. *Morning* (70) is set in Covent Garden, at ten minutes to eight on a bitterly cold winter's day. A strolling, overdressed spinster is shown wandering towards St Paul's Church on the north side of the square, accompanied by a freezing servant-boy carrying her Bible. A black beggar forlornly holds out her hand to the old maid, who ignores her pleas for charity while staring at two rakes fondling and kissing a pair of young market women. The men have just spilt out of Tom King's coffee-house, a notorious real-life hostelry

which remained open all night and was infamous as a place of dissolution and disorder. Here, its doorway is crowded with the signs of riot: criss-crossing staves and swords are brandished above a crush of bodies, and a wig flies out into the snow. In the background of the engraving the square's vegetable market begins to come alive, a quack-doctor cries his wares and smoke billows in front of the house of Lord Archer, the one remaining aristocrat still living in the Garden.

In *Noon* (71), meanwhile, the scene shifts to Hog Lane in Soho, one side of which is dominated by the walls of a French Huguenot chapel. The hunched and gloomy-looking members of the congregation troop out into the street, their sobriety of dress and expression deliberately contrasted with the clothing and demeanour of the couple in the left foreground, whose luxurious outfits, affected gestures and flirtatious conversation embody an alternative stereotype of Frenchness. On the right, meanwhile, separated by the gutter that runs down the centre of the street, we are presented with an extended allegory of physical excess and overflow: a black servant, following on from the rakes of *Morning*, fondles the breasts of a housemaid, whose spilling pot is itself pictorially linked to the food that has been dropped by a bawling boy and to the meal that falls out of an upstairs window in the background.

In the third picture of the series, *Evening* (72), we find another couple dressed in their best clothing, taking a summer's walk in Islington along a new, man-made waterway and drifting past Sadler's Wells Theatre, constantly satirized in the period as a suburban resort of vulgar tradesmen and their snobbish wives. Here again we find female vanity, lasciviousness and self-delusion being ridiculed: the central female's beefy coarseness is only accentuated by her clumsy attempts at elegance, while her physical and sexual appetite is conveyed by the nude gods and goddesses painted on her fan. Her husband, in contrast, is diminutive and henpecked, and revealed as a cuckold by the comic juxtaposition of his head with a cow's horns. In the background a scolding sister and her crying brother amplify the print's playful critique of

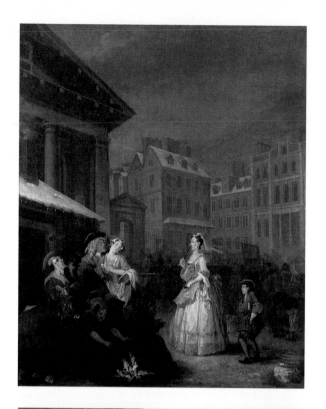

70
*Morning*,
1736–8.
Oil on canvas;
73·7×61cm,
29×24in.
Private
collection

71
*Noon*,
1736–8.
Oil on canvas;
74·9×62·2cm,
29½×24½in.
Private
collection

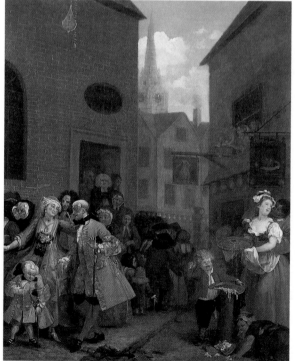

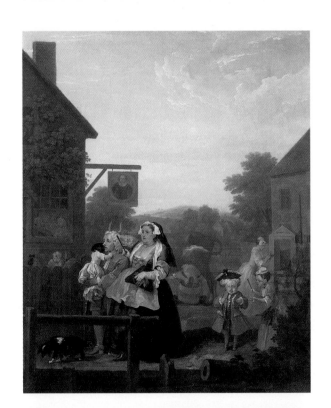

domineering females, while the milking-hands offer a crude echo of the fondling fingers of the two previous images. Meanwhile, some drinkers gather at one of the taverns that dot the landscape, the men with their puffing pipes foreshadowing a figure we find in the final plate of the series, *Night* (73), who empties a bucket into a huge barrel outside the Rummer Inn. This last image focuses on a drunken freemason, traditionally identified as the examining magistrate Thomas de Veil, famous for his prosecution of illegal liquor houses, who is ironically shown stumbling home accompanied by a servant, after a hard night's drinking at his Lodge. Drenched by a shower of urine, he is oblivious to the chaos that surrounds him. A passenger coach crashes and catches fire, a barber-surgeon clumsily shaves and squeezes the nose of a discomfited customer, and in the far background, beneath the statue of Charles I that dominated Charing Cross, a family of debtors escape from their house under the cover of night, carrying a coach-load of furniture with them. In a quiet, unnoticed corner, a homeless family sleeps under a flimsy shelter.

As in so much of Hogarth's work, including his two earlier *Progresses*, *The Four Times of Day* needs to be understood as part of a broader field of satiric representation offering contemporary Londoners a critical, witty commentary on their own urban culture. This kind of social satire, whether pictorial or literary, highlighted the aberrations and excesses of different parts of the city, and of various character types within them. The anonymous author of *The Man of Manners: or, Plebeian Polished*, published in 1737, for instance, attacks older women who combine their pretensions to Christian virtue with an over-reliance on the deceptions of make-up: ''tis a pretty sight to behold a lady with her Eyes lifted up to the Lord, with her real complexion incognito, and her charms retir'd over the Meridean of Fifty; yet the decays of Nature, so buoy'd up by Art, in a comely Varnish, over those Breaches time has made, that her cheeks wear June, and her hair December.' Clearly, the woman at the centre of *Morning* is another such figure, and is meant to be understood as a frustrated spinster who hopes to catch a husband at morning service, and whose

74
George Bickham Jr,
*The Rake's Rendezvous*,
c.1735.
Engraving;
21.3×34.8cm,
8⅜×13¾in

startled look at the activities taking place in front of her expresses both shock and a furtive, lascivious interest. Meanwhile, *The Rake's Rendezvous* by George Bickham Jr (*c.*1706–71; 74), which was probably issued sometime in the mid-1730s, offers an interesting reversal of *Morning's* viewpoint, for it is engraved from the perspective of someone sitting in the back room of Tom King's, looking out into the Garden through a distant doorway, rather than standing outside looking in. In this cramped, seedy space, drunken rakes and a stupefied cleric intermingle with bare-breasted, vomiting prostitutes, dogs copulate under the table and an effeminate and overdressed fop stands admiring a confidently posed gallant, caressing a strategically placed sword handle as he does so.

A similarly chaotic scene is depicted in an illustration to *Tom King's; or the Paphian Grove*, a mock-heroic poem published in the same year as Hogarth's series (75). Here, a bareheaded lawyer and visiting country squire brawl inside a room in Tom King's coffee-house crowded with prostitutes, their wigs having fallen to the ground.

These engravings and writings confirm that Hogarth's series of urban views took their place among a cluster of interconnecting and overlapping satires on the city, and suggest the extent to which he adapted and assembled a variety of familiar subjects and emergent stereotypes as he constructed his four images. Furthermore, Hogarth clearly saw his series in playful relation to more conventionally

respectable kinds of art, including the long-standing 'Times
of Day' graphic tradition and the topographic paintings which
offered more decorous representations of different spaces within
the city (76). Hogarth's pictures tie together this satiric aesthetic
with that form of mobile urban commentary repeatedly mentioned
in this chapter. *The Four Times of Day*'s sustained comic vision of
the modern city as a chaotic environment clogged by the teeming
presence of the vulgar, gross and pretentious again seems defined
by the perspective of the pedestrian travelling unobserved around
the metropolis. Indeed, returning to *Noon* (see 71), for example, it
is clear that our viewpoint is that of someone moving through Hog

75
**J Smith**,
Illustration to
*Tom King's;
or the Paphian
Grove*,
1738.
Engraving

76
**Balthasar
Nebot**,
*Covent Garden
Market*,
1737.
Oil on canvas;
64·8×123·8cm,
25¹⁄₂×48³⁄₄in.
Tate Gallery,
London

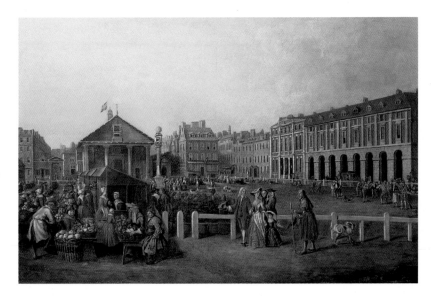

Lane, pausing before the comic spectacle offered by the street's
motley protagonists. Hogarth's depiction of Soho as a fragmented,
chaotic space in which bodies, signs and bits of buildings overlie
and obscure each other, offers a clear metaphor for the visually
cacophonous experience of walking through such a street in reality.
Here, the demand that the viewer decipher a mass of competing,
overlapping pictorial signs within *Noon* itself is clearly designed
to complement the ways in which he or she would have visually
negotiated the kind of modern urban environment which the
painting represented.

Paradoxically, however, *The Four Times of Day* can also be seen as having reinforced the artist's and viewer's sense of physical, social and moral distance from the scenes being depicted in the series. For Hogarth, the London described in the series was one which he himself was increasingly leaving behind, and in creating an image such as *Morning* in his studio in Leicester Square he was surely announcing not only his long-standing familiarity with the dubious narratives of places like Covent Garden, but also his new-found sense of estrangement from them, and his desire to occupy a different cultural realm. And for the affluent, educated individuals who came to see the four paintings and prints in the artist's show-room, this sense of alienation must have been even greater. Even as they vicariously travelled on a satiric tour of the city and imaginatively shared the pleasures of ironic observation, Hogarth's set of pictures confirmed these people's difference to the grotesque, vulgar, comic and corrupt individuals who populated his scenes, and their distance from the kinds of environment *The Four Times of Day* depicted. Hogarth's greatest and most sustained represen-tation of London, then, was one that served not to dramatize the bonds between polite culture and the wider world of the city, but to provide an image of metropolitan society against which both he and his audience could define themselves.

Sometime in the mid-1730s, Hogarth executed his first painted self-portrait (77). This picture, which seems never to have left the artist's studio during his lifetime, has often been seen as little more than an unfinished study. Looking at the painting more closely, however, it seems far more likely that it was an object that Hogarth would have displayed rather proudly to his intimates and clients at Leicester Square, and exploited as a form of self-advertisement. For one thing, the picture flaunts his confidence with oil paint, which he transforms from inert, insignificant matter – symbolized by those six blobs of paint lying on the palette – into something that, when dragged loosely by the brush across the canvas, or jabbed on to its surface, he shows he can use to approximate the fall of a neckcloth and the curls of a wig, or, when worked more tightly, and applied in a succession of dense layers, to brilliantly mimic the contours and expressions of the living face. As well as dramatizing his facility with paint, the self-portrait defines Hogarth as a gentleman at ease, wearing an expensive wig, dressed in elegant clothing and jauntily cocking his head at the viewer. The seemingly nonchalant manner in which he deploys and experiments with his medium would have reinforced this sense of gentility: rather than conveying the values and learning of the painstaking craftsman, Hogarth's bravura handling indicated that his painterly skill, and his practice, was spontaneous and free-flowing, the product of a refined sensibility rather than years of training and labour.

That this self-image was a kind of pictorial cover-up, designed to overlie Hogarth's other, more established identity as a satirical engraver, is interestingly suggested by x-rays of the image, which reveal that the artist's initial plan was to show himself in a far more modest guise, wearing the kind of velvet cap commonly worn by engravers in portraits of the period (78). The pictorial gentrification

*77*
*Self-Portrait,*
*c.*1735.
Oil on canvas;
55.9×52 cm,
22×20½ in.
Yale Center
for British Art,
Paul Mellon
Collection,
New Haven,
Connecticut

that Hogarth subsequently effected, as he painted over this cap and replaced it with a wig, points to the fact that, even as he remained highly active as a graphic artist in the decade after 1735, he was also eager to reinforce and extend his reputation as an ambitious painter. He did so partly through starting up a new St Martin's Lane Academy in the winter of 1735, which took over the equipment from the academy of Sir James Thornhill, who had died the previous year. Hogarth clearly saw himself as Thornhill's successor as London's leading painter, and as a guiding light to younger artists, and his new academy quickly became the central forum for modern British painting.

The artist ran the academy on unusually democratic lines. He refused to make any rigid distinction between governors and pupils, describing himself as 'an equal subscriber with the rest', and advocated a highly collaborative and informal pattern of instruction and practice. Subscribers were urged to draw from the living model, rather than from existing works of art, and were continually encouraged to work from nature when they depicted the body, and not from any pre-existent formulae. A group of London's most talented painters – including Francis Hayman (c.1708–76) and Hubert-François Gravelot (1699–1773) – were enrolled as fellow teachers, and managed to attract equally gifted younger artists into the academy, among them Thomas Gainsborough (1727–88) and, later, Joshua Reynolds (1723–92). Over the next twenty years or so, this second St Martin's Academy provided local painters with an increasing sense of corporate identity and confidence, and its members formed the core of the recognizably British school of painting which began to emerge at mid-century. In this respect, it is significant that Hogarth seems to have had few if any assistants or apprentices at his studio in Leicester Square; his academy, it seems, was the arena in which he preferred to pass on his methods and theories to younger painters, and to exert his influence on the contemporary art scene more generally.

Even more significantly for his own career, Hogarth began in the mid 1730s to tie his painterly practice to the ideals and institutions

78
Thomas Gibson, *George Vertue*, 1723. Oil on canvas; 73.7×60.9 cm, 29×24 in. Society of Antiquaries, London

of charity in London, and to the community of men and women who identified with them. 'Charity', declared the clergyman Philip Barton in a sermon of 1736, 'is the completion and consummation of every Virtue, and contains every article of Duty, that adorns a Christian'. While Barton's sentiments were meant to be universally applicable, they enjoyed a particular resonance for a specific, affluent sector of urban society. For the most privileged members of the capital's mercantile and professional classes, becoming involved in charitable initiatives not only signalled their religious

integrity and deflected any snobbery about the commercial origins of their wealth, but also provided them with an important social role as guardians of civic health, sponsors of virtuous public architecture and supervisors of plebeian morality. By supplying the financial backing and administrative expertise required to increase the number and size of hospitals and other charitable institutions in the city, this group of Londoners was able to promote itself as a philanthropic community which provided

much-needed sanctuaries for the urban unfortunate, contributed to a new kind of physical infrastructure for the city and disseminated the values of Christian charity across the wider metropolitan population. Thanks to these associations, charity became a crucial means by which moneyed, non-aristocratic Londoners fashioned a distinct, and distinctly virtuous, communal identity for themselves in this period, even as they continued to exploit an emergent capitalist economy for their own ends, and to work hand-in-hand with the urbanized aristocracy as they did so. Unsurprisingly, given these factors, the second quarter of the eighteenth century witnessed an outburst of charitable building projects in the English capital. During this period, established hospitals like St Bartholomew's and Bedlam were extensively rebuilt and expanded, and new, privately financed hospitals such as the Foundling Hospital and Guy's Hospital were designed and erected.

Hogarth was to play a remarkably prominent role in a number of these initiatives, both as a citizen and as an artist. This involvement began in earnest at St Bartholomew's Hospital which, in the early 1730s, was being transformed from a ramshackle conglomeration of medieval buildings into a streamlined, rationalized and grandiose modern structure, designed by the architect James Gibbs. As a book illustration of 1739 demonstrates (79), the basic layout and look of the new buildings echoed those of the fashionable London squares being built in the same period, which suggests the extent to which new hospitals like St Bartholomew's functioned as institutionalized extensions of that polite culture being fabricated within the smartest residential areas of the city. In reality, of course, the four blocks of the new building did not enjoy the grand isolation suggested by the illustration, nor indeed had they all been built when this image appeared. As is the case today, they were approached through an imposing gateway that had been erected in 1702. By 1734, four years after the foundation stone had been laid, only the North Wing, seen in the foreground of the illustration, had been completed. This was intended as the administrative and ceremonial centre of the new complex, and in that year the hospital governors were still searching for an artist to decorate the wing's

grand staircase, which led up to a Great Hall designed by Gibbs to cater for all the hospital's major civic functions. Hogarth, hearing that the governors were about to appoint the celebrated Italian decorative painter Jacopo Amigoni (*c.*1685–1752) to carry out this task, dramatically put his own name forward, and offered to do the work without charge. His proposal was quickly accepted and he soon began planning and painting two large-scale canvases to be installed in the stairwell. In undertaking this project, Hogarth was not only making a philanthropic gesture of his own. He was also embarking on an ambitious attempt to paint the kind of public history painting that contemporaries understood to be the most elevated and demanding pictorial genre of all.

Just at the time when Hogarth first became involved in this scheme, the *Universal Spectator* carried an essay about the shared characteristics of painting and poetry that rather dismissively pigeonholed his work as 'grotesque' satire, and then went on to discuss the far greater merits of history paintings which took their subjects from classical, biblical or native literature and history. Published on 16 March 1734, the piece declares that

Painting, like poetry, is divided into several classes. The Grotesque, in which the Dutch are said to excel, generally exhibits the Humours of a Country-Fair, a Wedding, a Drinking-bout etc. In this species,

**79**
**Richard Toms,**
*St Bartholomew's Hospital,*
from William Maitland's
*History of London,*
1739.
Engraving

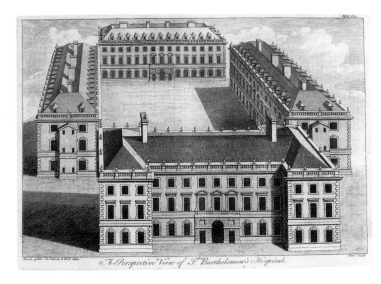

A Perspective View of St Bartholomew's Hospital.

we have at present a Gentleman of our own country very excellent,
I mean the Ingenious Mr Hogarth, who has given the Town a new
piece of Humour in his Harlot's Progress, and in that of a Rake,
which will shortly appear. These grotesque painters I take to be
exactly the same with the Burlesque poets, the Design of both
being to please, and move laughter. But, they are both too apt to
give up Decency for a joke: the Poet would leave modesty for a
merry rhyme or a clench; as the painter would good manners for
an arch conceit.

On the other hand, the same writer declares, heroic poetry and
history painting 'are the most excellent of their Arts, and their
similitude is most conspicuous. Epick or Tragic Poems, by the
strong ideas they convey, affect our minds more, move all our
Passions, and inspire us with the sentiments of heroes; so in
Noble pieces of painting, we are affected by the Greatness of
the Design, the Dignity of the Subject, and the expression of
the passions.' Such poems and pictures, the essayist concludes,
encourage 'Noble sentiments, and inculcate into our minds some
Divine Instruction'.

It is easy to imagine the ambitious and competitive Hogarth
reading these words with growing annoyance in the spring of 1734,
and being spurred on to demonstrate that he could successfully
move into the field of history painting. The St Bartholomew's
project not only gave him the chance to prove himself in these
terms, but also provided a rare opportunity for an English painter
to counter the widespread attitude that only Continental artists
trained in foreign academies of painting could carry out such
projects. Hogarth's two paintings for the hospital's stairway
(80, 81), which were installed in 1736 and 1737, and respectively
depict the New Testament episodes of Christ's visit to the Pool
of Bethesda and the Good Samaritan, made a grandiloquent
statement about the ability of a relatively untrained English artist
to produce works in the highest style. Even today, walking into the
hospital to look at these pieces provides a spectacular visual experi-
ence, particularly when we, just like Hogarth's contemporaries,

have become so used to the modest scale and modern subject matter of the great majority of the artist's works. The St Bartholomew's canvases are huge, with, in Hogarth's own words, 'figures 7 foot high'.

*The Pool of Bethesda*, the first of the two to be painted and installed, illustrates the biblical story of Christ's visit to a pool whose waters, when disturbed by the seasonal appearance of an angel, had the ability to cure the first person who entered them. Christ, moving through the multitudes of 'impotent folk, of blind, halt, [and] withered' who had gathered at Bethesda, encounters and miraculously cures a lame man who, because of his disability and poverty, had never been able to test the waters or afford a servant to carry him towards them. Hogarth's picture, while focusing on the exchange between the two men, details a mass of other individuals, including the crowd of diseased, blind and wounded people standing behind Christ and, on the right, the near-nude figure of a wealthy courtesan, whose paid entourage helps her towards the pool and hinders the progress of a poor mother carrying a sick baby. *The Good Samaritan* illustrates a complementary parable of benevolent authority, in which a citizen of Samaria takes pity on a robbed and wounded traveller from the rival city of Jerusalem, who had been ignored by both a priest and a Levite. In contrast, the Samaritan, in the words of the scriptural text that is affixed to the painting, 'had compassion on him, and went to him, and bound up his wounds, pouring in oil and wine, and set him on his own beast, and brought him to an inn, and took care of him'.

As has long been recognized, these two paintings fuse the established pictorial vocabulary of large-scale history painting with an imagery of the abject and the corrupt that is powerfully reminiscent of satire. Thus, on the one hand, *The Pool of Bethesda* can be suggestively understood as a self-conscious successor to Old Master paintings like the famous *Christ Healing the Paralytic at the Pool of Bethesda* by the Spanish painter Bartolomé Esteban Murillo (1617–82; 82), which was also painted for a hospital. While viewing the two images together suggests how closely Hogarth was

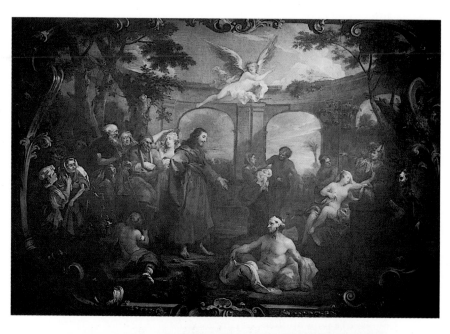

conforming to an established visual model, the comparison also reveals the extent to which he deviated from this pictorial prototype. In Murillo's canvas the figure of Christ, accompanied by a set of sombre companions, towers over a cleansed and decorous environment, in which all the afflicted, other than the lame man, are pictorially withdrawn and sparingly distributed across the space of the temple itself. In Hogarth's canvas, by contrast, the two main protagonists are embedded in a proliferating, chaotic mass of diseased and poverty-stricken bodies, spilling inward from the margins of the image, and in their grotesquery and variety threatening to overwhelm the dignified and idealized body

**80**
*The Pool of Bethesda*,
1736.
Oil on canvas;
416·6×617·2 cm,
164×243 in.
St Bartholomew's Hospital, London

**81**
*The Good Samaritan*,
1737.
Oil on canvas;
416·6×617·2 cm,
164×243 in.
St Bartholomew's Hospital, London

**82**
**Bartolomé Esteban Murillo**,
*Christ Healing the Paralytic at the Pool of Bethesda*,
c.1667–70.
Oil on canvas;
237×261 cm,
93⅜×102¾ in.
National Gallery, London

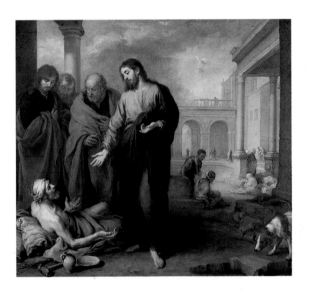

language found at the picture's centre. In giving these secondary characters such prominence and in introducing broader narratives of corruption through such figures as the courtesan, Hogarth can be seen to have translated into a historicized and magnified form that iconography of physical decrepitude and social injustice we have noted as a primary characteristic of pictorial satire in the period, and constantly found intruding into Hogarth's own, earlier *Progresses*. In this respect, a painting such as *The Pool of Bethesda* demands to be understood as one that puts the traditional forms of Continental history painting into creative tension with a more modern, more local, satiric vocabulary of the diseased and abused body.

Far more importantly, Hogarth's two paintings offered their intended audience a powerful allegory of their own benevolence as a community, and did so by providing a pictorially synchronized imagery of the rational, compassionate figure of authority. Looking at the visually paired figures of the Good Samaritan and Christ, the hospital governors and other civic worthies, as they proceeded towards some official function in the Great Hall (83), were clearly being invited not only to appreciate the example these biblical figures provided, but also to identify themselves with them – to see themselves as acting out a modern version of their charitable and ministering activities, and thus, in the words of the *Universal Spectator* essayist, to be inspired 'with the sentiments of heroes' as they walked up the Grand Staircase. This fantasy was made all the more palatable by the fact that Hogarth, in depicting the objects of charity, the wounded traveller and the lame man at Bethesda, removes all those obvious signs of disease and excess that mark many of the other figures in the St Bartholomew's canvases. Instead, however paradoxically, they are given the muscular, poised physiques and the near-nudity that had been seen from classical antiquity onwards as the properties of the suffering male hero in high art. Recipients of charity, they are also represented as idealized masculine nudes, aesthetically fit for the eye of the refined male beholder to dwell upon.

83
The Stairway,
St Bartholomew's
Hospital,
London

Hogarth's two images, as well as working in tandem within the environment of the stairway, were also part of a visual continuum extending across a broader area of the hospital, beginning at its gate and ending within the Great Hall itself. Significantly, the 1702 gate (84) is decorated with yet another figure of benevolent authority – this time, that of Henry VIII, the hospital's most celebrated royal benefactor – and, even more strikingly, with two stone statues symbolizing disease and lameness. Here it is worth pausing to remember the deliberate connection which Hogarth set up in his *Rake's Progress* between the figure of Rakewell sprawled on the floor of a newly developed wing of Bedlam hospital and the statues of *Melancholy* and *Raving Madness* standing over the hospital's doorway. In St Bartholomew's, too, his depictions of two derobed,

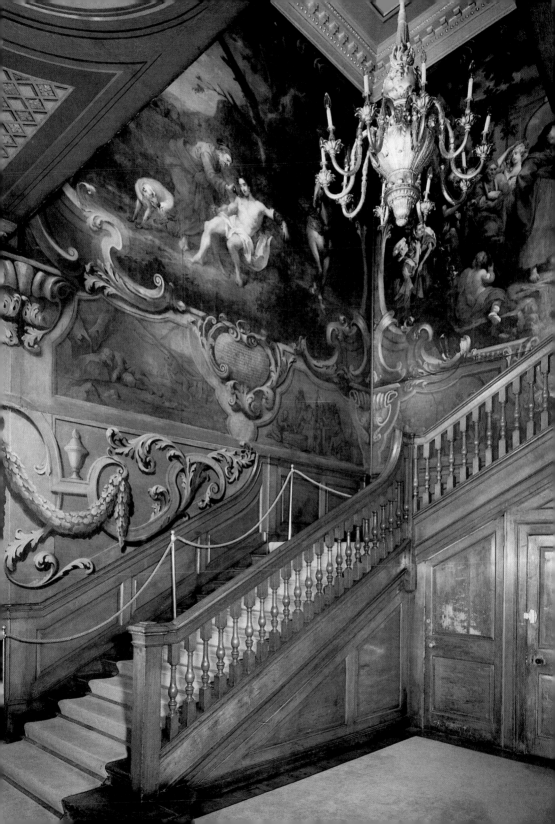

masculine unfortunates were deliberately designed to coordinate with those that straddled the hospital gateway, and thus be read as maintaining and extending a symbolic scheme inaugurated for the visitor as soon as he or she approached the hospital. While Hogarth's figures of the Good Samaritan and Christ can be seen to have occupied the same position claimed by Henry VIII in the gateway, it is worth noting that, when entering the Great Hall itself, the visitor was again confronted with an image of the Tudor monarch, a replica of the celebrated portrait by Holbein (1497/8–1543) which, with the assistance of Gibbs, Hogarth himself reframed and put in place in the spring of 1738. Hanging this picture, the artist must have been acutely aware of the symbolic symmetry he was establishing across the main ceremonial route within the hospital, and of the way in which his own canvases functioned as an intrinsic part of a longer parade of aesthetically elevated imagery, both sculptural and pictorial.

Recognizing the local points of reference for Hogarth's pictures makes us realize the extent to which the artist's two canvases, however compelling in their own right, operated within a carefully

84
The Gateway,
St Bartholomew's
Hospital,
London

85
Peter
Sheemakers,
*The Good
Samaritan*,
1734.
Bronze plinth
relief from
the statue of
Thomas Guy,
Guy's Hospital,
London

86
Peter
Sheemakers,
*The Pool of
Bethesda*,
1734.
Bronze plinth
relief from
the statue of
Thomas Guy,
Guy's Hospital,
London

choreographed visual field that was constantly traversed by the
hospital's dignitaries. We can go further than this, however, by
suggesting that Hogarth's canvases of *The Good Samaritan* and *The
Pool of Bethesda* can also be understood in relation to an even wider
realm of charitable imagery being produced in modern London.
Here, it is particularly suggestive to turn to a statue of Thomas
Guy executed by Peter Scheemakers (1691–1781) that was erected in
front of the newly built Guy's Hospital in January 1734. Guy, who
made an enormous fortune as a a publisher and stock-market
investor, was perhaps the most renowned of all non-aristocratic
hospital benefactors in this period, endowing the hospital he set
up in his own name with more than £200,000 on his death in 1724.
Scheemaker's statue supplemented its life-size depiction of Guy as
a philanthropic worthy with two reliefs, affixed to the plinth of the
statue. Strikingly, they depict the narratives of *The Good Samaritan*
(85) and *The Pool of Bethesda* (86). As the art historian David Solkin
has noted in his discussion of Guy's statue, these two pieces
'are likely to have influenced Hogarth in his choice of themes
(and almost certainly of designs as well) for the staircase of St
Bartholomew's Hospital'. More broadly, the reliefs also indicate
that Hogarth was consciously inserting his two canvases into an
evolving and remarkably homogeneous imagery of charity that was
developing throughout the city, and that made a collective appeal to
contemporary Londoners during the era of the hospital movement.

In the years that immediately followed his artistic involvement with St Bartholomew's, Hogarth was to make an even more sustained contribution to this widening realm of artistic practice through his work at Thomas Coram's Hospital for Foundlings. The Foundling Hospital, which officially opened at a temporary venue in Hatton Garden on 25 March 1741 and then moved into its own, specially designed building in 1745, was the result of another sustained philanthropic campaign by a man of commerce. Coram, who had made a sizeable fortune in shipping, began to garner support for a privately financed refuge for abandoned children in the early 1720s. Over the next two decades or so he amassed more

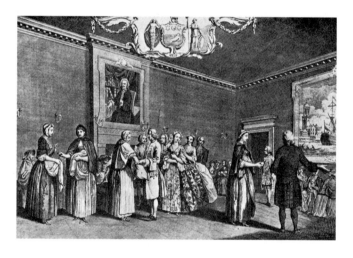

87
Nathaniel Parr
after Samuel
Wale,
*Admission of
Children to the
Hospital by
Ballot*,
1749.
Engraving

88
*The Foundlings*,
1739.
Engraved by
F Morellon
la Cave;
11.4 × 21cm,
4¹⁄₂ × 8¹⁄₄in

than three hundred willing subscribers to the project, predominantly drawn from the upper echelons of the London business and professional community, and also persuaded a band of aristocratic women to petition the King for his favour. Gaining support was more difficult than Coram had initially anticipated, thanks to a widespread suspicion that such an institution might actually encourage licentiousness and bastardy in the city, but in 1739 George II finally granted a Royal Charter for the hospital.

Once open, the hospital took in increasing numbers of abandoned children, sending them out to wet-nurses until they were five years old, giving them basic healthcare and accommodation when they returned, and then providing them with apprenticeships in

different trades. Gaining admission to the hospital, however, was quite literally a lottery: as an engraving of 1749 by Samuel Wale (*c.*1721–86) and Nathaniel Parr (87) demonstrates, the limited number of places available meant that desperate single mothers who brought their children to be deposited at the hospital had to place their hands in a bag and draw out a ball, which if white allowed entry and if black meant that they had to take their children away. In Wale and Parr's engraving, which is surmounted by a coat of arms designed by Hogarth, the ballot takes place in front of a clutch of elegantly dressed Londoners, who eagerly watch the supplicant women as they experience both relief and despair.

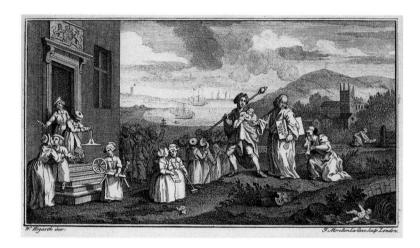

W.<sup>m</sup> Hogarth inv.<sup>t</sup>                                                    F. Morellon La Cave Sculp London

Hogarth was a subscriber and a governor at the Foundling Hospital from its inception, and actively participated as an artist in Coram's attempts to make the institution a success. Indeed, through his various works for the hospital and his organization of the artistic schemes that were associated with it, he provided a kind of pictorial packaging that helped publicize and legitimate Coram's project among the polite urban community as a whole. Hogarth's artistic involvement began with a headpiece he designed for a fund-raising circular issued by the hospital governors in 1739 (88). In this crowded image, Coram, accompanied by a beadle carrying a rescued baby, is shown in archaic dress, clutching the Royal Charter and the hospital seal, and wandering through an

environment that includes a woman hiding her child in a hedge and a baby abandoned by the side of a river. The philanthropist looks down at a distraught woman who, a knife at her feet, seems to have been contemplating murder or suicide before his timely intervention. He points reassuringly at the hospital gateway where his well-dressed and obedient charges are already learning a variety of professions. Here, Hogarth modernizes and subtly secularizes the Christian iconography of charity he had deployed at St Bartholomew's, depicting Coram as a contemporary Good Samaritan, dressed like a biblical figure but wandering through a recognizably eighteenth-century English landscape. Coram's activities, moreover, are tied not only to the venerable narratives of Christian charity but also to a modern economic and patriotic agenda: the children are being prepared for the world of work, and the ships in the background suggest one of the ways in which they will contribute to Britain's commercial and military prowess as a maritime nation. Finally, the presence of the church tower on the far right, which pictorially counterbalances the hospital gateway on the left, can be read in two ways: as a religious sanction of the activities being celebrated in the engraving and as a reminder of how a commercialized and secular sector of modern society was taking over many of the Church's traditional responsibilities.

A year later, Hogarth produced a large-scale painted portrait of Coram, destined to decorate the new hospital, which expanded and consolidated this image of the modern philanthropist (89). He is again shown clasping the hospital seal, and the Royal Charter lies by his right hand. Moreover, when the painting was originally executed, Hogarth included a picture of Charity nurturing children in the background, and painted ships on the distant sea, all of which have now faded from view, but which initially offered another pictorial link to the earlier letterhead imagery of mothers, babies and shipping. While such correlations suggest how Hogarth's graphic and painted products for the Foundling Hospital operated in intimate conjunction, his huge canvas is a complex work of art in its own right. As scholars have repeatedly noted, its scale and composition deliberately invoke

89
*Captain Coram*,
1740.
Oil on canvas;
238·8×147·3cm,
94×58in.
Thomas
Coram
Foundation
for Children,
London

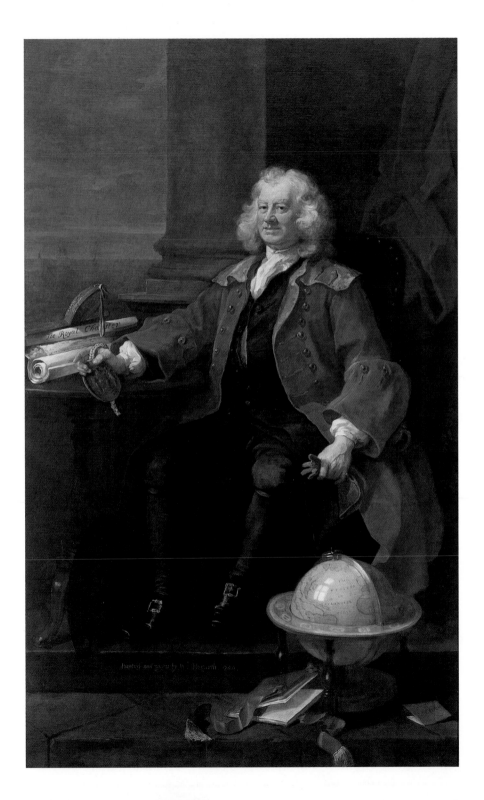

The Royal Charter

Painted and given by W. Hogarth 1740.

the most overblown kinds of contemporary French portraiture (90), which serves both to provide an appropriate sense of grandeur for Hogarth's sitter and, conversely, to heighten the contrast between the modestly attired and seemingly unpretentious English philanthropist and the extravagantly dressed and self-important subjects of such paintings. Meanwhile, certain internal features of Hogarth's painting help define Coram both as a charitable entrepreneur functioning in the public realm and as a highly sympathetic private individual.

One of the striking features of the portrait is that Coram is depicted as if he has just come in from outdoors. He is thus still partly understood in terms of the active public self he presents to the outside world. His plain black hat has been casually discarded at his feet, he clasps his newly removed gloves in his left hand, and his great red overcoat and black jacket – unburdened with any trace of aristocratic frippery – look as if they have only just been unbuttoned. These details suggest Coram's status as an energetic, hurried man of business and philanthropy. It is as if he is someone who is only pausing to have his portrait painted before he rushes outside again to pursue his great scheme. Yet Hogarth's depiction of the unbuttoned Coram sitting down in his chair can also be seen to indicate that he is just about to relax into his more private, informal self, something further conveyed by the openness of his stance and gaze. These features highlight Coram's refusal to assume the highly formalized identities conventionally associated with high society, and with high portraiture, which in turn suggests his personal transparency and unpretentiousness. Hogarth, in shuttling skilfully between two different modes of portraying his sitter, is thus able to promote the complementary virtues of businesslike vigour and individual sincerity.

In the decade that followed the painting and presentation of this portrait, a host of other pictures were given to the hospital by a variety of English artists. A portrait by Joseph Highmore (1692–1780) of the wealthy sugar baker Thomas Emerson, for instance, who was elected governor of the hospital in 1739, was donated after

Emerson's death in 1746, and we see it hanging in the room depicted by Wale and Parr in their engraving of three years later (see 87). More commonly, artists themselves donated portraits of hospital worthies and the kinds of maritime painting that we also see on display in Wale and Parr's print. Even as such gestures demonstrated their personal benevolence, these artists were also encouraged by the potential of the Foundling Hospital as an exhibition space. Painters other than Hogarth quickly saw the commercial benefits that might

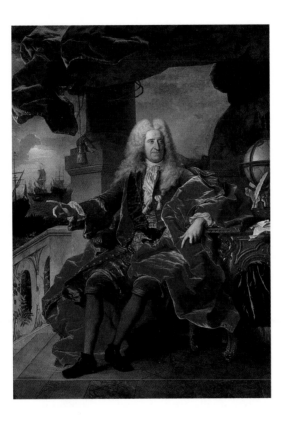

90
**Hyacinthe Rigaud**,
*Portrait of Samuel Bernard*,
1729.
Oil on canvas;
265×167cm,
104⅜×65¾in.
Châteaux de Versailles et de Trianon

follow if their works were put on permanent public display in an institution that was attracting growing numbers of polite, affluent visitors, and that was associated with the highest moral ideals. Thus, in 1746, Thomas Hudson (*c*.1701–99) donated a portrait of Theodore Jacobsen (d.1772), the architect of the new hospital, while in the following year, Allan Ramsay (1713–84) donated his imposing portrait of the celebrated physician Dr Richard Mead, who had been closely involved with the hospital from the start.

It is noticeable that pictures such as these, combined with the sea pieces by artists such as Charles Brooking (c.1723–59) and Peter Monamy (1681–1749) that also came to hang in the hospital, collectively represented a highly gendered kind of visual display. As Wale and Parr's engraving usefully suggests, the hospital was a place in which supplicant women and children, and the polite female visitors who came to express their sympathy with them, were frequently juxtaposed with images that celebrated the benevolence of men, and the quintessentially masculine narratives of military and naval valour. It is all the more interesting, then, that in 1746 Hogarth participated in, and probably inaugurated, a decorative project for the hospital that offered a spectacular counterpoint to this masculine imagery, through idealizing the benevolence and suffering of women, and the vulnerability and tenderness of infants.

In that year, Hogarth and three other painters – Joseph Highmore, Francis Hayman and James Wills (d.1777) – completed four biblical paintings for the Court Room of the hospital (91–94). Hayman and Hogarth depict successive episodes from the life of Moses, in which he is first found in bulrushes by the Pharoah's daughter, and then, having been put out to a wet-nurse who is actually his mother, is returned to the Egyptian princess five years later. Highmore, meanwhile, shows the angel of God intervening as Hagar is about to leave her child Ishmael abandoned beneath a bush, and Wills depicts the figure of Christ surrounded by women and children, having just told his disciples not to forbid them from approaching him. Collectively, of course, these four images offered a range of narrative prototypes for those modern forms of charity undertaken by the Foundling Hospital. They also offered a pantheon of pictorial doubles for those women – both rich and poor – who were involved in the hospital's activities, and the children whom it was designed to rescue. Thus, Hayman's canvas of a group of women gazing sympathetically at a newly discovered child included a range of surrogate viewers with whom élite female visitors could identify as they looked at the painting. Meanwhile, Highmore and Wills's paintings offered those same viewers, along

with their male companions, an imagery of humble and anxious mothers, and innocent and grateful children, that served as pictorially sweetened versions of the real single mothers and infants who were constantly passing through the hospital's gates.

Hogarth's *Moses Brought before Pharaoh's Daughter* (see 91) seems designed to elicit a similar form of identification and sympathy to its three companions in the Court Room. Again, the elegantly dressed, compassionate and beautiful princess must have functioned as a glamorous pictorial and historical stand-in for the painting's fashionable female spectators, and as someone whose benevolent downward gaze at Moses not only echoed their own response to the tentative and vulnerable child at the picture's centre, but also the ways in which they, too, looked down at the infant inmates as they passed through the hospital. Nearby, the depiction of the five-year old Moses and a woman who is both his mother and his wet-nurse was no doubt intended to offer a poignant pictorial parallel to the experiences of modern foundlings as they entered the hospital, either with their mothers, or – after five years of outside care – with their wet-nurses. Nevertheless, just as in his St Bartholomew's paintings, Hogarth complicates this seemingly sentimental story-line by introducing characters whom his fashionable white viewers would have found far more dubious: the hook-nosed (and thus stereotypically Jewish) treasurer paying off Moses' mother, and the whispering black servant, who is presumably gossiping about the child's parentage. At one level, of course, these figures serve to accentuate the supposed purity of the exchanges taking place at the centre of the canvas; at the same time, they functioned as racist symbols for the ways in which charitable activity might easily be corrupted or misconstrued, whether in biblical times or in contemporary London.

Paintings such as this, combined with the works of art that were on display in other hospitals across London, helped to make institutions like the Foundling and St Bartholomew's attractive places for polite men and women to visit, and offered a host of representational substitutes for, and idealizations of, their

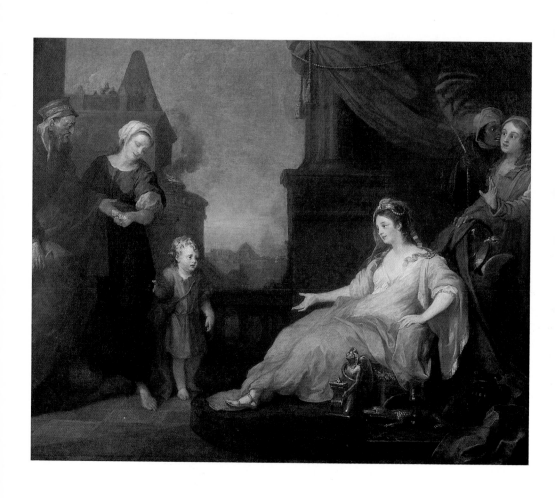

**91**
*Moses Brought
before Pharaoh's
Daughter*,
1746.
Oil on canvas;
177·8×213·4cm,
70×84in.
Thomas
Coram
Foundation
for Children,
London

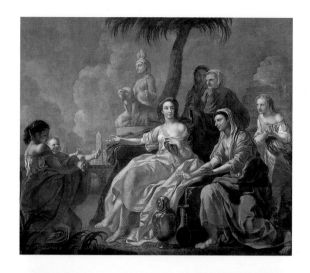

**92
Francis
Hayman**,
*The Finding of
Moses in the
Bullrushes*,
1746.
Oil on canvas;
173·4×204·5cm,
68¼×80½in.
Thomas
Coram
Foundation
for Children,
London

**93
Joseph
Highmore**,
*The Angel
Appearing to
Hagar and
Ishmael*,
1746.
Oil on canvas;
172·8×193cm,
68×76in.
Thomas
Coram
Foundation
for Children,
London

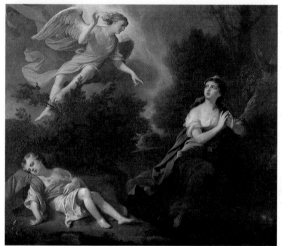

**94
James Wills**,
*Little Children
Brought unto
Christ*,
1746.
Oil on canvas;
172·7×209·6cm,
68×82½in.
Thomas
Coram
Foundation
for Children,
London

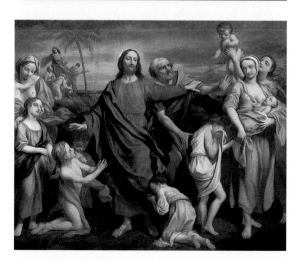

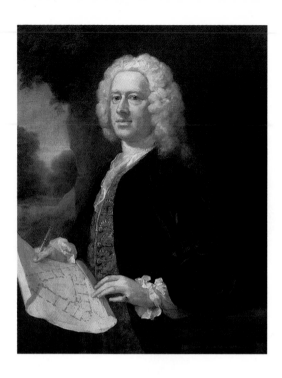

charitable activities. At the same time as he became involved in
producing such works, moreover, Hogarth was providing the
individual members of this same community with a more explicit
form of self-representation through the portraits he painted and
designed for them on a regular basis during the late 1730s and
early 1740s. Looking at these portraits as a group, what becomes
increasingly striking are the social and institutional connections
that we can trace between the different individuals Hogarth
painted. Many, for instance, were people who were directly
involved in the Foundling project. Thus, the artist produced
likenesses of a number of the hospital governors and depicted its
architect Theodore Jacobsen in 1742 (95). These men, unsurprisingly,
were often linked to other networks of influence, enquiry and
power within the contemporary city, including institutions such
as the Royal Society and the Church of England, and the more
informal groupings of merchants, professionals, politicians,
entertainers and wealthy shop owners which also characterized the
capital. These associations, and the individuals who populated
them, collectively made up that new kind of non-aristocratic urban

95
*Theodore
Jacobsen,*
1742.
Oil on canvas;
90.9 × 70.5 cm,
35¾ × 27¾ in.
Allen
Memorial
Art Museum,
Oberlin, Ohio

96
*William Jones,*
1740.
Oil on canvas;
127 × 102.2 cm,
50 × 40¼ in.
National
Portrait
Gallery,
London

97
*George Arnold
Esq., of Ashby
Lodge,*
c.1738–40.
Oil on canvas;
90.5 × 70.8 cm,
35⅝ × 27⅞ in.
Fitzwilliam
Museum,
Cambridge

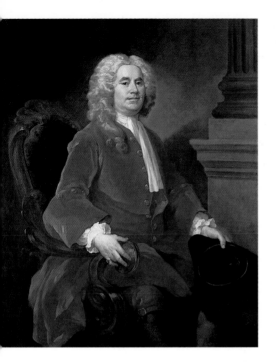
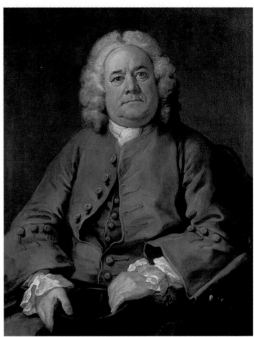

élite discussed at the beginning of this chapter, whose members were distinguished by their achievements in the fields of commerce, administration, law and education, even as they collaborated closely with those whose status had been conferred by noble birth. Hogarth's portraits in the decade after 1735 offer a kind of pictorial archaeology of this community, and of its values at a specific moment in history. For although he did indeed paint the occasional portrait of an independent-minded aristocrat in this period, he far more regularly painted merchants, scientists, physicians, mathematicians, clergymen, professionals, entertainers and – if not so commonly – their wives and daughters.

Two small-scale portraits of William Jones and George Arnold, painted in 1740, the same year that Hogarth depicted Thomas Coram, provide representative examples of this kind of picture (96, 97). Jones, born to a modest Welsh farming family, became one of the outstanding mathematicians of the early eighteenth century and was elected to the Royal Society in 1712. Having collaborated with the great philosopher and mathematician Isaac Newton early

in his career, he later edited some of his teacher's works, and spent much of his life formulating a general introduction to Newton's ideas. At the same time, he was a mathematics tutor to a succession of aristocrats and lived for many years at the house of the Second Earl of Macclesfield, himself not only a keen scientist and astronomer, but also one of the noble subscribers and governors of the Foundling Hospital. Arnold, meanwhile, was an urban merchant and alderman who was another of the Foundling subscribers. He also built himself a substantial country house, Ashby Lodge in Northamptonshire, where Hogarth's portrait was destined to hang alongside the artist's pictures of Arnold's son and daughter.

Hogarth's pictures of Jones and Arnold, like the men they depict, seem at the same time dependent on aristocratic associations and yet – in different degrees – remarkably independent of them. On the one hand, Jones's portrait seems to have been commissioned by the Second Earl to hang in his Oxfordshire castle, rather than by Jones himself, while Arnold's scheme of hanging a series of family portraits, including his own, in his new country estate is thoroughly redolent of aristocratic practice. On the other hand, when we actually look at these images we gain a powerful impression of 'middling' men of learning and business. It is quickly apparent that they conform very closely to the pictorial formula and cultural ethos of the Coram painting (see 89), shorn of its grandiloquence. Both men, clutching their hats firmly in their hands, are depicted as if they have only just sat down after being engaged elsewhere, and both are defined by the plainness and informality of their clothing, the openness of their stance and the directness of their address to the beholder. If the Jones portrait contains traces of aristocratic elegance in its florid handling and in details like the background column, the unfurling wig and the poised right hand, Arnold's is resolutely bereft of such touches. The sitter is placed in a bare setting. His torso and stance are almost aggressively square-on and his expression, when compared to those found in most contemporary portraiture, is strikingly blunt. All of these features are accentuated by the way in which Hogarth brings the sitter into dramatic close-up, and allows so little pictorial breathing space

98
*Frances Arnold,*
*c.*1740.
Oil on canvas;
88.9×68.6cm,
35×27in.
Fitzwilliam
Museum,
Cambridge

99
*Elizabeth Betts,*
*Mrs Benjamin*
*Hoadly,*
1741.
Oil on canvas;
76×63.5cm,
30×25in.
York City
Art Gallery

around his body. Arnold, we are meant to conclude, carries no airs, and is not interested in flattery. As such, his portrait marks a kind of beginning in the pictorial depiction of modern bourgeois masculinity.

Such images, as we have already seen, were frequently intended to hang alongside portraits of female family members. These pictures, whether of such women as Arnold's daughter Frances (98) or of newlyweds like Elizabeth Betts (99), who married the physician and playwright Benjamin Hoadly in 1740, are also characterized by a striking pictorial directness and simplicity. In 1745 Hogarth was to depict himself in a similarly direct way (100), although here he

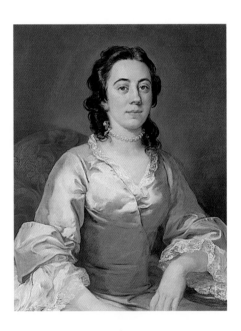

embeds his likeness – shown as an image within an image – within a programmatic assemblage of objects. Let us concentrate on this inner image first. Here, in contrast to the self-portrait discussed at the beginning of this chapter (see 77), he shows himself as the casually dressed artist rather than the bewigged gentleman. It is as if, thanks to the experience of painting and celebrating a non-aristocratic élite, his aspirations have gradually changed, and he no longer feels obliged to dress himself up. Interestingly, this self-portrait, just like the first, went through a dramatic process of revision, which in fact entirely reverses the direction of that

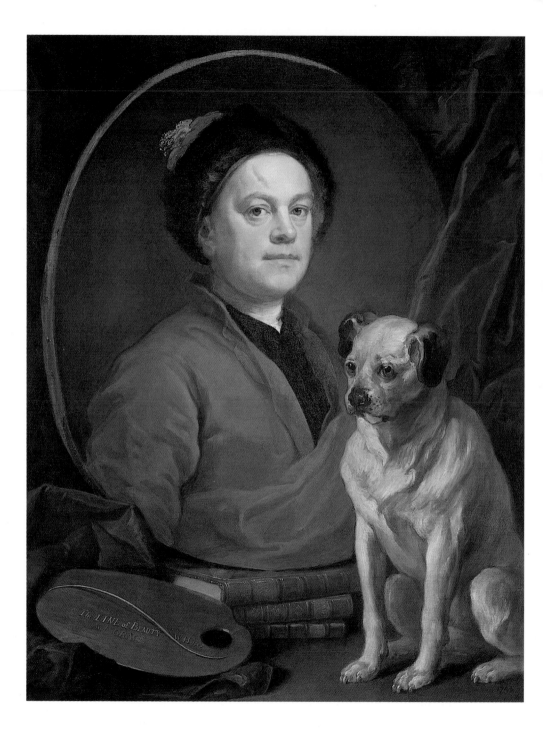

undergone by the earlier image. X-rays demonstrate that the work initially showed Hogarth in a similarly gentlemanly guise to the one he had assumed in his picture of the 1730s, wearing a full wig, a long white cravat and a gold-buttoned coat. Painting over such a self-image must have had a powerful symbolic value for the artist, and represented a dramatic indication that he had moved on and wanted to advertise his artistic status and ambitions very differently.

100
*The Painter and his Pug,* 1745. Oil on canvas; 90×69 cm, 35¹⁄₂×27¹⁄₈ in. Tate Gallery, London

101
*Gulielmus Hogarth,* 1749. Engraving; 33.7×26.4 cm, 13¹⁄₄×10³⁄₈ in

In the 1745 self-portrait, Hogarth defines himself as a man who has abandoned all pretensions to fashionable gentility and instead seeks to be understood in terms of his learning, wit and sincerity. His oval inner portrait rests on books which the engraving of the self-portrait (101) tells us are the works of Shakespeare, Milton and Swift, while the palette that lies in the foreground is traversed by a serpentine line accompanied by the words 'The Line of Beauty'

and the letters 'W.H.', which signal his growing ambitions as a
theorist of art. Significantly, when the painting was engraved and
given an inscribed title, Hogarth's name was Latinized, offering
a further suggestion that, in this image, the artist wanted to relate
his own identity and practice to the kinds of intellectual enquiries
being pursued by those scholars, scientists and clerics he had
recently been painting. Meanwhile, the inclusion of his pet pug
Trump works as a typically comic safety-valve, parodying the
dignified accessories traditionally found in high portraiture and
deflecting the hint of hubris that the other objects in the painting
might be seen to embody. At the same time, of course, the pug
offers a symbol of Hogarth's own loyalty and compassion, both as
the beloved object of his master's affections and as a metaphorical
stand-in for Hogarth himself, and for his increasingly celebrated
doggedness, pugnacity and lack of pretension. In depicting
himself in these ways, Hogarth was once again aligning himself
with a 'middling' sector of urban society, and a specific set of values
associated with it. These values, as the next chapter will explore,
had also found complex expression in his most recent satiric series,
entitled *Marriage à la Mode*.

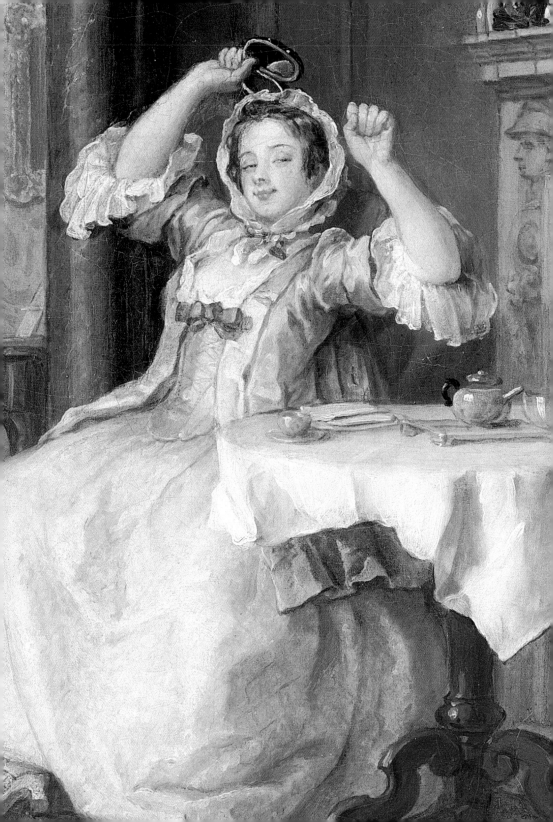

*Marriage à la Mode* was first announced to the London public in the spring of 1743, when a series of fastidiously worded newspaper advertisements declared that

MR HOGARTH intends to publish by Subscription, SIX PRINTS from Copper-Plates, engrav'd by the best Masters in Paris, after his own Paintings (the Heads for the better Preservation of the Characters and Expressions to be done by the Author); representing a Variety of Modern Occurrences in High-Life, and call'd MARRIAGE À-LA-MODE. Particular care will be taken, that there may not be the least Objection to the Decency or Elegancy of the whole Work, and that none of the Characters represented shall be personal.

The paintings remained on display in Hogarth's showroom in Leicester Fields until the engravings were finally published in the summer of 1745. These six pictures, unlike any of his previous satiric series, focused unblinkingly on high culture, offering both an extended critique of its values and, as we shall see, a powerful reassertion of satiric pictorial practice in the face of other, competing kinds of modern art being promoted in the capital.

*Marriage à la Mode*'s first pictorial instalment is set in the house of the gout-ridden Earl of Squander (103), depicted haggling with a bespectacled alderman over the arranged marriage of their two entirely incompatible children – the precious, snuff-taking figure of Viscount Squanderfield, looking not at his prospective bride, but into a mirror; and the sulky, bored alderman's daughter who, turned not to her prospective husband but to a flirtatious lawyer called Silvertongue, listlessly runs her engagement ring back and forth along a handkerchief. As in the rest of the series, the room they occupy is crowded with images – in this case, numerous copies

**103**
*Marriage
à la Mode* (1),
1745.
Oil on canvas;
68.6×88.9 cm,
27×35 in.
National
Gallery,
London

104
*Marriage
à la Mode* (2),
1745.
Oil on canvas;
68·6×88·9 cm,
27×35 in.
National
Gallery,
London

of Italian Old Master canvases, a portrait of the earl painted in an overblown 'French' style and a family tree which links the Squander dynasty to William the Conqueror. Hogarth's second picture (104), which he called *The Tête-à-Tête*, shows the viscount and his wife some months after their marriage, sitting in a home defined by its grandiloquent vulgarity. It is noon, and the young aristocrat has only just returned from a night out on the town: his broken sword lies nearby, and a dog sniffs the perfumed bonnet of a mistress that is jammed into his pocket. His wife has clearly been enjoying some nocturnal company of her own. The upturned chair indicates that her music teacher (a constant butt of sexual innuendo in this period) has had to make an undignified exit, and the scattered playing cards and the yawning servant suggest an all-night gaming session. While she indulges in a luxurious, sensual stretch, her slumped husband stares vapidly into space, blind to both his wife and the disgusted steward, who walks away with a stack of unpaid bills.

The next two images show the couple leading separate lives. In the third picture, Squanderfield and his mistress (shockingly revealed as a child prostitute) are shown in the cavernous, crowded rooms of a quack doctor's premises (105). A discussion – half-flippant, half-serious – is taking place about the effectiveness of some anti-venereal pills the viscount has been prescribed. The black spot on his neck – present from the first image of the series, but now made eerily explicit – is a sign that Squanderfield himself is a long-term sufferer from syphilis, which he now seems to have passed on to the young girl by his side, who dabs at a sore on her mouth. An older woman – probably the procuress who set up Squanderfield with the girl, and possibly also her mother – towers angrily above the seated aristocrat, while the doctor himself rubs his spectacles with a dirty handkerchief, as if preparing to look more closely at the evidence.

The fourth picture in Hogarth's series (106) depicts the alderman's daughter – now dignified by the title Countess Squander, thanks to the old earl's recent death – at her toilette, sitting in her boudoir

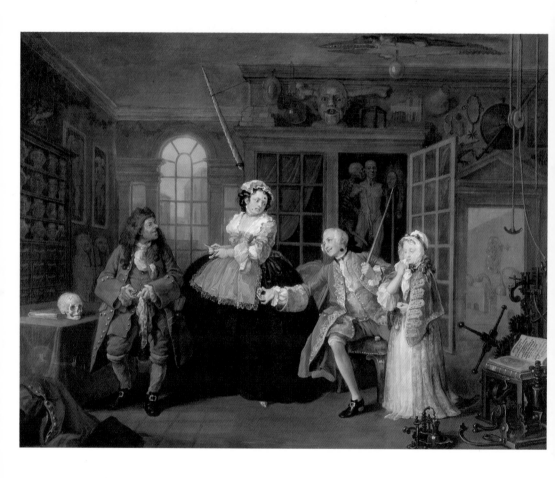

**105**
*Marriage*
*à la Mode* (3),
1745.
Oil on canvas;
68·6×88·9 cm,
27×35 in.
National
Gallery,
London

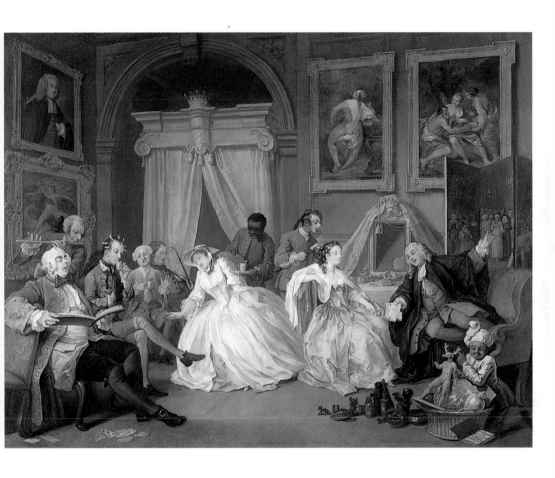

**106**
*Marriage
à la Mode* (4),
1745.
Oil on canvas;
68·6×88·9 cm,
27×35 in.
National
Gallery,
London

and fashionably receiving a host of visitors. Her hair is being curled, and she leans back and listens to the charming blandishments of Silvertongue, now revealed as her lover. Lounging on a sofa, he suggests an assignation at a masquerade similar to the one pictured on the screen behind him. Gathered around the adulterous couple, and placed below the erotic mythologies and portaits that hang on the walls, we find a motley collection of visitors and hired hands: an Italian opera singer, a beak-nosed flautist, two effeminate men (one sipping chocolate, his hair in paper curlers, the other wearing a fan on his wrist), a dozing country squire, his rhapsodizing wife, swooning at the sound of the castrato's voice, and a pair of black servants, one of whom points at a miniature figure of Actaeon, whose horns dramatize the cuckolding of the absent Squanderfield.

The bleak iconography of death dominates the final pair of pictures. In the fifth image of the series, entitled *The Bagnio*, we witness the bloody aftermath of the masquerade (107). Squanderfield has followed his wife and her lover to a room they had hired for sex, and fought his rival with swords. He has been fatally stabbed by Silvertongue, who slinks out of the window in his nightshirt, and is shown slowly collapsing to the ground, his body a dislocated jumble of limbs. The countess, shocked into a posture of prayer – she goes down on one knee and clasps her hands – looks up at her husband with horror. The brothel's proprietor stands at the doorway, accompanied by a nightwatchman whose lamp sheds dramatic light on the scene. In the final image (108), the countess herself is shown just about to die, having poisoned herself with laudanum after hearing of Silvertongue's execution for murder, announced and commemorated in the broadsheet that lies at her feet. Her death takes place in the austere environment of her miserly father's house in the City of London, dotted with Dutch genre paintings and looking out over old London Bridge. He stands at her side, concerned only with adding her wedding ring to his hoard of riches, and ignoring the pathetic final kiss between the countess and her child, who is already marked by the signs of disease and deformity. Nearby, the apothecary responsible for

107
*Marriage
à la Mode* (5),
1745.
Oil on canvas;
68·6×88·9 cm,
27×35 in.
National
Gallery,
London

supplying the countess's poison berates a retarded servant for so thoughtlessly bringing it to her, and a scrawny dog, unnoticed in all the pandemonium, jumps up on to the table to steal a pig's head lying on a platter.

In these six works, Hogarth simultaneously evokes an older, non-pictorial example of satire and offers a powerful intervention into contemporary literary and pictorial controversy. The title and

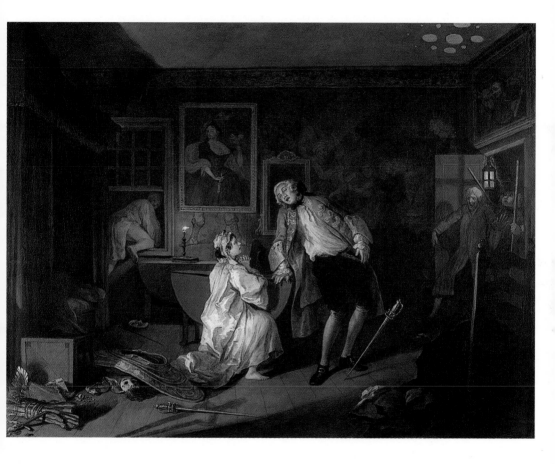

themes of Hogarth's series self-consciously refer to John Dryden's play *Marriage à la Mode*, first performed in 1671 and frequently republished during the first decades of the eighteenth century. Dryden's play includes a comic plot focusing on the upcoming marriage of a male courtier, Palamede, and an affected member of the urban bourgeoisie, Melantha, whose desire to appear sophisticated takes the form of a ridiculously exaggerated adoption

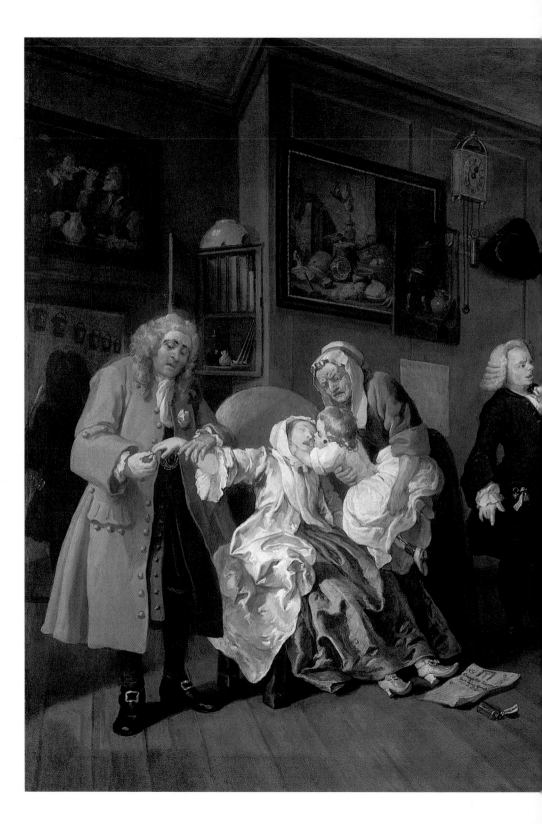

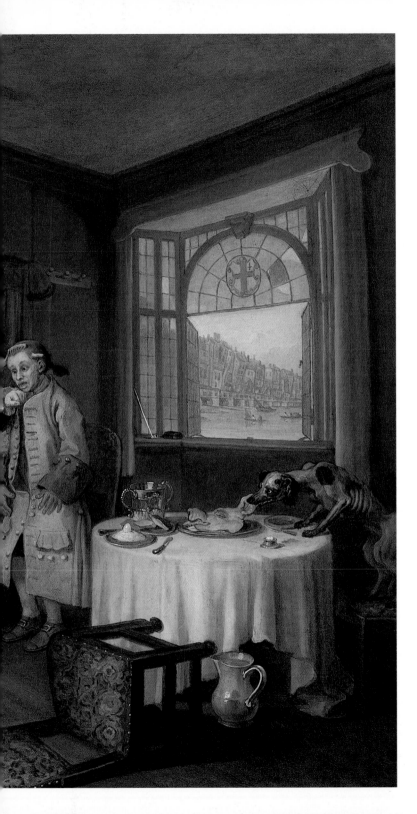

108
*Marriage
à la Mode* (6),
1745.
Oil on canvas;
68·6 × 88·9 cm,
27 × 35 in.
National
Gallery,
London

of French manners and phrases. Recognizing these features of Dryden's play, it becomes apparent that Hogarth's *Marriage à la Mode* – in which Squanderfield and his wife enjoy similar backgrounds and affectations – self-consciously modernizes and adapts a canonical satiric treatment of marriage in 'high life'.

More importantly, however, Hogarth's series also engaged with mid-eighteenth-century debates and anxieties relating to modern forms of wedlock. Numerous texts and images published at this time, ranging from conduct books to satirical prints, dealt with the topic, and collectively established and confirmed a recognizably modern ideal of companionate marriage. In this discussion, model marriages are contrasted with those destined to failure, frequently because of insurmountable differences of class, or because a desire for wealth and social prestige has overridden the need for companionship and compatibility. Thus, a May 1740 edition of the journal *Common Sense* carries a parable comparing the marital motivations and fortunes of two fictional, highly stereotypical couples. On the one hand, there is the successful marriage of Euphorbus and Sophronia, whose mutual esteem 'was not founded *upon Interest*, but *a thorough Knowledge of each other*'. On the other, the text describes the declining fortunes of the aristocratic Eugenio, 'addicted to Gaiety and Expense' who travels to London and courts Theana, 'the only daughter of a Gentleman of Fortune, by whose death she was lately come into possession of above 15,000 l'. They marry with purely riches and status in mind, and soon things take a turn for the worse: 'to avoid the Uneasiness of Home Eugenio *publickly* indulged himself in his Amours; and Theana was only *more private*. His money was thrown away at Hazard; *hers* religiously devoted to Quadrille.' Unsurprisingly, perhaps, both end up losing precisely those qualities of 'Happiness, Riches and Reputation' which their affectionate and responsible counterparts have gained through good sense, household economy and sexual virtue.

While such texts suggest the extent to which Hogarth was manipulating ready-made cultural stereotypes and narratives

in his series, it is also clear that *Marriage à la Mode* participated in a wider meditation upon marriage within contemporary visual culture. The acidic dissection of marriage in this series parallels that found in contemporary graphic satires on the subject. Hubert-François Gravelot's *Fore-warn'd, Fore-arm'd; or The Batchelor's Monitor* (109) is one such satire, heavily advertised in the 1741 newspapers, and wittily fusing the forms of allegory, contemporary courtship imagery and the financial balance sheet to offer 'A Modest ESTIMATE of the Expences attending the MARRIED LIFE.' A young, fashionable couple – the man offering a jointure (a property settlement granted for use after his death) to his future wife, the woman holding a bag of money – are brought together by an angel carrying a pair of handcuffs on a chain. Underneath them is an exaggerated and comic list of the demands that marriage will make on the bachelor, including, to give an example that echoes Countess Squander's fashionable extravagance, the annual expense of thirty pounds for 'Madam's Pocket Expences throughout the year, for Waterage, Coach-hire, Chair-hire, for Visiting, and for going to Operas, Balls, Plays, Concerts, publick Shews and Spectacles, publick Feasts, Vaux-hall, &c.'

In *Marriage à la Mode*, a focus on marriage comparable to those found in *Common Sense* and in *The Batchelor's Monitor* is fused with a sustained attack on the fashion for foreign goods, rituals and values within high culture. Throughout the paintings, from the depiction of Earl Squander among his French and Italian canvases onwards, there is the constant implication that native English values of virtue, sturdiness and manliness have been thoroughly adulterated by the widespread importation of, and slavish adherence to, continental modes of taste and identity. Other commentators of the period shared many of the artist's perspectives on this issue. In *Fashion: An Epistolary Satire*, published in London in 1742, for instance, an anonymous satirical poet ferociously attacks the corrupted contemporary taste for foreign art, music, food and clothes. He ridicules the 'purblind, poking Peer' who has 'run Picture-mad', and who stares 'with the same Wonder-gaping Face' at 'flat, Dutch Daubings' and at the works of the Italian

# Fore-warn'd, Fore-arm'd; *or*, The Batchelor's MONITOR:

### BEING

## A Modest *ESTIMATE* of the Expences attending the MARRIED LIFE.

*Published According to Act of Parliament by John Osborn in Pater-noster Row.*
1741

*This Estimate supposes, that the marry'd Man actually receives* 2000 l. *with his Wife; and has, in the Compass of Fifteen Years, Eight Children; Four of which die, and Four only are alive at one time. In this Case, if he live with tolerable Elegance, his Expences will be nearly as follow; viz.*

|  | l. | s. | d. |
|---|---|---|---|
| HOUSE-RENT at 40 l. *per Annum,* Taxes, Ward and Parish-rates, and Pew in the Church *&c.* | 49 | 0 | 0 |
| Wages of Two Maid Servants, and One Man, with his Livery | 22 | 0 | 0 |
| Fitting up the House, on Madam's Reception, suppose only 50 l. (for Glazier, Carpenter, Joiner, Painter, Bricklayer, Mason, Plaisterer, *&c.*) the annual Interest | 2 | 10 | 0 |
| Repairs, Alterations, Glasing, White-washing, Painting, every third or fourth Year, suppose *per Annum* | 5 | 0 | 0 |
| Houshold Furniture, as Linen, China, Brass, Pewter, Beds, Chairs, Bureaus, Cabinets, Tables, Screens, Carpets, Glasses, Chests of Drawers, Locks, *&c.* suppose 400 l. the Interest *per Annum,* (Principal daily impairing) | 20 | 0 | 0 |
| Plate, Rings, *&c.* suppose only 80 l. prime Cost, the Interest of which *per Annum* | 4 | 0 | 0 |
| Sunk by Fashion, *&c.* to the Value of *per Annum* | 1 | 0 | 0 |
| Firing, as Wood, Coals, Small-coal, *&c.* | 15 | 0 | 0 |
| Tallow-chandler, Wax-chandler, *&c.* | 12 | 0 | 0 |
| Butcher, at about 3 s. 4 d. *per Day* | 60 | 0 | 0 |
| Fishmonger, with Brawn, Venison, *&c.* | 12 | 0 | 0 |
| Poulterer | 12 | 0 | 0 |
| Baker, with Flour, Oatmeal, Pease, *&c.* | 30 | 0 | 0 |
| Cheesemonger, with Bacon, *&c.* | 7 | 0 | 0 |
| Butter | 10 | 0 | 0 |
| Brewer, including Ale now-and-then, (if they brew at home, it can't be less) | 15 | 0 | 0 |
| Wine, Cyder, Rum, Brandy, Cordial-waters | 35 | 0 | 0 |
| Herbs, Roots, Green-pease, Beans, (tho' not in the best Season) | 5 | 0 | 0 |
| Grocer, for Loaf, Lump, and Powder-sugar, Nutmegs, and all Sorts of Spices, Raisins, Currans, Rice, *&c.* | 15 | 0 | 0 |
| Tea, Chocolate, Coffee, *&c.* | 20 | 0 | 0 |
| Oil-man, for Oil, Vinegar, Pickles of all Sorts, Hams, *&c.* | 5 | 0 | 0 |
| Fruiterer, for Lemons, Oranges, Peaches, Plums, Apricots, Cherries, Gooseberries, Currans, in early Season often, Apples, Pears, *&c.* for Deserts, *&c.* | 5 | 0 | 0 |
| Washing and Laundry Business, with Soap, Starch, Blue, *&c.* | 25 | 0 | 0 |
| Physician, Surgeon, Apothecary (if Madam be vapourish or fanciful, it will be much more for herself and Children, the whole Right being includable in this Article) | 12 | 0 | 0 |
| Christmas Donations more as a House-keeper than Batchelor | 4 | 0 | 0 |
| Brushes, Brooms, Mops, Rubbers, Mats, Floor-cloths, Rotten-stone, Brick-dust, Sand, Fullers Earth, Whiting, Ashes, also other Turnery-ware | 8 | 0 | 0 |
| China-ware, Glasses, and Earthen-ware, annual Recruits | 5 | 0 | 0 |

Carry'd forward 405 10 0

|  | l. | s. | d. |
|---|---|---|---|
| Brought over | 405 | 10 | 0 |
| Confectioner and Pastry-cook, for Jellies, Conserves, Sweet-meats for Deserts, Children, *&c.* | 5 | 0 | 0 |
| Perfumer, for Essences, Powder, Hungary and Lavender Water, Elder-flower Water, Pomatums, Washes, Snuff, *&c.* | 3 | 0 | 0 |
| Mercer, Draper, Shoemaker, Clogmaker, Hosier, Tyreman, Staymaker, Mantuamaker, Milaner with the long and costly Train of Ribbands, Gloves, Laces, Fans, Pilgrims, Velvet and other Hoods, Scarves, Necklaces, Cambricks, Muslins, at a moderate Computation, for Wife, and Four Children upwards of a Year old | 90 | 0 | 0 |
| Madam's Pocket Expences throughout the Year, for Water-age, Coach-hire, Chair-hire, for Visiting, and for going to Opera's, Balls, Plays, Concerts, publick Shews and Spectacles, publick Feasts, Vaux-hall, *&c.* | 30 | 0 | 0 |

*And, for a Comfort in the marriage Life,*
*The little, pilf'ring Temper of a Wife!* Parnell.

|  | l. | s. | d. |
|---|---|---|---|
| Lying-in, at Eight in Fifteen Years, Christenings, Midwife, Nurse, Caudle, Hysterick Water, *&c. &c. &c.* suppose 100 l. the Interest of which *per Annum* | 5 | 0 | 0 |
| If but Four Children living at one time, out of Eight, there must be Four Funerals, the Expence of which allow at only *per Annum* | 2 | 0 | 0 |
| The Nursing, whether Wet or Dry, at home or abroad, of the Eight Children Part of the Time, of the Four more constantly, suppose | 18 | 0 | 0 |
| Schooling even in Infancy, with Presents for Entrance, Firing, and other Pickpocket Articles for Four Children | 10 | 0 | 0 |
| Education of the Four Children as they grow up, one Year with another, (supposing Dancing, Writing, casting Accounts, and not Musick, which is often the Case for the young Ladies — | 15 | 0 | 0 |
| The Baby-Catalogue, for Eight Children of a Year old or under, often recruited, and Numbers of most of the Particulars; *viz.* Child-bed Basket, and Pin-cushion and Pins, Chimney-line, fine Satten Mantle and Sleeves for the Christening; Cradle and its Furniture, Biggins, Headbands, Caps, Short-stays, Long-stays, Shirts, Wastecoats, Clouts, Beds, Blankets, Rollers, Mantles, Sleeves, Neckcloaths, Shoes, Stockens, Barrows, Petticoats, Dimity Coats, Stays, Frocks, Bibs, Quarter-caps laced, Coral, Ribbands, Cap and Feather, Cloak, First Coat and second, Dozens for the Nurse, Anodyne Necklace, *&c.* suppose only *per Ann.* | 10 | 10 | 0 |

Total 594 0 0

*Nor think th' Expences I have here laid down*
*A fond uncertain Notion of my own.*
*No! 'tis a Sibyl's Leaf, what I relate,*
*As fix'd and sure, as the Decrees of Fate!* Dryd.

*Probable Expences, not brought into the Account.*

Country-house, or Lodgings; perhaps Journies to Bath, Tunbridge, Scarborough; Chaise and Pair, or one Horse; possibly Saddle-horse for little Excursions; Riding-habits, *&c.* Card-playing, an Amusement that has banished the Needle, and many useful Employments, out of the modern Education for Ladies. Presents, as Watch and Equipage, Jewels, Rings, *&c.* Perhaps Lap-dogs, Parrots, Canary-birds, *&c.* To say nothing of the Chance of Extravagance, and other too common Incidents, which we forbear to mention out of Tenderness to the Ladies.

*These, and a Thousand, yet un-nam'd, we find;*
*Ah! fear the Thousand, yet un-nam'd, behind!* Parnell.

*Let us now see what may be deducted from this heavy Charge, by such Expences as a Batchelor must be at, who is suppos'd to have Chambers in any of the Inns of Court, or Lodgings in a private Family.*

|  | l. | s. | d. |
|---|---|---|---|
| The general Charge, as before, | 594 | 0 | 0 |
| I. The Rent of his Chambers or Lodgings *per Ann.* 30 | | | |
| II. To his Laundress, *&c.* | | | |
| III. To Firing | | | |
| IV. To Candles | | | |
| V. To Board 30 | | | |
| VI. To Tea, Sugar, *&c.* | | | |
| Total | 87 | 0 | 0 |

Which deduct from the above Sum, the Difference will be against Matrimony, *per Annum* 507 0 0

N. B. Plays, and Pocket Expences, Apparel, Linen, Perukes, *&c.* to the Man, pretty much alike in both States; so not being estimated above, is omitted here.

*From the above Estimate result the following Queries:*

Query, What Room will there be out of all this for Childrens Fortunes?

Query, What Reason has a Lady of 2000 l. Fortune to expect Settlements and Jointure, which are a further Cramp on the Industry and Circumstances of a marry'd Man: Since the whole Interest of it, at 5 l. *per Cent.* will bring but 100 l. *per Annum*; which will not defray the Expences attending her own Person only?

Query, From the Premises it will appear, that a Batchelor who is not a House-keeper, may live more elegantly for 200 l. a Year, than a marry'd Man for four times the Income?

Query, Ought not the Ladies then, in Justice and Gratitude, to think themselves under great Obligations to Gentlemen who will marry them under all these apparent Disadvantages, and to be kind, frugal, and obedient Wives?

Query, And in the preparative Courtship, ought they not to behave with Decency, Respect, and Openness of Heart?

If any Advocate for Matrimony thinks proper to hint at the Expence attending the Gallantry of some Batchelors, let him prove that Wedlock always prevents the like in a marry'd Man: Or, that a vicious Batchelor must of Necessity be a virtuous marry'd Man.

---

*It must be own'd, that the above Estimate affords a very melancholy Prospect to one who is a Well-wisher to the State of Matrimony. To enliven which therefore, we shall insert the following Lines from some of our most celebrated Poets, who have treated the Subject with a greater Regard to experienced Truth, than to poetick Severity.*

MARRIAGE is but a Beast, some say,
That carries double in foul Way;
Therefore 'tis not to be admir'd,
It should so suddenly be tir'd.
For after Matrimony's over,
He that holds out but half a Lover,
Deserves for every Minute, more
Than half a Year of Love before.
A Slavery beyond enduring,
But that 'tis of our own procuring.
As Spiders never feel the Fly,
But leave him of himself t' apply;
So Men are by themselves betray'd,
To quit the Freedoms they enjoy'd;
And their Necks into a Noose,
They'll break 'em, after, to get loose. Hudibr.

Few know what Care a Husband's Peace destroys,
His real Griefs, and his dissembled Joys. Dryd.

Minds are so hardly match'd, that ev'n the First,
Tho' pair'd by Heav'n, in Paradise, were curs'd;
He to God's Image, she to his was made;
So farther from the Fount the Stream at Random stray'd,
Not that my Verse would blemish all the Fair;
But yet, if most be bad, 'tis Wisdom to beware;
And better shun the Bait, than struggle in the Snare. Dryd.

For Discord ever haunts, with hideous Mien,
Those dire Abodes where HYMEN once has been. Garth.

With gaudy Plumes, and jingling Bells made proud,
The youthful Beast sets forth, and neighs aloud;
A morning Sun his tinsell'd Harness gilds,
And the first Stage a down-hill Green-sward yields,
But Oh —
What rugged Ways attend the Noon of Life!
Our Sun declines; and with what anxious Strife,
What Pain, we tug that galling Load, a WIFE? Congr.

MEN, born to labour, All with Pains provide;
WOMEN have Time to sacrifice to Pride.
They want the Care of Man; their Wants they know,
And dress to please, with Heart-alluring Shew;
The Shew prevailing, for the SWAY contend,
And make a Servant, where they meet a Friend.
Thus in a thousand Wax-erected Forts,
The Drones, a loit'ring Race, the painful Bee supports;
From Sun to Sun, from Bank to Bank he flies,
With Honey loads his Bag, with Wax his Thighs;
Fly where he will, at home the Drones remain,
Prune the silk Dress, and, murm'ring, eat the Gain.
Yet here and there, we grant, a gentle Bride
Whose Temper betters by the FATHER's Side.
Unlike the rest, that double human Care,
Fond to relieve, or resolute to share.
Happy the Man, whom thus his Stars advance!
The Curse is gen'ral, but the Blessing, Chance! Parnell.

1741

painter Guido Reni (1575–1642). Lambasting the interest in foreign
opera singers, he finds it astounding that 'each panting Warble of
Vesconti's Throat, / To Dick, is heav'nlier than a Seraph's Note; /
The Trills, he swears, soft-stealing to his Breast, / Are lullabies,
to soothe his cares to rest.' The writer goes on to directly accost
France, 'whose edicts govern Dress and meat', and to bemoan
that country's power to prescribe 'new rules for knots, Hoops,
manteaus, Wigs, / Shoes, Soups, Complexions, Farces, Jiggs.'

This kind of critique needs to be understood, like *Marriage à la
Mode*, as expressing a profound cultural anxiety in a decade when
Britain's political relations with the Continent – and especially
with France – were frequently hostile and often descended into
armed conflict. Indeed, the year in which Hogarth's series was
published witnessed French troops defeating the English at the
Battle of Fontenoy and a French-backed invasion of Britain by
soldiers supporting the exiled pretender to the throne, Charles
Edward Stuart. Even before these events, critics had warned
that the nation's capacity to withstand such threats was being
undermined by the widespread consumption of Continental
products and fashions. France was targeted as the chief source of
cultural and commercial corruption: the *Gentleman's Magazine* for
1738, for instance, castigated 'the absurd and ridiculous imitation
of the French, which is now become the Epidemical distemper of
this Kingdom … I behold, with indignation, the sturdy conquerors
of France shrunk and dwindled into the imperfect Mimics, or
ridiculous Caricaturas of all its Levity.' For such writers, the élite
absorption of a French culture they associated with luxurious
excess, effeminate display and courtly intrigue led inexorably
to a weakening of Britain's own moral and physical capabilities.
Hogarth's series makes the same kind of criticism in pictorial
terms. Across his six images the inhabitants of high society, both
aristocratic and bourgeois, are depicted as enslaved to the foreign.
*Marriage à la Mode* – the title gives the game away – is overridden
with signs of Italian, Dutch and especially French culture: foreign
paintings, clothes, ornaments, furniture, rituals – the *tête-à-tête* –
doctors, architecture, spaces – the bagnio, the boudoir – musicians,

diseases (syphilis was popularly known as the 'French' disease), servants, make-up and even literature – a copy of the French erotic novel, *La Sopha* by Claude Prosper Jolyot de Crébillon, lies next to Silvertongue as he flirts with the Countess at her toilette.

Hogarth's pictures also suggest how this addiction has perverted not only the morality but the sexual health of the London élite. Thus, Countess Squander is increasingly shown in relation to the signs of sexual excess: we move from her languorous pose in the second image to see her dramatically juxtaposed, in the third, with the painting of Io in sexual ecstasy, making love to the shadowy form of Jupiter, and in the fourth, with the painting of a brazen prostitute, lewdly dangling some kind of phallic object between her legs. Hogarth simultaneously depicts the sexuality of the countess's husband as diseased and deviant. The first picture of the series offers an intriguing context for this: if we turn to the paintings on the wall, we notice that the old earl's smiling portrait gazes across at a series of pictures concentrating on the stricken or dismembered male nude, suggesting a perverse, eroticized fascination with the narratives and imagery of masculine nudity and pain. Significantly, the engraved version shows the earl's son looking dreamily at the face of Silvertongue in the mirror. This suggestion of an ambiguous sexuality is developed and complicated as the series progresses: in *The Tête-à-Tête*, there is a clear implication of emasculation, even of impotence, in the contrast between the viscount's flaccid pose and that of his wife, and in the symbolism of the broken sword on the carpet; and in the next picture, we find that the young aristocrat's mistress is in fact a child, again implying his inability to practise conventional adult heterosexuality. Finally, in the penultimate image, he is pictured as thoroughly unmasculine – indeed, as a grotesque, enfeebled facsimile of heroic manhood, a foppish puppet made up of bent, splayed legs, flopping arms, a lolling head and a spineless torso.

In *Marriage à la Mode*, these details of sexual and physical decrepitude thus contributed to a complex pattern of pictorial commentary that highlighted the corrupted forms of marriage and the foreign modes of taste to be found in the affluent realms

110
Jean-François de Troy, *The Declaration of Love*, c.1724–5. Oil on canvas; 64·8×54cm, 25$\frac{1}{2}$×21$\frac{1}{2}$in. Williams College Museum of Art, Williamstown, Massachusetts

of urban society. Yet, at the same time, Hogarth's six images offer a pictorial catalogue of 'high life' that, however ironically, shares much of the luxurious elegance and *politesse* of the world they depict. Remember the words of his advertisement for the series: it was to be 'engrav'd by the best Masters in Paris', and Hogarth announced that he was going to make sure that there could be no objection to the 'Elegancy', as well as the 'Decency' of the whole work. Indeed, turning to the paintings and engravings themselves, it is clear that their appeal was built not only on their satirical polemics, but on their aesthetic status as exquisitely crafted, fashionably novel and

unashamedly 'foreign' luxury objects which competed with the imported commodities of élite culture. Here, it is also helpful to recognize how strikingly Hogarth's thematic and formal choices in pictures like *The Toilette* (see 106) echoed those of French artists such as Jean-François de Troy (1679–1752) who had, over the previous two decades, produced numerous images of courtship, conversation and luxurious extravagance within Parisian society (110). Furthermore, Hogarth actually travelled to Paris in 1743 to find engravers who could best provide that veneer of Continental

sophistication he was so obviously seeking for his series. How, then, can this seeming contradiction within *Marriage à la Mode*, between its xenophobia and anti-elitism on the one hand, and that clear appropriation of foreign forms and ostentatious appeal as a luxury product on the other, be best explained? To answer this question, it is necessary to consider the ways in which Hogarth used *Marriage à la Mode* to reassert the aesthetic centrality of satire at a time when the satiric art he was so closely associated with was coming under threat from other kinds of artistic practice in the city. First, however, these competing kinds of practice need to be examined in some detail, and this we can do by looking at the illustrations and adaptations of Samuel Richardson's celebrated novel *Pamela*.

Richardson's narrative, the first two volumes of which were published in 1740, details the history of a beautiful but modest young servant-girl working at a grand country house, who defiantly defends her virginity against the repeated entreaties and assaults of the young Mr B, the aristocratic head of the household. Pamela Andrews's moral virtue and sexual steadfastness eventually win over and reform her master, and they finally marry and begin a respectable and fertile alliance. In December 1741 a two-volume sequel was published, which detailed Pamela's adventures and encounters as wife to Mr B, in which she spends a season in London – offering a running commentary on places such as the masquerade and the playhouse – and takes two years travelling on the Continent with her husband. Finally, in 1742, a luxury edition of all four volumes was issued, generously illustrated with engravings by Francis Hayman and Hubert-François Gravelot, who was the designer of *The Batchelor's Monitor*. As the 1740s developed, Richardson's text, along with numerous spin-offs, sequels and imitations, became something of a commercial and cultural phenomenon, and was constantly hailed by its supporters for its promotion of a modern, polite model of marriage and morality, in which Pamela, the plebeian servant-girl, and Mr B, the aristo-cratic rake, find happiness because of their ultimate loyalty to new, thoroughly middle-class codes of sexual restraint, conversational decorum and affectionate companionship. As such, of course, the

novel made a powerful contribution to the British discourse on marriage that we have already identified as an important context for *Marriage à la Mode*. Equally, Richardson's four volumes offered a lengthy meditation on the impact of foreign mores on English upper-class identity. Pamela's travels to places such as Paris become occasions for her to comment at length on what she sees as the ideal fusion of English plainness and French refinement. Thus, she approvingly discusses an Englishman who has had 'the native roughness of his climate filed off and polished by travel and conversation', and who happily blends the 'natural boisterousness of a North Briton, and the fantastick politeness of a Frenchman'.

III
Hubert-
François
Gravelot,
Frontispiece
to Dryden's
*Marriage
à la Mode*,
1735.
Engraving

Hayman and Gravelot's illustrations to the 1742 edition of *Pamela* represented a pictorial version of this ideal combination of French style and English restraint, and are exemplars of a modern pictorial aesthetic that was becoming increasingly fashionable in London. Here it is worth pausing for a moment to note the English career of Gravelot, a French artist who came to London in 1732 and quickly became celebrated for his exquisite skill as a designer and etcher. In hundreds of different images produced from his studio in the city – including, intriguingly, a frontispiece to a 1735 edition of Dryden's *Marriage à la Mode* (III) – he fused

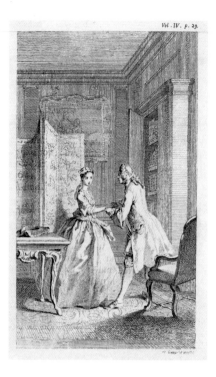

*Vol . IV. p. 29.*

the elitist subject matter and undulating forms of the French
Rococo with the conventions and categories of English pictorial
practice, generating a modern art that was perceived to combine
Continental sophistication on the one hand, and a native sobriety
and minimalism on the other. The *Pamela* illustrations – even
those designed by Hayman – are dominated by the French artist's
methods and style. In one (112), showing the recently married
couple discussing the proper way to bring up a child, Pamela and
Mr B are pictured as models of polite elegance, affection and
communication, placed in a setting that the contemporary viewer
could appreciate as a blueprint of tasteful decoration, depicted
using a formal and compositional language that combines
intricate, swirling lines and robust rectangularity.

That this kind of style and subject matter could develop into a
form of pictorial practice rivalling Hogarth's own was confirmed
when, in the spring of 1744, the artist Joseph Highmore issued a set
of newspaper advertisements declaring that 'Mr HIGHMORE
Proposes to Publish by SUBSCRIPTION, TWELVE PRINTS,

112
Hubert-
François
Gravelot,
Illustration to
Richardson's
*Pamela*,
1742.
Engraving

by the best French Engravers, after his own PAINTINGS, representing the most remarkable ADVENTURES OF PAMELA.' Highmore's images offered both an adaptation of the Rococo formulae associated with Gravelot and, significantly for our purposes, an exchange with Hogarth's own earlier satirical work of the 1730s. Comparing Highmore's first picture (113) with the 1742 illustration to *Pamela*, we can quickly see the similarity between the two protagonists and their setting. Mr B, despite being the villain of the piece, bursting into the room and demanding that Pamela show him the letter she is writing, is pictured as a thoroughly refined, fashionable and polite gentleman. Meanwhile, Pamela is given the same elongated body, delicate gestures, doe-eyed physiognomy and sartorial elegance – although here, it is important to note, she is still a servant – that she enjoyed in Gravelot's illustrations, and that was becoming established as a pictorial template of polite femininity. The room she sits in is powerfully reminiscent of the earlier interiors, fusing a decorative minimalism that borders on the austere with the discreet trappings of status, taste and wealth.

As well as building upon Gravelot's example, Highmore's series invoked Hogarth's own pictorial *Progresses* of the 1730s. When comparing the seventh plate of *Pamela* (114) to the third plate of *A Harlot's Progress* (see 42), for instance, it is clear that Highmore defined his heroine in relation to her satirical precursor. Structurally, of course, the later print – in which Pamela is shown getting ready for bed under the gaze of both her servant, Mrs Jewkes, and the disguised figure of Mr B, sitting dressed in woman's clothing – seems heavily dependent on Hogarth's satire. Again there is the young, beautiful and partly undressed woman framed by the curtained edges of the bed and turned towards the spectator, complete with a vulgar companion, and a male viewer who represents both an imminent threat and a comic, temporarily emasculated voyeur. While such a comparison might have invoked the scandalous possibility that Pamela herself was a similarly scheming and sexually manipulative figure, and undoubtedly reinforced the voyeuristic attractions of Highmore's image for

Jos. Highmore inv. et pinx.                                                                L. Truchy sculpsit.

Pamela is represented in this first Piece writing in her late Lady's
dressing room, her History being known only by her letters. She is here
surprised by Mr B. who improves this occasion to further his designs.

Pamela est représentée en ce premier tableau écrivant dans le cabinet de
toilette de sa défunte Maitresse, son Histoire n'étant connue que par ses lettres
elle est surprise par Mr B. qui profite de cette occasion pour pousser ses vues.

Published according to Act of Parliament July 1st 1745.                    1.

Jos. Highmore inv. et pinx.                                                                R. Truchy fecit.

Pamela undressing herself (Mrs Jewkes being first got to bed)
while Mr B. disguised in the maids clothes, with the apron thrown
over his face, is impatiently waiting for the execution of his plot.

Pamela se déshabille, Madme Jewkes étant déja couchée; tandis que
Mr B. déguisé sous les habits de la servante, et le tablier sur le visage,
attend avec impatience le moment d'executer son dessein.

Published according to Act of Parliament, July 1st 1745.                    7.

the male viewer, it was more obviously exploited to dramatize the contrast between his virtuous heroine and the corrupted figure of Moll Hackabout. Furthermore, the comparison with Hogarth also served to promote Highmore's project as embodying a rather different pictorial vocabulary to that of satire, one which flaunted its adherence to an anglicized Rococo, and which was harnessed to the narratives of polite virtue, gentility and refinement, rather than being tied, as Hogarth's graphic satires had traditionally been, to those of corruption, hypocrisy and abjection. As such, Highmore's series of paintings and prints – engraved by Frenchmen and issued with French as well as English captions – operated at the vanguard of a modern aesthetic that was confidently colonizing both painted and graphic culture in London, and that self-consciously distinguished itself from Hogarth's satiric example.

*Marriage à la Mode* actively responded to this crucial development in the artistic culture of the city, and in doing so maintained the traditionally dialectical relationship of satire with more fashionable and respectable kinds of art. Hogarth's six paintings and engravings, on this reading, integrated and imitated many of the features of the new art associated more generally with Gravelot, Hayman and Highmore, and more particularly with the pictorial adaptations of *Pamela* which they produced, and at the same time subjected those features to ironic critique. Thus, in choosing to concentrate on modern marriage, and by detailing the environments, commodities and rituals of 'high life', Hogarth's series unashamedly mimicked the subject matter of Richardson and his artistic translators. Similarly, in marketing his series as a set of luxury objects laden with the traces of both aristocratic and Continental culture, the artist was catering to a growing demand for such products within the affluent sectors of urban society, a demand that the *Pamela* pictures had already helped to satisfy. And in deciding to use a Rococo pictorial vocabulary for much of the series, and in searching so assiduously for the best French engravers – Bernard Baron (1696–1762), Simon Ravenet (1706/21–74)

113
Louis Truchy after Joseph Highmore, *Pamela*, plate 1, 1744. Engraving

114
Louis Truchy after Joseph Highmore, *Pamela*, plate 7, 1744. Engraving

and Gerard Scotin (1698–*c*.1755) – to reproduce his painted images, Hogarth seems to have been throwing in his artistic lot with artists like Highmore.

Yet what is equally evident is how Hogarth simultaneously parodies precisely those subjects, styles and tastes which, at first glance, his series might seem to support. Although *Marriage à la Mode* was clearly being marketed as a luxury commodity, it was one whose contents and criticism ultimately worked to undermine the values that underpinned luxury and commodification in contemporary culture. Furthermore, Hogarth's series plays with, and traduces, the forms and subjects of the anglicized Rococo just as much as it reproduces them. Comparing Hogarth's depiction of marital alienation in *The Tête-à-Tête* (see 104) with Pamela's imagery of marital affection (see 112) demonstrates the extent to which the satirist manipulates the same basic pictorial elements for entirely different ends, just as he does in his final plate, which cruelly parodies Gravelot's earlier illustration of a nurse handing Pamela her baby (115). In all of these ways, Hogarth's series maintains the intimate but double-edged relationship of satire to other, more conventionally respectable kinds of art, both exploiting and undermining their forms, content and appeal.

115
Hubert-François Gravelot, Illustration to Richardson's *Pamela*, 1742. Engraving

Hogarth's satirical manipulation of pictorial styles and narratives in *Marriage à la Mode* goes much further than this, however. For what becomes clearer, when the series is studied more closely, is its status as an especially dense pictorial assemblage, or montage, in which Hogarth self-consciously manipulates a kaleidoscopic variety of pictorial materials for satiric effect. To understand this practice a little better, it is worth bearing in mind another satirical format from the period, known as the medley print (116), in which a central image – normally a portrait of an individual – is wittily juxtaposed with a discordant mass of graphic objects, both pictorial and textual. A picture such as *The Toilette* (see 106) shares many of the medley's characteristic features. The countess and Silvertongue are also figures embedded in a bewildering spiral

H. Gravelot inv. s

of overlapping images and texts, both invented and reproduced, and drawn from a wide range of contexts. On the one hand, the decorated screen, the mythological and historical canvases, the idealized portrait, the painted plate in the basket; on the other, the book on the sofa, the opened catalogue in the foreground, the printed masquerade ticket in Silvertongue's hand, the visiting cards scattered on the floor. Through this strategy Hogarth generates a satirical dialogue between the figures in the countess's boudoir, and the images and objects that surround them. Indeed, the upper half of the picture space, in which the collection of reproduced images is particularly dense, is played off against the lower half – we are encouraged, for instance, to contrast Silvertongue's idealized portrait with his appearance and behaviour below, just as we read the imagery of Io in relation to the countess herself.

116
George
Bickham Sr,
*Postscript to
the Post-Boy*,
1706.
Hand-coloured
engraving;
42.8 × 28.5cm,
16⁷⁄₈ × 11⅛in.
Worcester
College,
Oxford

Hogarth extends and complicates this kind of pictorial montage by deliberately blurring the distinction between the static, framed images shown within his pictures and the figures supposedly moving in front of them. Mirrors are often used for this purpose, as in *The Toilette* where Silvertongue's head is pointedly shown cutting across the frame of a mirror. In the next picture in the series, this kind of framing is even more apparent, as the head of the dying Squander is placed directly in front of a hanging mirror. Meanwhile, in this same image, the escaping Silvertongue is framed by the bottom half of the window, and the bagnio keeper and nightwatchman are similarly enclosed by the frame of a door. Through such 'framing' devices, Hogarth further embeds his protagonists within the dizzying array of framed representations found throughout the series, and wittily calls into question the supposed distinctions between the two.

In *The Bagnio*, it is also worth noting, the central figures are again placed in a complex, overlapping field of 'background' represen-tations, including a picture of St Luke over the doorway and a tapestry telling the story of King Solomon. These references to biblical characters and narratives alert us to the fact that the

depiction of the dying earl and his wife also echoes Christian iconography: more specifically, Hogarth seems to be evoking Old Master paintings of Christ's Deposition from the Cross, with Silvertongue's falling body substituted for that of Jesus, and the countess taking the place of the mourning Mary Magdalene. These parallels accentuate that blurring of boundaries between 'reality' and representation found in the series as a whole, and reinforce the status of each image within *Marriage à la Mode* as a proliferating assemblage of overlapping visual forms. Adding to this sense of medley-like variety, Hogarth turns the foregrounds of his pictures into crowded still lifes, each of which works in playful dialogue with those layers of imagery occupying the higher reaches of the canvas.

When looked at in this way, the six images of *Marriage à la Mode* can be reread as pictorial composites that self-consciously – and quite systematically – bring different representational materials together and place them in creative, satirical tension. Furthermore, this kind of satirical dialogue does not merely operate within the images, it operates *across* them. As spectators, we are encouraged to appreciate the repetitions, connections and contrasts that emerge if we treat the series as an assemblage of disparate objects that can be broken down into different sequences. We have already noticed, for instance, the ways in which the series can be divided into three successive pairs. Yet it is also possible to shuttle directly between the first image and the last, and enjoy the ways in which the two depicted rooms are satiric counterparts, given the same basic structure and the same view out on to the city, but respectively depicted as the environments of aristocratic excess and bourgeois miserliness. Similarly, the second and fourth pictures can be put together to make up another pendant grouping: they are given adjacent settings and a similar composition – both are dominated by the grand archway on the left-hand side of the image – and offer a powerful pictorial contrast between wife and husband, on the one hand, and wife and lover on the other. Through such features Hogarth creates a series that can be read in succession – as six images in a line – but can also be creatively reassembled by the spectator.

117
*The Battle of the Pictures*, 1745. Engraving; 17·8×20 cm, 7×7⅞ in

The Bearer hereof is Entitled (if he thinks proper,) to be a Bidder for Mr. Hogarth's Pictures, which are to be Sold on the Last day of this Month

The Battle of the Pictures

*Marriage à la Mode*, as well as offering a complex commentary on controversial social issues, can now be understood as a particularly ambitious and aggressive reassertion of satire's traditional practice of pictorial juxtaposition and play, produced at a time when satiric art was coming under threat from more obviously polite artistic forms. That the series should be understood in relation to a conflict in contemporary representation is made all the clearer when we note that, just months before his six prints were published, Hogarth produced an image which defined the series in exactly these terms. *The Battle of the Pictures* (117), which Hogarth issued in the spring of 1745 to announce an auction of his paintings, shows *The Tête-à-Tête* standing in his studio being attacked by one of the numerous Old Master copies being sold in the contemporary auction houses. Here, of course, Hogarth's satire is aimed squarely at the connoisseurial obsession with foreign art that is only one of the concerns of *Marriage à la Mode*. Nevertheless, this small engraving – itself yet another medley of overlapping images – gives a powerful sense of how Hogarth perceived his position as an embattled one, and of how he was promoting his paintings not just as works of art, but as weapons in a cultural war. In *Marriage à la Mode*, this belligerent form of artistic engagement is more wide-ranging than in *The Battle of the Pictures*, extending to, and seeking to defeat, those locally produced genres of art that, even as they carried the traces of Continental sophistication, could be seen as English alternatives and successors to Hogarth's own pictorial satire.

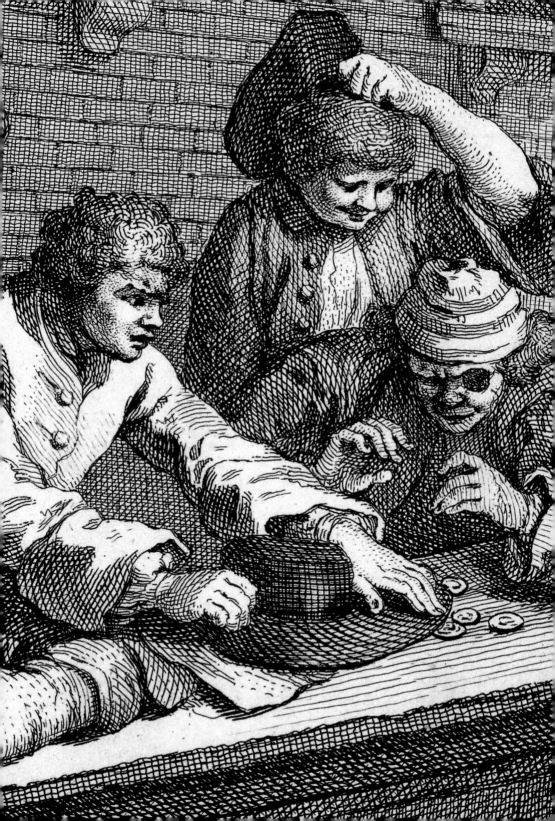

Having completed his most elaborate and sophisticated satirical
series, Hogarth soon forged ahead with other such projects.
Indeed, the late 1740s and early 1750s were particularly busy years
in this respect, something recognized by the poet Paul Whitehead,
who in 1747 imagined Hogarth standing in his studio, furiously at
work, and barking orders at an assistant: 'Load, load the Pallet,
Boy! hark! HOGARTH cries, / Fast as I paint fresh swarms of
Fools arise! / Groups rise on Groups, and mock the Pencil's Pow'r /
To catch each new blown Folly of the Hour.' The fruit of this
frenetic labour was a novel kind of graphic art, one that fused
the perspectives of satire with a far more explicitly propagandist
agenda than in the past, and that generated a durable image of
Georgian London as a fractured and conflicted city.

In *Industry and Idleness*, a series of twelve engravings published
in the autumn of 1747, and in *Gin Lane*, *Beer Street* and *The Four
Stages of Cruelty*, issued in the spring of 1751, Hogarth offered a
new, polarized vision of London as a city split into two halves.
In these works the English capital is starkly divided up into
separate social and cultural spheres, one dominated by the
criminal and the delinquent, the other made up of the virtuous
and the hard-working. And it was not only the subject matter
of these prints that was different: engraved directly from drawn
sketches in a dramatic, bold style, and costing far less than his
last graphic series, they were clearly distinguished in both
their look and their expected audience from the six *Marriage
à la Mode* engravings. As such they announced a return on
Hogarth's part to the 'low' subjects of satire with which he had
first made his name, and an ambitious, if somewhat ambivalent,
attempt to depict the ideals and anxieties of a modern urban
middle class.

118
*The Idle
'Prentice at Play
in the Church
Yard during
Divine Service*
(detail of 121)

*Industry and Idleness* begins in a weaver's workshop (119) where
Hogarth's two main protagonists, the apprentices Francis Goodchild
and Tom Idle, are placed within a lattice-like grid of pulleys,
struts, beams and machines. Their respective attitudes to labour
are already apparent. Goodchild sits contentedly at his loom,
carefully attending to the task of winding silk, while Idle slumps
drunkenly near an emptied tankard, entirely oblivious to the world
of work. The master weaver is shown bursting into the room, a
stave in his hand, clearly about to exact punishment on his errant
charge. From this point onwards the divergent paths of the two
apprentices are set, and the series develops through a rhythmic
succession of pictorial pairings in which Goodchild and Idle are
constantly placed in dramatic counterpoint. Thus, the second
engraving (120) depicts Goodchild singing a hymn with his
master's daughter inside a magnificently decorated church, while
the third (121) shows Idle gambling outside a church – presumably
the same church on the same Sunday morning – just as the Divine
Service is about to begin. He sprawls across a gravestone, trying to
cheat his crew of grotesque, misshapen companions, and is again
unaware of the threatening figure of authority – this time a parish
beadle – who looms behind him. The fourth image (122) depicts
Goodchild's master offering his model apprentice a share in the
business, his left hand resting informally on the younger man's
shoulder, his right gesturing to the crowded, factory-like work-
room beyond. The hand that rests on Idle's shoulder in the fifth
engraving (123) helps to articulate a very different transition. Idle
has been 'turn'd away' from the weaver's workshop because of his
misbehaviour, and is about to try his luck with the navy. As he is
taken to his ship, his mother cries into a handkerchief, and two
sailors threaten him with frightening tales of the sea. Ominously,
one of the sailors points to the hanging figure of an executed
criminal, seen swinging from a distant, windswept gallows.

The next pair of images show the two men with their chosen
female companions (124, 125). Goodchild, having completed his
apprenticeship, is depicted soon after his wedding to his master's
daughter. Framed by the impeccable exteriors of his house and

business premises, he interrupts tea with his wife in order to pay some musicians who have been performing a traditional serenade to the newly married couple. In contrast, Idle, having returned from sea and embarked upon a career as a highwayman, lies with a 'common prostitute' in a squalid, ramshackle garret. She inspects the goods he has stolen, while Idle, petrified of being caught, jumps up at the sound of a cat falling down the chimney, which he has mistaken for the noise of constables at the door. In the eighth and ninth plates of the series (126, 127), Goodchild and Idle are placed with their peers in more communal settings. The Industrious Apprentice has, as Hogarth's title tells us, 'grown rich' and become part of the city's administrative and governmental élite. He is now a sheriff of London, and sits with his wife underneath a portrait of King William III during a grand civic banquet. The Idle Apprentice, meanwhile, squats among a ragged and riotous cluster of people in the subterranean environment of a night cellar, sharing out his booty with one of his old churchyard companions. He has been betrayed by the prostitute, and is characteristically unaware of the arresting officer who – descending the steps with a group of stick-wielding subordinates and palming money into the prostitute's hand – approaches him from behind.

*Industry and Idleness*'s tenth engraving (128, 129) brings the two former apprentices back into the same image, as Goodchild, now an alderman and magistrate, is confronted by the desparate, manacled figure of Idle, who pleads with him for his life. Goodchild, however, turns his eyes away, and Idle's fate as a convicted thief is sealed by the corrupted testimony of his night-cellar associate. The last two plates of the series (130, 131) offer a spectacular final comparison between the two men, in which they ride at the symbolic centre of huge urban processions. In the penultimate plate, Idle forlornly reads the Bible as he is carried to the hanging site of Tyburn, where stands have been erected for the thousands of people who customarily turned up to watch the twisting bodies of the executed. His cart is followed by a phalanx of soldiers and surrounded by a swarming plebeian crowd of onlookers, entrepreneurs and thieves. On the outer edges of the engraving, in a detail that eerily predicts Idle's

The Fellow 'Prentices INDUSTR[Y

Spittle Fields

Moll. Flanders

Proverbs Chap: 23, Ve: 21,
The Drunkard shall come to
Poverty, & drowsiness shall
cloath a Man w.th rags.

Designed & Engrav'd by W.m Hogarth.

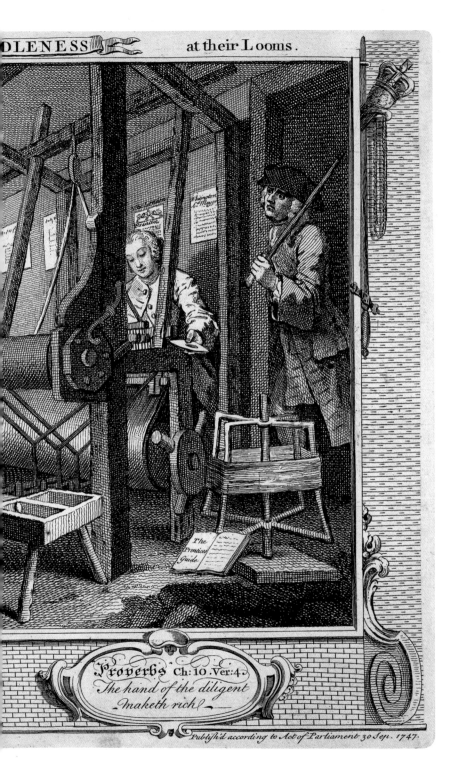

Proverbs Ch: 10 Ver: 4.
*The hand of the diligent*
*maketh rich.*

Publish'd according to Act of Parliament 30 Sep. 1747.

119
*The Fellow
'Prentices at
their Looms,*
1747.
Engraving;
25.7×34cm,
$10\frac{1}{8}×13\frac{3}{8}$in

The INDUSTRIOUS 'PRENTICE performing the Duty of a Christian.

Psalm cxix Ver: 97.
O How I love thy Law it is my
meditation all the day.

Design'd & Engrav'd by Wm. Hogarth.        Plate 2        Publish'd according to Act of Parliament Sepr. 30th. 1747.

The IDLE 'PRENTICE at Play in the Church Yard, during Divine Service.

Proverbs Ch:XIX Ve:29.
Judgments are prepar'd for scorners,
& Stripes for the back of Fools.

Design'd & Engrav'd by Wm. Hogarth.        Plate 3        Publish'd according to Act of Parliament Sepr. 30. 1747.

120
*The Industrious
'Prentice
Performing the
Duty of a
Christian*,
1747.
Engraving;
25.7×34cm,
10¹⁄₈×13³⁄₈in

121
*The Idle
'Prentice at Play
in the Church
Yard during
Divine Service*,
1747.
Engraving;
25.7×34.3cm,
10¹⁄₈×13¹⁄₂in

**122**
*The Industrious*
*'Prentice a*
*Favourite, and*
*entrusted by*
*his Master,*
1747.
Engraving;
25.1×34cm,
9⁷⁄₈×13³⁄₈in

**123**
*The Idle*
*'Prentice turn'd*
*away and sent*
*to Sea,*
1747.
Engraving;
25.4×34cm,
10×13³⁄₈in

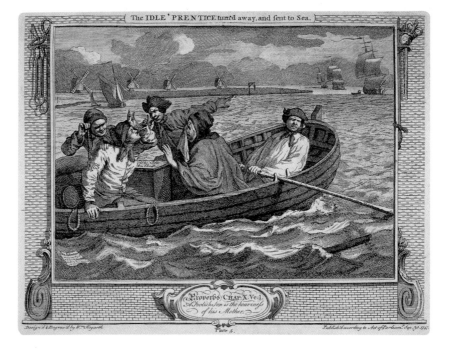

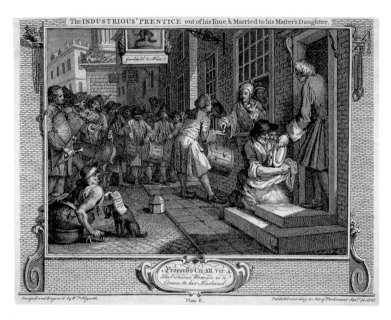

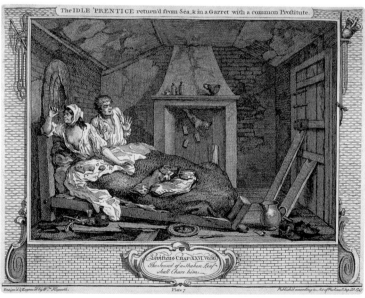

**124**
*The Industrious
'Prentice out of
his Time, &
Married to
his Master's
Daughter*,
1747.
Engraving;
25.4×33.7cm,
10×13¼in

**125**
*The Idle
'Prentice
return'd from
Sea, & in a
Garret with
a common
Prostitute*,
1747.
Engraving;
25.7×34.3cm,
10⅛×13½in

**126**
*The Industrious
'Prentice grown
rich, & Sheriff
of London*,
1747.
Engraving;
25.4×34cm,
10×13⅜in

**127**
*The Idle
'Prentice
betray'd by his
Whore, & taken
in a Night
Cellar with
his Accomplice*,
1747.
Engraving;
25.7×34cm,
10⅛×13⅜in

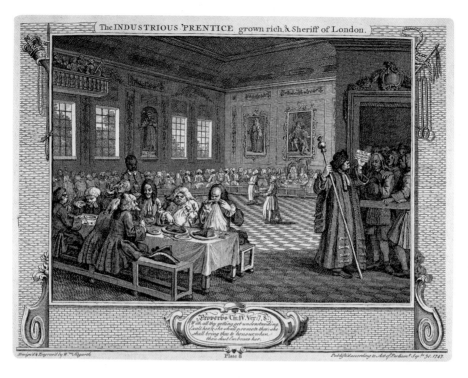

The INDUSTRIOUS 'PRENTICE grown rich, & Sheriff of London.

Proverbs Ch. IV. Ver. 7, 8.
With all thy getting get understanding
Exalt her, & she shall promote thee: she
shall bring thee to honour, when
thou dost embrace her.

Designed & Engraved by Wm. Hogarth.    Plate 8    Publish'd according to Act of Parliamt. Septr. 30, 1747.

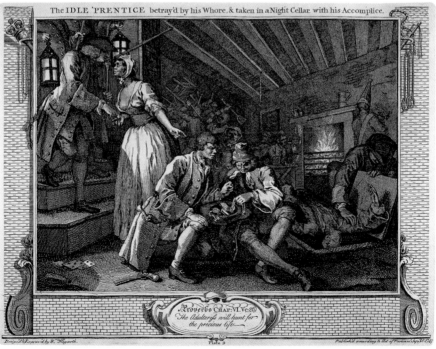

The IDLE 'PRENTICE betray'd by his Whore, & taken in a Night Cellar with his Accomplice.

Proverbs Chap. VI. Ver. 26.
The Adulteress will hunt for
the precious life.

Designed & Engrav'd by W. Hogarth.    Plate 9    Publish'd according to Act of Parliamt. Septr. 30. 1747.

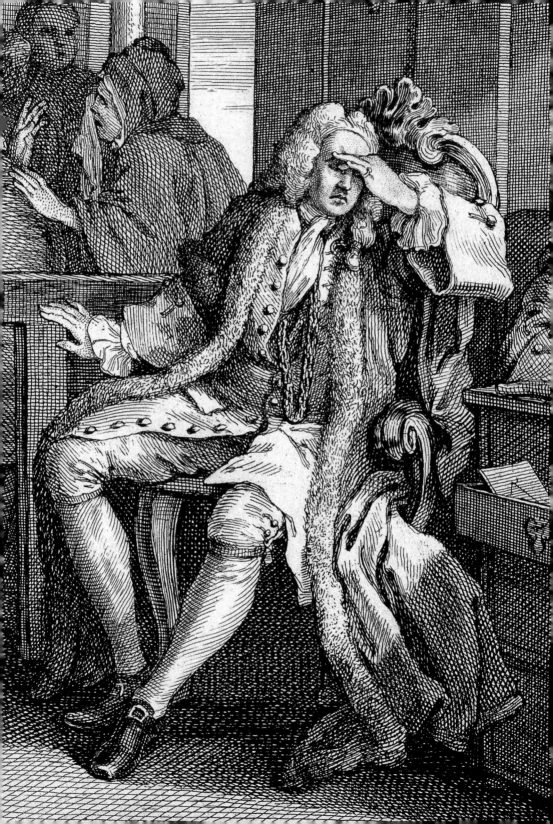

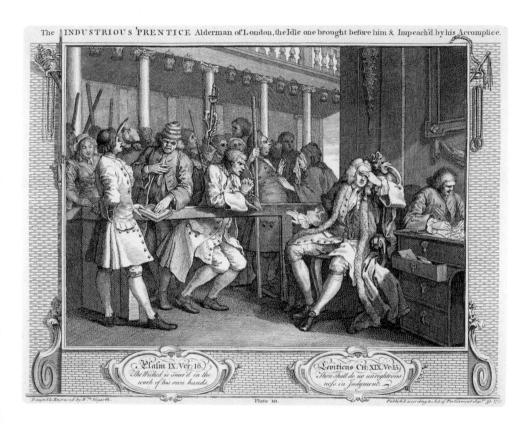

The INDUSTRIOUS 'PRENTICE Alderman of London, the Idle one brought before him & Impeach'd by his Accomplice.

Psalm IX. Ver: 16.)
The Wicked is snar'd in the
work of his own hands

Leviticus CH: XIX. Ve:15,
Thou shall do no unrighteous
nefs in Judgment.

Design'd & Engraved by W.m Hogarth.

Plate 10.

Publish'd according to Act of Parliament Sep.r 30. 1747.

128–129
*The Industrious
'Prentice
Alderman of
London, the Idle
one brought
before him and
Impeach'd by his
Accomplice,*
1747.
Engraving;
25.4 × 33.7 cm,
10 × 13¼in
**Left**
Detail

fate, two skeletons hang just like he will, their mouths fixed into terrible smiles. In the last image of the series the scene is a far more festive one. It is the day of the annual Lord Mayor's procession, when a cavalcade of vehicles and pageants traditionally commemorated the accession to office of a new mayor. Goodchild himself has been elected to the post and he leans back in the comfortable Mayor's coach, accompanied by the sword-carrying Marshal of the City and watched from a balcony by the Prince of Wales and his attendants. Here the crowd is a combination of dignified householders, packed into the windows on the other side of the street, and a more unruly combination of soldiers and lower-class Londoners, enjoying an uproarious day of drinking, kissing and cheering.

In *Industry and Idleness* Hogarth self-consciously drew upon the materials and mythologies of popular urban culture. His series yokes together the venerable folkloric tales of the good and bad apprentice, which had often taken the form of cheap ballads, broadsheets and pamphlets, frequently illustrated with bold woodcuts. A particularly famous and long-standing example was the fable of George Barnwell, which had circulated in ballad form since at least the mid-seventeenth century and described the downfall of an apprentice who, seduced and corrupted by a deceitful prostitute, Sarah Millwood, embarks on a crime spree that ends with his execution at Tyburn. In the words of the ballad, 'A London lad I was, / A merchant's prentice bound; / My name George Barnwell, that did spend / My master many a pound. / Take heed of harlots then, / And their enticing trains, / For by that means I have been brought / To hang alive in chains.'

Alongside such publications as this, the popular press also issued ballads and chapbooks telling the exemplary tale of Dick Whittington's rise from apprentice to Lord Mayor of London, which had become a testament to the more respectable ambitions and attractions on offer to the young men of the city. A comparable narrative of youthful achievement was found in old, illustrated tales of 'The Valiant Apprentice' who, having worked assiduously for his merchant master, travels to Turkey, wins a jousting

130
*The Idle 'Prentice Executed at Tyburn*, 1747.
Engraving;
25.7×40 cm,
10⅛×15¾ in

131
*The Industrious 'Prentice Lord Mayor of London*, 1747.
Engraving;
26.4×40 cm,
10⅜×15¾ in

The IDLE 'PRENTICE Executed at Tyburn.

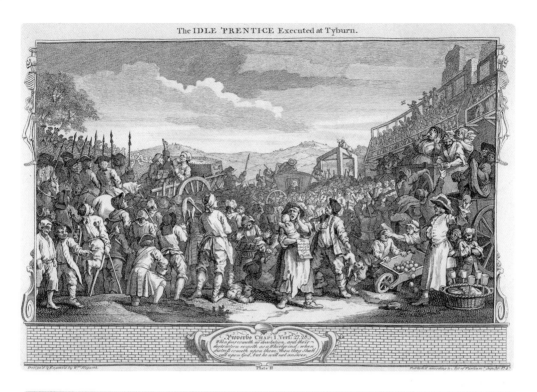

Proverbs Chap: I. Vert: 27.28.
When fear cometh as desolation, and their
destruction cometh as a Whirlwind: when
distreß cometh upon them. Then they shall
call upon God, but he will not answer.

Designed & Engraved by W.<sup>m</sup> Hogarth.    Plate II    Publish'd according to Act of Parliam.<sup>t</sup> Sep.<sup>r</sup> 30. 17.4.

The INDUSTRIOUS 'PRENTICE Lord-Mayor of London.

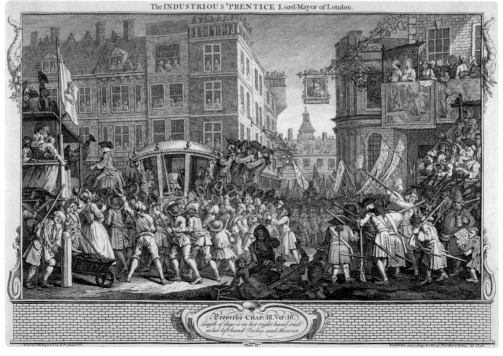

Proverbs CHAP. III. Ver: 16.
Length of days is in her right hand, and
in her left hand Riches and Honour.

Design'd & Engrav'd by W.<sup>m</sup> Hogarth.    Plate II    Publish'd according to Act of Parliament. 30. Oct.<sup>r</sup>

tournament and heroically kills two lions in competition, thus
gaining the hand of the Turkish king's daughter (132).

That such fables, and the stories they told, offered a populist
template for Hogarth's series is confirmed by the facts that he
himself jotted the name 'Barnwell' on one of his preliminary
sketches for *Industry and Idleness*, and that there are similar
kinds of publication being included as visual cues, or interpretative
starting-points, in the first engraving of the series (see 119).
Looking at the line of inscribed objects above the heads of Idle and

132
**Anonymous,**
Illustration to
*The Famous
History of the
Valiant London
'Prentice,*
*c.*1712.
Woodcut

133
**Anonymous,**
Illustration to
*The London
Apprentice,*
*c.*1730.
Woodcut

Goodchild in the weaver's workshop, it is possible to spot not only a
broadsheet ballad dealing with another infamous prostitute, Moll
Flanders, but also a sheet celebrating 'R Whittington, Lrd Mayor',
and a paean to the same 'Valiant London Apprentice' that has just
been discussed, the illustration for which Hogarth has copied
directly from another woodcut dealing with the subject (133).
The way in which these objects act like a backdrop, or an internal
caption, in this initial encounter with the two apprentices,
encourages us to read *Industry and Idleness* as a whole in terms of

its dialogue with the 'low', often highly traditional vocabularies and story-lines of cheap ballads and crude woodcuts.

At the same time, it is clear that Hogarth's depiction of Idle and Goodchild was also responsive to more self-consciously refined and modern categories of art and literature. More particularly, it is helpful to compare Hogarth's series with contemporary texts and images that tied popular narratives of urban delinquency and social progress to the interests, prejudices and tastes of the commercial and mercantile communities of the city. Significantly, the story of George Barnwell had itself undergone a thorough

process of transformation in the two decades before the appearance of Hogarth's series. George Lillo's play *The London Merchant: Or, The History of George Barnwell*, which was one of the great theatrical successes of the 1730s, recast the traditional narrative in polite and sentimental terms, relentlessly exploiting the fable's moralistic possibilities, and introducing alongside Barnwell and Millwood the figures of Thorowgood, an honest London merchant, Trueman, his hard-working apprentice and Maria, his virtuous daughter. Contemporary commentators celebrated the play's combination of sentiment and didacticism: in the words of the *Universal Spectator*, 'the play of George Barnwell

134
**Louis-Pierre Boitard**, Frontispiece to *The London Merchant: Or, The History of George Barnwell*, 1743. Engraving

… affects the mind with the feeling sense of the unhappy story, and shews how a good disposition may be corrupted; and seems happily calculated to do Good in such a City as London, where Thousands of young people are pretty near in the same condition.' Images as well as texts reinforced the message: Louis-Pierre Boitard's frontispiece to a 1743 edition of the play (134) shows Barnwell at Tyburn, praying for forgiveness, and surrounded by the same sort of crowds, gallows and armed soldiers that cluster around Tom Idle on his execution day.

While Lillo's text, and Boitard's engraving, focused on a young man who has deviated from the conventional paths of business, and come to occupy a space outside the realms of polite culture, others concentrated far more assiduously on exemplars of respectable citizenship. Here, it is suggestive to look at how Lord Mayors of London were celebrated in this period. Given that Lillo's play was dedicated to a former Lord Mayor of London, that Francis Goodchild eventually accedes to the same position, and that there is the reference to the Dick Whittington myth in Hogarth's first engraving, it is perhaps no surprise to discover that

contemporary Lord Mayors were frequently singled out for their combination of business achievement and civic service.

Interestingly, remembering the name of Hogarth's industrious protagonist, two of the most famous mayors of the city during the previous fifty years had been called Francis Child, father and son. Meanwhile, the decade before Hogarth's series was published saw numerous publications which eulogized another former Lord Mayor, Sir John Barnard, who had been elected to the post in 1737 and remained an alderman and a Member of Parliament in London throughout the 1740s. These texts promoted Barnard as a model of commercial man, someone who embodied financial acumen and mercantile success, fierce loyalty to the interests of the City of London, and personal integrity and benevolence. He became particularly famous for his leadership of the financial interests in the City and his defence of public credit during the invasion crisis of 1745, when the north of Britain was attacked and invaded by troops loyal to Charles Edward Stuart, Pretender to the English throne. George Bickham Jr's engraved response to this crisis (135), which allegorizes public credit as a polite businessman clutching an account book in his arms, holding a banknote in his hand and wearing an aldermanic robe and chain, suggests how this period witnessed a new assertion of heroic commercial identity in the city. A year later Barnard himself was celebrated in similar terms, in a new statue erected in the Royal Exchange, which was quickly reproduced in engraved form (136). In this print, issued only months before the appearance of *Industry and Idleness*, and entitled *The Reward of Virtue and Integrity*, the sculptural figure of Sir John is juxtaposed with numerous emblems of trade, justice and the City of London.

What these different engravings demonstrate is that, alongside the stereotype of idle apprenticeship exemplified by Lillo's George Barnwell, the writers and artists of early eighteenth-century London were also crafting a powerful, far more positive model of commercial, urban masculinity. That this ideal was one that could be made applicable to apprentices as well as to Lord Mayors is

confirmed when we discover that Barnard was also famed for his authorship of *A Present for an Apprentice*, which had reached a fifth edition by 1747. This shilling handbook was both a guide to good behaviour for the indentured young men of the city and a warning about the evils that constantly threatened to lure the apprentice away from his proper tasks. Thus, Barnard declares that 'to be frugal is not sufficient, you must be industrious too: what is saved by Thrift, must be improv'd by Diligence.' He cautions that excess is 'a pleasurable evil, that smiles and seduces, enchants and

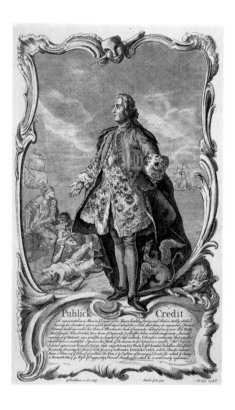

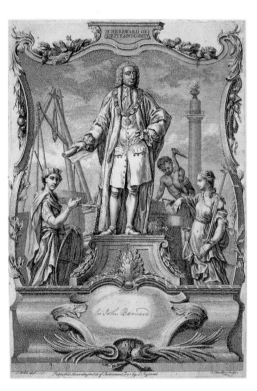

destroys', while the women of the town are 'Syrens, that have fascination in their Eyes, Musick in their Tongues, and Mischief in their Hearts.' Barnard's book was the most popular of a number of similar publications, which included Samuel Richardson's *The Apprentice's Vade Mecum* of 1734. This kind of manual offered both a bourgeois manifesto for the workplace and a testament to the anxieties that London's commercial communities continued to harbour about the anarchic, disruptive and disobedient potential

of the mass of young working males in the city. Two such guides lie at the feet of the apprentices in the first engraving of Hogarth's series (see 116), which makes it all the more apparent that the artist was engaging with similar preoccupations.

*Industry and Idleness* can now be understood as a pictorial narrative that manipulated powerful stereotypes of commercial virtue and masculine fecklessness, and that clearly mediated the hopes and worries of an emergent bourgeoisie in the city. It is worth looking again at the twelve engravings in these terms. One of the most striking features of the series, as the art historian Ronald Paulson has pointed out, is the way Hogarth exploits pictorial composition and space in order to reinforce the narratives of virtuous and vicious masculinity, and to split the worlds of Goodchild and Idle apart. Thus the first engraving (see 119) can be reread as one that, through the relentless vertical division of the picture space, emphasizes the distance – both physical and metaphorical – between the two men. Over the next eight engravings, in the images that deal with the virtuous apprentice's progress from church to banqueting hall, the artist places Goodchild in a pictorial world that – just like the first plate of the series – is relentlessly upright, in every sense of the word, and that continues to be split into rigidly demarcated compositional sections.

The closer we look at these four images, the more we find that Hogarth's upwardly mobile apprentice occupies a compositional grid in which the image is divided into a succession of near-geometric sections, some of which are privileged over others. In *The Industrious 'Prentice Performing the Duty of a Christian* (see 120), Goodchild sings in a church dominated by the crisscross of pews, columns and archways, and at the same time is partially sealed off from his surroundings: he stands in a separated, raised, boxed-in space, where he engages only with the respectable figure of the master's daughter. The image of Goodchild as 'a Favourite, and entrusted by his Master' (see 122) maintains the same formal and metaphorical patterns: the apprentice is part of an environment that is visually dominated by the rhythmic, right-angled overlap

135
George Bickham Jr, *Publick Credit*, 1746. Engraving; 32·4 × 19·7 cm, 12¾ × 7¾ in

136
Anonymous, *The Reward of Virtue and Integrity*, 1747. Engraving; 33·9 × 22·9 cm, 13⅜ × 9 in

of looms, partitions and columns, and yet he is simultaneously elevated and removed from the busy and crowded workroom.

In the engravings of Goodchild after his wedding, and at the civic feast, he is again framed, compartmentalized and coupled with a virtuous companion, whether leaning through the window of his new house in the City into the more chaotic space of the street (see 124), or sitting beneath the grand portrait of a king, discreetly cut off from the more vulgar aldermen feasting in the foreground and the poor supplicants at the door (see 126).

The four prints dealing with Idle's passage from churchyard to night cellar are organized very differently. Here Hogarth focuses on a succession of environments – garrets, cellars, boats, graveyards – that lie outside, or on the margins, of respectable society. They are pictured as unstable and punctured – note the succession of ominous holes opening up at the bottom of these images: the grave underneath the gamblers (see 121), the smashed floorboards in the garret (see 125), the night-cellar trapdoor into which a murder victim is pushed (see 127). Here pictorial as well as social decorum seem to be on the point of breaking down. The figure of Idle, rather than being placed in a hierarchical compositional grid, dominated by the virtuous aesthetics of the vertical line, is embedded in far more disordered compositions, in which visual weight is given to a central, horizontal sprawl of figures and objects. These formal mechanics consistently work to define Idle as part of an unregulated and amorphous criminal subculture that threatens to spill out across the city just as it spills out across the picture space. Significantly, however, the first and last images of this quartet (see 121 and 127) also contain representatives of that world of civic authority and violence associated with Goodchild, the beadles and officers who patrol not only the deviant realms of urban culture but also the pictorial spaces of *Industry and Idleness* itself. For these men with their weapons, such obvious successors to the master in the first plate, are pictorial as well as social guarantors of respectability, providing a reassuring iconography of discipline and punishment within Hogarth's imagery of the urban underworld.

In the tenth plate of the series, of course, Idle is returned to the physical and compositional order associated with polite, civic culture. Both he and the crowd of miscreants who surround him are subordinated to the vigorous, hegemonic lines of the columns, staves and barriers that hem them in, while Goodchild himself continues to occupy a cordoned-off space of privilege and power (see 129). *Industry and Idleness*'s last two scenes (see 130, 131), even as they focus on the mass urban procession, maintain the formal and narrative distinctions found throughout the series. The depiction of Tyburn fuses the imagery of a vast, seemingly unregulated crowd of people, stretched out across the open countryside north of the city, with that iconography of weaponry and punishment that continually trespasses into Idle's pictorial narrative: the pikes that swarm into the left-hand side of the image, the towering supports of the gallows that break across the skyline. Conversely, even as boisterous crowds cluster around the Lord Mayor's coach in the final plate, they are pictorially subordinated to the grid-like imagery of the four-storey houses on the far side of the street and the reassuring, dominant presence of the Prince of Wales looking down from the balcony. Meanwhile, Goodchild himself remains cocooned in an elevated pocket of polite space, screened off from the crowd by the coach window.

Being sensitive to the formal as well as the narrative movements of Hogarth's series confirms the extent to which *Industry and Idleness* needs to be understood as participating in a broader process of representational ordering in urban culture, in which stereotypes of polite and impolite identity were being defined in increasingly polarized opposition. In this sense, the figure of Francis Goodchild was available to be understood as yet another emblem of that commercial and civic masculinity being fabricated in contemporary graphic art, and as someone whose pictorial progress within the plates of the series conformed perfectly to a modern bourgeois mythology of social and commercial advancement. At the same time, the imagery of Tom Idle clearly conformed to a complementary stereotype, one which was equally necessary to the ideology of a polite commercial community in the city – that of the bandit or criminal who operates outside the regulated realms of urban

capital and business. In this sense, the pictorial dialectic of collapse and control found in Hogarth's depictions of Idle offered a metaphor for both the threat he symbolized and the need for that threat to be constantly policed.

Yet this is only part of the story. *Industry and Idleness* remains open to be read not only as a pictorial conduct book but also as a graphic satire. In particular, it is worth looking again at the imagery of the Industrious Apprentice and suggesting that it can easily be understood as satirizing the pretensions, blindness and corruption of the civic community he represents. Here, what is particularly intriguing is the way in which Goodchild is consistently pictured as someone who is unable and unwilling to move or look beyond the closed confines of his immediate environment, and whose self-interested absorption of polite, civic values develops into something approaching an enfeebled, cosseted effeminacy. Let us return, for a moment, to the image of the newly married apprentice, drinking tea with his wife at their window (see 124). From a satiric perspective, he can easily seem laughably affected – look at his little finger! – and haughtily patronizing, not so much in terms of his gesture to the drummer, but in relation to the slops that are so casually dumped into a poor woman's apron at his doorstep. And are not Mr and Mrs Goodchild depicted as wilfully blind to the violence, poverty and raucous laughter that characterize the street-space beyond their down-turned eyes? Now let us turn once more to Goodchild's expression and posture as he ignores Idle's later pleas for clemency (see 129). Are they those of sorrow or of distaste? And does his refusal to look beyond the physical and symbolic barriers that separate him from a wider social collective – a refusal that he maintains throughout the series – not mean that he signally fails to perceive the bribery and corruption that is taking place only yards away, as Idle's former confederate tells his fatal lies and a prostitute palms money into a clerk's hidden hand? Finally, we can look again at the various representatives of the civic authority which Goodchild symbolizes – from the beadle and the constable to the gorging aldermen and trigger-happy soldiers of the final plate – and recognize how easily

they can be reread as the gratuitously violent and endemically venal symbols of a crooked, brutal and money-grabbing urban establishment. Here, surely, Hogarth is to some extent satirizing, as well as reinforcing, the stereotypical representations of commercial gentility, benevolence and justice circulating in contemporary metropolitan culture.

Hogarth's series, which partially parodies those values it most obviously seems to promote, thus pursues a satiric agenda that, as has been observed throughout this book, exploited the conflicts and undermined the ideals of contemporary urban culture. In *Industry and Idleness*, this satiric perspective is conveyed most powerfully through Hogarth's manipulation of our own viewpoint. Having noticed all the different ways in which the civic and plebeian cultures of the city are shown to be blind to each other's presence in these twelve engravings – Tom, we will remember, is constantly unaware of the figures of authority who creep up behind him – it is now possible to recognize the extent to which Hogarth defines only himself, and his audience, as being able to perceive the tensions and the parallels between these two cultures. In plate after plate, and across the series as a whole, we are given a panoramic, all-encompassing viewpoint that is utterly denied to Hogarth's protagonists, and that exposes the institutions and communities they represent to the possibility of satiric ridicule.

Having now suggested that we can interpret *Industry and Idleness* in two rather different ways – as a pictorial conduct book that appropriated the themes of popular culture for bourgeois ends, and as a satiric series that consistently calls into question the values of commercial culture – it would be misguided, I think, to try to choose between these different readings. What I would like to suggest instead is that Hogarth, at mid-century, was self-consciously fusing two different categories of representation in his graphic art, and exploiting rather than defusing the complexities and contradictions that arose in this process. A similar pattern is at play in his famous engravings of *Beer Street, Gin Lane* and *The Four Stages of Cruelty*.

In *Beer Street* (137), Hogarth himself later declared, 'all is joyous and thriving. Industry and Jollity go hand in hand.' His vocabulary suggests that we should understand the engraving as one that complements the imagery of industry he had produced five years beforehand, and extends its perceived benefits to the craftsmen and petty tradesmen of the city. Dominating the image and surveying a square undergoing extensive reconstruction, a butcher, blacksmith and paviour are shown relaxing at a grand London public house, The Barley Mow, clutching overspilling tankards of ale, holding up a hunk of beef, leisurely smoking a pipe and cheerfully flirting with a local housemaid. It is the king's birthday, and in the distance a set of roofers raise their flagons to celebrate the occasion. Below them the square is busy with the rituals of work and leisure. Men are shown rebuilding the road and breaking off to slake their thirst; others momentarily pause and drink before they continue carrying a sedan chair and a basket of books around the city, and another delivers a tankard of beer to a local pawnbroker, whose crumbling shop and drooping sign offer eloquent testaments to the affluence of the local inhabitants. Two fishwives pause to share an ale and (rather improbably) to read a scheme designed to improve the national fisheries, while even a penurious sign-painter seems happy as he peruses his recently completed work, still drying in the sunshine.

In this engraving Hogarth creates a powerful myth of urban contentment and prosperity, which ties the physical and financial health of the city to the exchange and consumption of a range of patriotic goods: fish from British seas, meat from British livestock, vegetables from British fields and, most importantly and obviously of all, beer from British breweries, all of which are put on display below the Union Jack fluttering over the rooftops. Beer, both in Hogarth's print and elsewhere in this period, was being promoted as a patriotic elixir that fuelled the nation's workforce and stimulated a harmonious sense of community and freedom among ordinary Britons. Hogarth's caption salutes its virtues: 'Genius of Health, thy grateful Taste / Rivals the cup of Jove, / And warms each

137
*Beer Street*,
1751.
Engraving;
35.9 × 30.2 cm,
14$^1$8 × 11$^7$8 in

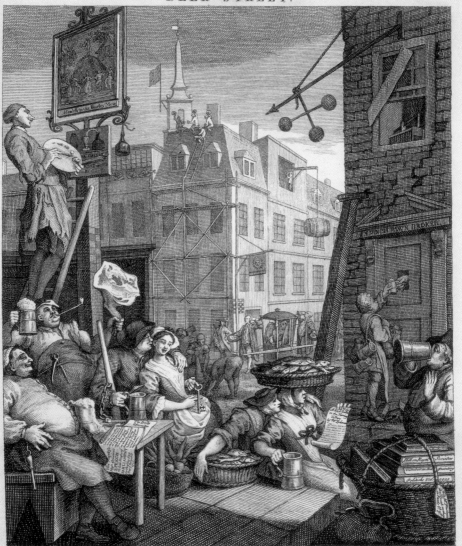

BEER STREET.

Beer, happy Produce of our Isle
Can sinewy Strength impart,
And wearied with Fatigue and Toil
Can chear each manly Heart.

Labour and Art upheld by Thee
Successfully advance,
We quaff Thy balmy Juice with Glee
And Water leave to France.

Genius of Health, thy grateful Taste
Rivals the Cup of Jove,
And warms each English generous Breast
With Liberty and Love.

Design'd by W Hogarth.                 Publish'd according to Act of Parliament Feb.1.1751.                 Price 1s

# GIN LANE.

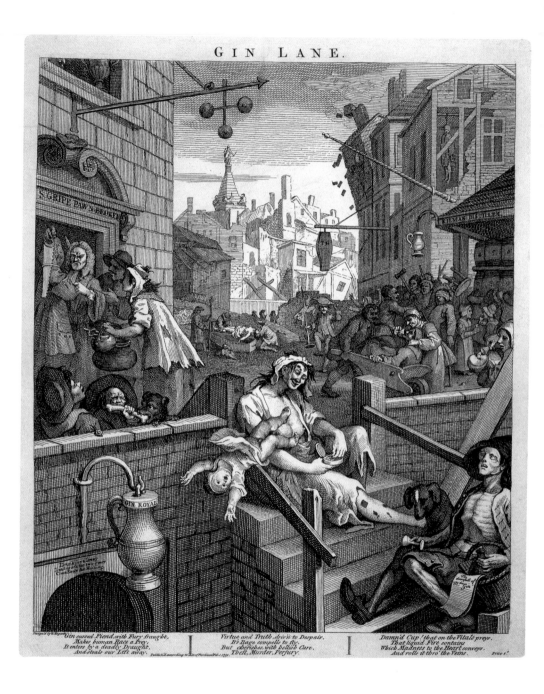

Gin cursed Fiend, with Fury fraught,
Makes human Race a Prey,
It enters by a deadly Draught,
And steals our Life away.

Virtue and Truth, driv'n to Despair,
It's Rage compells to fly,
But cherishes with hellish Care,
Theft, Murder, Perjury.

Damn'd Cup! that on the Vitals preys,
That liquid Fire contains,
Which Madness to the Heart conveys,
And rolls it thro' the Veins.

**138**
*Gin Lane,*
1751.
Engraving;
35.9 × 30.5 cm,
14⅛ × 12 in

English generous Breast / With Liberty and Love.' In *Beer Street*, its consumption is seen to bond together a mass of otherwise anonymous Londoners, to complement the collective rhythms of urban labour and to underwrite urban reconstruction and refurbishment: a new inn – the Sun – is being built on the other side of the square, and The Barley Mow itself is getting a fresh coat of paint.

Yet, even as *Beer Street* demands to be read as an image celebrating British commerce and urban labour, it is also – just like *Industry and Idleness* – open to be read in more satirical terms. Let us look again, for example, at the ways in which Hogarth depicts the three men in the left-hand corner of the image – at the huge pot-belly that laps over an apron, at the faces creased with expressions of stupefied contentment, sinking into ever-expanding double chins, at the lascivious, whispering mouth and wandering fingers of the paviour; and then look at the figure of the porter on the right, his fat face engulfed by an oversized tankard. Yes, these people may be happy, but they can also be seen as ridiculous, greedy and vulgar. And what are we to make of the fact that the one foregrounded male figure who deviates from *Beer Street*'s physical, sartorial and physiognomic norms is an artist – his activity echoing Hogarth's own – who smiles at what he has painted? Surely the contemporary spectators of the print, too, were meant to smile at what Hogarth had created, and in doing so keep a satirical distance from a section of the metropolitan community that, however prosperous, is still defined as plebeian, unsophisticated and overwhelmingly governed by the gross dictates of physical appetite.

If *Beer Street* can be suggestively juxtaposed with the celebratory iconography of *Industry and Idleness*, and recognized as a comparable fusion of commercial propaganda and irreverent satire, *Gin Lane* and *The Four Stages of Cruelty* extend and exaggerate the bleak pictorial narratives found in the engravings of the Idle Apprentice. *Gin Lane* (138) is a dystopian vision of the slum district of St Giles in London, shown ravaged by the

effects of gin. At the centre of the engraving a half-undressed, disease-ridden woman lies sprawled across the stairwell of a subterranean gin shop, pinching snuff. Her eyelids are heavy with alcohol, her mouth is pulled into a lopsided grin and her infant charge falls headlong over the railings at her side. Around her prone body a chaotic mass of the addicted, crippled and crazed are bartering their clothes and pans for gin, fighting with crutches and walking sticks outside Kilman the distillers and, in the case of one lunatic figure, running through the streets with a baby impaled on a spike. Gin glasses are everywhere – held to the mouths of elderly women and innocent children, and clutched by the dying hand of a skeletal ballad-seller. St Giles, meanwhile, is depicted as a mangled patchwork of tottering buildings, collapsed roofs and exposed rafters. Here, in contrast to *Beer Street*, the pawnbroker thrives.

Complementing this horrific imagery of urban breakdown and duplicating *Gin Lane*'s concentration on delinquent and bestial youth, *The First Stage of Cruelty* (139) launches the narrative of Tom Nero, significantly wearing 'S.G.' for St Giles on his arm, and shown torturing a squealing, terrified dog along with two accomplices. Ignoring the arguments and the cake offered by a boy who attempts to stop his cruelty, Nero sticks an arrow down the animal's anus. This image, and its three successors, are used by Hogarth to dramatize a continuum of brutal behaviour in the city, beginning with widespread cruelty to animals among male adolescents and leading with grim inevitability to the most terrible forms of criminal and judicial violence against the human body. In this first plate, Nero's infliction of pain is echoed throughout the rest of the street. A cat is thrown out of the window wearing a pair of makeshift wings, while two others are dangled upside down from a signpost and encouraged to fight. Elsewhere a bird is blinded, cockerels are prepared for battle and a dog gets a bone strapped to its tail. Unnoticed, another adolescent – someone who looks rather like a young Hogarth – scrawls a prophetic image of the hanged Tom Nero on a wall.

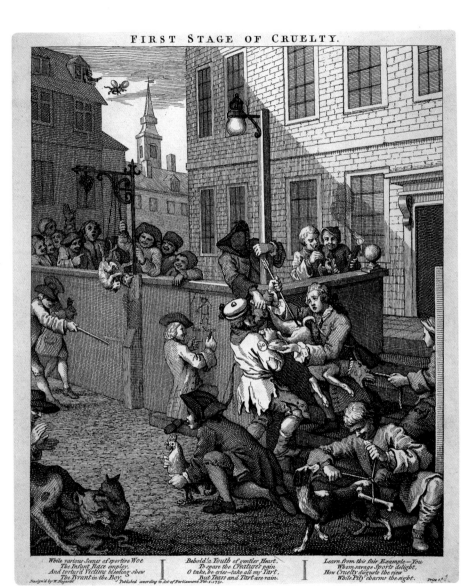

FIRST STAGE OF CRUELTY.

While various Scenes of sportive Woe
The Infant Race employ,
And tortur'd Victims bleeding shew
The Tyrant in the Boy.

Behold! a Youth of gentler Heart,
To spare the Creature's pain
O take, he cries—take all my Tart,
But Tears and Tart are vain.

Learn from this fair Example—You
Whom savage Sports delight,
How Cruelty disgusts the view
While Pity charms the sight.

Design'd by W. Hogarth. Published according to Act of Parliament Nov.1.1751.                              Price 1.s.

139
*The First Stage
of Cruelty,*
1751.
Engraving;
35·6 × 28·3 cm,
14 × 11⅛ in

The second image of the series (140, 141) depicts Nero some years later, when he has become a hackney coachman. He is shown sadistically beating his horse, which has collapsed under the weight of four penny-pinching lawyers, who have banded together to get the cheapest ride possible to the Inns of Court. Nearby, an exhausted lamb is beaten to death, a young boy is run over by a dozing drayman's cart, an overloaded donkey is prodded

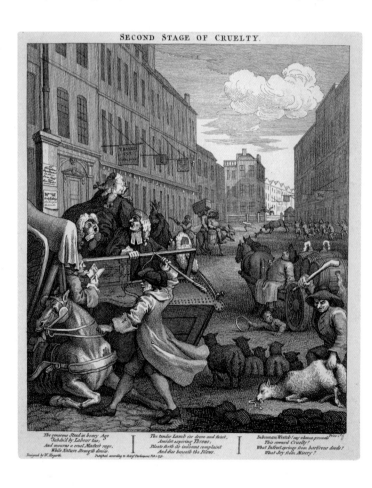

140–141
*The Second Stage of Cruelty*, 1751.
Engraving; 35.2 × 30.2 cm, 13⁷⁄₈ × 11⁷⁄₈ in
**Right**
Detail

with a pitchfork and, in the distance, a frenzied bull – taunted and attacked by dogs – tosses an onlooker into the air.

Hogarth's final two plates depict the human consequences of this habitual sadism: in *Cruelty in Perfection* (142) Nero is shown soon after killing his mistress, Ann Gill, who lies at his feet, her neck, wrist and finger sliced open by the dagger held up in front of her

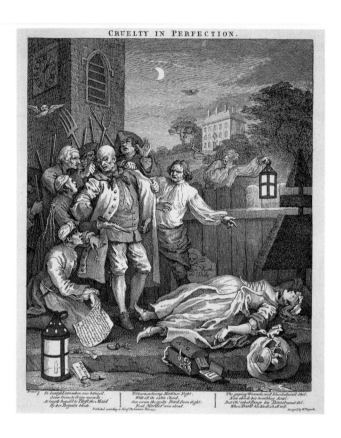

142
*Cruelty in Perfection*, 1751.
Engraving; 35·6 × 29·8 cm, 14 × 11¾ in

murderer. Nero, like Tom Idle, is depicted as a highwayman, who has clearly been operating outside the city, and who has persuaded his gullible lover to steal from her household and to meet him at a remote graveyard. The stolen goods, along with a conscience-stricken love-letter from Ann, lie scattered across the foreground, while Nero himself is surrounded by a posse of local worthies, armed with staves and forks, who are about to take him into custody. The last engraving of the quartet (143) shows Nero in the aftermath of his execution by hanging. As was frequently the case with executed criminals in this period, his corpse has been taken to a dissecting theatre, and is shown being cut up in public by two knife-wielding surgeons and their assistant, who begins slicing his ankle. Above Nero's prone body sits the magisterial figure of the chief surgeon, directing operations with a stick. At either side, as in the penultimate plate of *Industry and Idleness*, there hang two skeletons, while below, a servant squeezes Nero's entrails into a bucket, and –

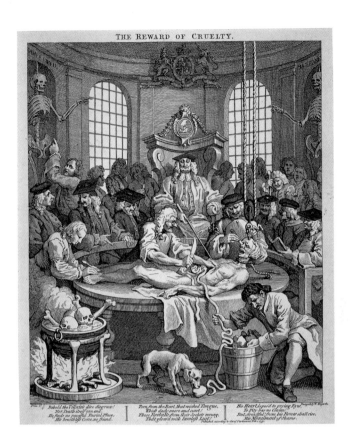

THE REWARD OF CRUELTY.

143
*The Reward
of Cruelty*,
1751.
Engraving;
35·6 × 29·8 cm,
14 × 11¾ in

as if in grim revenge for the events depicted in the first plate of the
series – a dog gnaws away at the dead murderer's jettisoned heart.

*Gin Lane* and *The Four Stages of Cruelty* can all be seen as sympto-
matic of a growing sense of urban crisis among London's ruling
élites, which focused in particular on a perceived rise in urban
criminality. Henry Fielding articulated this unease most famously
in his *Enquiry into the Causes of the Late Increase of Robberies*,
published in the same year as Hogarth's prints. Fielding wrote of
his anxiety about being 'assaulted, and pillaged, and plundered
… I can neither sleep in my own house, nor walk the streets, nor
travel in safety.' Significantly, Fielding assigned much of the blame
to 'a new kind of drunkenness … that acquired by the strongest
intoxicating liquor and particularly by that poison called Gin.'
Other writers followed his example, and focused in particular
on the plebeian female gin-drinker, who was seen to break all the

rules of femininity and to threaten the stability of metropolitan society itself. The author of *A Present for Women Addicted to Drinking*, first published in 1750, for example, declared that 'I take this pernicious custom of drinking, which prevails amongst women at present, to be the great source of that corruption and Degeneracy, which all the world must allow to be the subject of a just and general censure.' Thanks to writings like these, the figure of the female gin-drinker became dramatized as a grotesque symbol of urban crisis. *Gin Lane*, dominated by the anonymous lush in the centre of the engraving, herself part of an extended spiral of women stumbling drunkenly across St Giles, demands to be understood as a powerful pictorial translation of this gendered and chauvinistic symbolism.

At the same time, Hogarth was actively reworking an older graphic imagery of feminine stupor and metropolitan breakdown in *Gin Lane*. His engraving can be usefully related to a print published during an earlier gin crisis of 1736, entitled *The Lamentable Fall of Madam Geneva* (144). In this satire the allegorical figure of gin – 'Madam Geneva' – lies sprawled on a public stage, her skirt hitched up around her hips, her breasts bare and her hand clutching a glass. Nearby, a ragged woman stands crying, a lush vomits in the street and a swaying mother and child stroll miserably away. If these details remind us of *Gin Lane*, so do the disabled ballad-seller in the foreground, the wheelbarrow and its shadowed driver and the depiction of signposts, pamphlets, staves, steeples and crutches across the print. Meanwhile, a Billingsgate fishwife prefigures the pair of fish-sellers in *Beer Street*, while the cheering male beer drinkers on the left offer a suggestive precedent for the hearty tradesmen and workers who raise their tankards to the king in Hogarth's later engraving of urban reconstruction and masculine cheerfulness. Recognizing these continuities, it is clear that *Gin Lane* and *Beer Street* recycled and depended upon an older satiric imagery that had already focused in shocking detail on the abject female body, and that had defined it in counterpoint to an uproarious popular masculinity. Hogarth thoroughly modernizes this iconography and ties it to a new, polarized debate on the respective effects of patriotic beer and 'foreign' gin.

144
Anonymous,
*The Lamentable Fall of Madam Geneva*,
1736.
Engraving;
30.8 × 29.5 cm,
12⅛ × 11⅝ in

*The Four Stages of Cruelty* responds to many of the same concerns as *Gin Lane*, and pictorially extends the threat of plebeian disorder and chaos beyond the confines of St Giles. The four prints not only suggest a second cause for the urban violence and brutality that was worrying so many commentators – here, habitual cruelty takes the place of habitual drunkenness – but can suggestively be understood as images that raise the spectre of an entire city being

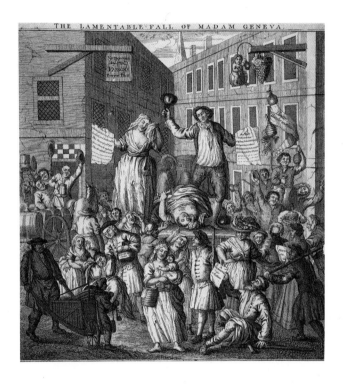

taken over by the mob. For one of the striking characteristics of the first two engravings of *The Four Stages of Cruelty* is the way in which London is given the appearance of a city abandoned to a teeming, swarming mass of riotous adolescents and brutal workers. In *The First Stage of Cruelty* (see 139), Nero carries the anarchic associations of St Giles with him into an environment that displays all the architectural traces of improvement and order – neat, regular buildings, dignified doorways, newly built pavements, street-lamps and signposts – but that has been totally colonized by the occupants and activities of another sector of the city altogether. It is as if all the respectable inhabitants have fled.

In the second plate (see 140), similarly, a grand urban avenue lined with three-storey buildings is transformed into a chaotic, sprawling conglomeration of crashed vehicles, collapsing animals and roving hooligans. While the third engraving of the series (see 142) suggests that the rampant spread of plebeian criminality and violence has spilt out from the environs of London itself and has begun infiltrating those districts that surrounded the city, the fourth image (see 143) represents a significant switching of focus. Suddenly, after spending so much time looking at the urban and suburban outdoors, we are taken inside and shown a scene that, even as it offers a reassuring demonstration of judicial control over the threat dramatized in the previous three engravings, also implies a satirical critique of contemporary forms of policing, punishment and power. The company of surgeons are themselves shown to be exploiting rather than alleviating criminality, and in doing so display a sadistic barbarity that is the equal of Nero's. Moreover, they are pictured in a way that deliberately evokes their counterparts in court: the chief surgeon sits as if in judgement, and the ridiculed figures of the surgeons standing in the front row of the dissection theatre offer a visual echo of the group of lawyers in *The Second Stage of Cruelty*.

As such, they become part of that network of urban authority which includes the bribing constables, threatening beadles and myopic aldermen that we saw in *Industry and Idleness*. Recognizing this and recognizing how consistently Hogarth depicts these figures of authority as corrupted mirror images of their targets and victims, again suggests how his work at this time not only catered to the mythologies and anxieties of an urban commercial community – in the case of *Gin Lane* and *The Four Stages of Cruelty*, through demonizing a proletarian underside of popular culture, and invoking the threat of an urban invasion from inside – but also satirized the representatives and values of that community itself.

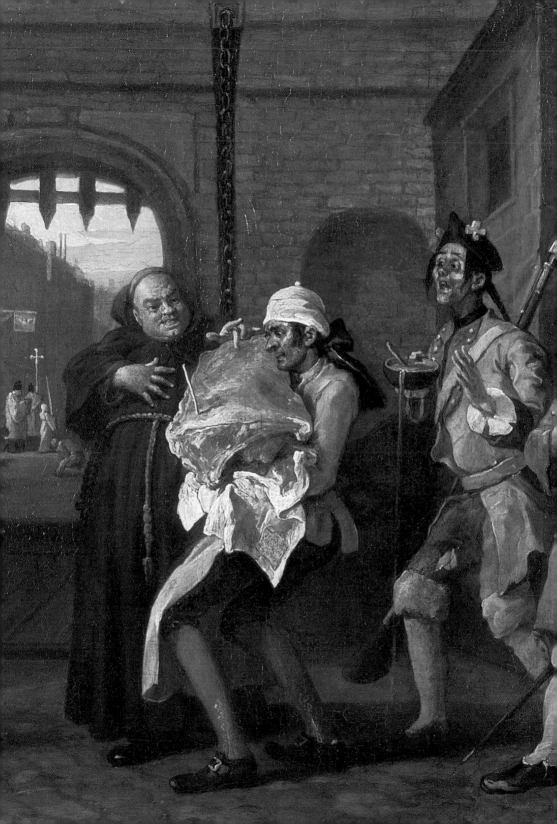

Besides concentrating on graphic art, at mid-century Hogarth
found himself involved in a number of other schemes and adventures.
Most dramatically of all, in the summer of 1748 – soon after a short-
lived armistice had been declared between the British and the
French – he went on a disastrous trip to France with a number
of artist-friends, including Francis Hayman. On this trip, by all
accounts, Hogarth indulged in an extended and boorish display
of anti-Frenchness. In the words of one early biographer, 'While
Hogarth was in France, wherever he went, he was sure to be
dissatisfied with what he saw … In the streets he was often
clamorously rude. A tattered bag, or a pair of silk stockings with
holes in them, drew a torrent of imprudent language around him.'
Cutting short their stay in Paris, Hogarth and Hayman quickly
turned around and headed for the port of Calais, and home. At
Calais, however, Hogarth made the mistake of killing some time
by sketching the old town gateway. In the middle of doing so
he was suddenly arrested as a possible spy. Despite avoiding any
charges, the artist suffered the indignity of being taken under
armed guard to the Governor's residence and then being bundled
unceremoniously on to a ship back to England.

**145**
*The Gate
of Calais*
(detail of 146)

Typically, Hogarth soon turned these calamitous personal events
to artistic effect. Over the following winter he painted and engraved
his famous *The Gate of Calais* (146), which includes a cheeky self-
portrait, in which we see him sitting in the background sketching
the gate, minutes before his arrest. Unsurprisingly, *The Gate of
Calais* is loaded with even more satiric vitriol than normal, depicting
the inhabitants of the French port as a grotesque collective of
crouching fishwives, ragged soldiers, spindly servants, poverty-
stricken Jacobites and corrupt clerics, dominated by the corpulent
figure of a friar who fingers an imported hunk of British beef.

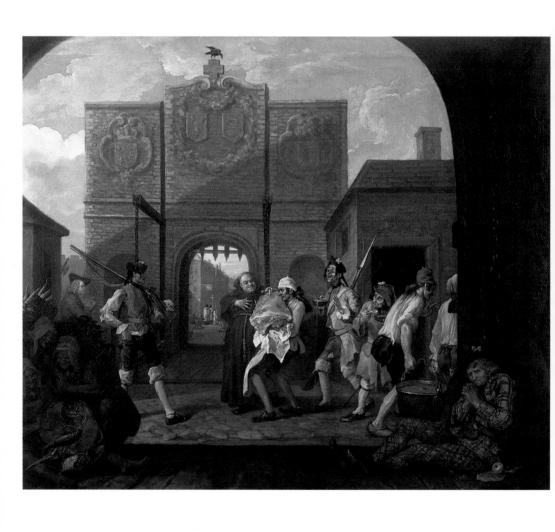

Here, Hogarth makes explicit the xenophobic critique of French culture implied in the *Marriage à la Mode* paintings he had produced earlier in the decade, and in doing so produces a powerful and enduring piece of comic propaganda. Indeed, this painting's imagery – and particularly that piece of beef at the canvas's centre – continues to resonate with political and cultural significance, focusing as it does on the most potent symbol of more modern cross-channel quarrels.

If Hogarth's jaunt to France demonstrates how the artist could still find himself caught up in his own personal dramas, and comedies,

146
*The Gate
of Calais*,
1748–9.
Oil on canvas;
78·7×94·6 cm,
31×37¼in.
Tate Gallery,
London

147
Hogarth's house
in Chiswick,
London

his other activities in the years around 1750 confirm his continuing desire for social, artistic and intellectual respectability. In 1749, for instance, he bought an elegant villa in Chiswick, just outside London (147), to which he and Jane retreated increasingly frequently, and which he populated with a loyal band of servants. Owning such a stylish and well-situated country-house – Lord Burlington's famous villa was nearby – undoubtedly gave him a more dignified status as both a man and an artist. Meanwhile, Hogarth's painterly output in this period was dominated by the resolutely high-minded

depiction of the biblical confrontation between Paul and Felix he produced for Lincoln's Inn Hall in 1748 (148). Most telling of all, however, was Hogarth's decision at this time to write an extended treatise on aesthetics, which was published in the spring of 1752 as *The Analysis of Beauty*. In doing so he clearly sought to define himself as a refined thinker as well as a serious artist, adept not only in producing distinctive paintings and engravings, but also in theorizing about the aesthetic basis of art and experience.

Hogarth made sure that the *Analysis* was widely advertised in the London newspapers. Thus, on 25 March, the *Covent-Garden Journal* carried an advertisement announcing that

MR HOGARTH *Proposes to Publish*, by SUBSCRIPTION, A short Tract in Quarto, called THE ANALYSIS OF BEAUTY. Wherein Objects are considered in a new Light, both as to Colour and Form (Written with a View to fix the fluctuating Ideas of Taste). To which will be added Two Explanatory Prints serious and comical engraved on large Copper-Plates, fit to frame for Furniture.

In a second advertisement, issued some eight months later, Hogarth declared that the two prints (149, 150) would depict 'a Statuary's Yard' and 'a Country Dance', and that he had endeavoured to render the *Analysis* 'useful and interesting to the Curious and Polite of both Sexes, by laying down the Principles of Personal Beauty and Deportment, as also of Taste in general, in the plainest, most familiar, and entertaining Manner'.

Hogarth's enterprise was unusual and multifaceted. In *The Analysis of Beauty* he sought to explain the central characteristics of beauty, both artistic and natural, and in doing so to promote the exercise of good taste on the part of his readers. At the same time he clearly intended his book to be an accessible manual of appearance and behaviour that would give those same readers – both male and female – the basic conceptual tools with which to construct a polite, urbane identity for themselves in their daily lives. Finally, his inclusion of two elaborate engravings as part of his scheme, which encouraged the contemporary reader to constantly move

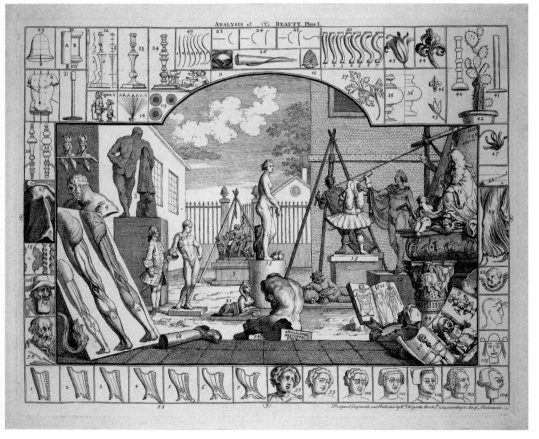

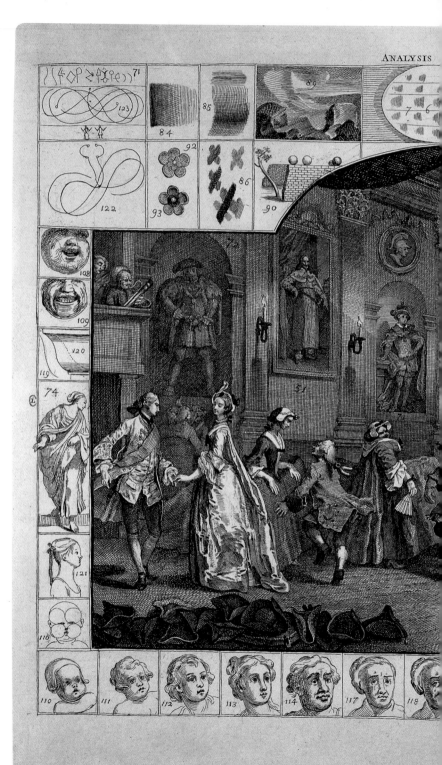

Designed, Engraved, and Publish'd by W<sup>m</sup> Hogarth March 5<sup>th</sup> 1753, according to Act of Parliament.

150
*The Analysis of Beauty*, plate 2, 1753. Engraving; 37·2×49·9 cm, 14⅝×19⅝ in

151
Title page to
*The Analysis
of Beauty*,
1753.
Engraving;
63·5×76·2cm,
25×30in

back and forth between page and picture, offered a novel and
complex combination of written and pictorial polemic. All these
different features of the *Analysis* worked together to generate a text
and an imagery that were self-consciously modern and innovative.

Eighteenth-century readers, on turning to the title page of Hogarth's
book (151), were immediately confronted by the visual motif of a
serpentine line, accompanied by the word 'Variety' and subtly
transmuted into the form of a snake, so as to complement the
Miltonic quotation included above. In the *Analysis* this serpentine
line – understood as gently undulating and twisting through space
– serves as the central embodiment of natural and artistic beauty,
and as the pictorial sign that most eloquently gestures towards
those principles that 'give elegance and beauty, when duly blended
together'. These principles Hogarth lists as 'FITNESS, VARIETY,
UNIFORMITY, SIMPLICITY, INTRICACY and QUANTITY
*– all of which co-operate in the production of beauty, mutually correcting
and restraining each other occasionally*'. Hogarth concentrates in
particular on 'Variety' and 'Intricacy', which he sees as crucial in

producing those 'compositions in nature and art, which seem most to *please and entertain the eye*, and give that grace and beauty which is the subject of this enquiry'. For Hogarth, indeed, all kinds of beauty – whether found in the pattern of a butterfly's wing, the curls of a woman's hair, or the sculpted musculature of an ancient statue – are ultimately dependent on variety, irregularity and intricacy. Their opposites – uniformity, regularity and simplicity – play a subordinate role in the *Analysis* as necessary correctives at times of excess: 'when the eye is glutted with a succession of variety, it finds relief in a certain degree of sameness'. In themselves, however, they are productive only of the boring and the insipid. It now becomes clearer why the serpentine line, whether detected snaking through the spaces and across the materials of nature, or perceived winding its way around buildings, statues and pictures, enjoys such importance in the *Analysis*. It not only signifies 'variety' and 'intricacy' in its own form, but invokes, as its antithesis, the straight, ordered line, which Hogarth argues is always indicative of a lack of grace, and which he uses as a metaphor for more general kinds of aesthetic banality.

In making such claims, and in using such abstract language, Hogarth entered a rather rarefied zone of aesthetic debate. Indeed, the *Analysis* flaunted its intellectual pedigree, quoting approvingly from the Renaissance writer on the arts, Lomazzo, and alluding aggressively to more modern writers on aesthetics such as the turn of the century philosopher and Whig politician, the 3rd Earl of Shaftesbury. At the same time, Hogarth's text clearly responded to developments in landscape theory. The central concept of the serpentine line, and the pleasures of variety, had already come to play a major role in discussions of garden design. In Batty Langley's *New Principles of Gardening* of 1728 (see 157), for instance, the serpentine path and the varied view are promoted as symbols of English liberty and informality in contradistinction to the 'regular, stiff, and stufft up Manner' of garden designs imported from abroad. Meanwhile, there is little doubt that the *Analysis* also drew upon the extended discussions on art and aesthetics that must have taken place within Hogarth's academy at St Martin's Lane. The

treatise's championing of an aesthetics of irregularity can be suggestively linked to the informal working habits and teaching methods of the academy, and to its long-standing suspicion of fixed rules of artistic practice.

Such concepts as the serpentine line, and such all-encompassing principles as 'Variety' and 'Intricacy', are also related by Hogarth to the experience – particularly the visual experience – of living among the people, art, buildings and spaces of contemporary London. Throughout the *Analysis* the vocabulary of aesthetic judgement is elided with the persona and perspectives of the keen-eyed urbanite, and with the objects and sights, both refined and vulgar, encountered on an everyday basis within the city. Hogarth moves easily from discussing the sculpture found on display in a Hyde Park statuary yard and the pleasures of pantomime at Lincoln's Inn Fields, to invoking the variegated urban prospect provided by the modern London churches designed by Sir Christopher Wren. Elsewhere, he writes of Thames watermen and West End chairmen, discusses the plebeian forms of connoisseurship found in the capital's poorer districts – 'I have heard a blacksmith harangue like an anatomist, or sculptor, on the beauty of a boxer's figure' – and describes visiting Bartholomew Fair, where he sees the head of a fat man comically juxtaposed with the cap and clothes of an infant. When first encountering Hogarth's text, it might seem that these everyday details of urban life serve only to provide colourful, anecdotal illustrations to his theses. By its end, however, the *Analysis* comes to imply that urban culture has actually provided many of the base materials out of which its aesthetics have been forged.

In this light, it is useful to return to the categories Hogarth introduces into his text and to relate them more closely to the values and phenomena of urban culture. Interestingly, in a section of the *Analysis* which deals explicitly with 'Variety' – and that in this instance discusses the way a 'gradual lessening' of size is 'a kind of varying that gives beauty' – Hogarth invokes a category of modern art closely associated with the urban landscape: 'thus perspective

152
John Maurer,
*A Perspective View of St Mary's Church in the Strand*,
1753.
Engraving;
18.1×27.3cm,
7⅛×10¾in

views, and particularly those of buildings, are always pleasing
to the eye.' The kind of image he may well have had in mind is
exemplified by John Maurer's 1753 perspective view of the Strand
in London (152). In gesturing to such a print, Hogarth immediately
alerts us to the intimate relationship between his arguments and
the visual and artistic encounter with metropolitan life. Similarly,
the rhapsodic language with which he discusses Wren's London
churches suggests how powerfully his notions of variety were
conditioned by his experience of the city: 'the great number of
them dispers'd about the whole city, adorn the prospect of it, and
give it an air of opulency and magnificence: on which account their

A Perspective View of S.t Mary's Church in the Strand / Vuë de L'Eglise de S.t Marie dans le Strand proche
near the Royal Palace of Somerset — London ·. . . le Palais Royal de Somerset a Londres —

shapes will be found to be particularly beautiful. Of these, and
perhaps of any in Europe, St Mary-le-bow is the most elegantly
varied.' These examples confirm the extent to which the principle
of variety, however much it drew upon existing aesthetic discourses,
and could be linked to the diversity found in the natural world or
in the landscaped garden, was also something both Hogarth and
his readers associated with the city, and understood in particular
as a metaphor for London's own diversity and heterogeneity.

Significantly, however, Hogarth declares that, in praising 'variety',
he only means to praise 'a composed variety; for variety uncomposed,
and without design, is confusion and deformity'. Hogarth's

suggestion that the variousness that he seems to associate in particular with metropolitan culture needs to be controlled and organized if it is not to become chaotic and degraded, can be read politically as well as aesthetically. It is as if he not only invites his readers to understand 'variety' of form and line as a metaphor for the heterogeneity of the city, but also to read 'variety uncomposed', and the 'confusion and deformity' it generates, as a metaphor for the frightening spectacle of a city in which, thanks to the absence of authority and design, heterogeneity has run riot, and led to a threatening lack of order and decorum. No wonder, then, that he invokes the perspective view and Wren's churches as examples of 'composed variety', for they represent both aesthetic and urban equilibrium. Maurer's image, as well as providing our eyes with an elegant visual journey from foreground to background, defines London as a place of social and commercial harmony. Similarly, the sight of Wren's churches dotting the skyline – which had recently been painted by the famous Italian artist Canaletto (1697–1768; 153) – provides both a pleasing visual rhythm across the city's horizon and a reassuring guarantor of ecclesiastical and civic authority within the crowded and potentially chaotic metropolis.

Placing aesthetic categories such as 'variety' in relation to that urban culture which Hogarth inhabited also encourages us to reread closely related categories such as 'intricacy' in similar terms. The section of the *Analysis* which focuses on this concept highlights Hogarth's own experience of watching someone taking part in a country dance. This was the somewhat misleading name for a dance that was most closely associated with the fashionable urban assemblies of the period, which typically took place in grand, purpose-built assembly rooms. While Hogarth seems to depict one such assembly in *The Country Dance* (other scholars have speculated that this print may, rather differently, be set in a country house), another is nicely described by the historian Mark Girouard, writing of an evening at the Bath assembly rooms:

at six o'clock the eleven musicians strike up from their gallery. For two hours minuets only are danced … At eight o'clock minuets give

153
Canaletto,
*The Thames and the City of London from Richmond House,*
1747.
Oil on canvas;
106×117.5cm,
41³⁄₄×46¹⁄₄in.
Goodwood House, Sussex

way to country dances. These are danced by pairs arranged in long columns; the successive pairs at the head of the column weave their way down to the bottom, until every pair has performed … During country dances the spectators gossip and peer from the benches, the participants flirt, and there is time to look around the company. It is very mixed. There are duchesses and countesses, ministers and members of Parliament, but also Bath shop attendants, and Bristol manufacturers and tradesmen of all kinds, from tobacconists to sugar-bakers.

Hogarth describes how, at one such event, in which a country dance had been in full flow, his eye 'pursued a favourite dancer, through all the windings of the figure, who then was bewitching to the sight'. The elegantly twisting outline of her dress and figure moving through the assembly room, he goes on to declare, provides a perfect example of '*the beauty of a composed intricacy of form*; and

how it may be said, with propriety, to *lead the eye a kind of chace*.'
Here, of course, we are given the perspective of Girouard's 'peering
spectator', whose appreciation of the aesthetics of 'intricacy'
emerges out of an experience – the assembly – that was a staple
fixture of metropolitan and civic society in the period. 'Intricacy',
thus, is something that Hogarth not only understands as an
abstract term, but that he also appreciates as a form of visual
sensation actively produced by the modern, polite and urbanized
culture in which he lived.

This passage is typical of the *Analysis* in its casting of Hogarth
in the role of the urban voyeur, whose eyes pursue an unnamed
female figure and trace its outlines as it moves through a mass
of other anonymous bodies. Earlier chapters of this book have
already explored this kind of looking in the persona of the roving
satirist who stalked the English capital, visually tracking selected
individuals as they moved through the city's crowded public spaces.
Moreover, we have seen that this perspective was frequently
eroticized in social satires such as *The Harlot's* and *The Rake's
Progress*, to which it is possible to add *Southwark Fair* of 1733
(154), where the spectator is given a view of an elegantly dressed
drummer-girl passing through a crush of holidaying Londoners,
*The Enraged Musician* of 1741 (155), in which we are given the
perspective of someone standing in the street looking at the
mobile, flirtatious figure of an idealized milkmaid, and Hogarth's
famous sketch of *The Shrimp Girl* (156), in which the viewer's eyes
catch the street-seller's vivacious smile as she turns to look back
over her shoulder.

The *Analysis* renewed this point of view in ways that might seem
more abstract, but that are also just as obviously eroticized. In the
episode of the country dance, for instance, Hogarth clearly fuses
the pleasures of aesthetic sensation with those of sexual attraction.
And in the *Analysis* as a whole he continually evokes the image
of the desirable woman, often dressed and made up in the most
stylish London fashions, as a central site of aesthetic pleasure. In
doing so, his language is frequently laden with sexual connotations.

154
*Southwark Fair*,
1733.
Engraving;
33.7×45.1cm,
13¼×17¾in

155
*The Enraged
Musician*,
1741.
Engraving;
33.3×39.7cm,
13⅛×15⅝in

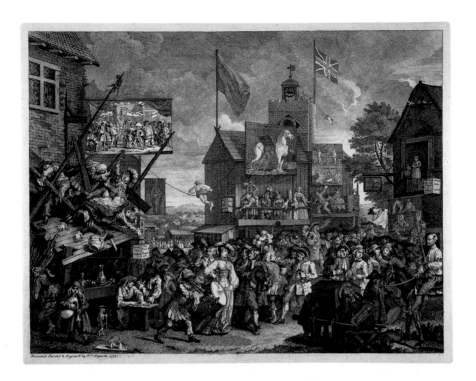

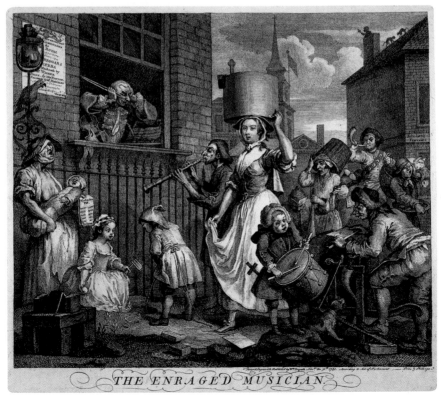

THE ENRAGED MUSICIAN.

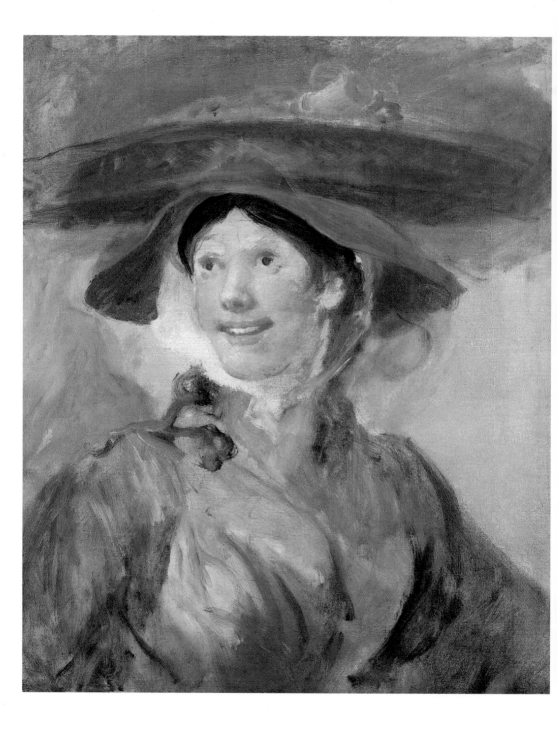

Thus, having suggested that intricate lines provide the eye with what he calls a 'wanton' form of pursuit, he goes on to discuss contemporary women's elaborate hairstyles in a similar language. Hogarth writes how 'the many waving and contrasted turns of naturally intermingling locks ravish the eye with the pleasure of the pursuit', and goes on to celebrate 'wanton ringlets waving in the wind'. Such descriptions, of which there are many, confirm the extent to which, in *The Analysis of Beauty*, the language of aesthetics is an unashamedly predatory and eroticized one, in which visual pleasure is related most closely to the perspectives of the wandering masculine eye, pursuing the alluring forms and outlines of the ever-elusive female body.

What is also striking about this concentration on feminine hairstyles, dress and appearance – which includes an extended discussion about women's stays – is that it again indicates the regularity with which the *Analysis* engages with commercialized sectors of modern urban culture such as fashion, and suggests – somewhat paradoxically – how determined Hogarth was to attract a female as well as a male readership. He clearly intended his long digressions on dress, hairstyle and appearance to have a particular appeal and resonance for women, even as he couched these discussions in terms of chauvinist erotics. Such features helped confirm the difference between his text and the canonical contemporary treatises on taste and aesthetics. These texts, of which the Earl of Shaftesbury's *Characteristicks of Men, Manners, Opinions, Times* (1711) was the most famous, had often registered an extreme suspicion of commerce and the city; furthermore, they were almost uniformly geared to an imagined public of educated male readers – indeed, in Shaftesbury's case, to an imagined public of aristocratic male readers. *The Analysis of Beauty*, in contrast, was self-consciously a product of, as well as a commentary upon, that commercial culture centred in cities such as London, and made – as Hogarth's advertisements confirm – a clear appeal to readers 'of both sexes'.

At the same time, of course, *The Analysis of Beauty*'s appeal was strengthened by its being tied to the two engravings that Hogarth

156
*The Shrimp Girl*,
*c*.1745.
Oil on canvas;
63.5×52.7cm,
25×20¾in.
National
Gallery,
London

released with his treatise. In *The Statuary's Yard* (see 149) and *The Country Dance* (see 150), a central picture crowded with objects and images described in the text is surrounded by numerous, compartmentalized sections, themselves carrying representations, both diagrammatic and figurative, relating to specific discussions within the *Analysis*. Here, very ingeniously, Hogarth combines the pictorial formulae of manual and dictionary illustration with the conventions of graphic satire. The outer edges of these engravings echo the illustrated, subdivided and diagrammatic pages that accompanied treatises like Batty Langley's *New Principles of Gardening* (157). Meanwhile, the two inner images combine their function as visual repositories for the *Analysis* with a powerful supplementary appeal as independent satirical engravings.

The first shows the statuary yard at Hyde Park Corner run by the sculptor and entrepreneur, John Cheere. Cheere's yard, even as it gives Hogarth a perfect opportunity to illustrate the classical sculpture he discusses in the *Analysis*, is castigated within the text itself as a place that supplies only 'leaden imitations' of the originals. In this sense, Hogarth's central engraving can be read as a satire on the degraded facsimiles of classical refinement available within contemporary urban culture and on the willingness of contemporary connoisseurs to consume such second-hand reproductions. At the same time, Hogarth plays satirically with the erotic connotations of these works. He shows an effeminate dancing master caressing the arm of a statue of Antinous, the classical epitome of male desirability, and juxtaposes the statue of the nude Venus with those of the Apollo Belvedere, his arm stretched out towards her like a suppliant lover, and a heavily bewigged judge, who can be imagined looking lasciviously across at her naked body just as Gonson looks across at Moll in *A Harlot's Progress* (see 42). Similarly, the central image of Hogarth's second plate, while incorporating many of the subjects and themes discussed within the *Analysis*, ranging from portraits of Henry VIII and Charles I to the rhythms of modern dance, is also clearly designed to be read in satiric terms. Here, in particular, Hogarth makes much of the disjunction between the elegant posture and

157
Thomas
Bowles after
Batty Langley,
Illustration to
Batty Langley's
*New Principles
of Gardening*,
1728.
Engraving

An Octangular Lemm.

Tho Bowles Sculp

**158**
**John Vardy**
**after Giles**
**Hussey,**
*Figure Seen*
*from Behind,*
*c.*1740–50.
Engraving;
33·9 × 21·4 cm,
13³⁄₈ × 8¹⁄₂ in

**159**
**Arthur Pond**
**after Pier**
**Leone Ghezzi,**
*A Travelling*
*Governour,*
1737.
Etching;
35·6 × 24·4 cm,
14 × 9⁵⁄₈ in

demeanour of the pair of dancers on the left and the grotesque shapes of their companions and, in doing so, offers a comic critique of the pretensions and incongruities typically found at modern assemblies. Looked at together, moreover, the prints offer a playful contrast of classical and modern bodies.

The ambitious, multifaceted status of Hogarth's plates is confirmed by the complexity of their composition. Just as Hogarth's writings in the *Analysis* made extended references to previous treatises on the arts, so his two engravings meshed together a mass of pictorial materials. Thus, to give just two examples of this, Hogarth reproduces part of an anatomical engraving after Giles Hussey (1710–88; 158) in the foreground of *The Statuary's Yard*, and places two figures from a caricature by Pier Leone Ghezzi (1674–1755; 159) in the engraving's outer frame. Here Hogarth maintains his habitual satirical practice of combining searching social commentary with an elaborate form of pictorial play, assemblage and juxtaposition. In this respect, indeed, the two engravings work not only to illustrate the artist's thesis about beauty, but to exemplify Hogarth's career-long practices as a graphic satirist. Interestingly, it seems that many people bought the prints independently of the *Analysis*, and framed and displayed them separately. It is easy to imagine how the satiric wit on display in the central images of the *Yard* and the *Dance* would have been enjoyed in its own right, before being linked to the surrounding, compartmentalized outer images, and to the language of beauty found in the *Analysis* itself.

Hogarth actively encouraged his readers to experience the pleasures of variety, heterogeneity and intimacy (explored and celebrated in his tract and his two engravings) as they proceeded through the *Analysis*. As we read his text we are constantly invited by Hogarth to turn to his engravings and look at the numbered illustrations which are contained within them. Yet the two plates are organized in a strikingly haphazard way. Going from one compartmentalized box to another, for instance, we quickly find that they are not numbered in perfect order, as might be expected, but are numbered unevenly and in clusters. Thus, moving from left to right across

the upper edge of Hogarth's second engraving, we encounter boxes 71, 84, 85, 89, 94, 91, 77, 82, 83, 79, 80 and 81. Moreover, within the central images, numbered objects are jumbled together in an even less regular fashion. What all of this means, in practice, is that when we seek to hunt down any given illustration within the two plates, we normally find ourselves drifting around the mass of different images collected in each and wandering past one intricately juxtaposed representation after another – sometimes for quite an extended period – before we discover what we are looking for. Having found what we wanted, we return to the text and, very soon, begin the whole process again. Over the time it takes to finish the text, then, the reader's eye is constantly invited to move back and forth between text and plate and, on scanning that plate, to repeatedly browse through its myriad contents, each time in a slightly different way from the last. This kind of optical passage on our part, of course, provides a perfect metaphor for, and example of, those pleasures of visual pursuit, variety, intricacy and irregularity so celebrated in Hogarth's text. Here the reader and spectator are asked not only to analyse an argument about visual pleasure, but also to experience that form of pleasure as they do so.

That the *Analysis* was intended as a treatise which allowed its readers both to discourse learnedly about beautiful forms of sensation and also to realize those sensations for themselves is confirmed when we turn to its final chapter, entitled 'Of Action'. In this important but frequently neglected section of his book, Hogarth explicitly translates his aesthetics into a highly developed system of bodily comportment and etiquette. Having noted that 'there is no one but would wish to have it in his power to be genteel in the carriage of his person', he gives his readers a series of detailed instructions about how they can best acquire this kind of gentility. Significantly, he suggests they begin by tracing a serpentine line with a piece of chalk on a flat surface, which ensures that their drawing hand and arm will simultaneously trace out a graceful line through space. Here the forms of art fuse with those of a polite body language – the aesthetics of the waving line become the foundations for one's physical movements in refined society.

160
Louis-Pierre
Boitard after
Bartholomew
Dandridge,
Illustration
from François
Nivelon's
*Rudiments
of Genteel
Behaviour*,
1737.
Engraving

Plate 6.

B. Dandridge Pinx.

L.P. Boitard Sculp.

*According to Act of Parliament.*

Hogarth goes on to advise that 'gentle movements of this sort thus understood, may be made at any time and any where ... [and] daily practising these movements with the hands and arms, as also with such other parts of the body as are capable of them, will in a short time render the whole person graceful and easy of pleasure'. Succeeding paragraphs provide equally specific guidelines for holding one's head, bowing, curtseying and dancing. In offering its readers such suggestions, the *Analysis* unashamedly duplicated the concerns of fashionable manuals of polite etiquette such as François Nivelon's *Rudiments of Genteel Behaviour*, which had been translated into English in the 1730s and which gave its readers similar, illustrated instructions on how to comport themselves in polite society, including the most graceful ways to bow and dance (160). Hogarth's *Analysis*, both in its text and in its plates – which, of course, also demonstrate ideal forms of deportment – can now be seen to have provided a comparable service for its 'polite and curious' consumers.

When looked at in this light, it is clear that *The Analysis of Beauty* needs to be understood as more than a sustained discussion of aesthetic sensation. It was also – crucially – designed as a kind of self-help manual that suggested a new aesthetics of everyday life in urban Britain. On the one hand, Hogarth outlined a novel formulation of beauty, and wittily played off satiric and polite modes of representation as he did so. On the other, the artist invited his readers to internalize the *Analysis*'s principles into their own bodies, into their own patterns of looking, and into their own physical and visual engagement with the other members of the modern culture to which they belonged. In doing so, he recognized how much his readers felt like actors on a stage, and required directions on how they should best perform. Significantly, the *Analysis* closes by moving uninterruptedly from discussing the body language of polite society to analysing the body language of actors in a playhouse. Hogarth obviously felt there were remarkable similarities between the two.

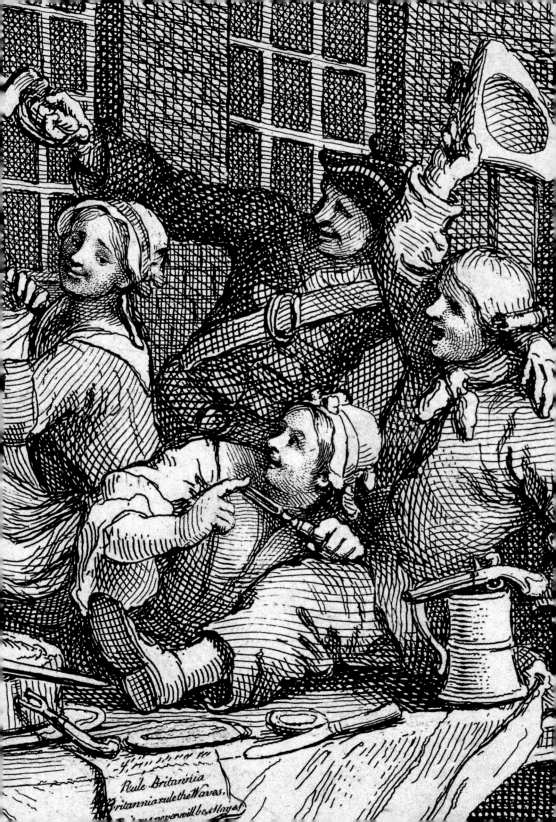

Rule Britannia
Britannia rule the Waves
never will be Slaves

Even as the London newspapers repeatedly advertised the published version of *The Analysis of Beauty* over the winter of 1753, Hogarth was busy on yet another ambitious pictorial satire. Very unusually for him, this work concentrated explicitly on contemporary party politics, and was deliberately designed to exploit the excitement and interest generated by the forthcoming April general election. Only weeks before the vote, Hogarth placed the painting of *An Election Entertainment* (162) on display in his studio, and announced the imminent publication of a print taken from the canvas. Presumably spurred on by the positive reaction the picture received, Hogarth soon afterwards decided to turn this one canvas into the starting point for a series of four paintings and prints, the latter of which were finally available as a set – *The Four Prints of an Election* – in 1758. This project testified to yet another form of artistic reinvention on Hogarth's part, in which he presented himself as a political as well as a social satirist. In the years that followed, Hogarth was to produce a number of other political satires, including *The Times* of 1762 (see 177 and 180), which offered a ferocious attack on the ministerial opposition, and his infamous etched portrait of John Wilkes (see 182), issued a year later. In looking at these and other such images, this chapter will illustrate one of the dramatic new directions Hogarth took as a painter and printmaker in the last decade of his life, and reveal how his decision to move into the controversial field of political satire was to have a profound effect on his reputation both as an artist and as a man.

The *Election* series, which represents a hilarious and brilliantly inventive critique of contemporary politics, begins in the hospitality room of a town inn, sometime during an election campaign in a country constituency. The room is packed with local worthies and

161
*The Invasion,*
*plate 2: England*
(detail of 173)

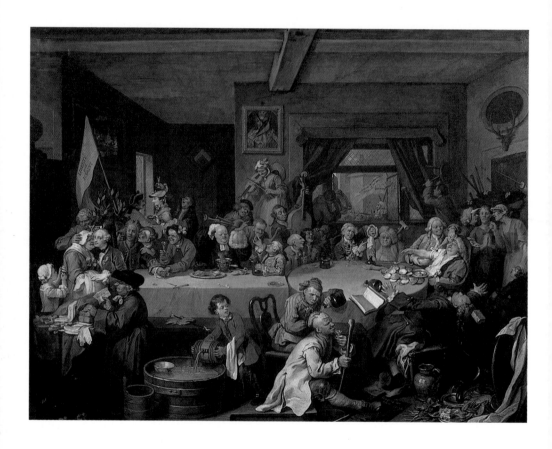

**162–163**
*An Election
Entertainment*,
1753–4.
Oil on canvas;
101·6×127cm,
40×50in.
Sir John
Soane's
Museum,
London
**Right**
Detail

their dependants, who are being 'treated' to a feast of food and drink by the two patrician candidates of the powerful Whig party, which over the previous half-century had become the dominant parliamentary force in England. The candidates are visible on the far left of the picture – one manages a feeble smile as his cheek is kissed by a brawny matron, while the other is embraced by a drunken countryman whose pipe billows smoke into the politician's eyes. The whole scene is characterized by excess and mayhem. A gluttonous, double-chinned parson wipes sweat off his bald head after demolishing a haunch of venison, while the local mayor faints away after gorging on a pile of oysters. Elsewhere, a hired political bruiser gets his head wound tended with a splash of gin, an election agent is felled by a brick that has come flying in through the window and an honest tailor, his hands clasped as if in prayer, is berated by his wife for refusing a proffered bribe. Supporters of the rival Tory party, carrying banners, effigies and swords, parade along the street outside and attempt to burst in through the doorway.

*Canvassing for Votes* (164), the second picture in the series, is set outside another inn, this time the Tory-supporting Royal Oak; the inn sign is partially obscured by a temporary hoarding attacking the Whig government's use of Treasury gold – shown being poured into a coach marked 'Oxford' – to finance its country election campaigns, which are symbolized by the image of 'Punch, Candidate at Guzzledown', distributing a barrowful of coins to local voters. Looking upwards from underneath the hoarding, one of the Tory candidates flirts with two women on the inn's balcony, and tries to win their support with trinkets bought from an itinerant Jewish pedlar. Nearby, a local farmer is surreptitiously offered money for his vote by representatives of both parties, while a barber and an old cobbler offer a mordant comment on contemporary decline by re-enacting the heroic 1739 naval victory of Portobello across their tabletop, as they sit, smoke and drink outside an alehouse of the same name. In the distance a Whig-controlled inn – which may well be the establishment depicted in the first picture – is again shown besieged by a Tory mob, who are shot at from an upstairs window.

164
*Canvassing for Votes*,
1754.
Oil on canvas;
101·6×127cm,
40×50in.
Sir John
Soane's
Museum,
London

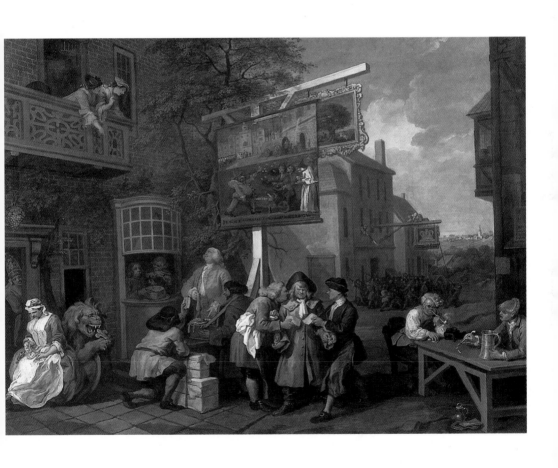

The third and fourth instalments of this series concentrate on the farcical culmination of the election campaign. In the penultimate canvas, entitled *The Polling* (165), a stream of disabled, lunatic and dying voters are hustled into a polling booth crowded with corrupt election clerks, arguing lawyers and, perched in the back of the booth, two of the candidates themselves. One scratches his head with worry, while the other is blissfully unaware that he is being ridiculed by a sketching caricaturist. In the middle distance a coach with the sign of England and Scotland painted on the

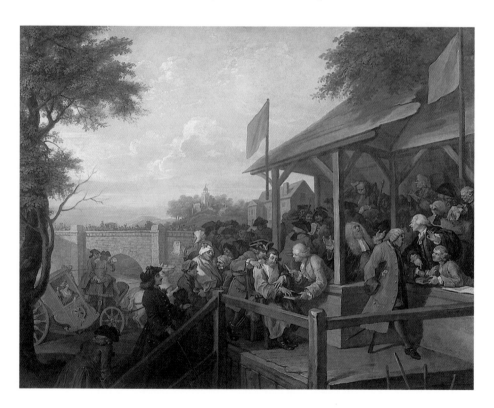

door, carrying a woman who clearly symbolizes Britannia, has broken down due to the inattention of the card-playing coachmen, themselves symbols of the country's incompetent political leaders. A bridge in the background is crowded with rival bands of voters leaving and arriving at the polling station. As in the second image of the series, a village church perches on the horizon. Finally, *Chairing the Members* (166) shows the victorious Tory candidates – one of whom is visible only as a shadow cast across the sunlit

wall of the town hall – being carried above an anarchic cavalcade of plebeian supporters. The position of the comically corpulent politician in the foreground has suddenly become highly precarious, as one of his carriers is accidentally hit on the head by another man fighting with a one-legged tailor. The fat Tory's eyes fall on the doom-laden emblem of a bespectacled skull placed on the gatepost of yet another church by two black adolescents, causing him to clutch his chair in fright. Adding to the pervasive sense of instability and disorder, a cluster of animals – a monkey, a bear, a donkey, a sow and her piglets – variously block and hinder the procession's passage. Meanwhile, a blind but cheerful fiddler strides onwards, oblivious to the chaos unfolding behind him and even to the sound of nearby gunfire.

Hogarth's four paintings and prints contributed to a long-standing debate about political electioneering that had become especially acute during the months leading up to the election of April 1754. In particular, numerous commentators criticized the widespread corruption and bribery that characterized the political campaigns taking place in county seats such as Oxfordshire, where thousands of pounds were being dubiously spent by local magnates to ensure the support of local voters for their chosen candidates. In the words of one contemporary, writing in the *London Evening Post* of 9 March 1754, 'Is any Candidate elected because his Character is unblemish'd, or his Abilities distinguish'd? No; he that gives the finest Treats, and the largest Bribes.' The long election campaign in Oxfordshire had become especially notorious for its underhand practices, generating a stream of critical and satirical works such as *The Oxfordshire Contest* of 1753, which wrote fantastically of a new 'poll-evil' whose symptoms included 'Convulsions, Distortions, Trimmings, Twistings, Kickings, Triflings, Inconsistencies of all kinds … Bitings, and Running-open-mouth'd at the yet sound and uninfected Part of the Herd.' Hogarth's *Election* series, which offers a minutely detailed account of the different stages of electoral corruption being witnessed in such country constituencies, and which refers in particular to the Oxfordshire contest, clearly shared its concerns with a wide range of literary commentaries and satires.

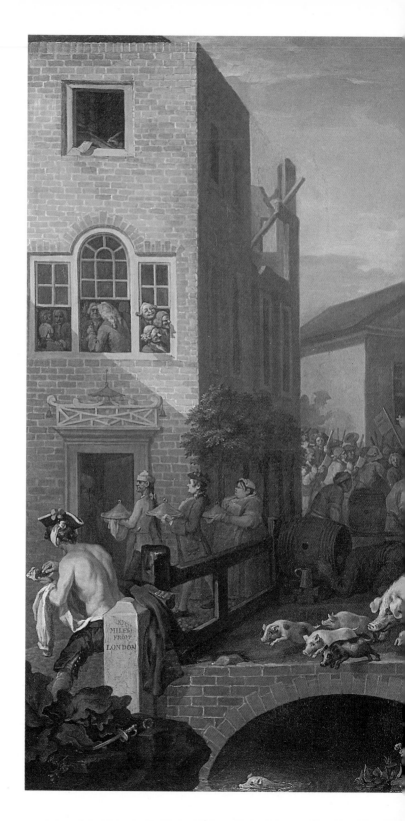

166
*Chairing the Members*,
1754.
Oil on canvas;
101·6 × 127 cm,
40 × 50 in.
Sir John
Soane's
Museum,
London

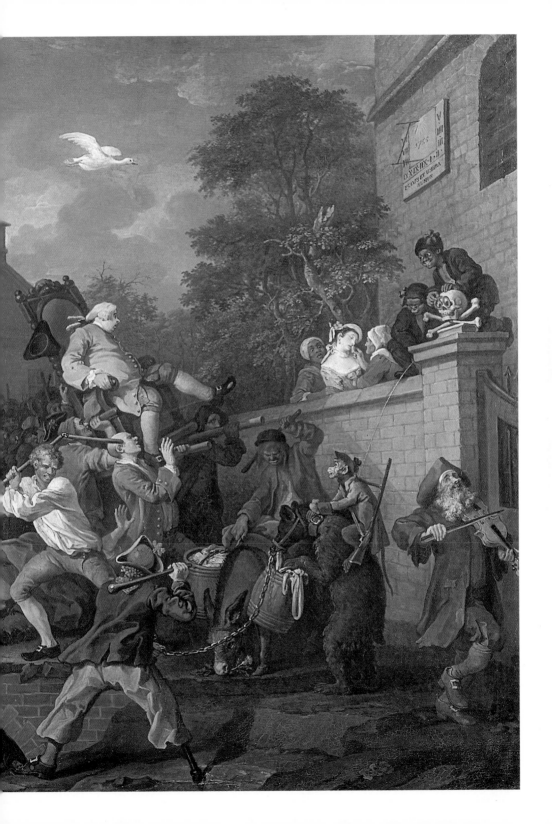

At the same time, Hogarth's pictures maintained many of the conventions and characteristics of engraved political satire. Political satire had long been a thriving sector of the graphic arts, combining acidic and witty commentary on the issues and personalities of politics with the pictorial formula of ironic assemblage and witty juxtaposition we have been noting throughout this book. From early in the century, such images had repeatedly focused on the bribery and blandishments that characterized election campaigns. In *Ready Mony the prevailing Candidate, or the Humours of an Election* (167), for instance, which was issued to coincide with the

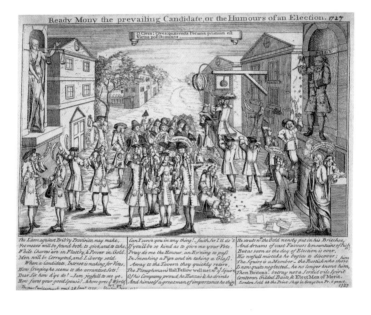

167
Anonymous,
*Ready Mony
the prevailing
Candidate,*
1727.
Engraving

168
After Hubert-
François
Gravelot,
*The Devil upon
Two Sticks,*
1741.
Engraving

1727 general election, the main street of a country town, leading into an uncluttered rural landscape, and dominated by an inn sign-board and two statues of Folly and blindfolded Justice, is packed with money-laden candidates, their agents and henchmen, and a crowd of expectant locals. The caption ridicules the country voter who, once paid, 'struts with the Gold newly put in his Britches, / And dreams of vast Favours & mountains of Riches; / But as soon as the day of Election is over, / His wofull mistake he begins to discover; / The Squire is a Member – the Rustick who chose him, / Is now quite neglected – he no longer knows him.' Meanwhile, Hubert-François Gravelot's *The Devil upon Two Sticks* (168), of

1741, shows the then prime minister, Sir Robert Walpole, being uncertainly carried above a stinking, infested piece of mud-land that has already left its traces on the group of ministerial politicians on the right. In the distance, standing in front of another rural landscape, we see Britannia being pickpocketed to provide the money and the drinks that are distributed among the local villagers.

THE DEVIL UPON TWO STICKS

Hogarth's four pictures drew upon and reworked the established components of such political satire. The frontispiece of *The Humours of a Country Election* (169), a collection of prose and poetry first issued in 1734, confirms the *Election*'s continuity with earlier satiric images. Here, as in Hogarth's series, the various stages of a country election campaign are depicted separately.

169
Anonymous,
Frontispiece to
*The Humours
of a Country
Election,*
1734.
Engraving

The print's first compartment shows one party's candidates and their entourage entering a country town, the second shows the feasting and the bribery that soon follows and the third, just as in the case of Hogarth's final picture, shows the victorious members being raised aloft by their plebeian supporters.

Hogarth's large-scale and fastidiously executed canvases also demand to be understood in relation to the traditions of painting. In particular, the *Election* series offered a modernized, party-politicized version of those well-known village scenes of riot, drunkenness and imbecility associated with seventeenth-century Dutch painters such as Jan Steen (1626–79; 170). Through linking his canvases to such an established pictorial genre, and to such famous predecessors as Steen, Hogarth ensured that his project could be appreciated as an exercise in ambitious painting as well as a highly sophisticated piece of political satire.

To understand the *Election* series further, it is helpful to recognize that its image of rural politics was expressive of specifically urban perspectives. Significantly, many of the attacks on country election-eering practices written in this period adopted a metropolitan brand of satire which comically exaggerated the crudity and gullibility of those rural freeholders who voted in such elections,

**170**
**Jan Steen,**
*A Village Revel,*
1673.
Oil on canvas;
110·5×149·2cm,
43¹₂×58¹₄in.
Royal
Collection

and the slyness and criminality of those local aristocrats who bought their support. Thus, the *London Evening Post* of 15 January 1754 carried a fictional comic conversation between the yokel-like Bailiff Brazen of the corrupt borough of Guzzledown, his idiotic but avaricious friends the Burgesses Bumper, Smuggle and Brownhead, the last of whom remembers how 'we hadden lazt Electhion Toim Theirty Pownds a Mon, bezides a deel a gud Veeasting', and the smooth-talking election agent Robert Canvas, working on behalf of a candidate named Mr Bribeall. Hogarth's *Election* pictures, the second of which includes a reference to Guzzledown on the hoarding draped over the Royal Oak's sign, similarly played on a long-standing urban mythology of rural backwardness, turpitude and vulnerability to élite manipulation, which, within the canvases and engravings themselves, is embodied by the scores of drunken, brutal, idiotic and greedy plebeian protagonists who spill across the pictorial space, and by the four precious and manipulative aristocrats who find themselves temporarily in their midst.

Hogarth's pictures must also have confirmed his urban audience's sense of participating in a very different kind of political culture to that which he depicted. Here, it is worth remembering that

the borough of Westminster in which the artist lived and worked
enjoyed an exceptionally wide franchise and was an electoral
constituency in which even men from the 'middling' ranks of
society felt themselves involved and informed about political
affairs, particularly since the emergence of the daily newspaper and
the metropolitan coffee-house as forums of political information
and debate. The political excesses and social polarities of
Hogarth's *Election* series, while they might well have reminded
some spectators of city as well as country contests, would have

171
Thomas
Gainsborough,
*Conard Wood*,
*c.*1746–7.
Oil on canvas;
121·9×154·9 cm,
48×61 in.
National
Gallery,
London

served to convince many others that they belonged to a far more
sophisticated and socially inclusive political public than that
found in the English provinces.

Even as Hogarth systematically deploys a host of negative,
urbanized stereotypes relating to rural society and politics, he
plays these off against an alternative, more positive iconography
of the countryside that was emerging in contemporary British art,
and that offered a nostalgia-tinged myth of the English landscape
as a repository of social harmony, traditional values and Christian
virtue. In paintings such as Thomas Gainsborough's *Conard Wood*
(171), executed six years before Hogarth's series, countrymen and

women work and live happily alongside each other, and humble walkers and wealthy horse-riders travel unmolested through a tranquil forest of old English oak trees, discreetly parted to allow us a glimpse of an open landscape dominated by the steeple of a village church. Hogarth, in his *Election* series, subtly refers to the values such pictures represent through the delicate landscapes that he himself places in the background of *Canvassing for Votes* (see 164) and *The Polling* (see 165), both of which are similarly punctuated by the presence of a church. If, at first sight, their inclusion seems to introduce the reassuring concept of a Christian Arcadia existing just outside the country town's boundaries, on further inspection they can be seen as representing an ideal that has been utterly obscured by the violence and fraudulence that characterize the scenes depicted in the foreground. Just as the idealized pictorial language of patriotism and nature found on the Royal Oak's signboard becomes overlaid with the satiric iconography of bribery and waste contained in the political hoarding, so, we can conclude, a similar form of pictorial eclipse takes place across Hogarth's series as a whole, in which the Eden-like ideal of a tranquil and ordered English countryside is overshadowed by the satiric iconography of provincial corruption and mob power.

Alongside all of its other details, the *Election* series is also laden with references to England's long-standing conflicts with France. In *Canvassing for Votes*, the nostalgic invocation of British victory at Portobello signified by the two drinkers is coupled with the depiction of an abandoned ship's figurehead, showing the British lion devouring a French fleur-de-lis, now used as a seat by the Royal Oak's landlady. These details must have become especially topical in 1756, when the country again found itself at war with France, in the conflict known as the Seven Years War, and was temporarily threatened by the possibility of invasion. Exploiting the widespread anxiety about these events, Hogarth issued a pair of engravings titled *The Invasion* (172, 173) in March of that year, which he advertised as 'representing, one a Scene in England, the other a Scene in France; both relative to the present Posture of

Affairs.' In the first print, set near a beach where the French are preparing for attack, a sadistic friar bends over a pile of equipment used for executions, running his finger along the blade of an axe with glee, while a clutch of scrawny and miserable French soldiers cower behind him, waiting to feed on a meagre meal of roasted frogs. The second engraving, in contrast, shows English soldiers and sailors cheerfully preparing for war with their female companions outside yet another country inn, which this time serves as the backdrop to a far more positive and propagandist message. Even here, however, Hogarth cannot resist introducing some low humour, in which a fork, held and measured in one of the women's hands, stands in for a sailor's penis, and is advantageously compared to the sword held by the King of France on the tavern wall.

These prints clearly marked a continuation of Hogarth's earlier attack on Frenchness in *The Gate of Calais* (see 146), and also maintained many of the preoccupations of his *March to Finchley* of 1749–50 (174), which comically focused on a group of English soldiers getting ready to repulse the French-supported Jacobite army which invaded the country in 1745. The two prints of 1756 are much more rapidly executed and more obviously topical images than these earlier canvases – and far less impressive as works of art – but they confirm that Hogarth was becoming increasingly willing to produce smaller-scale works that responded particularly quickly to contemporary events and debates. But when, six years later, he turned again to such events – after a period in which a debilitating respiratory illness had temporarily slowed his output – and did so in a highly politicized manner, he found himself facing some of the most fervent and sustained criticism of his life.

The spring of 1762 marked the accession to prime-ministerial power of John Stuart, 3rd Earl of Bute, a Scottish peer who enjoyed a particularly close relationship to the recently crowned George III, and who opposed the continuation of war with France. Over the following months, Bute came under vociferous attack from numerous commentators and satirists who criticized his unhealthily intimate ties to the king and the court, his conciliatory foreign

172
*The Invasion, plate 1: France,* 1756.
Engraving; 29.2 × 45.4 cm, 11 1⁄2 × 17 7⁄8 in

173
*The Invasion, plate 2: England,* 1756.
Engraving; 29.5 × 37.5 cm, 11 5⁄8 × 14 3⁄4 in

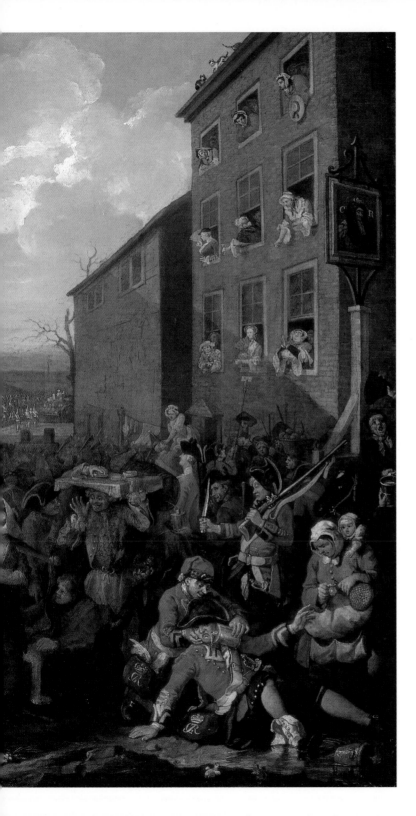

174
*The March
to Finchley*,
1749–50.
Oil on canvas;
101·6×133·3 cm,
40×52½in.
Thomas
Coram
Foundation
for Children,
London

policy and his supposed promotion of Scotsmen to governmental positions. Leading commentators such as John Wilkes and Charles Churchill continually contrasted him with his predecessor William Pitt, who, they claimed, had led the country to some of its greatest military and naval victories over the French. These attacks took pictorial as well as literary form, in political satires such as *The Jack-Boot Exalted* (175) which plays on the earl's name and shows

him regally distributing gold to his kilted supporters while a group of 'poor Southern Men' are hounded from office. Towards the end of the summer the *London Magazine* maintained this kind of ridicule by distributing individual satires against Bute with each issue. Engravings such as *The Caledonian March and Embarkation* (176), released with the August number, depicted a stream of

Scotsmen heading south for pensions and preferment. Significantly, these *London Magazine* prints repeatedly claimed to be the inventions of Hogarth, and were inscribed with his name. Although it is obvious now that they are not the artist's productions, it must have been galling for Hogarth to find his signature being misused in this way, particularly in the service of a political programme that he did not personally share.

For he himself had become closely associated with the royal court in this period and in 1757 had been appointed to the post of Serjeant-Painter to the King, in succession to his brother-in-law John Thornhill. This was a prestigious post that, while carrying only a nominal yearly salary of £10, gave its occupant an extremely lucrative form of financial control over all royal commissions for painting and gilding. Hogarth came to enjoy an annual income of some £200 – a substantial sum in the period – from the position, the day-to-day responsibilities of which he delegated to a team of assistants. While this must have made Hogarth particularly sensitive to attacks upon the court being made in his name, it also seems clear that he himself had come round to supporting what he described as Bute's policy of 'peace and unanimity'. At any rate, Hogarth decided to enter the fray himself in September 1762 with the first of a projected pair of political satires, the second of which was never completed or published.

*The Times, Plate I* (177) offers an extended allegory of domestic faction and international crisis. The scene is a city representing Europe in the throes of the continuing Seven Years War. Two of the burning houses in the distance – one with the sign of the two-headed eagle, the other with that of the fleur-de-lis – stand respectively for Germany and France, while that on the right, with a globe above its doorway, provides an ominous symbol of worldwide conflagration. At the centre of the scene, and placed beneath a hovering dove, a helmeted fireman, his arm emblazoned with the royal initials 'GR', attempts to put out the flames of conflict. He seems to stand either for the king himself or for his representative Bute, and is assisted by the sturdy Scotsman and

175
Anonymous,
*The Jack-Boot
Exalted,*
1762.
Engraving

176
Anonymous,
*The Caledonian
March and
Embarkation,*
attached to
the *London
Magazine,*
August 1762.
Engraving

Englishman carrying buckets of water to and from the blaze. Pitt is perched on stilts nearby, supported by a mob of aldermen and butchers, and carrying a bellows with which he feeds the fire. The ministry's critics, leaning from the windows of the Temple Coffee House in the middle distance and probably including the figures of John Wilkes and Charles Churchill in the garret, direct their own jets of water away from the blaze and towards the fireman himself. Meanwhile, the abandoned, dilapidated and sign-festooned house on the left signifies old Britain, ravaged by the policies of Bute's predecessors. The sign being hoisted up the ladder, which shows four fists clenched against each other, suggests the infighting of

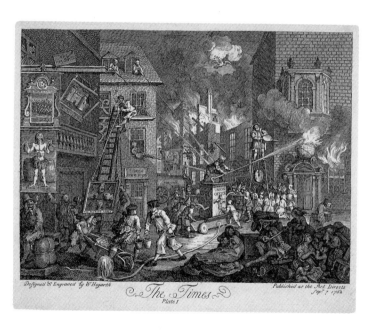

177–178
*The Times,
Plate 1,*
1762.
Engraving;
21·9×29·5cm,
8⁵⁄₈×11⁵⁄₈in
**Far right**
Detail

Pitt's so-called patriot supporters and is contrasted with the image of four clasped hands fixed to the side of the fire engine, which symbolizes not only the Union of England and Scotland, but also the hope that unity will replace the factionalism which had characterized recent politics.

In *The Times* Hogarth returns to the pictorial language of civic breakdown and crisis found in his early satires of the 1720s, and which resurfaced in works such as *Gin Lane* (see 138) and *The Four Stages of Cruelty* (see 139–143). Thanks to this, the print's urban

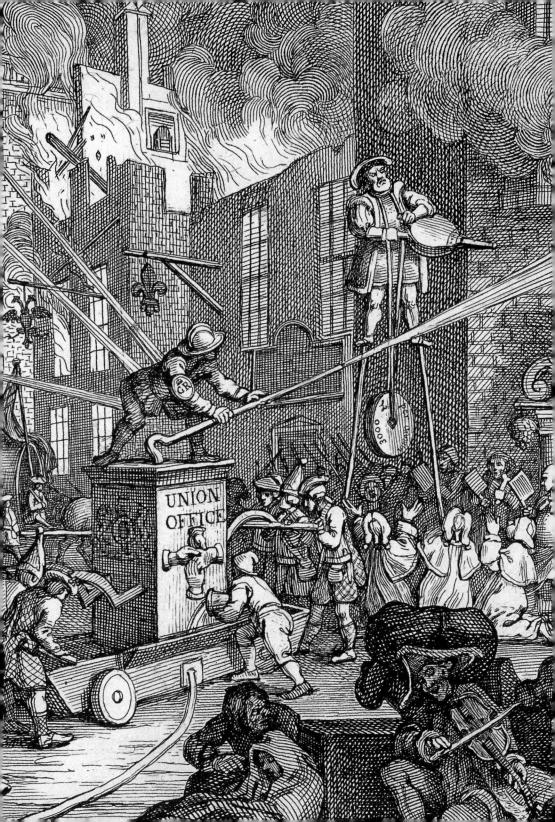

UNION
OFFICE

consumers, even as they appreciated that the scene functioned as an allegory of Europe's devastation, would also have been keenly aware that it more immediately conjured up the horrific image of their own capital city, London, as a place eaten by fire, overrun by the mob, ravaged by decay and littered with the abject bodies of women and children. *The Times* deliberately tapped into the deepest anxieties of Hogarth's affluent urban consumers about their own city.

In this respect, the muscular fireman at the centre of the print not only functions as a stand-in for the king or Bute, but also as a new kind of metropolitan hero who fights against the destruction and breakdown that surrounds him. Hogarth reinforces this symbolism by placing him at the centre of what seems like a busy city inter-section or thoroughfare. In this position, and standing as he does on a fire engine that raises him up like a plinth, he is given a striking resemblance to the heroic statuary that dotted London's major streets and squares, towering above the citizens of the city (179). In *The Times* the firefighter functions like such statues as a symbolic guarantor of authority and order, both political and civic, shown under severe threat from both the political enemies of the state and the forces of urban anarchy and chaos. Interestingly, in Hogarth's unfinished companion piece (180), which offers a far

179
Joseph
Nickolls,
*A View of
Charing Cross*,
1746.
Oil on canvas;
50.8×76.2cm,
20×30in.
The NatWest
Group Art
Collection,
London

more utopian vision of political and metropolitan life, exactly such a statue – of George III – is placed centre-stage, and clearly acts as a kind of counterpart or parallel to the living statue found in the earlier print.

Nevertheless, it was the political aspects of the *The Times* that caused the greatest impact and that quickly drew a stinging rebuke from the pen of John Wilkes. In his journal the *North Briton* of 25 September, Wilkes temporarily turned from his usual task of denouncing Bute in order to attack Hogarth's decision to defend the ministry and lampoon Pitt. In a devastating critique that took up the entire issue and that quickly turned into a wide-ranging survey of the artist's career, Wilkes accused Hogarth of malevolence and vanity and, far more woundingly, of plagiarism and decrepitude. He suggests that *The Times* steals many of its features from a print issued only a few days beforehand, entitled *John Bull's House Sett in Flames* (181), which in fact seems more likely to have been a pre-emptive response to Hogarth's satire, and then goes on to declare that 'THE TIMES must be confessed destitute of every kind of original merit. The print at first view appears too much crouded with figures; and is in every part confus'd, perplex'd, and embarrass'd.' Wilkes then criticizes Hogarth's move into this kind of personalized political satire, arguing that it demonstrates a

180
*The Times,
Plate 2,*
1762–3.
Engraving;
23·2×30·2cm,
9⅛×11⅞in

terrible fall from his previous standards and is an indication of his failing powers as an artist: 'I own too that I am grieved to see the genius of Hogarth, which should take in all ages and countries, sunk to a level with the miserable tribe of party etchers, and now, in his rapid decline, entering into the poor politics of the faction of the day, and descending to low personal abuse, instead of instructing the world, as he could once, by manly moral satire.' Finally, Wilkes ridicules the artist's post as Serjeant Painter to the King by implying – quite erroneously – that Hogarth has been

IOHN BULL'S HOUSE sett in FLAMES

employed only as the most lowly kind of decorator: 'I think the term means the same as what is vulgarly called house-painter; and indeed he has not been suffered to caricature the royal family … Mr Hogarth is only to paint the wainscot of the rooms, or, in the phrase of the art, may be called their pannel-painter.'

This scathing criticism, coming from one of the most prominent journalists of the day, seems to have wounded the artist deeply. Typically, however, Hogarth soon sought revenge. In the following spring Wilkes was arrested for seditious libel against the king, and sensationally placed on trial at Westminster Hall.

181
Anonymous,
*John Bull's
House Sett
in Flames*,
1762.
Engraving;
24.5×30.3cm,
9¾×11⅞in

Hogarth travelled to court, sketched his accuser, and on 7 May, released a savage portrait print of the journalist, 'Drawn from the Life and Etch'd in Aquafortis' (182). In this astonishingly vibrant image Hogarth depicts Wilkes as a squinting, leering, rakish and satanic figure, the contours of his wig adapted to suggest a pair of devil's horns, lounging next to the copies of the *North Briton* in which he had criticized Hogarth and the king. Meanwhile, a staff leans against his shoulder carrying an emblem of the cap of liberty, both of which were the traditional attributes of Britannia. While, at one level, Hogarth uses these details to present Wilkes as a devilish antithesis to Britannia – someone who steals her instruments and uses them for his own corrupt purposes – he also seems to deploy the staff and cap in order to conjure up the picture of Wilkes as a dangerous rabble-rouser. For it is as if Wilkes is just about to take them out into the streets and to raise them aloft as part of a mob parade such as the one depicted in the last image of the *Election* series, where sticks carrying cockaded hats ride above the crowd. Extending his critique, Hogarth – as he himself declares in the advertisement for the print – shows Wilkes in the same medium and format he had used when portraying the Jacobite traitor Simon, Lord Lovat, in the days before his execution in 1746 (183). In making such a direct pictorial comparison between the two men, Hogarth defines the *North Briton* journalist as a similarly threatening and treasonous figure to Lovat, and even – more shockingly – implies that he deserves a fate similar to that of his traitorous predecessor.

Even as Hogarth mounted this brilliant attack on his opponent, he himself became subject to increasing criticism and ridicule. A few months after the publication of the Wilkes print, Charles Churchill released an acidic *Epistle to Mr Hogarth*, which included a horrific if riveting image of Hogarth's decline into artistic and personal senility. Writing of the Wilkes portrait, Churchill declares that

VIRTUE, with due contempt, saw HOGARTH stand, / The murd'rous pencil in his palsied hand … / With all the symptoms of assur'd decay, / With age and sickness pinch'd, and worn away, / Pale

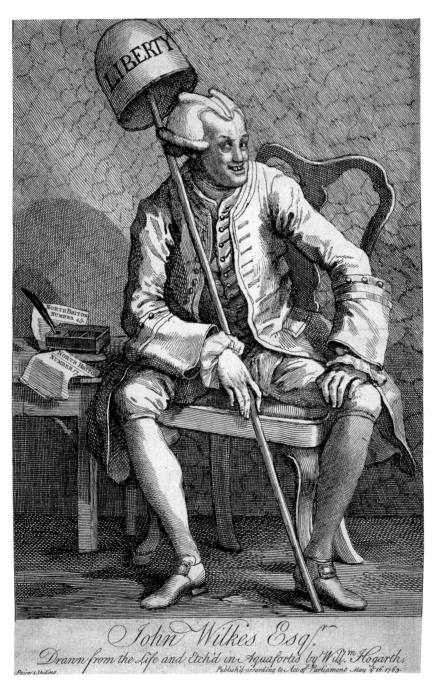

John Wilkes Esq<sup>r</sup>.

Drawn from the Life and Etch'd in Aquafortis by Will.<sup>m</sup> Hogarth.

Price 1 Shilling.                    Publish'd according to Act of Parliament May y<sup>e</sup> 16. 1763.

**182**
*John Wilkes*
*Esqr.*,
1763.
Etching;
31·8×22·2 cm,
12¹⁄₂×8³⁄₄ in

**183**
*Simon, Lord*
*Lovat*,
1746.
Etching;
33·3×22·5 cm,
13¹⁄₈×8⁷⁄₈ in

**184**
**Anonymous**,
*Tit for Tat or*
*Wm Hogarth*
*Esqr., Principal*
*Pannel Painter*
*to his Majesty*,
1763.
Engraving;
26·7×15·6 cm,
10¹⁄₂×6¹⁄₈ in

quiv'ring lips, lank cheeks, and falt'ring tongue, / The spirits out of tune, the nerves unstrung, / Thy body shrivell'd up, thy dim eyes sunk / Within their sockets deep, thy weak hams shrunk / The body's weight unable to sustain, / The stream of life scarce trembling thro' the vein.

**In the same period, a raft of graphic satires targeted the artist. One of the most potent was *Tit for Tat or Wm Hogarth Esqr., Principal Pannel Painter to his Majesty*, issued in May 1763 (184), whose subtitle, of course, borrows from the *North Briton's* description of Hogarth's royal office. In this image Hogarth's fall from**

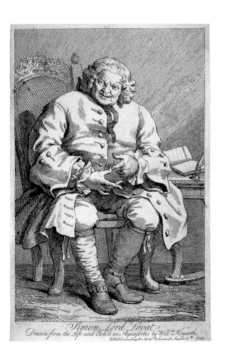

**what Wilkes had described as 'manly moral satire' is dramatized by turning him into a perverted composite of animality and effeminacy, whose over-muscled forearms, gargantuan hands and bulbous, meaty face are incongruously juxtaposed alongside his ribboned shoes, long, flowing night-dress and girlish wig.**

**This print, even as it gestures to Hogarth's political satires by showing him working on the Wilkes portrait and turning conspiratorially to the standing figure of Bute, also wittily parodies the**

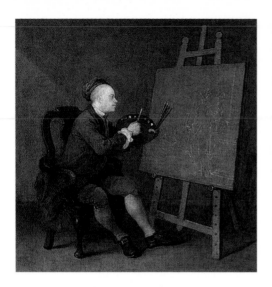
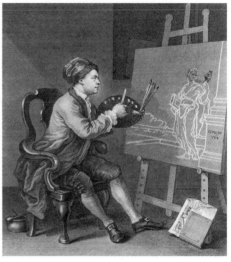

artist's own *Self-Portrait as Serjeant Painter to His Majesty* (185),
which – in its engraved form (186) – depicts him painting the
allegorical figure of the comic muse, near a folio containing one
of the illustrations to *The Analysis of Beauty*. In making this
reference, *Tit for Tat* suggests quite how extensively Hogarth was
being denounced in this period, not only as a producer of graphic
satires, but also as a painter and theorist. Such criticism, no doubt,
was partly a consequence of Hogarth's own decision to deploy a
particularly personalized form of satire in *The Times*, which made
him open to a similarly personalized form of retribution. But the
sheer number of attacks on the artist, and their severity and range,
are also symptomatic of a broader shift in the English art world,
in which a new generation of writers, artists and arbiters of taste,
aggressively searching for figures and values against which they
could define themselves, increasingly dramatized Hogarth as an
elderly, marginalized and irrelevant representative of an outmoded
and unsophisticated artistic culture. As the next chapter will go
on to explore, this kind of criticism focused not only on Hogarth's
graphic satire, but also on the other kinds of art he produced in
the last years of his life.

185
*Self-Portrait as
Serjeant Painter
to His Majesty*,
c.1758.
Oil on canvas;
39·4×37·5cm,
15$^{1}$⁄$_{2}$×14$^{3}$⁄$_{4}$in.
National
Portrait
Gallery,
London

186
*Wm Hogarth
Serjeant Painter
to His Majesty*,
1758.
Engraving;
37·2×34·6cm,
14$^{5}$⁄$_{8}$×13$^{5}$⁄$_{8}$in

187
*Sigismunda*
(detail of 195)

On 21 April 1760 the first public art exhibition ever held in London opened on the Strand, in the Great Room owned by the Society for the Encouragement of Arts, Manufactures and Commerce. Entry was free, and thousands of visitors flocked to see the one hundred and thirty works on display, made by a group of sixty-nine artists. The following spring, after this group had split acrimoniously over the question of admission charges, London housed two large-scale art exhibitions: a second show at the Society of Arts and a new display organized by a body calling itself the Society of Artists and held in a large hired room near Charing Cross. For this exhibition visitors were charged a shilling, upon the payment of which they received a catalogue carrying a frontispiece decorated by Hogarth (188) showing Britannia watering the trees of painting, sculpture and architecture, and being supplied by a fountain symbolizing the support for the arts promised by the newly crowned King George III. Exhibitions such as this heralded a new era for British art, and for British painting in particular. For the first time, those contemporaries who were interested in the visual arts could see the newest canvases by hundreds of native artists hanging in the same environment, and were given the chance to compare one with another. In this process, the leading painters of the day found themselves actively competing with one another within the exhibition room for the approbation of a large and critical public, itself informed by the growing amount of art criticism that was being published in the daily and weekly newspapers, and in specially commissioned tracts and pamphlets.

The new world of painting inaugurated by the annual exhibitions – more visible, more competitive and more laden with textual commentary than the one that had preceded it – offered both an opportunity and a threat to Hogarth. On the one hand, it gave him

the chance to display his works on canvas to a public that extended beyond the relatively small community of men and women who actually commissioned ambitious British paintings and, in doing so, to finally confirm his status as a leading painter as well as an engraver. On the other hand, the changed conditions of display and reception offered the threat that Hogarth's work and identity as a painter, forged in a pre-exhibition era that was already being

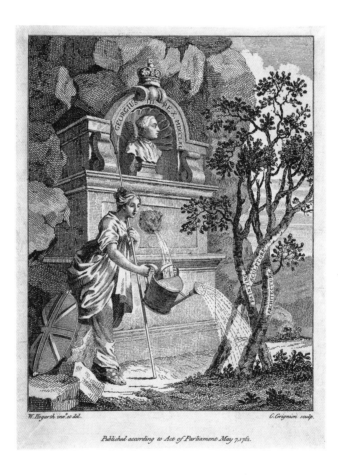

188
Frontispiece to the *Catalogue of Pictures Exhibited in Spring Gardens*, 1761.
Engraving; 17.5 × 13.7 cm, $6^7\!/8 × 5^3\!/8$ in

derided by some as primitive and parochial, might be exposed as outmoded, even slightly distasteful, within London's modern art world. And, indeed, he was to face both kinds of response in the final years of his career. Showing a representative collection of his recent paintings in the Society of Artists exhibition of 1761, he was simultaneously hailed as the greatest living English artist and treated as something of an embarrassment.

In the years immediately preceding these developments, however, Hogarth was preoccupied with other forms of painterly display. In 1755 he received his first commission for a large-scale history painting since producing *Paul Before Felix* for the Inns of Court some seven years earlier (see 148). This time his patron was the governing body of the parish church of St Mary Redcliffe in Bristol, who paid the substantial fee of £525 for an enormous altarpiece to hang at the end of the building's Gothic nave. Having visited Bristol to look at the church and meet with the vestry, Hogarth decided to produce a triptych of the Resurrection, which ended up being some five metres high and fifteen metres wide (17 × 51 ft). The central panel (189), taking its narrative from the New Testament book of St John, shows Christ having ascended to heaven, while below him the area around his empty tomb is filled with the reassuring figures of two standing angels, a cluster of astonished disciples, a crowd of gaping onlookers and, running across the centre of the painting, the figure of Mary Magdalene. For the left-hand panel (190), meanwhile, Hogarth painted a scene preceding this one in the New Testament narrative, in which a Pharisee and four soldiers seal Christ's tomb with wax, chains and a huge boulder. A contemporary writer in the *Critical Review*, comparing this panel with its companion on the right-hand side of the triptych (191), declared that 'the labour and exertion which is naturally expressed in this scene is very happily contrasted by the tenderness and elegant softness which prevails in the other side-piece, where the three Marys are come to visit the empty sepulchre. The angel who is speaking to them, and pointing up to heaven with an expression which explains itself, is a figure of singular beauty.'

These comments point to one of Hogarth's organizing principles in this work, whereby his two framing images are dramatically contrasted in terms of gender. The left-hand picture is not only filled with the figures of men, but is also dominated by those pictorial forms and rhythms that *The Analysis of Beauty* had identified as particularly masculine and authoritarian in nature – the hard right angles made by the soldiers' elbows, the straight lines made by the priest's gesturing left arm and, most dramatically,

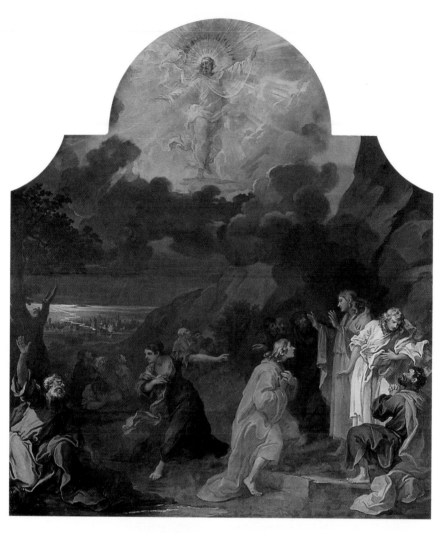

the side of the foreground soldier's body, which clearly echoes the diagonal of the staff used to lever the boulder towards the tomb. Conversely, the right-hand picture is occupied by the figures of three women – Mary, the mother of James, Mary Magdalene and the Virgin Mary – and the markedly tender, soft and beautiful angel, whose smooth skin, delicate profile and flowing hair and dress are dramatically feminine in appearance, even if, as the *Critical Review* correspondent claims, he 'still retains in his look the native dignity of a superior being'. Furthermore, as against the rigid geometry of the left-hand panel, here the undulating and unfolding lines and shapes that dominate the image are those Hogarth had theorized in the *Analysis* as the pictorial vocabulary of feminine beauty and liberty.

Interestingly, the central image offers a powerful reconciliation of these polarities, whereby Mary Magdalene (having moved, as it were, out of the side panel and into this picture) and the two ministering angels – again distinguished by their delicacy of posture, gesture and address, and reassuring the similarly softened figure of St John – are juxtaposed with the bearded, intensely masculine figures of St Peter and St Thomas found in the left- and right-hand corners of the painting, and placed underneath the all-powerful figure of the bearded Christ. Across the triptych as a whole Hogarth isolates and then integrates a gendered pictorial language of power and pliancy, sublimity and beauty, and in doing so suggests an ideal Christian fusion of authority and tenderness. At the same time the various figures he distributes across the lower band of the triptych provided the church-goers of St Mary's with a crowded band of surrogate spectators and story-tellers, whose interaction paralleled that between priest and congregation within the church itself, and whose ultimate reference point was also the gigantic figure of Christ towering overhead.

Having completed this intensely time-consuming and physically wearing project in 1756, and still heavily engaged with preparing the *Election* prints, Hogarth temporarily decided to stick to less demanding tasks. In February 1757 he announced in the *London*

189
*The Ascension,*
1756.
Oil on canvas;
672×584cm,
267×230in.
City of Bristol
Museum and
Art Gallery

190
*The Sealing of
the Sepulchre,*
1756.
Oil on canvas;
422×364cm,
166×144in.
City of Bristol
Museum and
Art Gallery

191
*The Three
Marys Visiting
the Sepulchre,*
1756.
Oil on canvas;
422×364cm,
166×144in.
City of Bristol
Museum and
Art Gallery

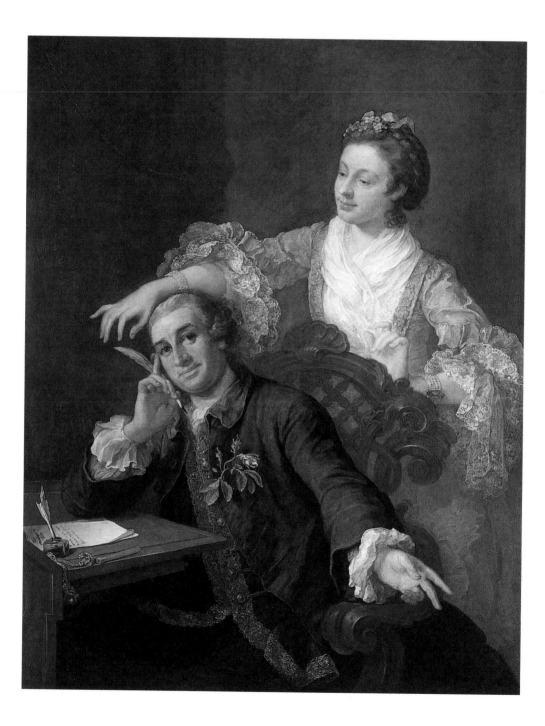

*Evening Post* that he intended to 'employ the rest of his Time in PORTRAIT PAINTING chiefly', and proceeded to work on canvases such as his affectionate depiction of the actor David Garrick and his wife (192), which supplemented the dramatic theatrical portrait of Garrick in the character of Richard III that he had painted more than a decade earlier (193). Soon, however, Hogarth was again working on narrative and history paintings. Significantly, the last two major pictures of this kind that he produced – *The Lady's Last Stake* and *Sigismunda*, which took up much of 1759 – were works that, even though they were initially

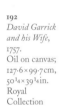

**192**
*David Garrick and his Wife*,
1757.
Oil on canvas;
127·6 × 99·7 cm,
50¼ × 39¼ in.
Royal
Collection

**193**
*Garrick in the Character of Richard III*,
1745.
Oil on canvas;
190·5 × 250·2 cm,
75 × 98½ in.
Walker Art
Gallery,
Liverpool

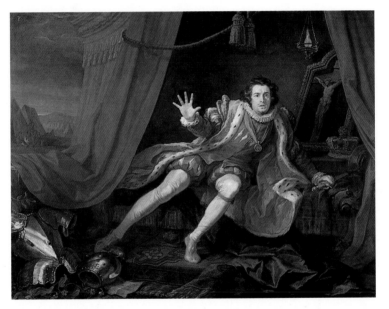

painted for an aristocratic clientele, eventually found themselves under the scrutiny of the thousands of men and women who attended the Society of Arts exhibition of 1761. As such, they offer a fascinating confirmation of the rapidly shifting conditions under which Hogarth's late canvases were produced and displayed, and the dramatically dissenting opinions he attracted about his worth and identity as a painter.

*Picquet; or Virtue in Danger*, which has come to be known as *The Lady's Last Stake* (194), was commissioned by the Irish peer James Caulfield, First Earl of Charlemont, who persuaded Hogarth to

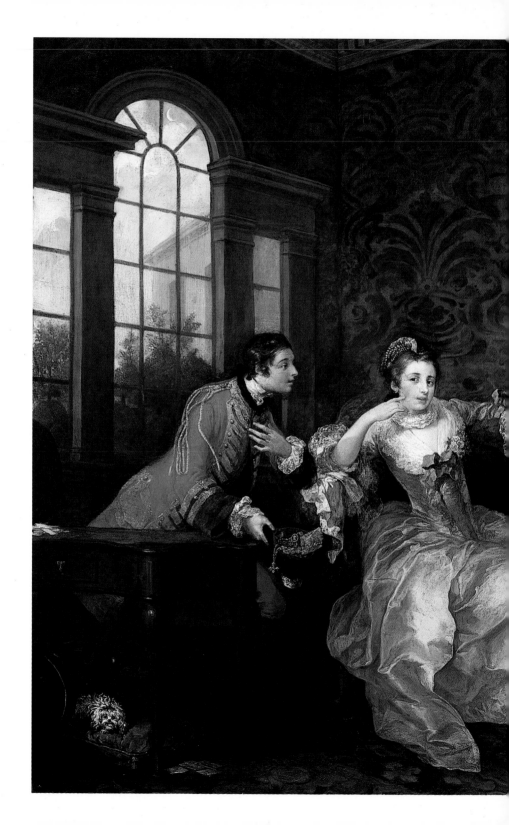

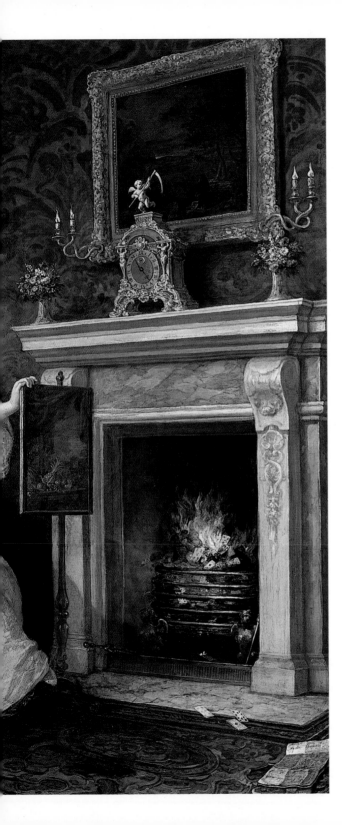

194
*Picquet; or
Virtue in
Danger
(The Lady's
Last Stake)*,
1759.
Oil on canvas;
91.4×105.4 cm,
36×41½in.
Albright-Knox
Art Gallery,
Buffalo,
New York

give up his self-imposed retirement from narrative painting by declaring that if the artist painted one such picture for him, he could name both his subject and his price. The artist shrewdly decided to flatter his patron's social status and adapt the satirical formula employed in projects such as *Marriage à la Mode* by setting his new picture in the household of an élite aristocrat, and focusing on a moment of intense moral and sexual drama. Adapting a scene from Colly Cibber's famous theatrical comedy of high manners, *The Lady's Last Stake*, Hogarth depicts a hitherto virtuous married gentlewoman who, addicted to gambling, has lost her fortune playing the card game picquet with a young army officer. If we follow Cibber's dramatic lead, we can assume that the picture shows the officer offering the woman the chance of one last game, played according to his terms: if she wins, she will regain her fortune, and have no more obligations to him; if she loses, she will still have her valuables returned, but be obliged to take him as her lover. In Hogarth's own words, she is shown 'wavering at his suit whether she should part with honour or no to regain the loss which was offered to her'. Those familiar with Cibber's version of this dilemma might have surmised that, as in the play, she will agree to the officer's wager, lose, but be happily rescued, her virtue intact. But Hogarth leaves the situation more open than this. His original title for the painting, and subsequent description, which make no direct reference to the theatrical *Lady's Last Stake*, suggests that we can also interpret the picture's protagonists as a different pair of characters to those created by the playwright, and imagine them going on to act out an alternative – and possibly less virtuous – narrative.

This brilliantly polished picture, which flaunted its continuity with Hogarth's previous high-life satire, *Marriage à la Mode*, and confidently placed itself alongside modern French paintings such as Jean-François de Troy's *The Declaration of Love* (see 110), also made an unmistakable erotic appeal. Hogarth's *The Lady's Last Stake* explicitly presents a woman as an object of sexual desire within the image, and implicitly offers her in similar terms for the imagined male viewer standing outside the painting. Significantly, in his depiction of the stricken female card player, Hogarth seems

to fuse the signs of anxiety with those of allurement. From one perspective, she is someone desperately holding on to the last remaining shreds of her respectability, a feeling conveyed most powerfully by the way her left hand clutches the protective symbol of the fireguard. But at the same time, and more insidiously, Hogarth depicts the woman in a way that clearly emphasizes her beauty and desirability, and that even suggests she is momentarily basking in a sense of sexual attractiveness and arousal herself. Here, the delicate touch of her finger on her blushing cheek seems as much a token and promise of sexual pleasure as a sign of her shock and anxiety at hearing the soldier's words. And even as this gesture is, at one level, geared solely to the handsome young officer, it is also obvious that it extends outwards, along with her gaze, to take in the spectator. In this respect, as so often in Hogarth's satiric works, the sympathy that the viewer is meant to feel, and the moral reading he or she is asked to make of the pictured scene, is combined with a more obviously chauvinistic appeal to the pleasures of voyeurism, and an invitation to read the central heroine in explicitly eroticized terms.

This pictorial appeal to sympathy and fantasy, combined with the painting's technical refinement, aristocratic setting, Continental associations and wealth of symbolic detail, undoubtedly helped ensure that *The Lady's Last Stake* was attractive not only to Charlemont himself, but also to his male friends and associates. Indeed, even before it was finished, the aristocrat Sir Richard Grosvenor, taking up Charlemont's recommendation to go and look at the painting in Hogarth's studio, was so impressed – and so eager to imitate his friend's largesse – that he pleaded with the artist to produce another painting on precisely the same terms as those proposed by Charlemont. It seems likely that, despite this encouragement of artistic licence, he expected a similar kind of painting to *The Lady's Last Stake*. What Hogarth decided to paint, however, was something very different, and ultimately far less welcome: *Sigismunda* (195). Hogarth's new painting, which he produced while Charlemont's canvas still remained in his studio, drew upon a seventeenth-century *Fable* by the English poet John

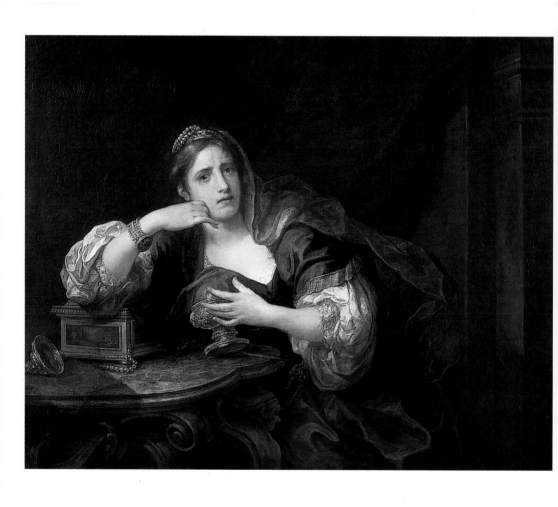

Dryden, itself an adaptation of a famous poem by Boccaccio. Dryden wrote of how a noble classical heroine, Sigismunda, had fallen in love with and married Guiscardo, a common-born member of her father's household. Her father, outraged on hearing of this match, proceeds to murder Guiscardo and – in a gesture that crushes Sigismunda – sends the dead man's heart to his daughter in a jewelled goblet. Distraught, she fills the goblet with poison, drinks from it and ultimately dies in front of her father.

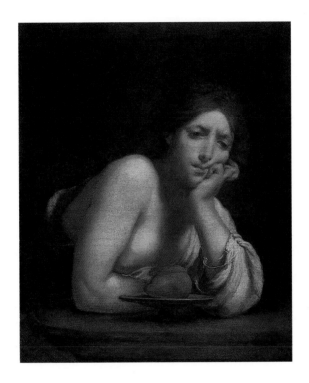

**195**
*Sigismunda*,
1759–61.
Oil on canvas;
99·1×105·4cm,
39×41¹⁄₂in.
Tate Gallery,
London

**196**
**Francesco
Furini,**
*Sigismunda*,
c.1640.
Oil on canvas;
73×59cm,
28³⁄₄×23¹⁄₄in.
Birmingham
Museum and
Art Gallery

Hogarth, in choosing to paint this subject, deliberately invited comparison with those Old Masters such as the Italian painter Correggio (c.1489–1534) who enjoyed the highest respect among contemporary connoisseurs and critics. It seems that the artist's long-standing resentment about the inflated prices attracted by such painters was exacerbated by the sale of the connoisseur Luke Schaub's collection of pictures in the spring of 1758, which included a painting of Sigismunda, then attributed to Correggio but now known to be by Francesco Furini, that fetched more than four hundred pounds (196). Numerous scholars have suggested that

Hogarth painted his *Sigismunda* in order to prove a point, by showing Grosvenor, who had bought heavily at Schaub's sale, and the wider community of aristocratic art buyers to which he belonged, that a contemporary British artist could produce an even more powerful version of the same subject. Yet it is also possible to imagine that Hogarth, on beginning the project, might well have thought that his painting of a classical heroine would perfectly suit his aristocratic patron's refined tastes, and fit comfortably alongside the Old Master canvases that already hung in Grosvenor's burgeoning collection. Furthermore, Hogarth, his eye on the profits he might gain from future reproductions of *Sigismunda*, would also have been encouraged by the success of engraved images of such subjects in the contemporary print market. Robert Strange, for example, was already making a speciality of producing highly refined engravings after Old Master pictures, many of which concentrated on the kind of virtuous heroine Hogarth himself chose to paint.

*Sigismunda* was clearly intended to make a powerful sentimental impact on the viewer – in Hogarth's own words, 'my whole aim was to fetch a Tear from the Spectator'. As such it suggests both a dramatic continuation of, and a radical departure from, the form and content of *The Lady's Last Stake*, which hung alongside Hogarth's new canvas in his studio. Looking at the two pictures together, we can simultaneously appreciate the striking continuity between the poses of the two women – in which their heads turn towards the viewer in the same way, and their right arm and hand similarly move up towards their cheeks – and remain highly conscious of the utter contrast that Hogarth makes between them. While Hogarth's representation of the female gambler combines an appeal to the viewer's sympathy with a self-conscious eroticism and playfulness, his depiction of Sigismunda's far more melancholy predicament, designed to appeal to our deepest emotions, is unleavened by any hint of sexuality or comedy. More disturbingly, Hogarth's depiction of Sigismunda's grief is tied to a horrific pictorial language of the bloody and the corporeal, centred on the gory image of her lover's heart, freshly ripped from his body. In a

remarkable confirmation of the artist's lingering concentration on the gross, abject details of Guiscardo's dismemberment, Sigismunda's fingers were originally shown stained with the blood that still dripped from his heart.

Hogarth, then, has partially maintained the imagery of vulnerable femininity found in *The Lady's Last Stake*, but translated this imagery into an entirely different idiom, in which the pictorial language of sentimentality and abjection is brought into shocking conjunction. For Hogarth, no doubt, the repetitions and contrasts between the two pictures announced an ambitious but successful transition from elegant satire to tragic history painting. For his patron, however, things were very different. Grosvenor, coming to Hogarth's studio to look at *Sigismunda*, and seeing it hanging alongside that picture of Charlemont's which he had so admired, clearly found it a repulsive, debased and overwrought counterpart to the earlier image, distinguished neither by the wit and eroticism that he saw as Hogarth's stock-in-trade, nor by the age, provenance and decorum that he appreciated in the foreign paintings he was buying at auction. He was also shocked by the price of 400 guineas asked by Hogarth, which testified to the artist's belief that his modern painting was worth just as much as the Old Masters which the aristocrat had been collecting. Eventually, after a string of apologies and excuses, Grosvenor wheedled his way out of either receiving or paying for the painting altogether.

Grosvenor's rejection of *Sigismunda* is indicative not only of his own personal distaste for the picture, but also of a broader hardening of attitudes towards Hogarth and his work in high culture. In the last few years of his life, Hogarth was increasingly seen by the members and spokesmen of élite society as an artist who deserved praise for his satire and portraiture, but whose attempts at the highest pictorial genre – history painting – were flawed and spoilt by his preoccupation with the grotesque and the low. These kinds of perceptions were symptomatic of an increasingly hierarchical attitude to painting that was developing within a certain section of the cultural élite, who sought to dissociate the production and

consumption of ambitious works of art from the trappings of
commerce and the vulgar interests of the wider urban public, and
link them instead to a purified, abstracted and socially elevated
sphere of creation and appreciation. From this perspective, Hogarth
was someone whose personal character, social origins and pictorial
preoccupations could easily be derided as too crude, lowly and
miscellaneous for him to be admitted into the highest echelons
of the artistic canon. Recognizing this development, it becomes
easier to understand the scorn that continued to be poured on
*Sigismunda* subsequent to its rejection by Grosvenor, and some of
the viciously patrician language with which it was uttered. Thus,
the aristocratic connoisseur and historian Horace Walpole, seeing
the painting in the studio in May 1761, described Hogarth's heroine
as 'a maudlin whore tearing off the trinkets that her keeper had
given her, to fling at his head … her fingers are bloody with the
heart, as if she had just bought a sheep's pluck in St James's market'.

For Hogarth, the exhibition at the Society of Artists held in the
same month as Walpole's visit clearly offered the opportunity to
appeal to a broader public than that represented by such men,
whom he privately castigated as blinkered connoisseurs whose
interests extended only to works of Renaissance and Baroque
artists from Continental Europe, and who were thus utterly unable
to appreciate the merits of contemporary painting. Significantly,
his frontispiece for the exhibition catalogue, noted at the
beginning of this chapter, was accompanied by a tailpiece (197)
which offered a comic parody of the connoisseur as a foppish
monkey, armed with a magnifying glass and vainly attempting to
water the dead wood of three Old Masters. The Society of Artists
exhibition, he implies, was going to attract a very different kind
of viewer – men and women who were enthusiastic about the work
of modern English artists, and who appreciated a broad range
of pictorial achievements. Accordingly, Hogarth planned his
contribution carefully, choosing to display *Sigismunda* (see 195),
*The Lady's Last Stake* (see 194), *An Election Entertainment* (see 162),
*The Gate of Calais* (see 146) and three portraits, including one of
the cleric Benjamin Hoadly. At the exhibition itself, these seven

197
Tailpiece to the
*Catalogue of
Pictures
Exhibited in
Spring Gardens*,
1761.
Engraving;
11·4×13cm,
4¹2×5¹8in

W. Hogarth inv<sup>t</sup>.                                                                    C. Grignion sculp.

*Esse quid hoc dicam?—vivis quod Fama negatur!*

Mart.

*Publish'd according to Act of Parliament May 7.1761.*

paintings took their place among one hundred and forty other canvases, which were dominated by portraits, but which also included landscapes, still lifes and the occasional history painting.

Hogarth's selection of exhibits represented a mini-retrospective of his last fifteen years as a painter which highlighted the eclecticism of his output and his technical brilliance within a variety of pictorial genres. Visitors to the show were clearly meant to be impressed by the sheer diversity of subjects Hogarth had covered in his work, ranging from the political festivities of a country election to the sexual dalliances of an aristocratic household, from a Church of England worthy to a classical heroine. This kind of versatility was unique within the exhibition. At the same time, Hogarth had chosen paintings which served to illustrate his increasing refinement and ambition as an artist. Thus, the earliest of the narrative paintings on display, *The Gate of Calais* of 1748, is by far the crudest of the set. This is followed by the more complex and smoothly painted *An Election*

*Entertainment* of 1754, before the sudden move towards greater pictorial elegance signified by *The Lady's Last Stake* of 1759, itself followed by the latest and most grandiloquently ambitious of all Hogarth's paintings, *Sigismunda*, which the artist had continued to rework right up until the eve of the exhibition. From this perspective the cluster of canvases that Hogarth sent to the Society of Artists show dramatized his own transformation, over the last decades of his career, from an accomplished painter of pictorial satire and comedy to the greatest representative of modern English history painting.

For a number of newspaper critics who attended the exhibition, and who focused on Hogarth's most recent canvas, this story was a perfectly plausible one. Most interesting of all is an anonymous 'Admirer of the Polite Arts' in the *St James's Chronicle*, who wrote a humorous account of a young Etonian and his connoisseurial friend attending the exhibition, in which the latter warns his companion beforehand that Hogarth is nothing more than 'an absolute Bartholomew droll [*ie* a vulgar fairground entertainment], who paints Country Elections, and pretends to laugh at the Connoisseurs'. The Etonian, entering the exhibition, is nevertheless immediately transfixed by a single painting:

'Heavens, said I, what's yonder; the unhappy Sigismunda with Guiscard's heart! Would my friend Dryden could but come to Life again to see his Thoughts so expressed, so coloured: Who did it my Lord?' 'Hogarth, said he, and he is quite out of his Walk.' 'Hogarth! Said I, I could not indeed have expected this even of him.'

Yet, despite all Hogarth's attempts to promote himself as a painter who excelled in different pictorial categories, both high and low, and despite all the praise he received, the exhibition seems to have turned out disastrously for the artist. A number of later accounts, anecdotal but trustworthy, describe how Hogarth, enraged by the amount of scornful attention *Sigismunda* was continuing to receive, withdrew the painting from the exhibition after only ten days, and replaced it with his picture of *Chairing the Members* (see 166), the fourth painting of the *Election* series. While Hogarth's extraordinary

decision might be attributed to his justifiable anger at hearing the disdainful and blinkered comments of visiting connoisseurs, it also has to be said that by placing *Sigismunda* among his other paintings the artist had surely opened himself up to such criticism. Even if he intended his display to demonstrate his eclecticism and development as an artist, that same display can also be seen to have fatally undermined the seriousness and status of *Sigismunda* by juxtaposing it with paintings like *The Gate at Calais* and *An Election Entertainment*, which so obviously focused on the low and the grotesque, and did so in such a boisterously comic way. The excesses and crudities which these two pictures depicted can be imagined as having metaphorically seeped into, infected and overwhelmed their more rarefied companion hanging nearby. Or, to put it another way, *Sigismunda* must have become newly vulgarized by a process of visual association, in which, just to give two examples, Hogarth's supposedly heroic protagonist suddenly found herself near a clutch of hag-like French fishwives crouching in the shadow of Calais Gate, and Guiscardo's heart, gently brushed by Sigismunda's fingers, was juxtaposed with a similarly fingered hunk of raw meat being clutched to the breast of a scrawny French cook. Under such circumstances, it is perhaps no wonder that Hogarth's painting should lose much of its dignity.

Of course, the withdrawal of *Sigismunda* meant that Hogarth could all the more easily be pigeonholed as a comic satirist whose talents were unsuited to pictures of a higher calling. This kind of prejudice became even stronger in the following year, when the artist, having exhibited nothing at the second Society of Artists show, was widely reported to be one of the organizers of an irreverent Sign-Painters' Exhibition that parodied the pretensions of the new exhibitions of paintings. This comic display of popular art announced its indebtedness to Hogarth's example immediately: the first signboard on show portrayed him at work, while the second – hanging underneath – alluded to his famous 'Line of Beauty'. Well-disposed critics reinforced this link. One prefaced his account of the Sign-Painters' Exhibition with a long paean to the artist, while another declared that 'a Man who has the least

spice of that inimitable and matchless Humourist, H—h, will
there find Entertainment, and many Strokes of true Wit and
Humour.' Finally, a correspondent in the *St James's Chronicle*
commended one signboard as 'almost worthy the hand of
Hogarth', and even suggested that Hogarth himself had
participated, and struggled to 'suppress his superiority of Genius'
in painting 'down to the common stile and Manner of the School
of Sign-Painting'. Even if Hogarth didn't directly contribute to the
show, as this writer suggests, it seems likely that he was involved

198
Anonymous,
*A Brush for the
Sign-Painters*,
1762.
Engraving;
27.4 × 22.5 cm,
10¾ × 8⅞ in

in some way, and saw the event as a means of puncturing the
pretentiousness and snobbery that had so affected the reception
of his own works the previous year. Again, however, his perceived
participation in the Sign-Painters' Exhibition meant that he could
easily be lampooned as a coarse and populist artist-craftsman who
had found his proper home among the sign-painters, and who was
inadequate at painting anything more refined. Thus, *A Brush for
the Sign-Painters* (198), which again parodies Hogarth's self-
portrait as Serjeant-Painter to the King, and transforms him

into a bestial combination of man and dog, describes him as
'Mr Hoggum Pugg, a justly celebrated Sign-Painter though an
Englishman and a Modern'. He is shown, of course, at work on his
ill-fated *Sigismunda*, while the lower half of the canvas makes a
pointed reference to Aesop's fable of the frog that tried to puff
itself up into the size of an ox and burst in the process.

These kinds of attacks helped to reinforce Hogarth's own sense
that, in old age, his art and ideas were being increasingly rejected
within London's modern art world and that he himself was being
given less and less personal respect. This feeling was no doubt
accentuated by his growing physical frailty and by his tendency to
retreat to his country villa in Chiswick ever more frequently. As
well as feeling marginalized and vulnerable, he was clearly cutting
himself off. It is as if he knew his time at the centre of things had
come and gone. Significantly, he devoted the last year of his life to
organizing a definitive portfolio of his graphic work, accompanied
by a new commentary on his life and career. This critical autobiog-
raphy was never finished, but what Hogarth did jot down offers
a poignant blend of nostalgia, justifiable pride in his immense
achievements and extreme bitterness. Significantly, the manuscript
ends with Hogarth railing against the critics of his *Analysis* – 'the
torrent was against me' – and declaring that 'I ever had the worst
on't.' Meanwhile, he also worked on an engraving, *The Bathos*
(199), published in the spring of 1764, which was designed, he
declared, to 'serve as a Tail Piece to all the Author's engraved
works, when bound up together'. The print is dominated by the
dying figure of Time, lying near the sign of 'The World's End'.
His hourglass is smashed, his scythe and pipe are broken. A cracked
palette, clearly Hogarth's own, lies near a burning copy of his print
*The Times*. A shadowed gravestone, ruined church tower, dying
tree, crumbling house and an eclipsed sun complete this
apocalyptic scene, together with the image of a prone Apollo and
his dead horses drifting across the darkened sky.

Typically, this print maintains Hogarth's career-long commitment
to satire. *The Bathos* ridicules the newly fashionable taste for the

sublime, and parodies those paintings and prints which were already turning the concept into a cliché through an exaggerated focus on darkness, death and desolation. At the same time, the print represents a profoundly autobiographical allegory of creative exhaustion and individual mortality. In *The Bathos*, Hogarth communicates his own sense of having been broken as an artist by the repeated attacks on such works as *The Times*, and signals a melancholy awareness of his own impending death. In making this print, Hogarth clearly identified himself with the collapsed figure of dying Time, surrounded by the abandoned and fractured relics of an artistic career, and saw his own fate paralleled in that of the lonely and forlorn victim shown hanging on the gallows in the distance. Here, as so often in his career, his aim was true. Some six months after publishing this print, on the night of 25 October 1764, Hogarth died of a ruptured artery at his home in Leicester Fields. A week later, on 2 November, he was buried in the graveyard at St Nicholas's Church, Chiswick, where his monument still stands today.

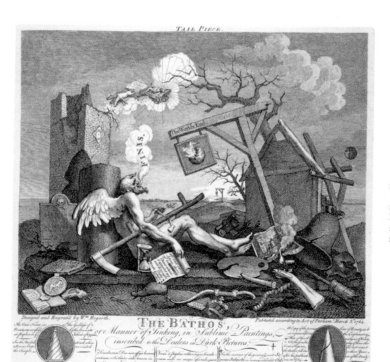

**199**
*The Bathos*,
1764.
Engraving;
26 × 32.4 cm,
10¼ × 12¾ in

The anxiety about his artistic reputation that Hogarth expressed in *The Bathos* proved unwarranted. Ever since his death in 1764, Hogarth's life and work have remained central to all accounts of British art in the first half of the eighteenth century and have provided an enduring repository of artistic and pictorial models for later painters and engravers to adapt for their own purposes. Hogarth, partially thanks to his sheer diversity as an artist, has proved endlessly open to scholarly, critical and artistic reappraisal, and his name has come to mean very different things to successive generations, each of which has analysed and responded to the artist's life and output according to their own sets of preoccupations.

200
Steve Bell,
*Rigour,
Realism and
Responsibility:
A Medley*
(detail of 209)

In this process, unsurprisingly, certain aspects of Hogarth's life and work have been extravagantly praised and mythologized while others have been pointedly ignored, diluted or decried. Indeed, in the decades immediately following the artist's death two spokesmen for high culture managed to both celebrate and damn Hogarth in the same breath. The year 1780 saw the publication of the fourth volume of Horace Walpole's history of English art, *Anecdotes of Painting*, in which he declared that Hogarth was a 'great and original genius', 'a writer of comedy with a pencil' whose pictures always carried an improving moral alongside their wit and humour. Yet Walpole also criticizes Hogarth for attempting to distinguish himself as a history painter: 'not only his colouring and drawing rendered him unequal to the task; the genius that had entered so feelingly into the calamities and crimes of familiar life, deserted him in a walk that called for dignity and grace.' Some eight years later, Sir Joshua Reynolds, President of the Royal Academy of Arts – the state-sponsored successor to the informal and private academies that had flourished earlier in the century – suggested that Hogarth was to be praised for 'inventing a new

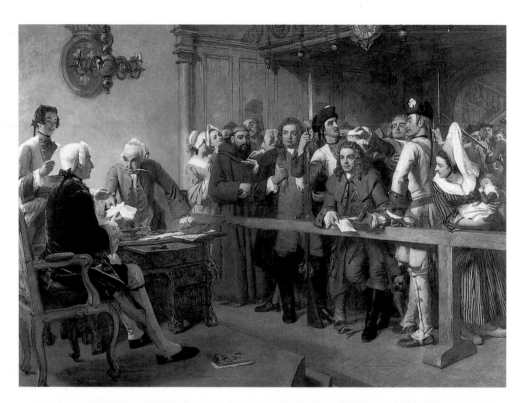

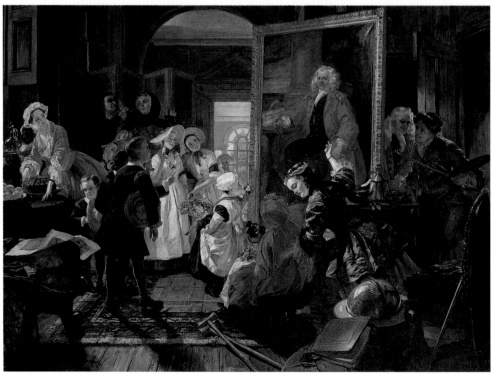

species of dramatic painting, in which probably he will never be equalled' and for storing 'his mind with infinite materials to explain and illustrate the domestick and familiar scenes of common life'. Yet, Reynolds goes on to declare, 'he very imprudently, or rather presumptuously, attempted the great historical style, for which his previous habits had by no means prepared him … It is to be regretted, that any part of the life of such a genius should be fruitlessly employed.'

Such comments testify to the continuing condescension towards Hogarth's work that existed within the most self-consciously elevated artistic and critical circles in the late eighteenth century. In contrast, the Victorian period saw Hogarth being idealized as a patriotic and benevolent bourgeois painter whose suspicion of the aristocratic and the foreign was entirely legitimate. *Hogarth Before the Commandant at Calais* by William Powell Frith (201), for instance, depicts the artist having been caught by the French while sketching at Calais, and undergoing interrogation by a foppish and aristocratic French captor. Here, Frith builds upon Hogarth's own self-portrait in *The Gate of Calais* (see 146) and the engraving of Tom Idle being interrogated by Francis Goodchild in *Industry and Idleness* (see 129) in order to construct an image of the artist as a plainly dressed, clear-eyed and unpretentious representative of middle-class Englishness. Meanwhile, in *Hogarth's Studio in 1739* by Edward Matthew Ward (202), painted in 1863, the artist is shown crouching with Thomas Coram behind his portrait of the Foundling Hospital's benefactor, indulgently listening to the adoring and admiring comments of a group of impossibly clean and well-behaved orphans. This cloyingly sweet version of bourgeois benevolence is completed by the image of Hogarth's wife Jane leaning over the table slicing cake for the children.

Such paintings, when coupled with the comments of Walpole and Reynolds, usefully suggest the wide variety of identities which Hogarth has accumulated in the years since his death. Nevertheless, it seems clear that his most fundamental and enduring importance for later generations has been his role as an interpreter of

201
William Powell Frith, *Hogarth Before the Commandant at Calais*, 1851. Oil on canvas; 111.7×152.7cm, 44×60⅛in. Private collection

202
Edward Matthew Ward, *Hogarth's Studio in 1739*, 1863. Oil on canvas; 120.6×165.1cm, 47½×65in. York City Art Gallery

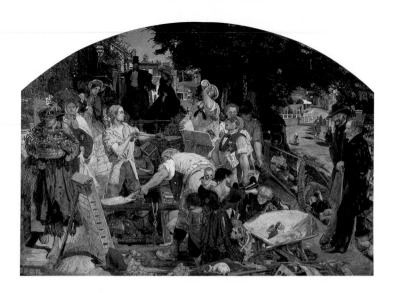

modern urban life and as a social and political satirist. To suggest his lasting artistic impact as a painter and engraver of urban experience, it is useful to turn to the pictures of Victorian, Edwardian and modern artists such as Ford Madox Brown (1821–93), Walter Sickert (1860–1942) and David Hockney (b.1937). Brown's *Work* (203) of 1852–65, for instance, is a complex and panoramic depiction of a London street scene that, in juxtaposing beer-drinking workers, sheltering families, youthful street-sellers, fashionable strollers, juvenile beggars, urban worthies and, in the foreground, a symbolically eloquent trio of dogs, unmistakably invites comparison with Hogarth's similarly crowded and pointed cityscapes of a century or so earlier. It is no surprise to find that Brown was a prime mover in the creation of the Hogarth Club of 1858–61, which provided exhibition facilities for those that saw themselves, just as their eighteenth-century predecessor increasingly did, as men confronting an entrenched and hostile artistic establishment.

Meanwhile, paintings such as Sickert's *Gallery of the Old Bedford* (204), which focuses on the anonymous consumers of modern urban entertainment, and asks the viewer to contemplate a mass of other spectators, can be seen to suggestively update the preoccupations of prints such as Hogarth's famous *Laughing Audience* (205), which the artist had issued as a subscription ticket

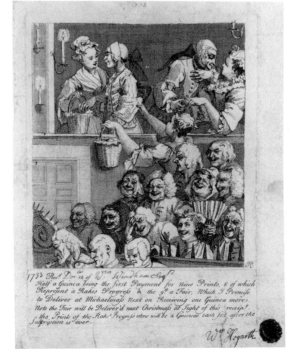

**203**
**Ford Madox
Brown**,
*Work*,
1852–65.
Oil on canvas;
136·8×197·2cm,
53⅞×77⅝in.
Manchester
City Art
Galleries

**204**
**Walter
Sickert**,
*Gallery of the
Old Bedford*,
1900.
Oil on canvas;
76·2×59·7cm,
30×23½in.
Walker Art
Gallery,
Liverpool

**205**
*The Laughing
Audience*,
1733.
Engraving;
17·8×15·9cm,
7×6¼in

to *A Rake's Progress*. Finally, Hockney has directly responded to Hogarth's example in his own etched *Rake's Progress* of 1961–3, which again concentrates on the experience of entering and traversing the city – this time the American city – and on modern forms of urban alienation. Hockney's series, which ends by replacing the image of the rake dying in the lunatic asylum (see 63) with the haunting image of a new Bedlam populated by faceless, robotic drones (206), provides a powerful testimony to the relevance and interest of Hogarth's work to modern artists.

Hockney's *Progress* also demands to be read as an extended satire on America, and on the relationship of English culture to America

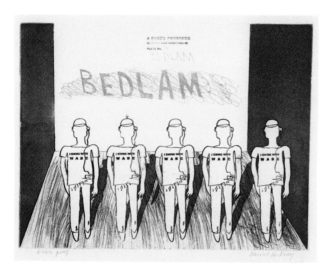

in the years following World War II. This confirms the extent to which Hogarth's works have continued to function as seminal pictorial blueprints for graphic satire ever since they were first produced. In the eighteenth century itself, for example, the satirist James Gillray (1756–1815) frequently encouraged his viewers to imaginatively map his own prints onto those produced by his celebrated predecessor. Thus, his great etching of the Prince of Wales as a languid and feckless dissolute in *A Voluptuary under the Horrors of Digestion* (207) evokes Hogarth's image of Viscount Squanderfield in the second instalment of *Marriage à la Mode*, while *The Morning after Marriage* of 1788 (208) offers another

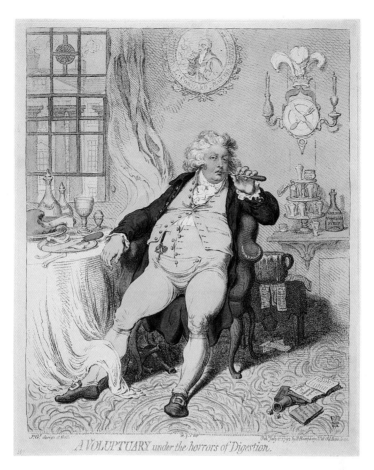

A VOLUPTUARY under the horrors of Digestion.

The MORNING after MARRIAGE _ or _ A scene on the Continent.

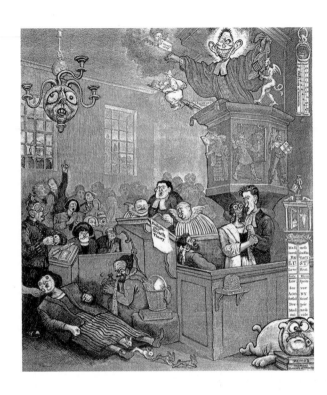

209
**Steve Bell,**
*Rigour,*
*Realism and*
*Responsibility:*
*A Medley,*
1997

210
*Credulity,*
*Superstition*
*and Fanaticism:*
*A Medley,*
1762.
Engraving;
36·8×57·5cm,
14$^1$2×22$^5$8in

subtle echo of the same image, in which Gillray wittily transposes
the early-morning postures of the yawning viscountess and her
new husband on to the figures of the prince and his new 'bride',
Maria Fitzherbert.

Today, these kinds of references to Hogarth's art continue to
characterize the political and social satire we encounter in our
newspapers and magazines, and see on our television screens.
Thus, to give a final example, Steve Bell's cartoons for *The
Guardian* have regularly engaged with Hogarth's works. His
*Rigour, Realism and Responsibility: A Medley* (209), for instance,
fuses an extended and playful critique of Tony Blair's New Labour
government with the components of Hogarth's late attack on
Methodist enthusiasm, *Credulity, Superstition and Fanaticism:
A Medley* (210). Meanwhile, Bell's earlier satiric response to the
news that the Conservative Party was being partially funded by
drink companies, *Free the Spirit, Fund the Party* (211), offers a
sparkling revision of Hogarth's *Gin Lane* (see 136). At the same
time, this cartoon confirms how Hogarth's characteristic satiric

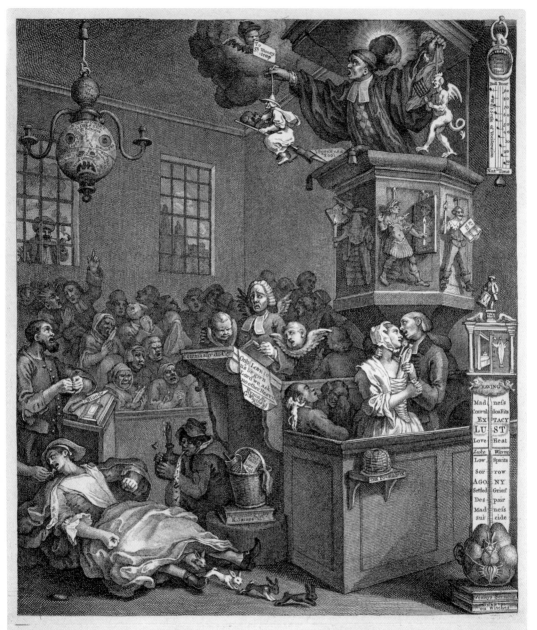

CREDULITY, SUPERSTITION, and FANATICISM.

A MEDLEY.

Believe not every Spirit, but try the Spirits whether they are of God: because many false Prophets are gone out into the World.

1 John. Ch. 4. V. 1.

Design'd and Engrav'd by W.ᵐ Hogarth.

Publish'd as the Act directs March 5.ᵗʰ 15.ᵗʰ 1762.

**211**
**Steve Bell,**
*Free the Spirit,*
*Fund the Party,*
1995

**212**
Advertisement
for Smirnoff
vodka,
1991

practice of drawing from a range of different visual materials, and
wittily juxtaposing them across the picture space, is still alive and
well. Here, Bell not only draws upon Hogarth's example, but also
adapts the central pictorial conceit of Smirnoff vodka's advertising
campaign (212) and – in depicting John Major as a feeble stooge
who wears his underpants outside his trousers – plays ironically
with the iconography of Superman. Hogarth, we can be sure,
would thoroughly approve.

# Glossary

**Academies** Academies of art – institutions organized for the purposes of training young artists and providing more mature artists with a forum for practice and debate – had a long Continental history. The first English example of such an institution, however, was an academy founded on 11 October 1711, in Great Queen Street, London, with the portraitist **Sir Godfrey Kneller** as governor. Teaching was based on students drawing from life and from other artists' works. Following a quarrel in the academy after the painter **Sir James Thornhill** had become governor in 1716, a number of other such organizations were set up, including an Academy at St Martin's Lane, which Hogarth joined in 1720. Hogarth himself provided the impetus for the founding of a second St Martin's Lane Academy in 1735, which he ran on noticeably non-hierarchical lines. This remained a crucial arena for the teaching and practice of modern art for the next two decades. From mid-century, however, there was a growing call among artists for the founding of a public academy of art, supported by the king, which they foresaw promoting an ambitious British school of painting and asserting their dignity as a profession. Hogarth greeted these developments with suspicion, arguing that they would lead to the formation of a rigidly hierarchical academy on the French model, and to a dangerous centralization of artistic power in the hands of a few professors. Finally, after a prolonged campaign, the Royal Academy of Arts was set up in 1768, with the backing of George III. The Royal Academy's first president was **Sir Joshua Reynolds** and it quickly became the central site of artistic instruction, theory and display in the capital. The Royal Academy not only trained scores of students, but also housed a huge annual exhibition of contemporary paintings, first at its original headquarters in Pall Mall, and then, after 1780, in purpose-built exhibition rooms at its new headquarters, Somerset House.

**Connoisseur** A term that was often used in the eighteenth century to describe a figure – almost always male – who was distinguished by his knowledge of, and sensitivity towards, works of art. When used in a positive light, the term suggested an extreme refinement of taste, honed through a long process of assessing and comparing works of art. It became synonymous with high social and cultural status, and was often applied to aristocratic collectors. The term could also be used satirically, however, and was frequently deployed by contemporaries such as Hogarth to castigate men whose interest in the arts was blinkered, precious and suspect. In this light, the connoisseur was lampooned as someone who was interested only in Old Master canvases, who spouted pretentious platitudes about painting and who found it impossible to distinguish between good art and bad. He was easily fooled by fakes, had no real aesthetic judgement of his own and happily paid outlandish prices for the most mediocre works of Continental art.

**Conversation Piece** A category of portrait painting that came to prominence in the 1720s and 1730s, and which typically focused on groups of affluent men, women and children – often members of the same family – depicted within their homes or estates. As the name of this pictorial genre suggests, these figures are frequently shown as if in the middle of a polite conversation. One's skill in sustaining and guiding such conversations had become a marker of genteel social status in this period, and conversation itself was frequently hailed as an intrinsically civilizing process, bringing people of different stations and sexes together into a harmonious whole. In the conversation piece, the imagined talk of the painting's protagonists takes place in environments exhibiting other symbols of refinement and sociability, including tea services, playing cards and oil paintings. Later in the century, the conversation piece enjoyed a resurgence in England, adopted and adapted by artists such as Johan Zoffany (1733–1810) and Joseph Wright of Derby (1734–97).

**Engraving** A term commonly used in the eighteenth century to describe all kinds of print, but more specifically meaning the process whereby an image was produced by printing an incised and inked copperplate onto paper. Lines were cut into a thin copperplate with a sharp instrument called a burin or graver. Once the image had been engraved, the copperplate would be inked, wiped clean so that the ink was left only in the incisions and then printed. Done properly, the whole process required exceptional skill and patience. The engraver, or the print publisher who had paid him, was rewarded by the fact that the engraved copperplate would sustain hundreds, often thousands, of impressions before beginning to wear noticeably.

**Etching** Etching is both a specific method of producing a graphic image and the kind of object produced by this process. As in **engraving**, a copperplate provided the basic material upon which an image was generated. The plate was covered in a layer of acid-resistant material, normally wax. This was smoked black and then the artist would cut into the wax using a needle. The plate was then immersed in acid, which would bite into the copper at those points where it had been exposed by the action of the needle. Etching, thanks to the fact that the artist cut into wax rather than the copper itself, was a far freer method of producing graphic images than engraving, and provided a subtly different pictorial effect. Far fewer crisp impressions could be gained from the bitten rather than the cut copperplate, however, and so etchings were normally issued in much smaller numbers than engravings. Many artists, including Hogarth, combined etching and engraving on a single copperplate.

**Graphic Satire** This is a term used to describe prints that attack, parody or critically comment on factual and fictional events, characters, institutions and environments. Graphic satire – whether engraved, etched or cut in wood – was a distinct and well-established branch of the graphic arts in the eighteenth century, having come to prominence in the previous century as a vehicle of religious and political critique. As well as engaging with a range of cultural, social and political issues, graphic satires were appreciated for their playful and frequently complex pictorial organization. They often fused together a wide variety of pictorial and textual forms, drawn from both the highest and lowest categories of art and literature. Hogarth's engraved and etched work was celebrated as the most ambitious example of contemporary graphic satire.

**History Painting** Often ranked as the highest branch of art in this period, history painting conventionally depicted subjects, themes and narratives drawn from the most venerated religious, historical and mythological texts. This pictorial category centred on the figure of a heroic or tragic human protagonist, and tended to be executed on a large scale in an expansive, generalizing pictorial manner. History painting, which had been formally placed at the head of a hierarchy of genres by the French Academy of Painting in the seventeenth century, was ideally intended to be displayed in the most distinguished and grandiose public spaces, commissioned by the most refined and powerful patrons and spectators and produced by the most gifted and ambitious painters. As was often noted at the time, however, artists in early eighteenth-century England enjoyed very limited opportunities to paint such works.

**Illustration** Producing engraved or etched illustrations – particularly book illustrations – was an important area of artistic practice in the early eighteenth century, and provided aspirant engravers in particular with a crucial means of making money at the beginning of their careers. Newly developing literary genres such as the novel and the travel story were often published with illustrations, while well-established formats such as plays and histories would also frequently carry such images. Hogarth's early book illustrations varied from the elaborate engravings he produced to accompany Aubry de la Mottraye's *Travels through Europe, Asia, and into Part of Africa*, published in 1724, to the sketchy and quickly produced pictures he executed for Charles Gildon's *The New Metamorphosis*, published later in the same year. Following his later success as a painter of conversation pieces and an engraver of ambitious satires, Hogarth resorted to book illustration only occasionally, and more often as a designer than as an engraver.

**Old Masters** A frequently used term in the eighteenth century describing those artists (and paintings) of previous centuries that enjoyed the highest critical respect among collectors and historians, and that commanded the highest prices on the art-market. These typically meant sixteenth- and seventeenth-century artists from Italy, France and the Low Countries such as Raphael, Poussin, Rubens and Rembrandt. Native-born contemporary artists such as Hogarth often suggested that the respect given to Old Master painters and paintings had turned into a blind enthusiasm for all old paintings produced abroad, and bemoaned the fact that an attachment to such works led to a wilful neglect of modern English art of equal merit.

**Rococo** A term that, although post-dating the phenomenon it describes, has come to be associated with a particular artistic vocabulary that emerged in the early decades of eighteenth-century France, and that was adopted on a widespread basis in Georgian London. Linked to French court and aristocratic culture, and in particular to the decorative schemes of the Parisian nobility, the rococo was a pictorial style and an aesthetic that typically focused in its subject matter on the sophisticated protagonists, theatrical narratives and exquisite objects of high society, and that was formally characterized by a flamboyant use of the swirling, undulating line. In England, where it became closely associated with visiting French artists such as **Hubert-François Gravelot**, and was normally less extravagant in its effects, it quickly became a byword for aesthetic elegance and was deployed across a variety of artistic sites, ranging from book illustration to the country-house interior.

**Sublime**  A term that, although a staple of pictorial and literary criticism from earlier in the eighteenth century, came to acquire a more specific meaning upon the publication, in 1757, of Edmund Burke's *A Philosophical Enquiry into the Origin of our Ideas of the Sublime and the Beautiful*. Burke declared that 'whatever is fitted in any sort to excite the ideas of pain and danger, that is to say, whatever is in any sort terrible, or is conversant about terrible objects, or operates in a manner analogous to terror, is a source of the sublime.' The sublime was linked to dramatic natural landscapes and phenomena such as crags and thunderstorms, to the most cataclysmic events of human history and to the great narratives of apocalypse and terror found in art and literature. At the same time, the sublime was recognized as an awe-inspiring as well as a terrifying phenomenon which could generate a pleasurable sense of self-preservation and a vicarious thrill of the nerves given a safe distance from the actual dangers themselves.

**Subscription**  The means by which many ambitious engravers, including Hogarth, were able to finance large-scale print projects in this period. Typically, the engraver would advertise proposals for a given scheme – such as Hogarth's *A Harlot's Progress* – in the London newspapers, and call for subscribers to the project, who would normally be asked to pay a certain sum in advance and the remainder on receipt of the completed engravings. This method, which had already proved successful in book publishing, provided engravers with enough capital to embark on long-term graphic undertakings without fear of making too substantial a loss. Subscribers would often be named on subscription lists sent out with the finished works.

**Topographic** paintings and prints (also called prospects)  These are images depicting the architectural and physical features of specific rural and urban environments. In eighteenth-century London, such pictures (both painted and engraved) were produced on a regular basis and typically featured well-known public spaces such as newly built squares, grand thoroughfares and markets, and often depicted easily recognizable public buildings and monuments. Such paintings and prints conveyed a powerful image of the city as a harmonious and ordered metropolis, across which decorously spaced groups of pedestrians and travellers pass with comfort and ease.

# Brief Biographies

**Joseph Van Aken** (1699?–1749) Flemish-born painter who worked in Antwerp before coming to London at the beginning of the 1720s. First achieved success as a painter of conversation pieces that offered subtle meditations on morality and behaviour. A painting such as *An English Family at Tea* (*c*.1720), wittily plays off the figures of demurely seated women and confidently standing men, the imagery of tea and wine drinking, and the depiction of the carpeted interior and the spacious outdoors, and places the associations of each in delicate balance. Like his near contemporary and fellow immigrant **Angellis**, Van Aken also produced numerous images of Covent Garden market. He went on to specialize as a drapery painter working for a variety of artists, including **Highmore** and **Ramsay**. In 1748 he travelled to Paris with Hogarth and **Hayman**. He died in London the following year.

**Peter Angellis** (1685–1734) French-born painter who trained in Antwerp before settling in London in 1716. Produced numerous paintings of Covent Garden and its market which juxtaposed the square's urbane architecture with the plebeian figures of market women. Angellis also produced a number of early conversation pieces which, while highly sophisticated in their technique and seemingly decorous in their manner, clearly played on the edges of satire and licentiousness. These include *A Company at Table* and *A Musical Assembly* of *c*.1719. Angellis also painted three of the images of *The Reign of Charles I* that were engraved as a series of prints published in 1728. The artist left for Rome in 1728 and appears never to have returned to England.

**George Bickham Jnr** (1706?–71) English draughtsman and engraver who was trained by his father, George Bickham Snr, himself famous as an engraver of medley prints and calligraphy. By the late 1730s, the younger Bickham had become as well known as his father, and was marked by his willingness and ability to turn his hand to a wide variety of work. He increasingly specialized in graphic satire, however, and produced scores of political prints in the early 1740s that were relentlessly antagonistic to the ruling Whig Ministry of Sir Robert Walpole. These prints are frequently characterized by an extraordinary wit and inventiveness, which typically takes the form of a playful adaptation and re-assemblage of pictorial and textual materials drawn from a wide variety of sources.

**Canaletto** (1697–1768) The most famous topographic painter of mid-eighteenth-century Europe. Canaletto travelled to London from his native Italy in 1746, and for the next decade or so he produced a series of remarkable views of England's capital, focusing in particular on the River Thames, on the newly redeveloped public spaces of Westminster and on modern structures such as Westminster Bridge, which linked the two. He can be said to have produced a view of the city that conformed to the perspectives of his élite patrons and that defined the sprawling, chaotic metropolis pictured by Hogarth as an ordered, subtly partitioned space, dominated by the architectural symbols of civic authority, urban improvement and aristocratic power. Canaletto also painted views of Vauxhall and Ranelagh Gardens, two important sites of leisure and entertainment in eighteenth-century London, and produced a number of designs for prints representing views within Vauxhall. He returned to Italy in 1755.

**Bartholomew Dandridge** (1691–*c*.1755) Painter of portraits and conversation pieces, and an important propagator of a new, 'polite' mode of modern art through his designs for booksellers and print-publishers. Born in London, by the end of the 1720s he was producing paintings such as *The Price Family* (*c*.1728) which redrew the social and leisurely rituals of polite society according to the Rococo model offered by French painters such as Antoine Watteau (1684–1721). He continued painting portraits that focused on the skills and accessories of politeness, such as *A Lady Reading 'Belinda' Beside a Fountain* (*c*.1740). At the same time, he was in demand as a designer and illustrator of books and manuals concerned with the codes of polite comportment and conversation, including François Nivelon's influential *Rudiments of Genteel Behaviour*, published in 1738.

**Thomas Gainsborough** (1727–88) Celebrated portrait and landscape painter who, having been brought up in Suffolk, studied painting at London's St Martin's Lane Academy during the 1740s. He developed his craft as a portraitist in Ipswich and Bath between 1748 and 1774, and having regularly exhibited at the Society of Artists exhibitions after 1761, he moved to London and established a highly successful painting practice. His portraits fused the poses, gestures and scale of **Van Dyck's** canonical aristocratic portraits of

the previous century with a modern pictorial language of flickering paintwork and vibrant colour which glamourized the fashionability and beauty of his female subjects and dramatized his male sitters' membership of an élite, urbane culture. Gainsborough was also famous for his landscape paintings and 'fancy' pictures, which offered his metropolitan public a powerful fantasy of rural harmony and plebeian deference. Having been a regular exhibitor at the Royal Academy, he controversially seceded from the institution in 1784 and subsequently held a series of one-man shows in his showroom at Schomberg House in Pall Mall.

**Hubert-François Gravelot** (1699–1773) French draughtsman and painter who trained in the studio of the famous painter François Boucher (1703–70) before travelling to England sometime in 1732 or 1733 to work on the English edition of Picart's *Ceremonies et Coutumes Religieuses des Peuples Idolatres*. During his fourteen-year stay in England he obtained, in the words of **George Vertue**, 'a reputation of a most ingenious draughtsman' and made himself a considerable fortune. He designed hundreds of images, including book illustrations, trade cards, portrait surrounds, fashion plates and graphic satires, and occasionally executed paintings such as *The Judicious Lover* of c.1745. His work was celebrated for introducing into English graphic art a modern and exceptionally elegant French rhetoric of drawing, and typically focused on the protagonists, settings and rituals of polite society. Gravelot's methods and style were further disseminated through his position as a teacher of drawing at the St Martin's Lane Academy.

**Gawen Hamilton** (1697?–1737) Scottish painter who established a successful portrait practice in London before his early death. He specialized in conversation pieces and was Hogarth's main rival in the genre. Indeed, his close associate and friend **George Vertue**, writing immediately after Hamilton's death, declared that 'it was the opinion of many Artists … that he had some peculiar excellence wherein he out did Mr Hogarth in Colouring and easy gracefull likeness'. Hamilton produced conversation pieces depicting aristocrats such as the 3rd Earl of Oxford and his family, as well as subjects whose status was built on commerce, such as the family of James Porten. He also, in 1734–5, painted a fascinating portrait of a 'club of artists' – including Vertue and Hamilton himself – gathered together at the King's Arms in New Bond Street.

**Francis Hayman** (1708–76) English artist whose early career was dominated by his work as a scene painter at Goodman Fields Theatre and Drury Lane during the 1730s. Later in the same decade, however, he began establishing himself as a painter of portraits and conversation pieces. In the early 1740s he supervised the painting of numerous canvases designed to hang at the back of open-air dining booths at Vauxhall pleasure gardens. Hayman's works for this scheme ranged from laundered images of rustic ritual and painted illustrations of scenes from Samuel Richardson's best-selling novel *Pamela*, to depictions of high society at play. In effect, these pictures offered a new kind of scene-painting, in front of which the diners at Vauxhall became actors in a modern form of polite theatre, played out under the eyes of other visitors to the gardens. Hayman went on to paint more elevated subjects for Vauxhall, including episodes from Shakespeare and, in the 1760s, scenes from the Seven Years' War. He also collaborated with **Gravelot** in producing book illustrations and with Hogarth in the decorative scheme at the Foundling Hospital. A highly active and central figure within the London art world, he also helped organize the founding of the Society of Artists in 1761 and the Royal Academy in 1768.

**Joseph Highmore** (1692–1780) English painter who, having attended **Kneller's** Academy from 1713, decided to give up a burgeoning career in the law. He first set himself up as a portraitist with a studio in the City of London, but moved to the more conducive environment of Lincoln's Inn Fields in 1723. From there, Highmore produced numerous portraits and conversation pieces, the most famous of which is undoubtedly *Mr Oldham and his Friends* of c.1740, which celebrates middle-class ease and masculine sociability in its depiction of four men gathered informally around a table, variously holding pipes and wine glasses, leaning over chair backs and sitting in their seats with stolid self-satisfaction. In the mid-1740s Highmore, following Hogarth's example and recognizing the increasing fashionability of the pictorial series as a category of modern art, produced twelve paintings – quickly reproduced as engravings – which depicted scenes from Samuel Richardson's *Pamela*. Highmore subsequently became involved in the decorative scheme at the Foundling Hospital and, later still, contributed paintings to the first public exhibitions in London during the early 1760s. He retired from painting in 1762.

**Thomas Hudson** (1701–79) English portrait painter who, after training with the painter and art theorist Jonathan Richardson (1665–1745), established a successful practice in London. Hudson became the most popular portraitist working in London in the 1740s, producing numerous single, double and family portraits. He contributed to the decorative scheme at the Foundling Hospital by donating a portrait of its architect Theodore Jacobsen (d.1772). Hudson was important as a teacher as well as an artist. He took a number of talented pupils into his studio, including **Sir Joshua**

**Reynolds**, who began to challenge his former master's supremacy in the fashionable portrait market from the mid-1750s onwards. Hudson, having earned enough to buy himself a villa in Twickenham in 1755, gradually retired from painting altogether after this date.

**Sir Godfrey Kneller** (1646–1723) German-born painter who, after training in Amsterdam and travelling to Italy, settled in London around 1675. He soon achieved success painting portraits of the English and Scottish aristocracy, and rose to particular prominence after executing a portrait of Charles II in 1678. In 1682 he established a palatial portrait studio in Covent Garden, which he ran in a famously efficient and businesslike manner, delegating responsibility for all but the most crucial aspects of a portrait to assistants and working in close collaboration with local engravers. His position as court portraitist was made official in 1688 and he was knighted in 1692. Among his most innovative and influential works was a series of portraits of members of the Whig Kit-Cat club, painted between 1700 and 1720, which established a new pictorial ideal of informal, urbane masculinity. In 1711 Kneller set up the first Academy of Painting to be established in Britain.

**Bernard Picart** (1673–1733) French-born engraver who eventually settled in Amsterdam, where he converted to the Protestant faith and established a thriving studio. Picart's graphic work was highly respected, widely emulated and consistently publicized within the early eighteenth-century print market in London, where it achieved a status comparable to that later enjoyed by the work of his compatriot **Gravelot**. Picart produced elegant and frequently highly complex designs for, among other things, large- and small-scale book illustrations, graphic satires and independent engravings depicting scenes from mythology.

**Allan Ramsay** (1713–84) Scottish artist and theorist who, having travelled to Italy in 1736, set himself up in 1738 as a portrait painter in London and Edinburgh. His practice soon thrived, partially thanks to his extraordinarily sensitive portraits of women, which quickly became popular within élite culture. He also produced a series of remarkable male portraits, including an imposing image of the physician and connoisseur Dr Richard Mead, which he donated to the Foundling Hospital in 1747. The artist also wrote the *Dialogue on Taste* in 1755 in response to Hogarth's *The Analysis of Beauty*. Ramsay was made painter to the king in 1760, and thereafter devoted most of his artistic energies to supervizing the production of the monarch's official portraits.

**Sir Joshua Reynolds** (1723–92) English painter who first came to prominence in the mid-1750s when he set up a portrait practice in London after returning from an extended trip to Italy. Over the next four decades, Reynolds became arguably the most commercially and critically successful painter in England. He was famous for fusing the conventions of high portraiture with the pictorial vocabulary of Old Master paintings and artistic forms derived from classical sculpture. Between 1769 and 1790 Reynolds set out an elevated agenda for modern British art in the *Discourses* he delivered as the first President of the Royal Academy of Arts. These *Discourses*, together with the institutional power he wielded as President, exerted a significant influence on the development of British painting and art criticism in the second half of the eighteenth century.

**Sir James Thornhill** (1675–1734) The most famous English painter in the first three decades of the eighteenth century. Thornhill worked as an assistant on decorative wall-paintings and was soon being commissioned to design and execute such paintings himself. He worked in great country houses such as Chatsworth and in prominent public buildings such as the Royal Naval Hospital at Greenwich. At Greenwich he produced a particularly ambitious and complex series of allegorical wall-paintings, begun in 1708, that established him as a serious English challenger to visiting French and Italian decorative painters such as Louis Laguerre (1663–1721) and Sebastiano Ricci (1659–1734). Between 1714 and 1717 he decorated the interior of the dome of St Paul's Cathedral with depictions of episodes from the life of St Paul. Thornhill also painted portraits and conversation pieces and designed book illustrations. He was a director of **Kneller's** Academy of Painting and, between 1716 and 1720, its governor. In 1718 he was appointed Serjeant Painter to the King and was knighted in 1720. He set up his own informal Academy of Arts in his Covent Garden house in the mid-1720s, where it is likely he first came into regular contact with Hogarth, who married his daughter Jane in 1729.

**Anthony Van Dyck** (1599–1641) Antwerp-born painter who came to enjoy international fame as a portraitist, at different times practising in the Low Countries, Italy and England. Having trained in the studio of Peter Paul Rubens (1577–1640), he first travelled to London in 1620 before spending the next decade working in mainland Europe. He returned to London in 1632, when he was knighted and made principal painter to the king. Over the next nine years, before his early death at the age of forty-two, he produced numerous portraits of the English nobility and royal family that were widely celebrated for their technical sophistication and their brilliant evocation of aristocratic elegance.

**Gerard Vandergucht** (1696–1777) English-born engraver and print-dealer who came from a family of graphic artists originating from Antwerp. Trained in the rudiments of engraving by his father Michael, and attending Louis Chéron (1660–1725) and John Vanderbank's (1694–1739) Academy in St Martin's Lane, he embarked on a varied career by becoming a well-known and versatile printmaker who engraved from his own designs and, more commonly, reproduced the designs of others. As in the case of other talented graphic artists, he worked on a wide range of goods, including graphic satires, book illustrations and trade cards. He also reproduced pictures by Old Masters such as Nicolas Poussin (1594–1665) and modern history painters such as **Thornhill**. At the same time, he developed a successful parallel career as a print-seller, print publisher, print cleaner and stationer. He occupied a variety of substantial shops across the centre and west of the city, and ended up settling in premises at Brook Street, near Grosvenor Square, from where he sold prints, drawings, artists' materials and instruments, and also offered his services as a picture repairer.

**George Vertue** (1684–1756) Engraver and antiquary who is most famous for his highly informative notes on the history of English art and the personalities and events of the contemporary art world. These notes, now collected in various volumes of the *Walpole Society Journal*, formed the basis for Horace Walpole's multi-volume *Anecdotes of Painting in England* (1765–71), the first modern history of English art. Vertue was himself a successful artist, producing painstakingly crafted reproductive engravings for both private patrons and the open market. He was also an active member of the worlds of art and learning in London and the provinces, joining the Academy for Painting set up by **Kneller** early in the century, becoming engraver to the Society of Antiquaries in 1717 and later enjoying the support of men such as Edward Harley, 2nd Earl of Oxford, and Frederick, Prince of Wales. His notebooks, which focus on the everyday details of his own life as an engraver as well as on the schemes, achievements and failures of other notable British painters, sculptors, architects and engravers, offer an unrivalled insight into the activities and attitudes of artists, patrons and audiences in this period.

**Samuel Wale** (1721–86) Versatile and prolific painter and print designer. Wale was apprenticed to a goldsmith in 1735 but went on to make a career as an independent painter and draughtsman. He studied at the St Martin's Lane Academy, worked as a decorative painter in partnership with **Hayman** and produced three roundel paintings for the Foundling Hospital. More frequently he executed designs for topographical prints, including views of the interior and exterior of the Foundling Hospital, and numerous detailed views of the Vauxhall Pleasure Gardens. He also produced scores of book illustrations and trade cards. He was a founder member of the Royal Academy in 1768, and became its first Professor of Perspective. His career was brought to a halt by a paralytic stroke in 1778.

## Key Dates

Numbers in square brackets refer to illustrations

### The Life and Art of William Hogarth

### A Context of Events (primarily English)

1697   William Hogarth born in the City of London, 10 November

            1702   Accession of Queen Anne (after William III)

1713   Hogarth apprenticed to the silver engraver Ellis Gamble

            1714   Accession of George I

1718   Death of Hogarth's father, Richard

1720   In April, Hogarth sets up shop as an independent engraver, with business premises at his mother's house in Long Lane. In October he subscribes to the St Martin's Lane Academy

            1720   South Sea Bubble crisis

1721   Produces his first satirical engraving, *The South Sea Scheme* [9] and probably begins work on the small *Hudibras* illustrations [6, 7]

            1722   Robert Walpole is made First Lord of the Treasury

1724   Publishes *The Bad Taste of the Town* [11]. Now living and working in Little Newport Street near Leicester Fields (now Leicester Square). At the end of the year Hogarth joins Thornhill's free academy in Covent Garden

1725   Works on large plates of *Hudibras* [13, 14]

1726   Large *Hubibras* plates published in February

            1727   Accession of George II

1728   Hogarth paints first *Beggar's Opera* canvases [24]. Begins career as painter of conversation pieces such as *The Assembly at Wanstead House* [28], which Hogarth starts painting this year

            1728   Opening performances of John Gay's *The Beggar's Opera*

1729   Marries Jane Thornhill. Moves with his wife to the Little Piazza, Covent Garden. Busy with conversation pictures

1730   Begins work on the painted version of *A Harlot's Progress*. Paints *The Wollaston Family* [29]

1731   Hogarth and his wife move into the Thornhill house in the Great Piazza, Covent Garden. Hogarth begins subscription for the engraved *A Harlot's Progress*

            1731   First performance of George Lillo's *The London Merchant, or the History of George Barnwell*

1732   *A Harlot's Progress* published as a set of engravings [40–5]. Hogarth travels on a 'peregrination' across Kent with a group of friends in May

1733   Moves to Leicester Fields. Begins advertising the forthcoming prints of *A Rake's Progress* [56–64, 69]

            1733   Excise Crisis, Walpole introduces highly unpopular Excise Bill and is then forced to withdraw it from Parliament

1734   Working on *A Rake's Progress*

            1734   General Election

| | The Life and Art of William Hogarth | | A Context of Events |
|---|---|---|---|
| 1735 | Passage of the Engravers' Copyright Act, known as 'Hogarth's Act'. Publication of eight prints of *A Rake's Progress*. Sets up new St Martin's Lane Academy. Begins *The Pool of Bethesda* [80] for St Bartholomew's Hospital | | |
| 1736 | Finishes *The Pool of Bethesda* | 1736 | Gin Riots |
| 1737 | Opens subscription for *The Four Times of Day* [70–3]. Finishes painting of *The Good Samaritan* [81] at St Bartholomew's Hospital | | |
| 1738 | Paints *The Strode Family* [30]. Publishes prints of *The Four Times of Day* | | |
| 1739 | Appointed governor of the Foundling Hospital | 1739 | War of Jenkins's Ear (to 1741): England declares war on Spain after a British merchant is accused of smuggling and tortured; Victory at Portobello. Foundling Hospital given Royal Charter |
| 1740 | Paints portrait of Captain Coram [89], which he donates to the Foundling Hospital | 1740 | War of the Austrian Succession (to 1748). Publication of Samuel Richardson's *Pamela* |
| 1741 | Begins painting *Marriage à la Mode* [102–8] | 1741 | General Election |
| 1742 | Working on *Marriage à la Mode* | 1742 | Resignation of Sir Robert Walpole |
| 1743 | Travels to Paris to find engravers for *Marriage à la Mode* | 1743 | George II defeats the French at Battle of Dettingen. Henry Pelham becomes prime minister |
| | | 1744 | Installation of 'Broad-bottom' administration in government. France declares war on Britain |
| 1745 | Publication of *Marriage à la Mode* in May. Completes *The Painter and his Pug* [frontispiece, 100] | 1745 | French defeat the Duke of Cumberland in the Battle of Fontenoy. French-backed invasion of Scotland and northern England by Jacobite troops |
| 1746 | Publishes etching of Lord Lovat [183]. Paints *Moses Brought before Pharoah's Daughter* for the Foundling Hospital [91] | 1746 | Jacobites defeated in Battle of Culloden |
| 1747 | Presentation of *Moses Brought before Pharoah's Daughter* at the Foundling Hospital. Publication of *Industry and Idleness* [118–31] | 1747 | General Election |
| 1748 | Paints *Paul Before Felix* [148]. Travels to France with a group of artist companions. Expelled from Calais on suspicion of spying. Paints *The Gate of Calais* [145–6] | 1748 | Treaty of Aix-la-Chapelle concludes peace between France and maritime powers |
| 1749 | Buys small country house in Chiswick [147]. Paints *The March to Finchley* [174] | 1749 | Westminster by-election |
| 1750 | Publication of engraved version of *The March to Finchley* | 1750 | Publication of Henry Fielding's *An Enquiry into the Cause of the Late Increase in Robberies* |
| 1751 | Publication of *Beer Street* [137], *Gin Lane* [138] and *The Four Stages of Cruelty* [139–43] | 1751 | Death of Frederick Lewis, Prince of Wales |
| 1752 | Writing *The Analysis of Beauty* [149–51] | | |
| 1753 | Publication of *The Analysis of Beauty* | | |
| 1754 | Finishes paintings of *Election* series [162–6] | 1754 | Death of Pelham. General Election. Duke of Newcastle becomes prime minister |

| The Life and Art of William Hogarth | A Context of Events |
|---|---|

1755   Publication of *The Election Entertainment*. Begins paintings for altarpiece of St Mary Redcliffe, Bristol [189–91]

1755   Publication of Samuel Johnson's *Dictionary of the English Language*

1756   Publishes two prints of *The Invasion* [161, 172–3]

1756   Beginning of Seven Years' War

1757   Appointed Serjeant Painter to the King. Paints *Self-Portrait as Serjeant Painter to His Majesty* [186] and executes portrait of the actor David Garrick and his wife [192]

1757   Pitt–Newcastle ministry

1758   Works on *The Lady's Last Stake* [194]

1759   Finishes *The Lady's Last Stake*. Presents *Sigismunda* [187, 195] to Sir Richard Grosvenor, who refuses to buy the painting

1759   Publication of first volume of Lawrence Sterne's *Tristram Shandy*

1760   Suffers illness, which lasts into following year

1760   Accession of George III

1761   Produces frontispiece and tailpiece for Society of Artists' exhibition catalogue [188, 197]. Shows seven paintings in exhibition

1761   General Election. Resignation of Pitt

1762   Sign-Painters' exhibition. Publishes *The Times, Plate 1* [177–8] in early September. Attacked by the political journalist John Wilkes in the *North Briton* later that month

1762   Resignation of Newcastle. John Stuart, 2nd Earl of Bute, becomes prime minister

1763   Publishes *John Wilkes Esqr.* [182]

1763   Peace of Paris. Resignation of Bute

1764   Publishes *The Bathos* in April [199]. Dies on the night of 25–6 October. Buried at St Nicholas's Church, Chiswick on 2 November

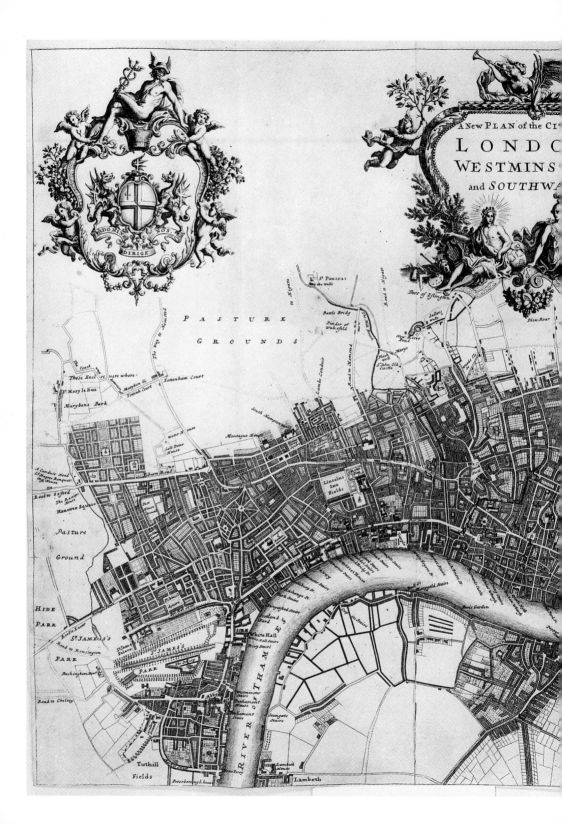

A New PLAN of the CI

LONDO

WESTMINS

and SOUTHWA

St Pancras
the wells

Part of Estington

Battle Bridg

Pinder of
Wakefield

Sadler's
Wells

Blew Boar

New River Head
New River Pond

Black
Mary's
St John Old
Castle

Lambs Conduit

PASTURE

GROUNDS

These Enclosures where

St Mary le Bon

Marybone Park

Marybon St

Tottenham Court

Tottenham Court

Road to Islington

South Hampton

water house

Montague House

St Peter House

Tiburn Road

Lincolns
Inn
Fields

A Conduit Head

Banqueting House

Road to Oxford

The Rosamond House

Hanover Square

Boris Garden

Pasture

Ground

HIDE

PARK

St James's
Palace

White Hall

Scotland
Yard

PARK

St James's
Road to Kensington

PARK

Buckingham house

Road to Chelsey

Westminster
Stairs

Parliament
House

Parliament
Stairs

RIVER OF THAM

Stangate
Stairs

Tuthill

Fields

Peterborough house

Horseferry

Lambeth house

Lambeth

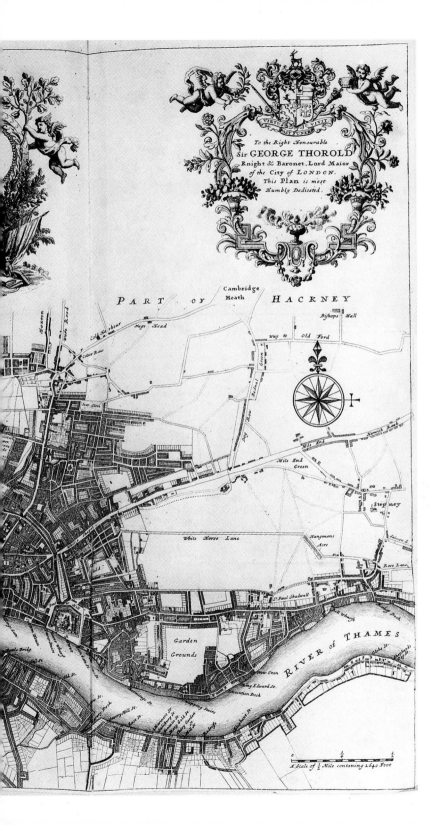

**John Strype,**
*Plan of the City
of London,*
*c.1720*

## Further Reading

### General

Brian Allen (ed.), *Towards a Modern Art World* (New Haven and London, 1995)

John Barrell (ed.), *Painting and the Politics of Culture: New Essays on British Art 1700–1850* (Oxford, 1992)

David Bindman, *Hogarth* (London, 1981)

—, *Hogarth and his Times: Serious Comedy* (London, 1997)

John Brewer, *The Pleasures of the Imagination: English Culture in the Eighteenth Century* (London, 1997)

Joseph Burke, *English Art 1714–1800* (Oxford, 1976)

Timothy Clayton, *The English Print 1688–1802* (New Haven and London, 1997)

David Dabydeen, *Hogarth, Walpole and Commercial Britain* (London, 1987)

Elizabeth Einberg (ed.), *Manners and Morals: Hogarth and British Painting, 1700–1760* (exh. cat., Tate Gallery, London, 1987)

—, *Hogarth the Painter* (exh. cat., Tate Gallery, London, 1997)

Elizabeth Einberg and Judy Egerton, *Tate Gallery Collections, II: The Age of Hogarth, British Painters born 1675–1709* (London, 1988)

Lawrence Gowing, *Hogarth* (exh. cat., Tate Gallery, London, 1971)

Mark Hallett, *The Spectacle of Difference: Graphic Satire in the Age of Hogarth* (New Haven and London, 1999)

Paul Langford, *A Polite and Commercial People: England 1727–1783* (Oxford, 1989)

Joachim Moeller (ed.), *Hogarth in Context: Ten Essays and a Bibliography* (Marburg, 1996)

Frederic Ogée (ed.), *The Dumb Show: Image and Society in the Works of William Hogarth* (Oxford, 1997)

Ronald Paulson, *Emblem and Expression: Meaning in English Art of the Eighteenth Century* (London, 1975)

—, *Popular and Polite Art in the Age of Hogarth and Fielding* (Notre Dame and London, 1979)

—, *Breaking and Remaking: Aesthetic Practice in England 1700–1820* (New Brunswick and London, 1989)

—, *Hogarth's Graphic Works* (3rd revised edn, London, 1989)

—, *Hogarth, vol.1, The 'Modern Moral Subject', 1697–1732* (London, 1991)

—, *Hogarth, vol.2, High Art and Low, 1732–1750* (Cambridge, 1992)

—, *Hogarth, vol.3, Art and Politics, 1750–1764* (Cambridge, 1993)

Iain Pears, *The Discovery of Painting: The Growth of Interest in the Arts in England, 1680–1768* (New Haven and London, 1988)

Roy Porter, *English Society in the Eighteenth Century* (London, 1982)

—, *London: A Social History* (London, 1994)

Michael Snodin (ed.), *Rococo: Art and Design in Hogarth's England* (exh. cat., Victoria & Albert Museum, London, 1984)

David H Solkin, *Painting for Money: The Visual Arts and the Public Sphere in Eighteenth-Century England* (New Haven and London, 1993)

Jenny Uglow, *Hogarth: A Life and a World* (London, 1997)

George Vertue, *Notebooks*, 6 vols, The Walpole Society Journal, 18, 20, 22, 24, 26 and 30 (1930–55)

Ellis Waterhouse (with an introduction by Michael Kitson), *Painting in Britain 1530–1790* (New Haven and London, 1994)

### Chapter 1

Timothy Clayton, *The English Print 1688–1802*, op. cit., pp.1–102

David Dabydeen, *Hogarth, Walpole and Commercial Britain*, op. cit.

Mark Hallett, 'The Medley Print in early Eighteenth-Century London', *Art History*, vol.20, no.2, (1997), pp.214–37

—, *The Spectacle of Difference*, op. cit., pp.1–92

Ronald Paulson, *Hogarth's Graphic Works*, op. cit., pp.1–74

—, *Hogarth, vol.1*, op. cit., pp.1–94

R Raines and K Sharpe, 'The Story of Charles I', *Connoisseur*, 184 (1973), pp.38–46

Jenny Uglow, *Hogarth: A Life and a World*, op. cit., pp.1–129

### Chapter 2

David Bindman and Scott Wilcox (eds), *'Among the Whores and Thieves': William Hogarth and The Beggar's Opera* (New Haven and Farmington, 1997)

Elizabeth Einberg (ed.), *Manners and Morals*, op. cit.

Rica Jones, 'The Artist's Training and Techniques', in Elizabeth Einberg (ed.), *Manners and Morals*, op. cit, pp.19–22

Ronald Paulson, *Hogarth, vol.1*, op. cit., pp.155–236

Iain Pears, *The Discovery of Painting*, op. cit.

Charles Saumarez Smith, *Eighteenth-Century Decoration: Design and the Domestic Interior in England* (New York, 1993)

David H Solkin, *Painting for Money*, op. cit., pp.27–105

## Chapter 3

Sophie Carter, '"This Female Proteus": Representing Prostitution and Masquerade in Eighteenth-Century English Popular Print Culture', *Oxford Art Journal*, 22.1 (1999), pp.55–79

Michael Godby, 'The First Steps of Hogarth's *Harlot's Progress*', *Art History*, vol.10, no.1 (March 1987), pp.23–7

Mark Hallett, *The Spectacle of Difference*, op. cit., pp.93–130

David Hunter, 'Copyright Protection for Engravings and Maps in Eighteenth-Century Britain', *The Library*, 6th series, vol.9 (1987)

Ronald Paulson, *Hogarth, vol.1*, op. cit., pp.237–336

## Chapter 4

*Apollo*, vol.148, no.437 (August 1998). Special issue on *A Rake's Progress*

Mark Hallett, *The Spectacle of Difference*, op. cit., pp.1–26

David Kunzle, 'Plagiaries by Memory of the Rake's Progress', *Journal of the Warburg and Courtauld Institutes*, 29 (1966), pp.311–48

Ronald Paulson, *Hogarth, vol.2*, op. cit., pp.15–47 and pp.127–51

Christina Scull, *The Soane Hogarths* (London, 1991), pp.7–30

Sean Shesgreen, *Hogarth and the Times of Day Tradition* (London, 1983)

## Chapter 5

Donna T Andrew, *Philanthropy and Police: London Charity in the Eighteenth-Century* (Princeton, NJ, 1989)

Elizabeth Einberg (ed.), *Manners and Morals*, op. cit., pp.172–87

Ronald Paulson, *Hogarth, vol.2*, op. cit., pp.77–103 and pp.323–56

David H Solkin, *Painting for Money*, op. cit., pp.157–213

—, 'Samaritan or Scrooge? The Contested Image of Thomas Guy in Eighteenth-Century England', *Art Bulletin*, vol.78, no.3 (September 1996), pp.467–84

## Chapter 6

Robert L S Cowley, *Marriage A-la-Mode: A Review of Hogarth's Narrative Art* (Manchester, 1983)

Judy Egerton, *Hogarth's Marriage A-la-Mode* (exh. cat., National Portrait Gallery, London, 1997)

Elizabeth Einberg (ed.), *Manners and Morals*, op. cit., pp.153–9

Ronald Paulson, *Hogarth, vol.2*, op. cit., pp.203–45

Michael Snodin (ed.), *Rococo*, op. cit.

## Chapter 7

Mark Hallett, *The Spectacle of Difference*, op. cit., pp.197–233

Ronald Paulson, *Emblem and Expression*, op. cit., pp.58–78

Sean Shesgreen, 'Hogarth's *Industry and Idleness*: A Reading', *Eighteenth-Century Studies*, 9 (1976), pp.569–98

Peter Wagner, *Reading Iconotexts: From Swift to the French Revolution* (London, 1995), pp.101–38

Barry Wind, '*Gin Lane* and *Beer Street*: A Fresh Draught', in Joachim Moeller (ed.), *Hogarth in Context*, op. cit., pp.130–42

—, 'Hogarth's *Industry and Idleness* Reconsidered', *Print Quarterly*, 14.3 (1997), pp.235–51

## Chapter 8

Joseph Burke, *William Hogarth. The Analysis of Beauty* (Oxford, 1955)

Mark Girouard, *The English Town* (New Haven and London, 1990) pp.127–44

William Hogarth (edited by Ronald Paulson), *The Analysis of Beauty* (New Haven and London, 1997)

Robert Jones, *Gender and the Formation of Taste in Eighteenth-Century Britain: The Analysis of Beauty* (Cambridge, 1998), pp.37–78

Ronald Paulson, *Hogarth, vol.3*, op. cit., pp.56–151

Michael Podro, *Depiction* (New Haven and London, 1998), pp.109–46

## Chapter 9

Herbert Atherton, *Political Prints in the Age of Hogarth: A Study in the Ideographic Representation of Politics* (Oxford, 1964)

M Dorothy George, *English Political Caricature to 1792: A Study of Opinion and Propaganda* (Oxford, 1959)

Ronald Paulson, *Hogarth's Graphic Works*, op. cit., pp.161–70 and p.179–85

—, *Hogarth, vol.3*, op. cit., pp.152–84 and pp.362–412

Christina Scull, *The Soane Hogarths*, op. cit., pp.32–46

Jenny Uglow, *Hogarth: A Life and a World*, op. cit., pp.538–61 and pp.663–83

**Chapter 10**

John Brewer, *The Pleasures of the Imagination*, op. cit., pp.201–51

Joseph Burke, *William Hogarth. The Analysis of Beauty*, op. cit., pp.201–31

Michael Kitson, 'Hogarth's "Apology for Painters"', *Walpole Society Journal*, 41 (1968)

M J H Liversidge, *William Hogarth's Bristol Altarpiece* (Bristol, 1989)

Ronald Paulson, *Hogarth, vol.3*, op. cit., pp.204–35 and pp.302–61

David H Solkin, *Painting for Money*, op. cit., pp.174–90 and pp.247–76

**Chapter 11**

David Bindman, *Hogarth and his Times*, op. cit., pp.64–70

Draper Hill (ed.), *Mr Gillray the Caricaturist* (London, 1965)

—, *The Satirical Etchings of James Gillray* (New York, 1976)

David Hockney (edited by Nikos Stangos), *David Hockney by David Hockney: My Early Years* (London, 1976)

—, *That's the Way I See It* (London, 1993)

Julian Treuherz, *Victorian Painting* (London, 1993)

# Index

Numbers in **bold** refer to illustrations

# Acknowledgements

This book was written over the spring and summer of 1999, and I would like to thank all those who offered their familial support and friendship over this period. Life between March and October was made better, as always, by Roger and Linda Hallett, Bart Hallett, Rafe, Anna and Olivia Hallett Kisby, Bill and Jeanne Murphy, and David, Pauline, Billy and Matilda Smith. I would also like to thank those friends and colleagues who broadened my thinking and stimulated my enthusiasm for this project, who include Brian Allen, John Barrell, David Bindman, John Brewer, David Peters Corbett, Mathew Craske, Gregory Dart, Diana Donald, Amanda Lillie, Richard Marks, Martin Myrone, Christopher Norton, Angela Rosenthal, Michael Rosenthal, David Solkin, Katie Scott and Michael White. My students at the University of York have patiently helped me develop many of the arguments made in this book, and rightly raised their eyebrows at many that have been rejected. Finally, I would like to thank the editors and picture researchers at Phaidon – Pat Barylski, Sarah Hopper, Giulia Hetherington and, especially, Cleia Smith – who have steered me in the right direction from start to finish.

M H

For Lynda and Katherine

# Photographic Credits

Advertising Archives, London: 212; Albright-Knox Art Gallery, Buffalo, New York: Seymour H Knox Fund through special gifts to the fund by Mrs Marjorie Knox Campbell, Mrs Dorothy Knox Rogers and Seymour H Knox, Jr (1945) 194; Allen Memorial Art Museum, Oberlin College, Ohio: R T Miller Jr Fund (1942) 95; Governors of the Royal Hospital of St Bartholomew's, London: 80–1; Steve Bell, Brighton: 209, 211; Birmingham Museums and Art Gallery: 24, 196; Bridgeman Art Library, London: 26, 32, 76, 202, Bridgeman/Bearsted Collection 70, 73, Bridgeman/Grimsthorpe Trust 71–2, Bridgeman/Thomas Coram Foundation 89, 91–4, 174, Bridgeman/Yale Center for British Art 25, 34, 77; Bristol Museums and Art Gallery: 189–91; British Library, London: shelf mark Cup363gg30(3) 39, shelf mark 241129 65, shelf mark 225e23 66, shelf mark 11633e22 75, shelf mark 1457e14 112, 114, shelf mark 1079i15 (3) 132, C40m10 (110) 133, shelf mark 11785de4 134, shelf mark 1812a28 160, shelf mark 1609/2478 169, shelf mark 5108 176; British Museum, London: 1, 3, 8–9, 11–17, 21–3, 40–45, 48–9, 51–2, 64, 74, 88, 101, 113–4, 109, 117, 119–127, 129–131, 135–9, 141–4, 149–50, 152, 154–5, 167–8, 172–3, 175, 177, 180–5, 188, 197–9, 207–8, 210; Burghley House Collection, Stamford: 37; Christie's Images, London: 201; Dalmeny House, Edinburgh: by permission of the Earl of Rosebery 36; Fitzwilliam Museum, Cambridge: 97–8, 205; Trustees of Goodwood House, Chichester: 153; Giulia Hetherington: 84–6; David Hockney No 1 US Trust, Los Angeles: 206; Hounslow Archives and Local Studies: 147; courtesy of Leicester City Museums Service 29; Honourable Society of Lincoln's Inn, London: 148; Manchester City Art Galleries: 203; Museum of London: p.340–1; National Gallery, London: 33, 82, 103–8, 156, 171; National Gallery of Ireland, Dublin: 2; National Monuments Record, London: 83; National Museums on Merseyside/Walker Art Gallery, Liverpool: 193, 204; National Portrait Gallery, London: 20, 96, 186; NatWest Group Art Collection: 179; Philadelphia Museum of Art: John H McFadden Collection 28; RMN, Paris: 90; The Royal Collection © 2000, Her Majesty Queen Elizabeth II: 19, 53, 170, 192; by courtesy of the Trustees of Sir John Soane's Museum, London: 56–63, 162, 164–66; Society of Antiquaries, London: 78; Sotheby's Picture Library, London: 27, 47; Tate Gallery, London: frontispiece, 30, 67, 100, 146, 195; University of York Library: 79; Williams College Museum of Art, Williamstown, Mass: gift of C A Wimpfheimer, Class of 1949 110; the Provost and Fellows of Worcester College, Oxford: 116; Yale Center for British Art, Paul Mellon Collection, New Haven: 35; York City Art Gallery: 99

**Phaidon Press Limited**
Regent's Wharf
All Saints Street
London N1 9PA

First published 2000
© 2000 Phaidon Press Limited

ISBN 0 7148 3818 7

A CIP catalogue record for this book is
available from the British Library.

Typeset in Caslon, chapter numbers
in Shelley

Printed in Singapore

**Cover illustration** Detail from *Self-Portrait as
Serjeant Painter to His Majesty*, *c.*1758 (see p.292)